10|04

O.S.
741.65
CAR

4x (12/13)

6x 6/17

WESTERN HEMISPHERE

MAP of DISCOVERY

THE ART OF
NATIONAL GEOGRAPHIC

A CENTURY OF ILLUSTRATION

ALICE A. CARTER

FOREWORD BY STEPHEN JAY GOULD

AFTERWORD BY CHRISTOPHER P. SLOAN

NATIONAL
GEOGRAPHIC

WASHINGTON, D.C.

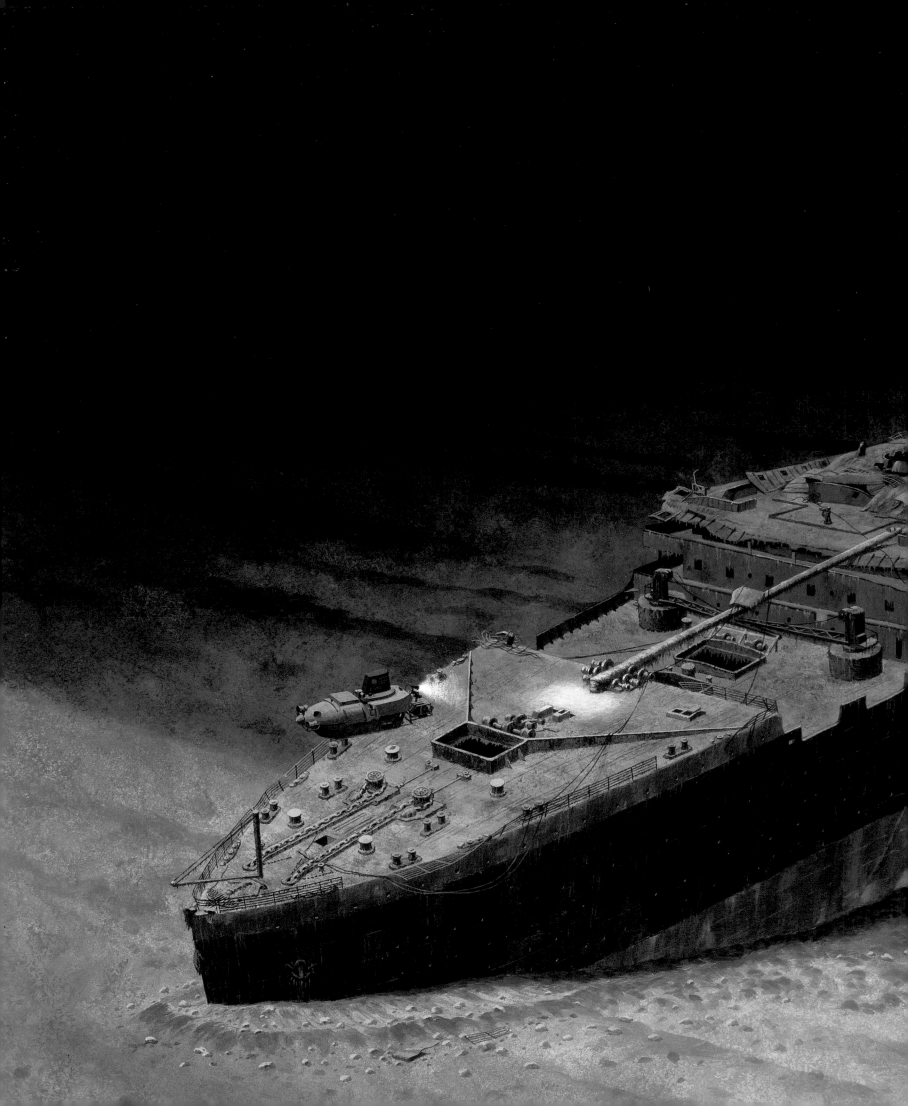

THE ART OF
NATIONAL GEOGRAPHIC

CONTENTS

FOREWORD: THE JOY AND NECESSITY OF ILLUSTRATION
BY STEPHEN JAY GOULD 6

INTRODUCTION BY ALICE A. CARTER 13

(PRECEDING PAGES) PIERRE MION
"A LONG LAST LOOK AT TITANIC" *December 1986*

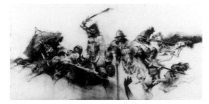

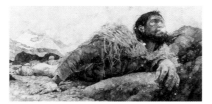

(TITLE PAGE) **NEWELL CONVERS WYETH**
EASTERN HEMISPHERE

The Joy and Necessity of Illustration

Stephen Jay Gould

ammals originated at the same time as dinosaurs, some 200 million years ago. The first mammals were small, probably nocturnal creatures, living at the periphery of terrestrial ecosystems dominated by dinosaurs. This subordinate status persisted for about 120 million years — that is, for the first two-thirds of mammalian history — until the impact of a large extraterrestrial object triggered the extinction of dinosaurs (along with about 50 percent of all animal species) 65 million years ago.

Following this basically fortuitous removal of dinosaurs, mammals finally began to proliferate toward their current successes. One relatively small branch of mammals adopted an arboreal lifestyle (literally in the branches). This modest lineage evolved two outstanding variations upon the original and ancestral mammalian design — first, much more flexible limbs, hands, and feet for scurrying along branches and jumping from one to the next; second, a keen sense of vision for daytime life in a three-dimensional world filled with more dangerous airspace than safe landing points (where a miss after a leap usually meant a splattered death on the ground and the instant conversion of a promising breeder into a Darwinian cipher).

Today, this group — the order Primates (monkeys, apes, and humans) — includes about 200 species. As another evolutionary reason for the success of primates, big eyes and binocular vision seem to correlate with large brains. The earliest primates possessed both keener vision and larger brains than any other contemporary mammals of similar body size. That linkage has persisted throughout the past 65 million years, presumably because bodily movement in a maximally complex (and dangerous) three-dimensional arboreal world requires an unusual amount of neurological control and complexity. In other words, and to caricature a complex story slightly, primate eyes have always led primate brains to maximal sizes among mammals.

This short evolutionary romp through our history may strike readers as an odd way to introduce a book on the history of illustration in NATIONAL GEOGRAPHIC magazine. But I make this appeal to our deep biological origins for a definite purpose. Intellectuals often tend to demean or to underestimate the importance of illustrations. I should like to allay the slight insecurity thus conveyed and to restore full confidence in the inevitable primacy of visual representation. This book represents a human essence at its best.

John's Gospel opens by stating: "In the beginning was the word." Although this famous line bears a different meaning in its original context, I think that scholars usually live by its literal import. That is, they assume that speech (or writing) represents the quintessential act of the human mind (for language — and I do not dispute this point — forms the centerpiece of our evolutionary distinctiveness from all other creatures). Therefore, they reason, feelings and arguments must be conveyed primarily by words. Any buttressing modality — a diagram or illustration, for example — can only rank as a reinforcing frill, perhaps to be tolerated for beauty or clarity, but really only a crutch at base and therefore not truly necessary. How else can we explain the absence of pictures from so many densely scholarly works that cry out for visual relief? How else can we understand the relegation of illustrations to inconvenient gatherings bound far away from the textual pages that require their input?

In the world of scholarship, I have never encountered a more foolhardy argument than this degradation of illustration. Primates are, above all, visual animals from the very core and beginning of our evolutionary construction

(the reason for my introductory paragraphs). The word is a latecomer. The famous pseudo-Confucian statement that "one picture is worth a thousand words" surely had validity, but it does not proceed nearly far enough. We cannot state a legitimate formula at all, whatever the imbalance in bulk across the equal sign. A good picture provides insights that words cannot convey at any length.

Humans learn visually and integrate pictorially. Until the last generation or two (and even now in many lands and cultures) the vast majority of humans were illiterate. From the caves at Chauvet (the oldest dated European Paleolithic art at 35,000 years before the present) to the Sistine ceiling to Guernica, we have conveyed the integrating sagas of our cultures, and the pains and conundrums of our lives, by images — either as evoked in the mind's eye by great storytellers, or depicted literally, as to the nonreading faithful in the glass storychambers of medieval cathedrals.

The visceral impact of illustration can hit us so hard in the primal gut that we must often fear the enormous power of pictures to distort, particularly in the hands of clever demagogues. More benignly, but with equal prejudicial power, standard icons create some of the most powerful myths of our cultures. The historical Jesus, for example, cannot possibly have been tall, bearded, and white — the first two perhaps (although Byzantine art depicts him clean-shaven, as does Michelangelo in the Sistine Chapel), but surely not the last. In fact, we have no textual evidence at all about the actual person. The only potential hint — that he may have been short! — founders on a grammatical ambiguity. Luke's Gospel states that when Jesus entered Jericho, a supporter named Zacchaeus wished to see his master, but "could not for the press, because he was of little stature" (Luke 19:3). So Zacchaeus "climbed up into a sycamore tree to see him." But did Zacchaeus have to climb because he himself was too short to see Jesus amidst the crowd, or because Jesus was too short to stand out above the surrounding multitude?

The history of illustration forms one of the noblest chapters in the annals of science, not a peripheral backwater. The growth and refinement of knowledge in my own field of paleontology, for example, can be defined by pictures as significantly as by words — from the crude woodblocks of Gesner in 1565 (the first published illustrations of fossils), to the gorgeous handpainted engravings of Knorr and Walch in the mid-18th century, to the wonderful chromolithographs of Agassiz's fossil fishes in the 1830s. Great illustrators rank among the most important figures in the history of knowledge about the natural world — from the sumptuous beauty of Maria Merian's plates of insects, drawn from life in Surinam in the late 1600s, to the stunning accuracy of Wandelaer's anatomical and botanical engravings for Albinus and Linnaeus in the early 18th century, to the more celebrated ornithological paintings of Audubon, Gould, and Edward Lear (an illustrator by profession and a writer of limericks only by avocation) in the 19th century.

Among pictorial media, illustration may seem hard to defend, at first, in light of a general belief in the superior veracity of photographs. Why should a magazine launched after the invention of photography and dedicated above all to the diffusion of accurate information to spur our appreciation of nature ever use illustrations when photographs supposedly cannot lie? Alice Carter writes in her introduction that "the Society has a long-standing policy never to use a painting when a photograph would serve" — and I do understand, and can even support, this approach to building the trust of readers and fostering a

love of nature as an entity with robust existence quite apart from human hopes and impacts.

But an apologetic feeling about illustration in comparison with photography rests upon a doubly false argument based on invalid dichotomies — first, the erroneous distinction, and status ordering, of science as factual (objective and accurate) from art as imaginative (subjective and compromised by personal intrusion); and second, the equation of photography with science and illustration with art.

I do not wish to defend illustration by demeaning photography in any way. Rather, the debunking of standard myths about photography can only benefit this wonderful and transforming achievement of human inventiveness, while also freeing illustration from two imposed stigmata — "superseded" and "subjective." We may thus establish a partnership of equality between photography and illustration — two different and equally indispensable approaches to supplying the preeminent visual component for any proper grasp of nature's wonder.

Two common claims, if valid, should have driven illustration to extinction long ago, or at least to peripheral subservience (for use only in rare circumstances inaccessible to photography).

1. Some people argue that photography must extinguish art throughout the domain of representational imagery, thus driving art to its only appropriate realm of subjective experience — a trend that spawned the spectrum of 20th-century movements from cubism to abstract expressionism. But art, contrary to this claim, has retained its vigor in the representational realm, gaining strength instead from the new definitions and avenues that photography imposed upon old complacencies. Impressionism discovered a new representational mode for genuine sensory experience. Even the most representational styles of hyperrealism retain their force with new salience in contemporary painting — for example, in portraying major philosophical concepts in brilliant pictorial epitome (Mark Tansey) or in constructing challenging imaginary scenes made entirely of real organisms (Alexis Rockman).

2. Others have maintained that photography guarantees an objective rendering of the natural world, while art can never expunge subjective human choice. I trust that this old canard can be dismissed without much comment, given the blurred boundaries now so routinely exploited in photographic manipulation for humor (from *Zelig* to *Forrest Gump*), political prevarication, and high art.

If either of these arguments were valid, they should have operated with special force in science and the depiction of nature, where the supposed objectivity of photography should have driven illustration to rapid extinction. Instead, as this wonderful book proves, illustration retains full vigor and continues to expand in importance. The illustrations of this book shine forth with beauty and truthful integrity (often the same, as Keats proclaimed in his famous lines on a Grecian urn: "beauty is truth, truth beauty").

The illustrations of this book exemplify the two great categories of natural phenomena that photography cannot depict at all (and in principle) or that illustration renders with greater accuracy and insight than photography can ever hope to achieve.

1. *Greater visibility and definition.* I often surprise friends by telling them that technical scientific publications continue to use illustrations extensively, often in preference to photography, and that professional illustrators often hold full-time jobs in museums and other scientific institutions. The common impression that

photographs must always be more objective, or informative, than drawings lapses into incoherence when we analyze the issue more deeply. Yes, a photo shows what a machine records under definite material conditions and numerous decisions about lighting, exposures, et cetera, made by a photographer (or, increasingly, by automatic devices within a camera). In this trivial sense – that the personal "hand" of the photographer does not etch or color the "canvas" – a photo may seem more objective than a drawing. But human decisions of what, when where, why, scale, framing, timing, number, frequency, and a thousand other variable factors launch the taking of every photograph. I don't have to put my literal pen to paper in order to insert my human presence into a visual representation.

Illustrations can surpass photographs in expressing more accurate details with greater clarity for a wide variety of important phenomena in natural history. Consider, for example, the three major categories that lead almost all professional naturalists to use illustration rather than photography in many technical publications: *Details* (better shown by the clear lines and shadings of a drawing than in the jumbled ensemble of a photograph); *Layerings*, as in skin above muscles above organs above bones in human bodies (distinguished with maximal clarity in drawings that can emphasize separations and penetrate opacities); *Scale*, (the very large and the very small, where photography remains difficult, impossible, or merely unsatisfactory).

2. *Reconstructions.* We often need to depict entire scenes that cannot be photographed for a panoply of reasons, ranging from the practical and utterly pedestrian (it could have been photographed, but no one was there with a camera) to the physically ineluctable (historical scenes that unfolded before the invention of the camera, not to mention before the evolution of humans). Moreover, we often wish to portray a collective scene (all the birds that live in my backyard throughout the year, but never together at a photographable moment), or a general truth that must juxtapose parts of many actual snapshots into one primal scene. Would anyone question the integrity of N. C. Wyeth, (as quoted on pages 13–14), explaining to Gilbert Grosvenor why he needed to paint Byrd's flight to the North Pole. not with the actual weather conditions of the historical day, but with the archetypal background of both the general realities and our symbolic meanings of the frozen north?

Finally, the influence of great illustrators has been profound and controlling – the major reason for insisting, as this Society has always done, upon an ethic of maximal accuracy. If we ask: What 20th-century figure has been most responsible for setting the public's conception (also the scientist's for that matter) of dinosaurs? – the answer can only be Charles R. Knight, the great artist of prehistoric life who graced the pages of NATIONAL GEOGRAPHIC with his wonderful (and scrupulously accurate) paintings for decades, not any excavator. anatomist, researcher, or wordsmith from the community of scientific professionals.

Illustration must not be viewed as a dark force from the subjective, egotistical, idiosyncratic world of art, one that must be tamed and controlled to enter the realm of natural history. Illustration is an essential friend and helpmeet to all other modes of description that allow a primarily visual creature like *Homo sapiens* to appreciate the natural world with accuracy and understanding. Art and science are not antagonists, but indivisible components of a totality called human creativity.

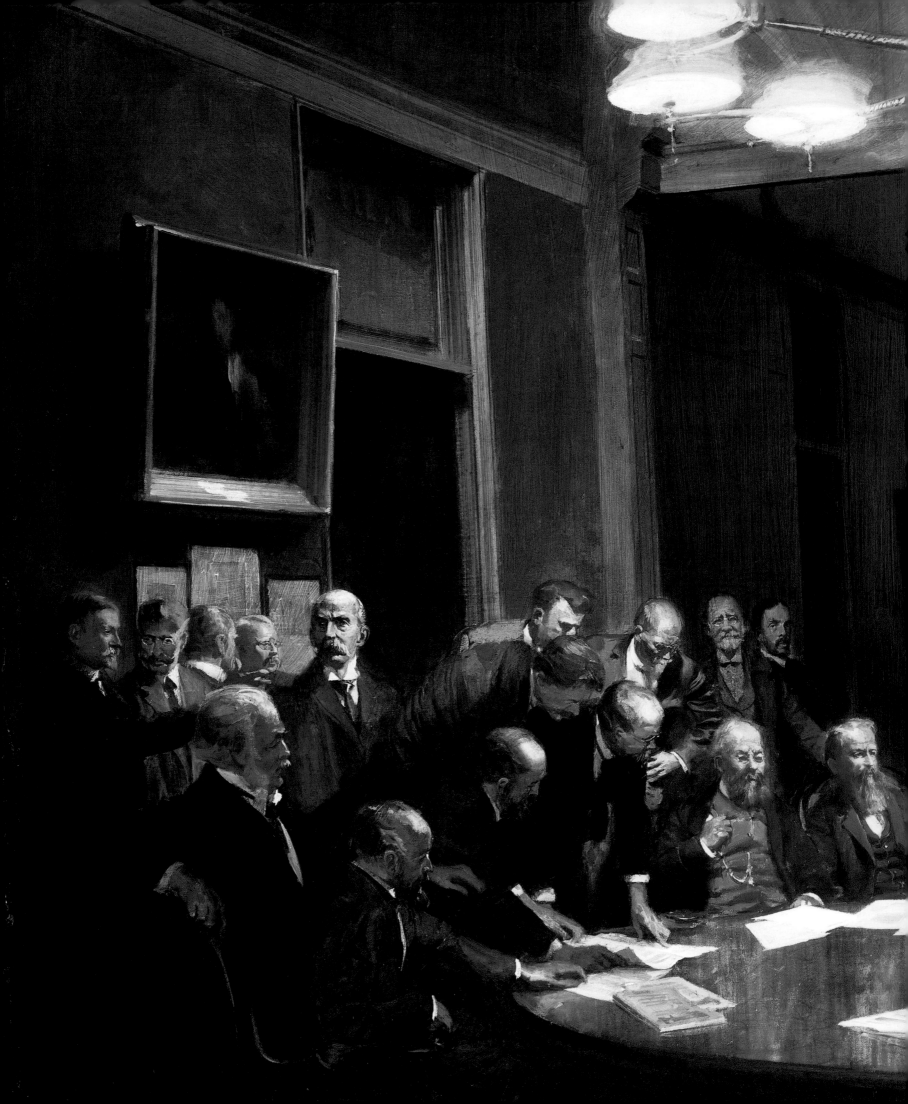

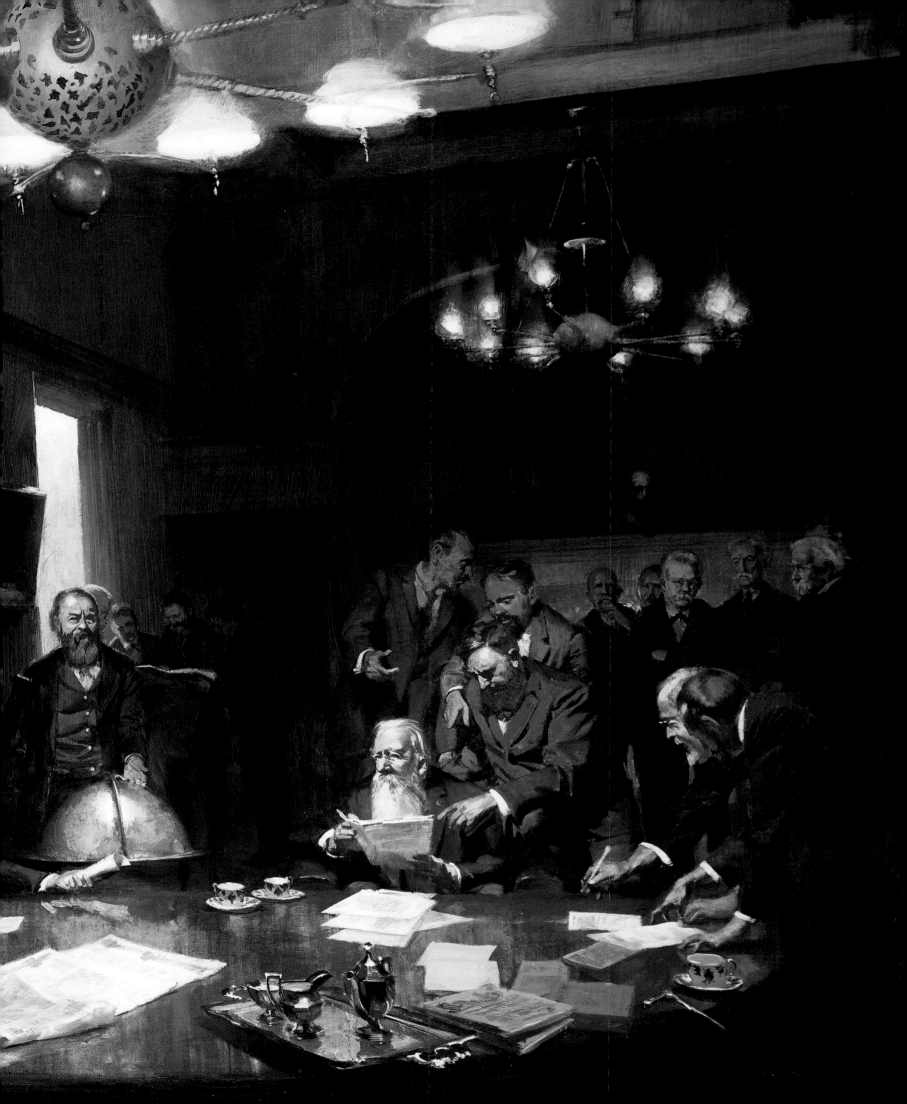

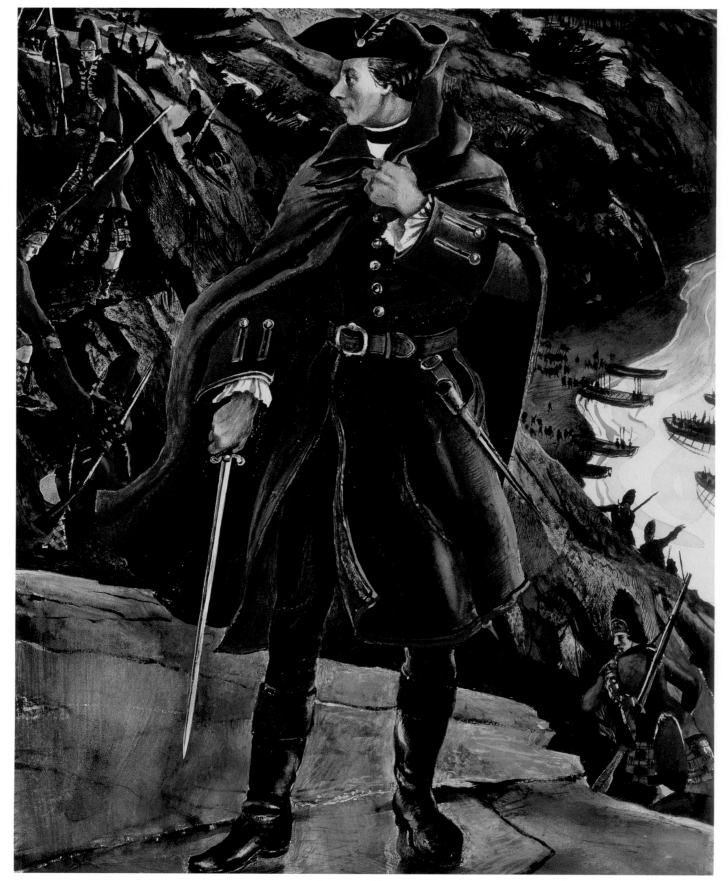

12

ANDREW WYETH
"THE BRITISH WAY" *April 1949*

It may seem ironic that the National Geographic Society, an organization justly celebrated for its use of extraordinary photography, has also been a constant champion of illustration. For more than a hundred years, it has commissioned and published thousands of stunning paintings and drawings by internationally acclaimed painters such as Andrew Wyeth as well as by artists whose names are not widely known. Their scientifically detailed and artistically compelling illustrations – ranging from intricate prehistoric reconstructions to futuristic astronomical projections – have slipped unobtrusively onto the pages of the Society's publications. The artwork blends so successfully with the text and photographs that the reader is often unaware that an image has bypassed the camera's lens and filtered instead through an artist's imagination. Nevertheless, many of the paintings that have appeared in National Geographic Society publications profoundly affect the way we visualize our world.

In 1926, when John Oliver La Gorce, Vice President of the Society, commissioned the eminent illustrator Newell Convers (N. C.) Wyeth, Andrew's father, to create a series of five murals to "heighten the geographic atmosphere of the Society's offices," Wyeth was at the peak of his fame. His illustrations for much-loved children's classics, including *Treasure Island, The Last of the Mohicans, Robin Hood,* and *Mysterious Island,* graced bookshelves in homes throughout the nation. He also had extensive experience as a muralist and was well respected for his historically accurate and emotionally evocative canvases for the Missouri State Capital in Jefferson City, the First National Bank in Boston, and the Hotel Roosevelt in New York City.

After completing the first two murals for the Society successfully – "The Discoverer" and "The Caravels of Columbus" – Wyeth encountered a problem while compiling his research for the third, "Through Pathless Skies to the North Pole." The painting was to commemorate Richard E. Byrd's triumphant 1926 flight, but Wyeth became concerned about the project when he interviewed Commander Byrd at King's Bay, on the Norwegian island of Spitsbergen. Everyone associated with the expedition assured the artist that the historic flight occurred on an unremarkable day when, as Wyeth recalled later, "sky, ice, and water were bereft of any particular sensational effect." Nevertheless, Wyeth decided that Byrd's momentous accomplishment could not be described effectively by reproducing the prevailing weather conditions. To be authentic, the canvas would have to evoke the mystery of the frozen north, the stark magnificence of the seemingly endless ice floe, and the excitement in the hearts of the triumphant adventurers. Mixing equal parts of hyperbole and logic, Wyeth explained his viewpoint in a letter to Society President Gilbert H. Grosvenor.

When we the masses, who ploddingly crawl around on the face of the earth, think of the winged explorers in glorious flight over the Arctic, we conceive their adventures in majestic and almost fantastic terms of clouds, fogs, shimmering lights, queer elongated shadows, a sun rolling in a flattened curve over the brim of the globe, strange formations of ice, and phenomenal twisting "leads" exposing arctic waters of hues suggesting awesome depths.

Now – it is some of this that I must get into my mural canvas. The mystery and glamor of the Frozen North must be expressed in moving terms for the layman. I must pack into this panel not what one man saw on a particular day at a particular time, but what all men have seen and felt as they

swept above the ice pack and the more northern areas of endless ice. To do this requires a greater latitude than the restricted visual experience of Commander Byrd allows me.

His point was won. Wyeth was allowed to depict the emotional as well as the physical reality of the event, and the resulting canvas was a great success. When Richard Byrd viewed the painting for the first time, he turned to John La Gorce and said, "Jack, this is one of the proudest moments of my life, and I don't feel worthy of the honor that is done me by this great artist, Mr. Wyeth, and the National Geographic Society. This magnificent canvas of our plane in the North Polar region thrills me more than I can tell you, and I shall never forget it." All five of the N. C. Wyeth murals were reproduced in NATIONAL GEOGRAPHIC magazine over the course of the next year.

The Society has a long-standing policy never to use a painting when a photograph would serve, yet there are events and situations that a camera cannot capture. Wyeth appreciated photography and valued its accuracy, but he knew that the camera is fallible. His approach to authenticity – to achieve a balance between visual and emotional perception – has been the goal of National Geographic Society artists for the past century.

The National Geographic Society was founded in 1888, at the beginning of what is now known as the "golden age" of illustration. During the Civil War, sketches artist-correspondents made of bloody battle scenes and war-torn cities appeared in weekly magazines and whetted the national appetite for illustrated periodicals. After the conflict and well into the 20th century, most successful magazines continued to be illustrated by artists, not photographers. NATIONAL GEOGRAPHIC was an anomaly during this period and one of the few conspicuous proponents of photography. Thus, in the early summer of 1913, when Editor Gilbert H. Grosvenor published a major series of color paintings by the renowned ornithological illustrator Louis Agassiz Fuertes, the resulting plates came as a surprise to many Society members, who had come to expect the innovation of photography. Grosvenor, however, had sound reasons for using artwork. The first was practical. Fuertes's paintings had been commissioned initially for a pamphlet issued by the United States Department of Agriculture, and when Grosvenor heard that all 100,000 copies of the circular were gone in a week, he knew there was great interest in the subject. His second reason was philosophical and had to do with the purpose of the Society.

Grosvenor was committed to the National Geographic Society's mission to "increase and diffuse geographic knowledge"; and to achieve that goal, he used whatever means were most effective. For documenting the topography of mysterious lands, exotic customs, foreign cultures, and scientific expeditions, the camera was an invaluable tool. When an archetypal image was called for, however, illustration was clearly the best vehicle. Fuertes's paintings provided readers with classic portraits of common birds, a contribution to ornithological knowledge that Grosvenor felt was important. He spared no expense to assure that Fuertes's delicate colors – subtle shades that the camera was as yet unable to capture – were reproduced with absolute accuracy in the magazine. At great expense, the sheets of paper were sent through color presses eight times, for a total of nearly two million impressions. The resulting article, "Fifty Common Birds of Farm and Orchard," became a standard text. In many households, it

was the definitive means of identifying backyard visitors such as the robin, the bluebird, the russet-backed thrush, and the melodious rose-breasted grosbeak.

Historically, illustrators have excelled at creating iconographic images. The Republican elephant, the Democratic donkey, and the American Santa Claus were all born in the mind of illustrator Thomas Nast, whose satirical illustrations appeared in *Harper's Weekly* in the late 1800s. Frederic Remington's ebullient paintings chronicling the last days of the Old West sparked a mythology that has fired the imagination of the nation for over a century. Although the origin of the American Uncle Sam figure is ambiguous, James Montgomery Flagg's World War I recruiting poster, "I Want You," provides the consummate portrait. Charles Dana Gibson's Gibson girl set the standard for women's fashions at the turn of the century; and during a single month in the early 1920s, Joseph Leyendecker's drawing of the Arrow Collar man generated 17,000 fan letters covering a full spectrum of emotions, from vows of eternal love to at least one threat of suicide. During World War II, Norman Rockwell painted a series of covers for the *Saturday Evening Post* portraying the adventures of a young soldier, Willie Gillis, who became America's surrogate son as war-weary readers dreamed of peace and longed for the day when their own sons would come marching home.

In the same way that these illustrators created lasting cultural images, National Geographic artists have

John Oliver La Gorce in his office at the National Geographic Society headquarters in Washington, D. C., September 1933. La Gorce began working for the Society in 1905; over the course of a 54-year tenure, he eventually became President of the Society and Editor of NATIONAL GEOGRAPHIC. (Photograph by Clifton R. Adams.)

shaped our awareness of science, history, and geography. Fuertes was the first of many talented National Geographic artists who would catalogue flora and fauna in the pages of Society publications. In the nineteenth century, the monumental task of surveying comprehensively the Earth's diverse plant, insect, and animal life held great interest for both scientist and layman. This fascination also coincided with technological advances that made travel to remote regions less perilous, and expeditions sent to explore unknown territories often returned with spectacular finds. By the early 20th century, this great effort was not yet complete. Numerous animals and plants had yet to be described, fossil finds were enigmatic, trackless jungles and vast deserts were still unexplored, the North and South Poles had not been reached, and the depths of the sea were inaccessible, black as night, and shrouded in mystery.

National Geographic artists made important contributions to this effort to explain the complexity of the living world through taxonomic classification. Following his 1913 contribution, Louis Agassiz Fuertes illustrated eight more articles categorizing birds and animals before his untimely death. Hailed as John James Audubon's successor in 1895, when he was just 21, his work was highly respected and certainly would be more visible today had his car not collided with a train in 1927, ending his life at the age of 53. Fuertes's work influenced a succession of illustrators who continued the task of describing plants and animals.

Beginning in 1915, botanical illustrator Mary Eaton spent ten years supplying NATIONAL GEOGRAPHIC with six hundred meticulously rendered watercolors of American wildflowers. Charles R. Knight's association with

NATIONAL GEOGRAPHIC began in 1913 and spanned 30 years, during which he reconstructed prehistoric plants and animals. From 1921 to 1939, staff artist Hashime Murayama painted watercolors of fish with a flowing, graceful line and an eye for accuracy that inspired Editor Gilbert Grosvenor to claim Murayama counted every scale.

Else Bostelmann accompanied scientist William Beebe to the waters off Bermuda, where Beebe and his associate, Otis Barton, squeezed themselves into the two-ton steel ball they dubbed the Bathysphere and were lowered into the sea on a cable paid out from their research barge. Beebe and Barton descended more than 1,426 feet — deeper than anyone had previously ventured. The Bathysphere was a primitive craft that sometimes leaked ominously, yet the pair of explorers

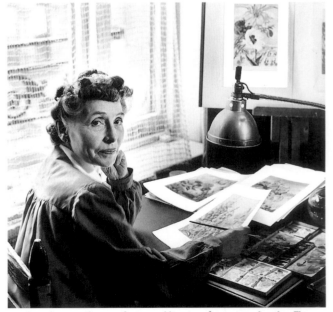

A regular contributor to Society publications for over two decades, Else Bostelmann is pictured here preparing watercolors for a 1947 NATIONAL GEOGRAPHIC article. (Photograph by B. Anthony Stewart.)

emerged from these forays exhilarated by discoveries of creatures that had never been seen before. While the memory was still fresh in his mind, Beebe would send for Else Bostelmann. It was she who made his recollections come alive. Using notes and his own crude drawings, Beebe would work with Bostelman until, little by little, each new species materialized, refined by the imagination of both scientist and artist, the proportion, color, and size exactly right. It was difficult work since Beebe often glimpsed a particular fish for only a few seconds. As an indication of Beebe's respect for her work, when he described one of Bostelmann's illustrations of a new species christened abyssal rainbow gars, he wrote, "they swam slowly and stiffly out of my sight, leaving in my mind only what the artist has drawn."

Natural history is one area of scientific investigation that has profited from artistic interpretation, but there have been many others. In the 1930s, NATIONAL GEOGRAPHIC initiated a succession of comprehensive articles on ancient civilizations, beginning with the extraordinary cultures of the Western Hemisphere. Artists Herbert M. Herget and W. Langdon Kihn were commissioned to provide illustrations for this important endeavor. A generation culled its impressions of the Maya, Inca, and Aztec from Herget's paintings. His reconstructions of these lost kingdoms were delineated in flat, broad colors and rounded shapes so reminiscent of archaeological finds that they might have been painted from life. Kihn spent more than ten years working with Matthew Stirling, Chief of the Bureau of Ethnology of the Smithsonian Institution, on a series of 125 vibrant paintings of the Indians of North America. He traveled the continent by car, train, boat, horseback, and canoe,

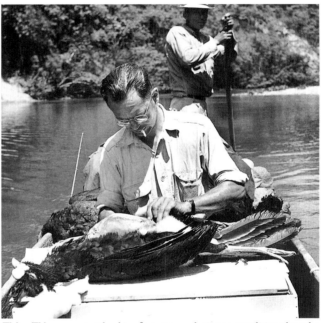

Walter Weber preparing the skin of a curassow during an expedition along the upper Rio de las Plias in Vera Cruz, Mexico, 1943. A skilled hunter, Weber shot the bird, donated the skin to the Smithsonian, saved the bones for research, and fried up the meat for dinner. (Photograph by Richard H. Stewart.)

recording with his facile brush the last vestiges of unspoiled desert, towering forest, and honored traditions. His emotional connection to the subject matter was evident in every brush stroke. Looking back over the 14 years necessary to complete this impressive series for NATIONAL GEOGRAPHIC, Kihn wrote that he was "sometimes overwhelmed with an acute feeling of nostalgia. The friends I have made, the thousand anecdotes I recall, the life I have lived with these people, and the incomparable beauty of the wilderness where the most remote trails lead to nature's unsurpassed primeval gardens and desolate wastes, is a wealth of experience for which I will always be grateful."

N. C. Wyeth also felt the pull of nostalgia for customs and cultures on the cusp of extinction, so in 1945,

18 years after he completed his murals for the Society, he wrote to Franklin Fisher, Chief of the NATIONAL GEOGRAPHIC Illustrations Division, to propose an article on the lobstermen of Maine. Wyeth's suggestion was that the story encompass both the mysterious habits of the lobster and "the terrifically dramatic life of the lobsterman himself." The paintings he might create came alive through his imagination – boats storm-hauling in ominous swells; a lone vessel at night, girdled by a sea of brilliant phosphorescence. By July, it was agreed that Wyeth would provide the Society with four paintings and a 3,000-word manuscript – the illustrations to be rendered in oil on 39-inch wooden panels coated with a gesso ground – but the project never began. On October 19, 1945, Wyeth tragically and ironically met the same fate as Louis Agassiz Fuertes.

"The Maine American and the American Lobster," written by John D. Lucas and illustrated with photographs by staff photographer John E. Fletcher, was published in the April 1946 issue of NATIONAL GEOGRAPHIC. The text was informative; the photographs competent and accurate. Their captions describe them aptly. One photograph of an elderly man bent over his work was described, "Nowadays only old-timers cut lobster pegs by hand." Another, of a lobsterman baiting a spike, bore the legend, "Putting bait on the bait spike at sea is tricky business." A third is self explanatory, "Two comely girls select fine lobsters just out of the cooker." One can easily imagine what Wyeth might have done with the article, since, in the late thirties, he had painted several tributes to the lobsterman, whom he conceived

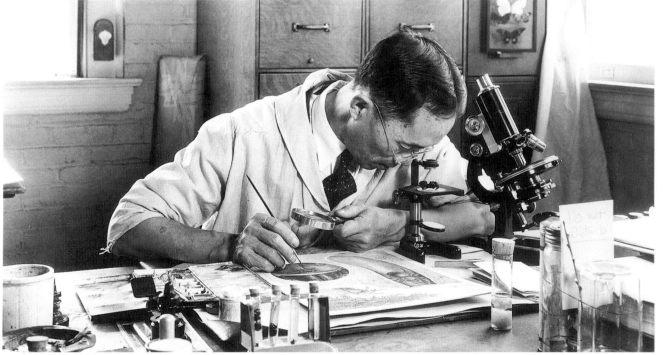

Hashime Murayama, the first staff artist for NATIONAL GEOGRAPHIC, working on a watercolor, 1932. (Photograph by Clifton R. Adams.)

as a solitary figure in a vulnerable wooden dory. He painted his protagonist against a backdrop of harsh rocks and spectacular skies, wresting his livelihood from an adversarial sea. In his proposal for the 1945 project, Wyeth wrote to Franklin Fisher that he wanted to capture all the rich details and textures of the industry from the "homey, snug activities such as trap building…to the final heroic and oft-times losing struggle with wild seas." Without a doubt, Wyeth's article would have been a classic, collected and treasured today.

Over the last century, artists have created unforgettable images explaining and clarifying the language of science for readers of National Geographic Society publications, and the unknown still beckons. In recent years, as the focus of the Society has shifted from classification to edification, from description to explanation, illustrations have been commissioned to help make this knowledge accessible. Each artist brings his or her own sense of wonder and excitement. Ned Seidler's paintings of ecological communities teem with life. James Gurney's dinosaurs kick up prehistoric dust and look out from the pages with cunning eyes. Syd Mead's interplanetary vehicles float weightlessly in the cold blue light of outer space. The images stir our imaginations now, just as they have over the years. The artist's vision has been at the forefront of some of the Society's most exciting expeditions — to exotic and diverse cultures and to the depths of the ocean, on a 65-million-year journey into the distant past, or on a voyage of discovery into our uncharted future.

—*Alice A. Carter*

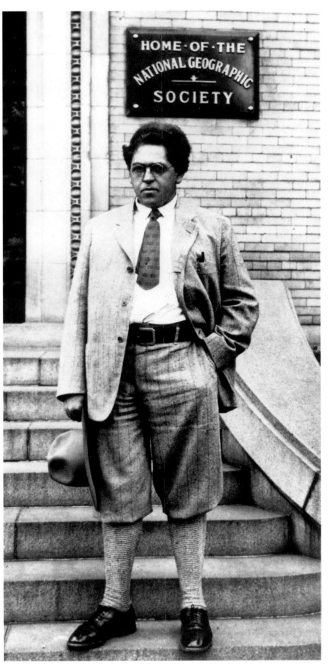

N. C. Wyeth outside the National Geographic Society, 1920s.
(Reproduced by permission of Christian C. Sanderson Museum.)

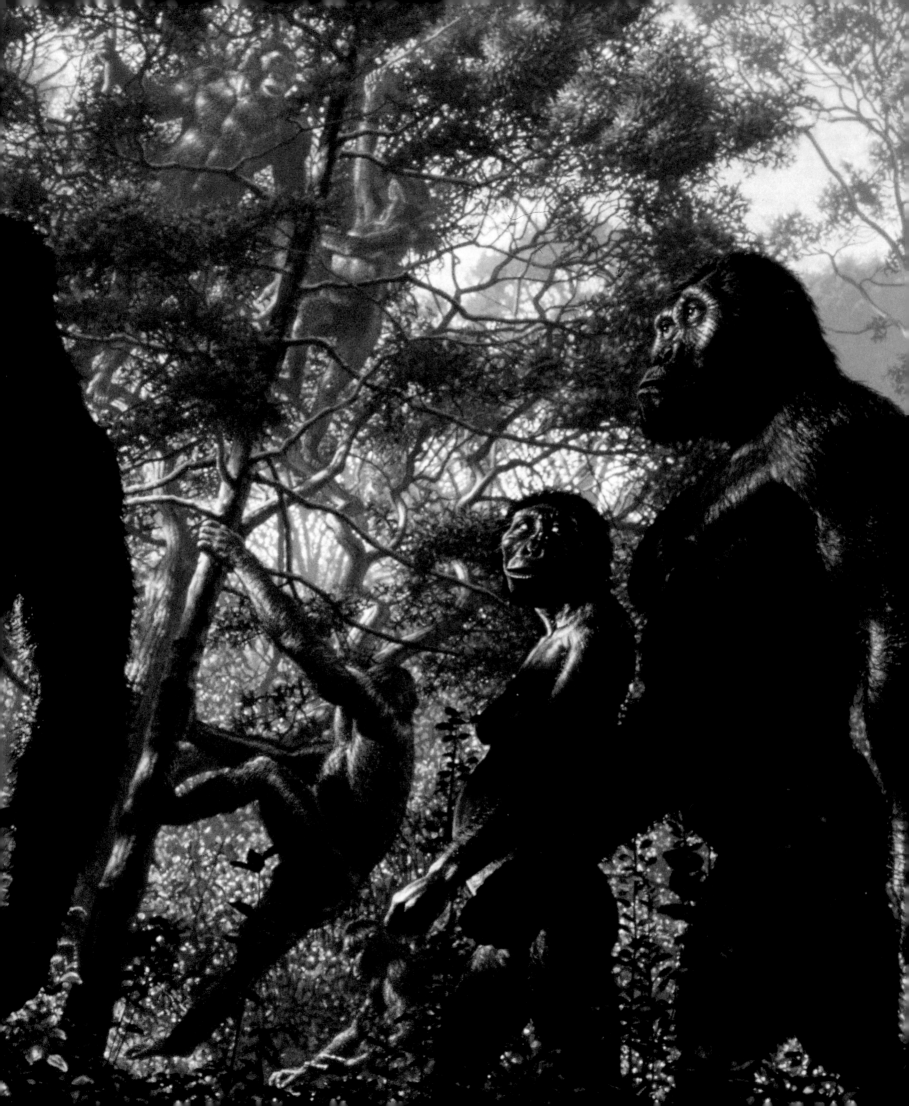

PALEONOTOLOGY
AND ANTHROPOLOGY

PALEONTOLOGY AND ANTHROPOLOGY

One of the obstacles inherent in reconstructing history, according to Pulitzer Prize–winning author Wallace Stegner, is that while the future thunders forward full of possibilities, the past often has "a sober sound." Taking the physical law known as the Doppler effect as an analogy, Stegner once wrote, "The sound of anything coming at you has a higher pitch than the sound of the same thing going away." ~ The first scientists and artists who attempted the difficult task of resurrecting the distant past for National Geographic Society publications seemed caught and held by the Doppler effect. The world they recreated was remarkably serene and operated at a very low pitch. In his ambitious 1942 NATIONAL GEOGRAPHIC article "Parade of Life through the Ages," author and noted paleontological illustrator Charles R. Knight, whom the Society considered "the world's foremost authority on prehistoric animals and man," populated the Mesozoic era with gigantic dinosaurs like *Diplodocus* and *Brontosaurus.* In spite of their awesome size, the huge beasts were inexplicably hushed. "All were harmless monsters, feeding and moving quietly about in the midst of large masses of floating vegetation and leading a placid and peaceful existence," Knight wrote. Early hominids were likewise silenced; stripped of their struggle for survival, all their likely fears and frustrations were muted by the long span of history separating their world from ours. "All in all, " Knight wrote, "the Neanderthal man was a most unprepossessing little fellow, but abundantly able to look after himself in the cold, wet, and dreary climate of the time." ~ In recent years, an avalanche of new discoveries has helped unravel ancient mysteries, enabling contemporary scientists and artists to turn up the volume on prehistory. Reversing the Doppler effect, they now reveal a past that assaults us with an intensity so magnificent that, in comparison, the future seems subdued. Scientific research has debunked the notion that dinosaurs lumbered slowly through a silent world dragging heavy tails. Artists like James Gurney, Mark Hallett, John Sibbick, and John Gurche now paint agile, intelligent creatures that hunted, battled, and cared for their young with a degree of activity that suggests an active metabolism. ~ John Gurche, who has contributed

(PRECEDING PAGES) **JOHN GURCHE**
"THE DAWN OF HUMANS: FACE-TO-FACE WITH LUCY'S FAMILY" *March 1996*

paleontological and anthropological paintings and sculpture to the pages of Society publications since 1989, has a genius for giving loud resonance to the rich textures of the past. Gurche's paintings are meticulously researched and rendered, and it is not unusual for him to spend six months on a single illustration, including the many weeks necessary for consulting with experts, making drawings and models, and studying fossils. "To make a scene work, you have to get the scientific end of it right," Gurche contends. "Otherwise, you're just creating a fantasy." ∼ Gurche's dedication to precision and accuracy enables him to bring the indistinct edges of the past into sharp focus. His paintings reach out with disarming immediacy. A *Pachycephalosaurus* caught off-balance in a crushing battle for dominance reels in the dusty air and seems to breathe in heaving gasps. A watchful *Saurolophus* tends her nest in the incendiary light of a prehistoric dawn. Hominids barely rustle the leaves as they glide through an ancient forest, nervously watchful. ∼ "The evolution of our own species is a very powerful subject that fascinates me," says John Gurche. The painting "Between Two Worlds" that introduces this chapter is the result of years of personal research and study by the artist and countless hours of consultation with scientific experts who often disagree. While finalizing the composition for the illustration, Gurche had to weigh conflicting viewpoints regarding the amount of time these early hominids might have spent in the trees, as well as a variety of opinions on how *afarensis* may have communicated. Gurche elected to have part of the group take to the treetops, and he created some degree of social consciousness within the small band. "I wanted to add some human qualities," he says. "I didn't want to take it too far, because things like language came much, much later, but I did want them to be very expressive." ∼ A desire to lend a convincing timbre to the prehistoric world is obvious in all Gurche's work, and the sound of the past he creates is not a sober one. "I come at this from the perspective of being fascinated with evolution," says Gurche, who earned degrees in geology and anthropology before deciding to become an artist. "The aesthetic power of this field is so strong that I'm surprised that all paleontologists and anthropologists are not also painters."

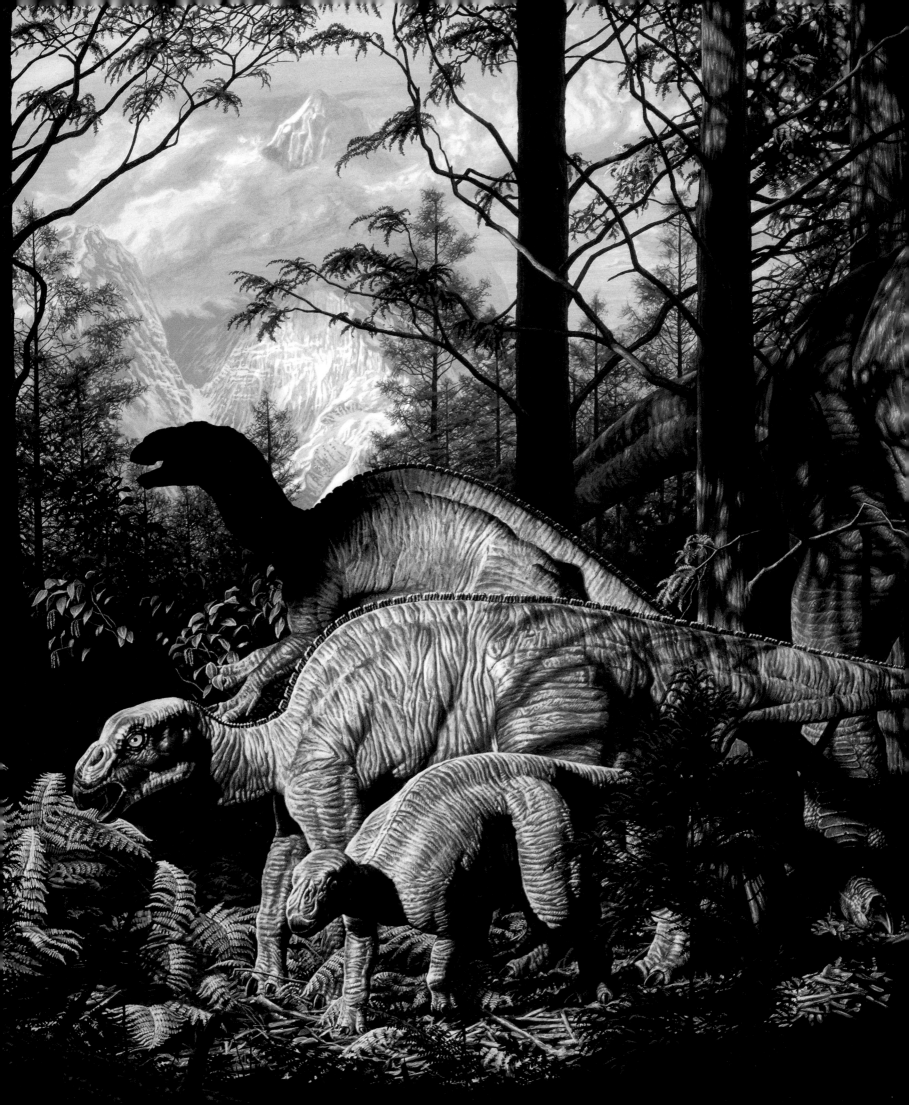

JOHN GURCHE

(LEFT) MIDNIGHT SUN GILDS ALASKA PEAKS
66 MILLION YEARS AGO AS YOUNG *EDMONTOSAURS*
BROWSE IN A CONIFER FOREST.

(FOLLOWING PAGES) BATTERING A RIVAL MALE, A
ONE-TON, THICK-SKULLED *PACHYCEPHALOSAURUS*
ESTABLISHES DOMINANCE.

———

"DINOSAURS"

January 1993

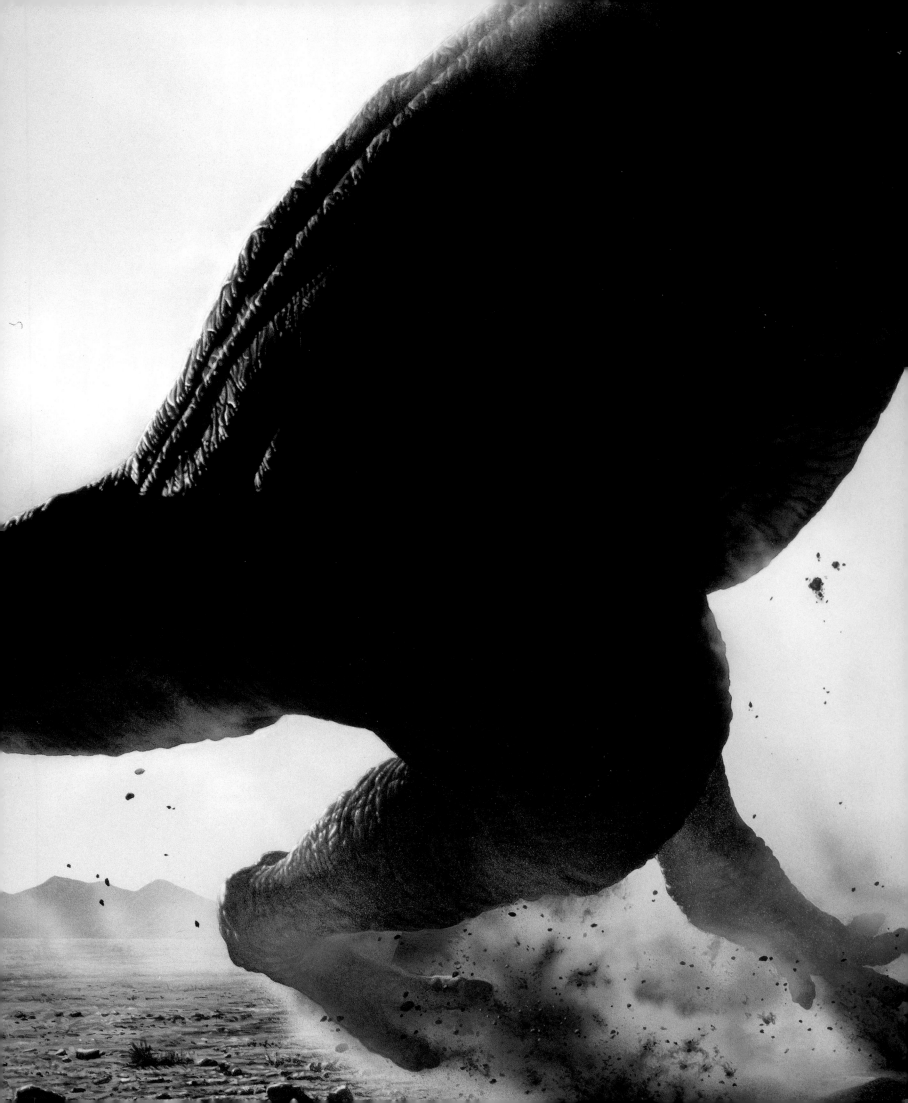

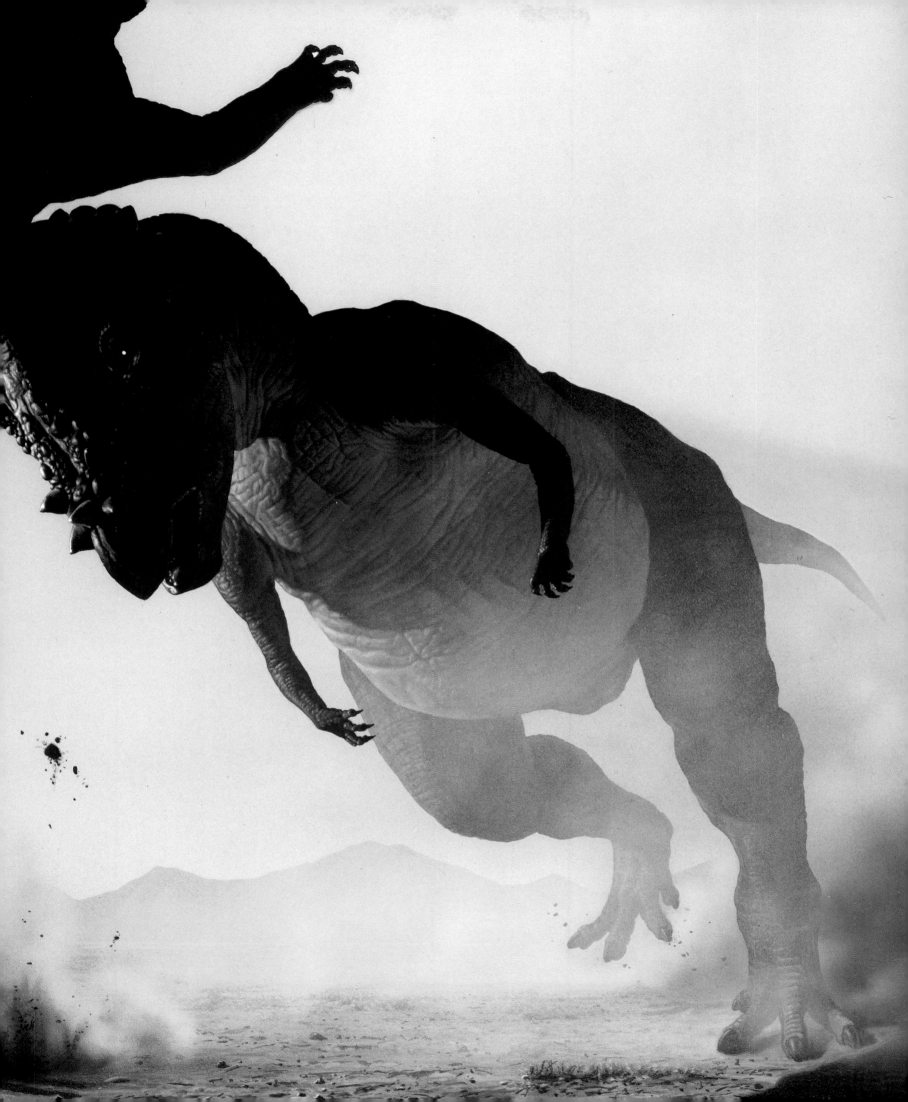

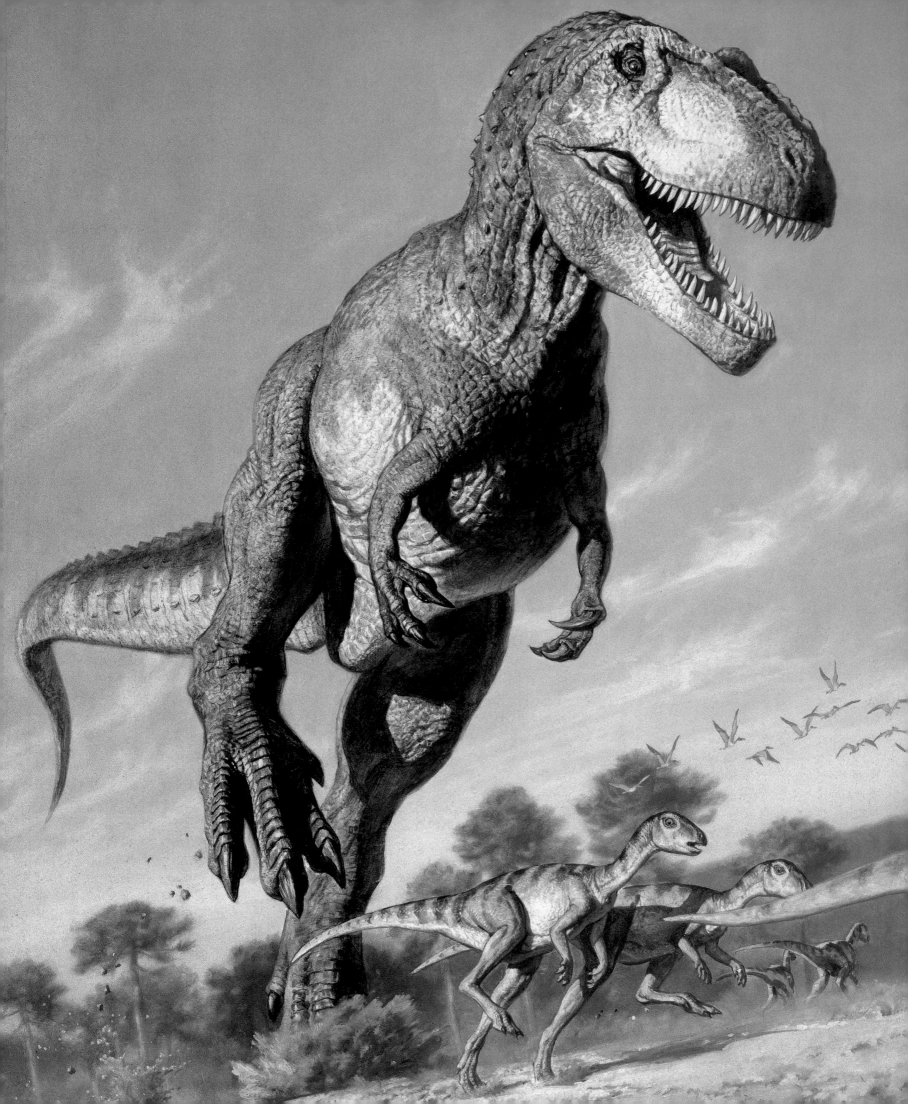

JOHN GURCHE

(ABOVE) MATERNAL INSTINCTS: AT FIRST LIGHT 70 MILLION YEARS AGO,
A *SAUROLOPHUS* NESTING COLONY IN MONGOLIA BEGINS TO STIR.

———

"DINOSAURS"

January 1993

JAMES GURNEY

(OPPOSITE) CHARGING THROUGH THE CRETACEOUS LANDSCAPE, EIGHT-TON,
42-FOOT-LONG *GIGANOTOSAURUS*, ONE OF THE LARGEST OF ALL CARNIVORES, DWARFS
A HERD OF HUMAN-SIZE HERBIVORES, LARGER COUSINS OF *GASPARINISAURA*.

———

"PATAGONIAN DINOSAURS"

December 1997

John Gurche's inspiration for the painting above came from extensive research on dinosaur anatomy and behavior, as well as from some poignant photographs. "I'd seen photography of flocks of birds — water birds — in a similar situation," the artist recalls. "I liked the way the morning sun was just catching the fog in those photographs and making it almost look like it was on fire. That was the look I wanted in my painting — the feeling I attempted to capture. I liked the contrast between the placid posture of the dinosaurs and the incendiary quality of the light."

Critically acclaimed author and illustrator James Gurney says this was no ordinary dinosaur, but a rather famous challenger to [what paleontologists have called] the century-long dominance of *T. rex* as king of dinosaurs. Best known for his award-winning *Dinotopia* books, Gurney was pleased when NATIONAL GEOGRAPHIC commissioned him to paint *Giganotosaurus* (left). He had already reconstructed the giant animal for his book *Dinotopia: The World Beneath* and was impressed with its ferocity and power. Gurney chose a low horizon for this illustration to emphasize the animal's immensity. A cloud of dust burgeoning under one colossal foot accentuates the animal's earth-shaking impact, while the tilted horizon keeps viewers off balance, and relieved that *Giganotosaurus* no longer roams.

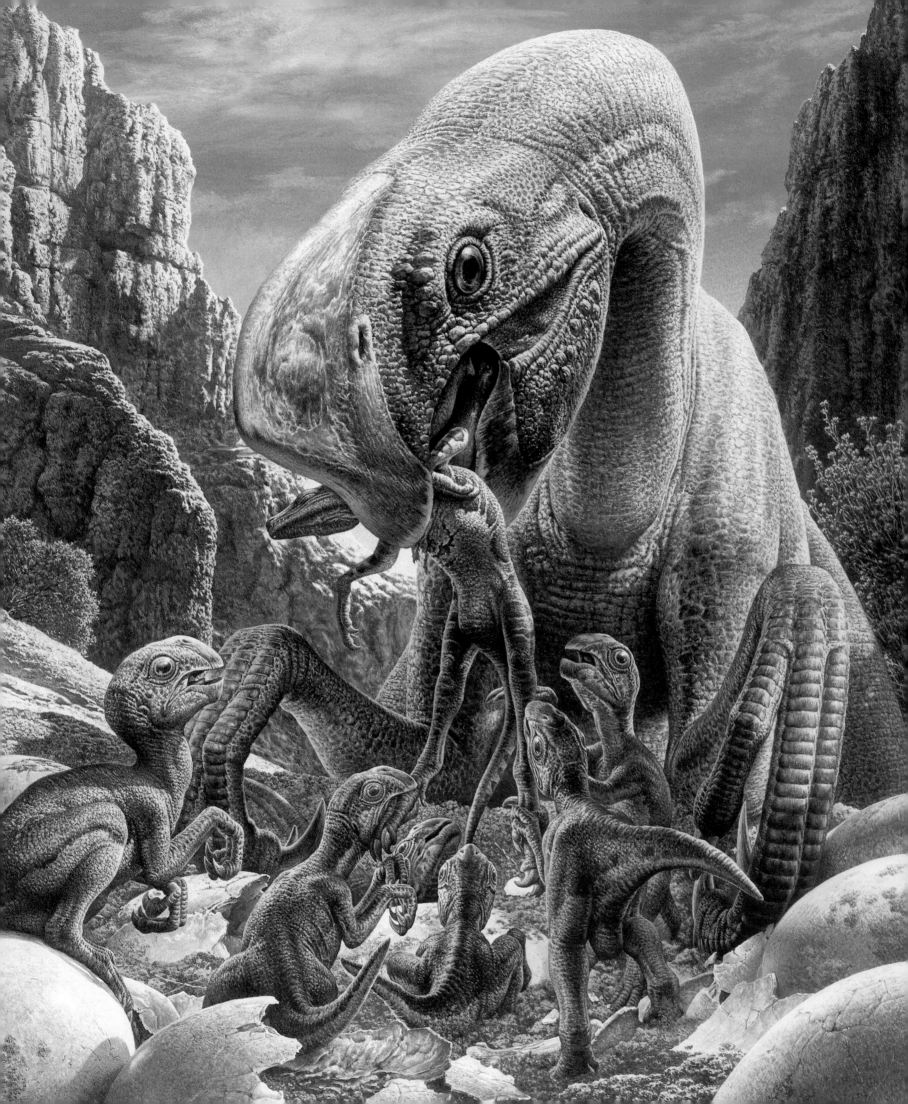

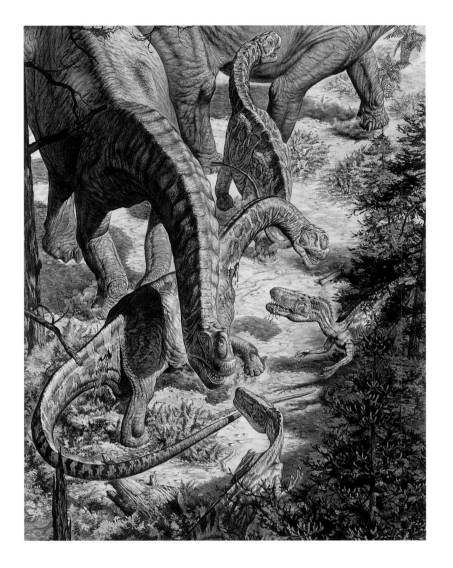

JOHN SIBBICK

(OPPOSITE) IMAGINE *OVIRAPTOR*, A BEAKED
DINOSAUR THAT RESEMBLES AN OSTRICH WITH
A TAIL, RETURNING TO ITS NEST AND FEEDING ITS
YOUNG JUST LIKE A MOTHER BIRD.

———

"DINOSAURS OF THE GOBI:
UNEARTHING A FOSSIL TROVE"

July 1996

MARK HALLETT

(ABOVE) DRIVEN BY HUNGER 130 MILLION
YEARS AGO, TWO [*AFROVENATOR*] HUNTERS EMERGE
FROM THE UNDERBRUSH AND STRIKE QUICKLY
AT A YOUNG SAUROPOD.

(FOLLOWING PAGES) THREATS REVERBERATE ACROSS
A DELTA IN WHAT IS NOW THE SAHARA AS
CARCHARODONTOSAURUS GUARDS ITS KILL AGAINST
DELTADROMEUS.

———

"AFRICA'S DINOSAUR CASTAWAYS"

June 1996

While Mark Hallett was working on his article for NATIONAL GEOGRAPHIC, a tree felled by 75-mile-an-hour winds crashed into his barn and caused a three-day power outage in his nearby studio. Up against a tight deadline, Hallett used Coleman lanterns to illuminate his paintings while he finished them. Although the artist had a difficult time gauging his colors in the lamp glow, the paintings turned out beautifully and were delivered on time.

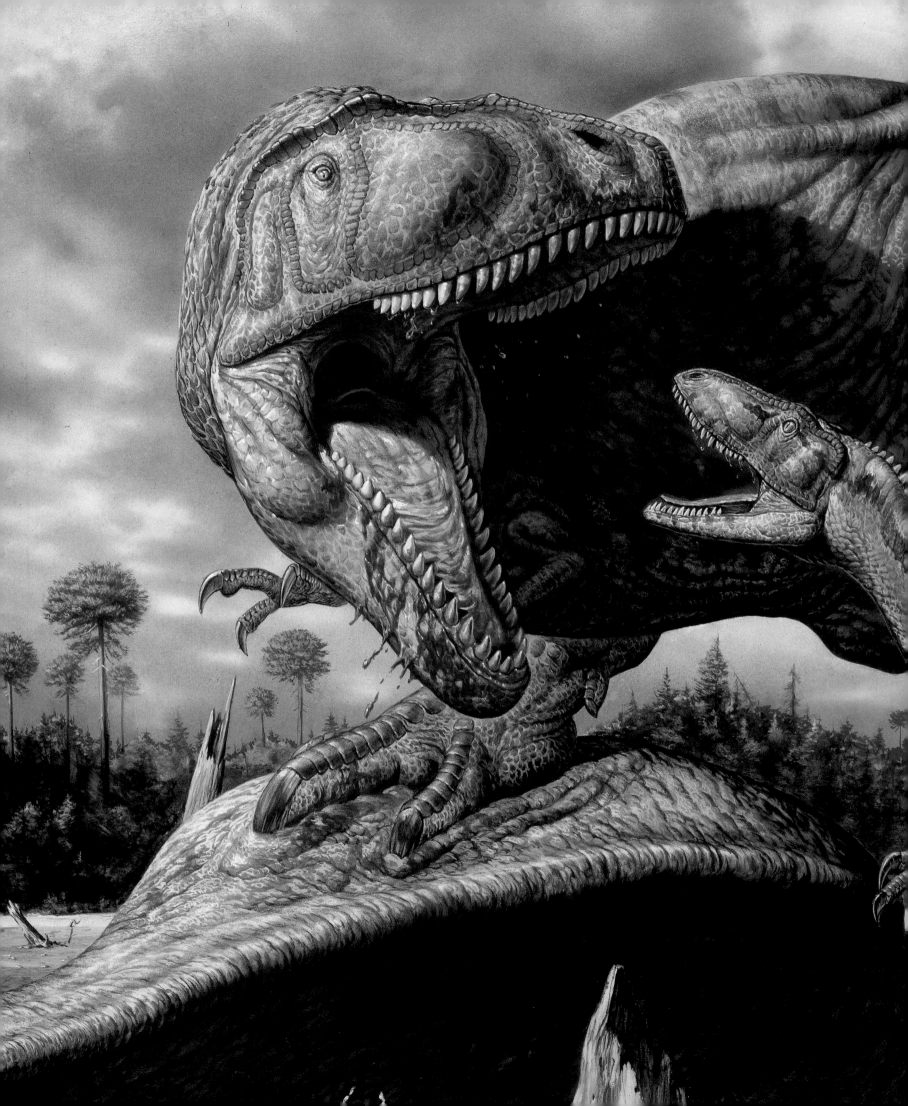

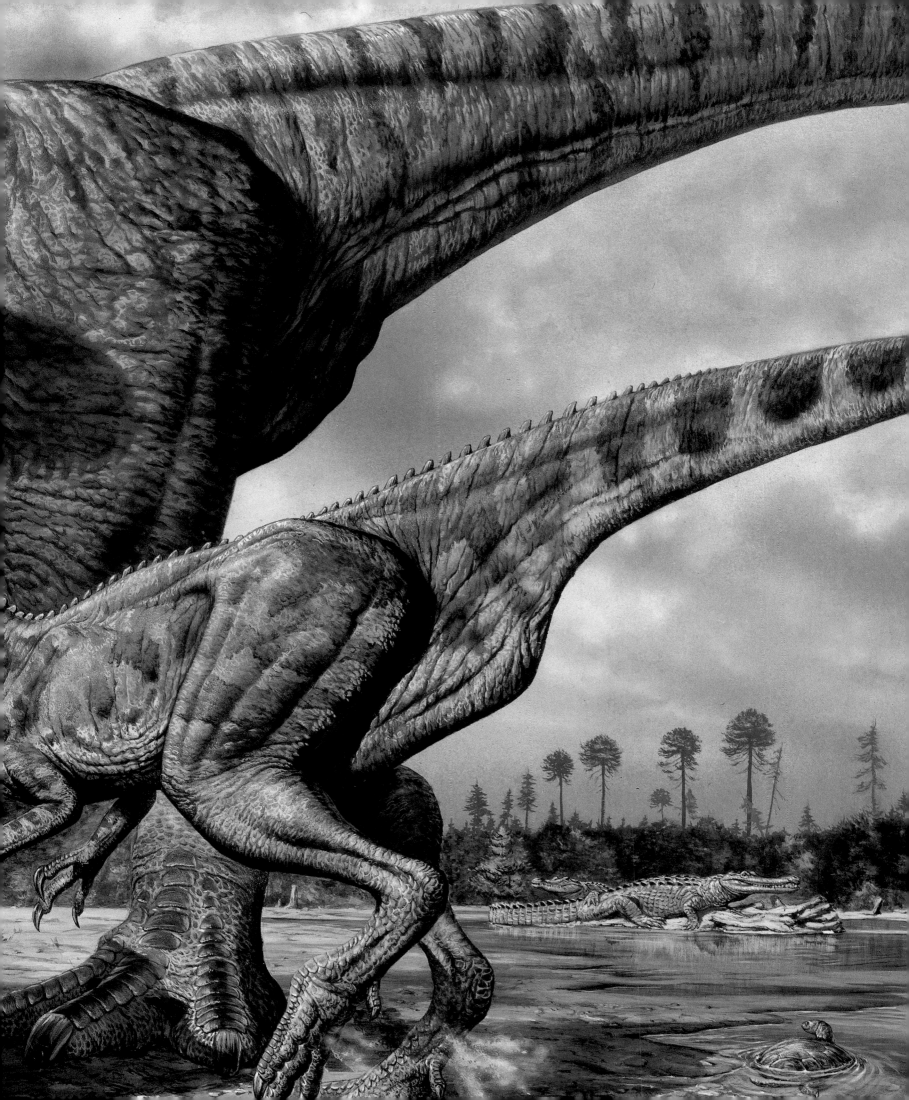

MOSASAURUS RULED THE WAVES WHEN THEY ROLLED OVER WESTERN KANSAS.
"PARADE OF LIFE THROUGH THE AGES" *February 1942*

CHARLES R. KNIGHT

CHARLES R. KNIGHT

(ABOVE) HARMLESS AND STUPID, THE GROTESQUE *DIPLODOCUS*
ASKED ONLY TO BE LEFT IN PEACE.

———————

"PARADE OF LIFE THROUGH THE AGES"

February 1942

Charles R. Knight was the first artist to supply a major series of full-color illustrations of prehistoric animals to NATIONAL GEOGRAPHIC. Although he was a noted expert on paleontology, the Society still checked and rechecked his work with scientists — a procedure that did not always please Knight, who felt he knew his subject as well as anyone. When asked to adjust the color on one of his paintings, Knight refused. "The coloring is realistic," he declared emphatically. "I never spare time nor expense to myself in accomplishing these results, and I think it would be much wiser to depend upon my judgment." Neither Knight's judgments nor the opinions of the leading paleontologists of his day proved to be entirely correct. The widely held conception of dinosaurs as slow, dull-eyed creatures pulling their tails behind them has been refuted. Errors notwithstanding, Knight pioneered the field of paleontological illustration, and his paintings inspired a number of young artists to begin their careers. Noted illustrator Kazuhiko Sano recalls looking at Knight's paintings with a sense of wonder when he was a child. "The painted dinosaurs were still very upright and dragging their tails, but I was entranced by looking at Charles Knight's paintings because there weren't many other illustrations on the subject at the time."

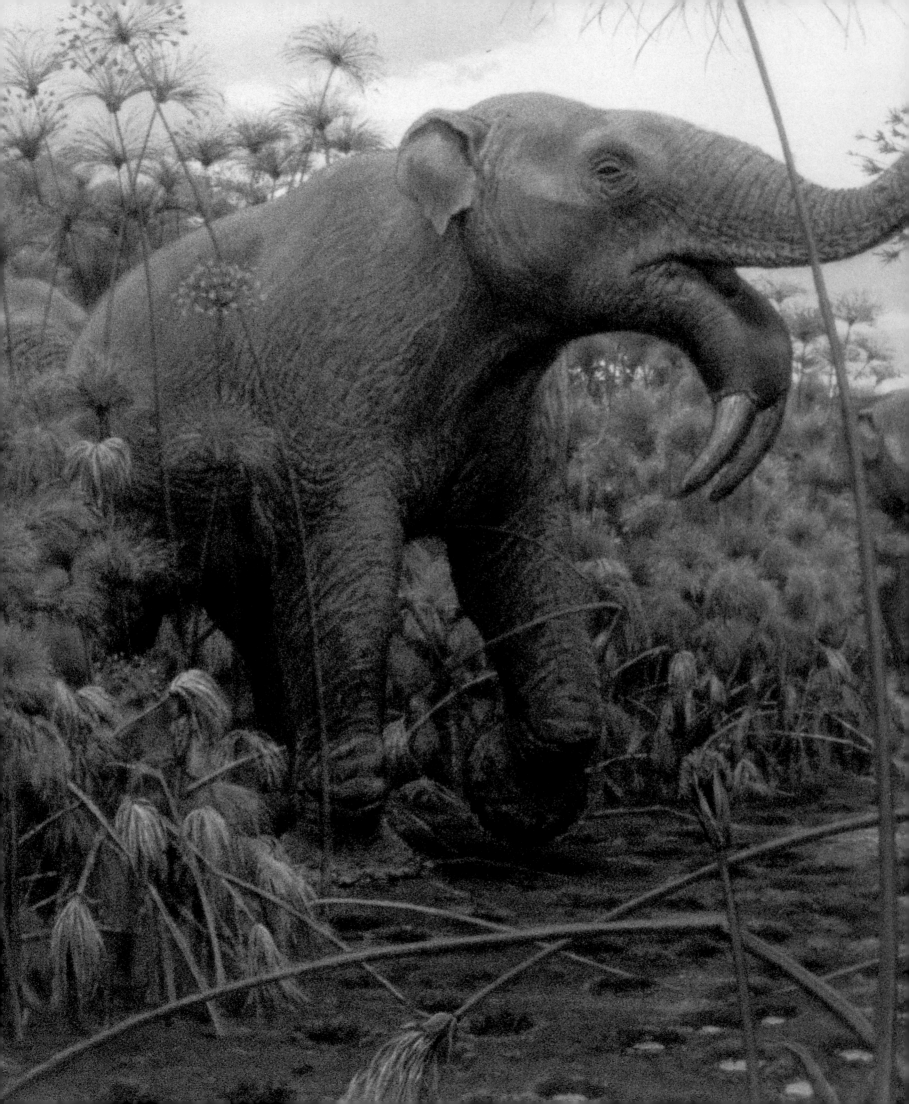

JAY H. MATTERNES

(LEFT) MASSIVE *DEINOTHERES* — "HUGE BEASTS" —
CRASHING THROUGH PAPYRUS CLUMPS.

(FOLLOWING PAGES) GIANT BABOONS
SYMBOLICALLY CONFRONT FOUR SMALLER
RELATIVES, THE PRESENT DAY *PAPIO ANUBIS*,
ON A GRANITE OUTCROP IN EAST AFRICA.

———————

ANIMALS OF EAST AFRICA

1973

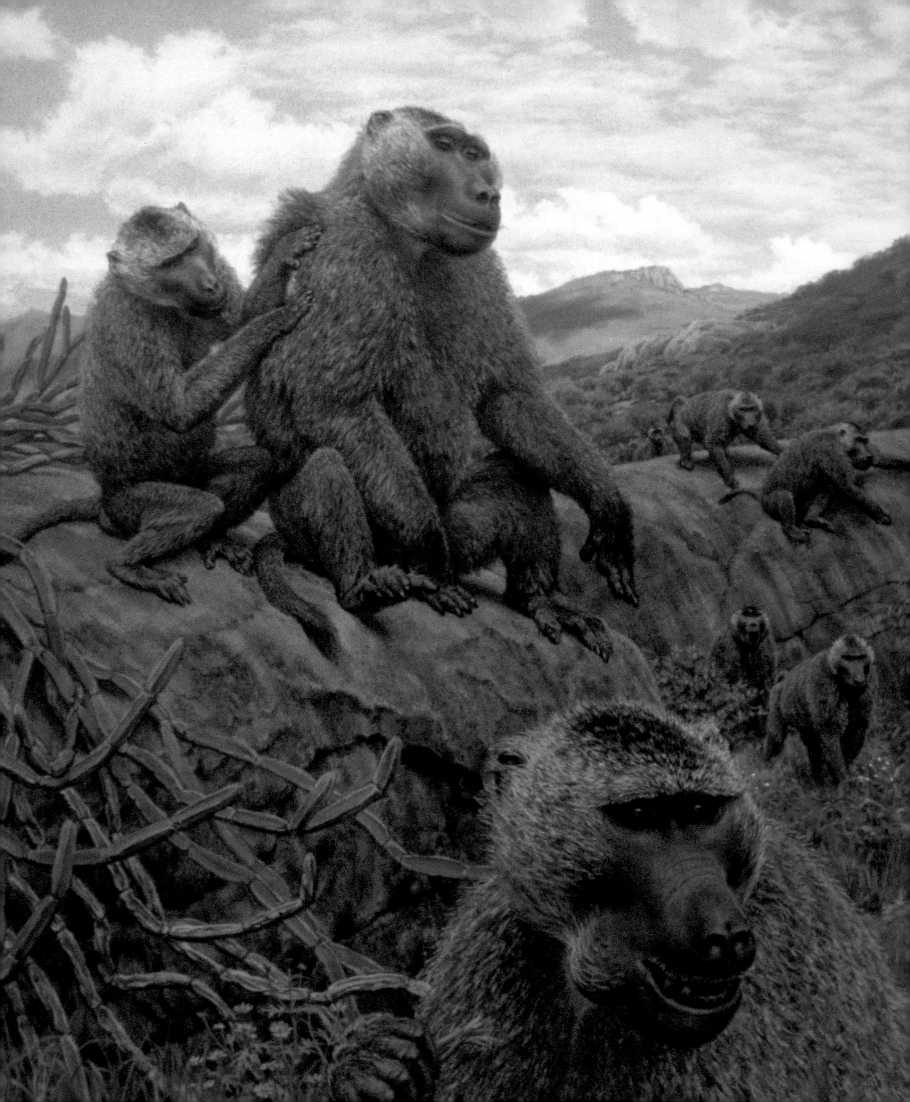

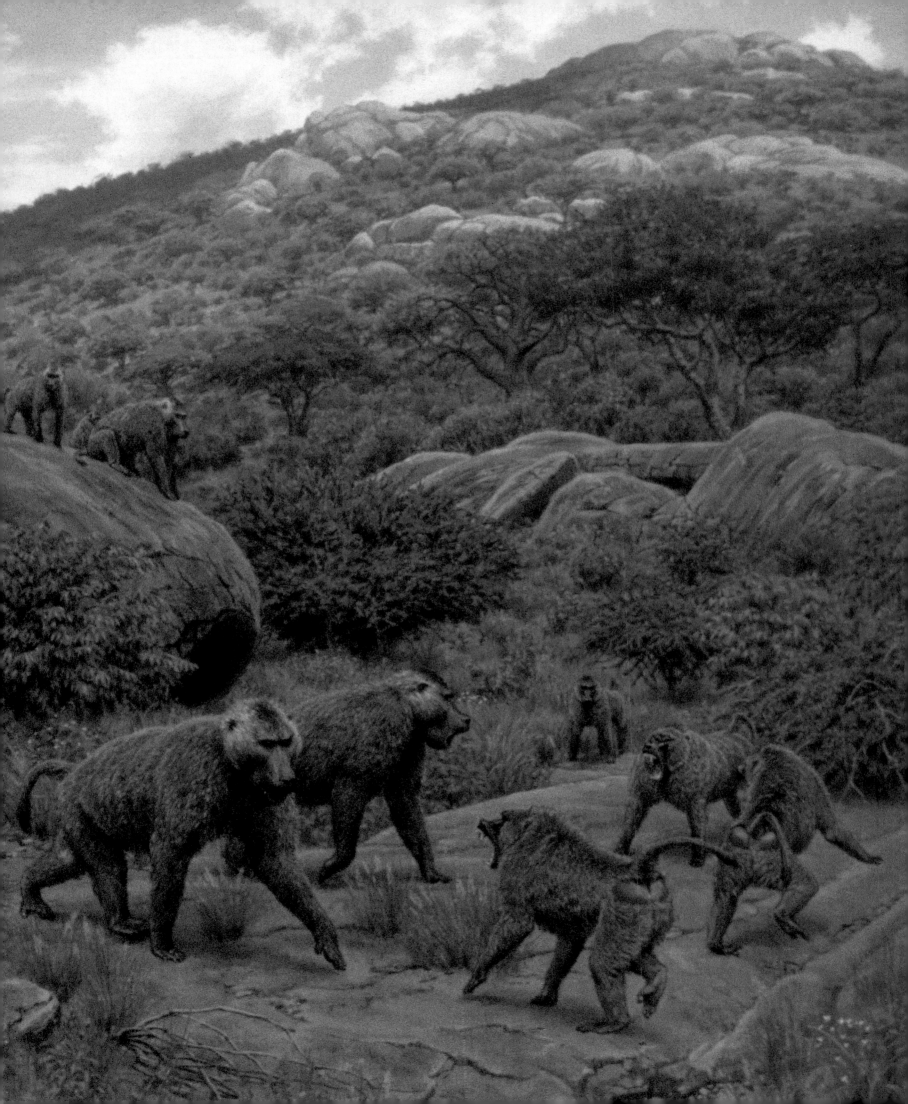

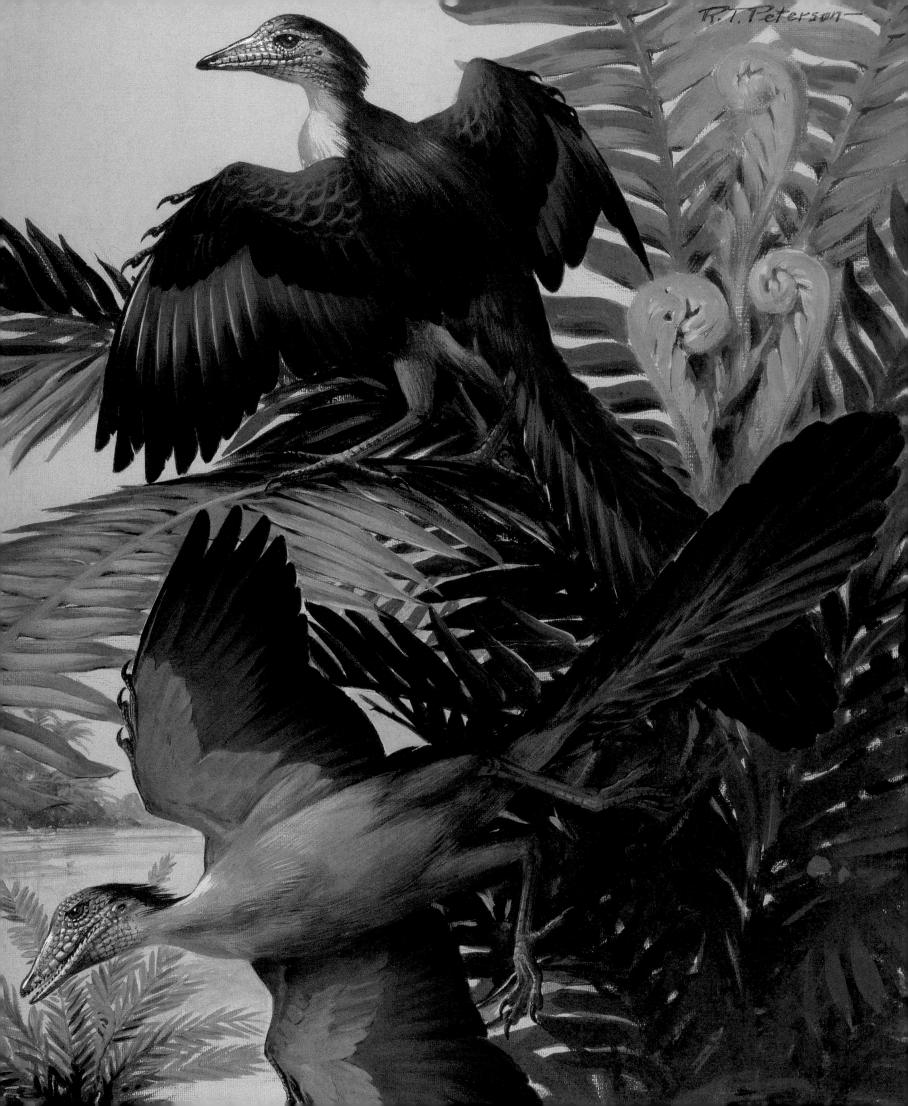

ROGER TORY PETERSON

(OPPOSITE) ADAM OF THE BIRD WORLD,
ARCHAEOPTERYX SAILED FROM HIS PRIMEVAL PERCH
150 MILLION YEARS AGO.

———

WATER, PREY, AND GAME BIRDS OF NORTH AMERICA

1973

KAZUHIKO SANO

(FOLLOWING PAGES) A FISH-EAT-FISH WORLD. A 12-FOOT-LONG
REASON TO TAKE TO THE LAND: DEVONIAN TETRAPODS
LIKE *HYNERPETON* SHARED WATERWAYS WITH SOME OF THE
NASTIEST FISH IN EARTH'S HISTORY.

———

"DEVONIAN PERIOD"

May 1999

Kazuhiko Sano drew his first paleontological and anthropological illustra-
tions in 1959, when he was in the second grade. "I drew *Stegosauruses,
Crinoids,* a saber-toothed tiger, woolly mammoths, *Coelacanths,* and some
Neanderthals," Sano says. "I daydreamed about the prehistoric world and was
proud to know the words *pithecanthropus* and *australopithecus* when nobody else
in the class had any idea what they were." Almost 40 years later, this assignment for
NATIONAL GEOGRAPHIC gave Sano the opportunity to revisit the ancient world
that fascinated him as a child. This time, Sano says, the assignment gave him the
opportunity to "daydream professionally." Although he had to reconstruct the
Devonian scene carefully to reflect the latest scientific knowledge, Sano was able to
interpret the information according to his own artistic vision. Painting drama,
Sano maintains, is always his main consideration.

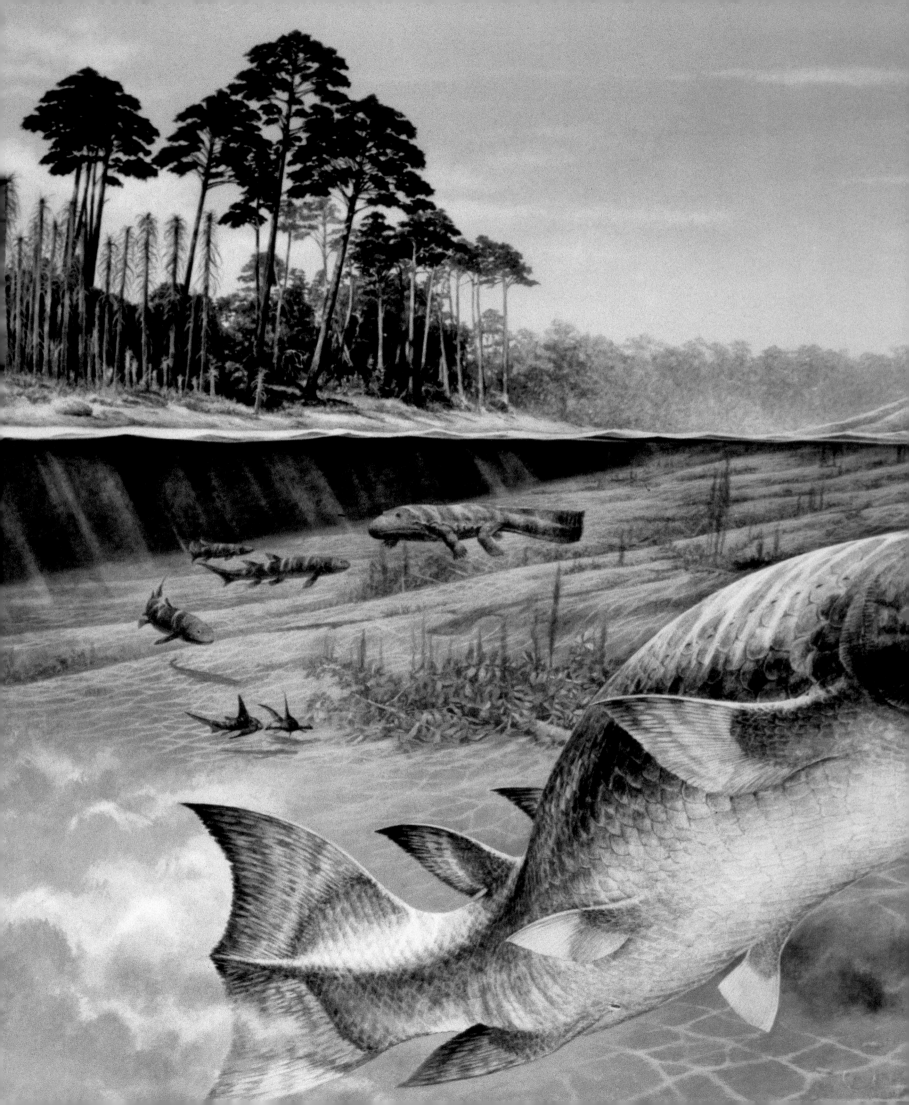

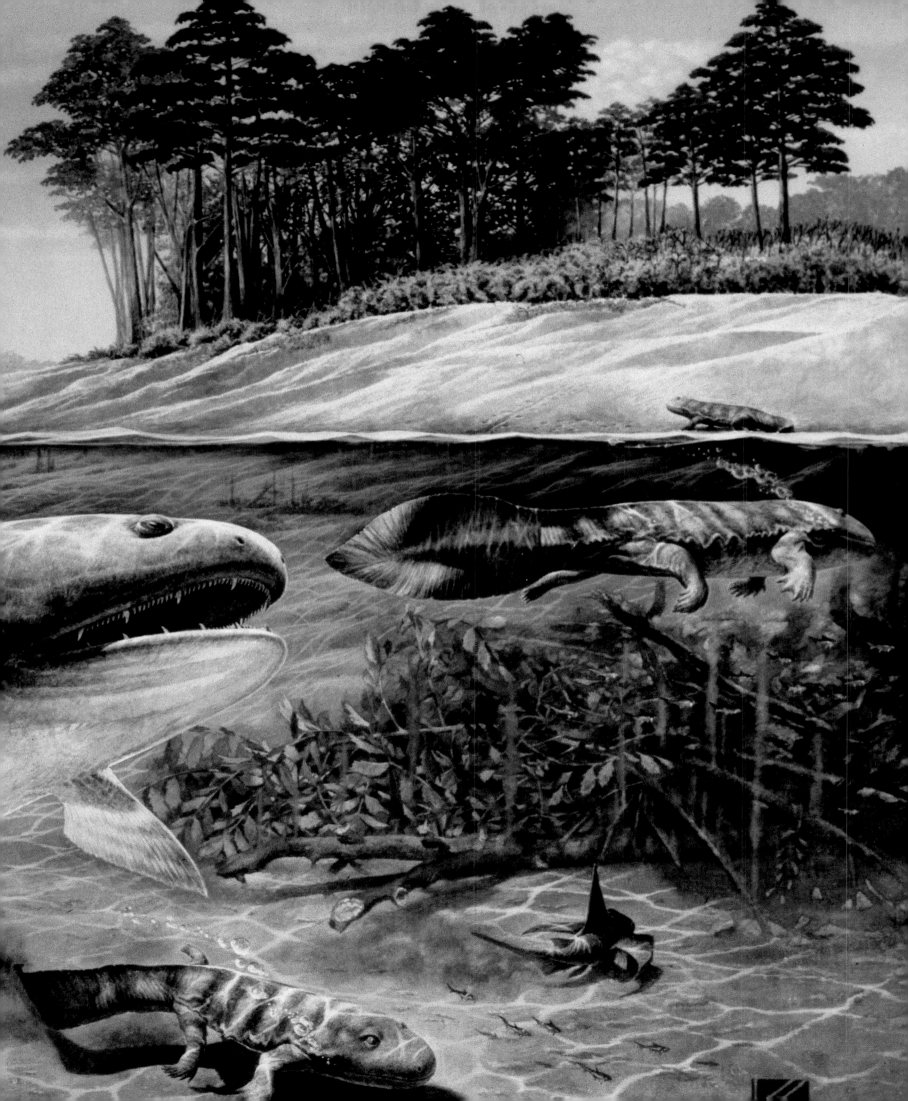

44

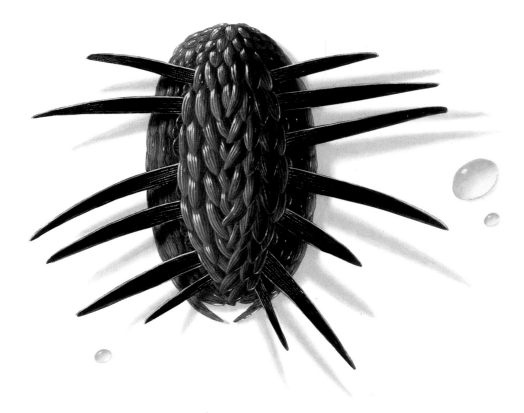

PREDATION PROBABLY ENCOURAGED THE BURGESS SHALE CREATURE *WIWAXIA* TO EVOLVE AN ARMOR OF OVERLAPPING SCALES.
"THE CAMBRIAN PERIOD: EXPLOSION OF LIFE" *October 1993*

THE CARNIVOROUS WORM, *OTTOIA*, SNAPPED UP PREY WITH ITS WHIPLIKE PROBOSCIS.
"THE CAMBRIAN PERIOD: EXPLOSION OF LIFE" *October 1993*

KAM MAK

KAM MAK

(ABOVE) *HALLUCIGENIA*, THE BURGESS
SHALE'S MOST FAMOUS FOSSIL ODDBALL, SEEMS
LESS STRANGE SINCE SWEDISH RESEARCHER
LARS RAMSKÖLD FOUND A SECOND SET OF
LEGS HIDDEN BEHIND THE ANIMAL. BEFORE,
SCIENTISTS THOUGHT IT WALKED
ON STIFF SPINES.

———

"THE CAMBRIAN PERIOD:
EXPLOSION OF LIFE"

October 1993

MARVIN MATTELSON

(FOLLOWING PAGES) NEW WORLD OF PREDATORS
AND SHELLS: WHEN *ANOMALOCARIS* HUNTED EARLY
CAMBRIAN SEAS, THE CONTINENTS WERE BARREN,
BUT THE SEAFLOOR WAS A HOTBED OF NEW CREATURES.
ANIMALS HAD JUST EVOLVED THE ABILITY TO
SECRETE SHELLS, BUILD SKELETONS, MOVE AGILELY —
AND PREY ON ONE ANOTHER.

———

"THE CAMBRIAN PERIOD:
EXPLOSION OF LIFE"

October 1993

"Other kids wanted to be on the cover of *Time* magazine," recalls Marvin Mattelson. "I wanted to paint the cover." As a child, Mattelson also wanted to paint for NATIONAL GEOGRAPHIC, and in his student days he found inspiration in the historical paintings by Tom Lovell that appeared in the pages of the magazine. When he was commissioned to paint the complex illustration on the following pages depicting life in the Cambrian period, Mattelson was excited about the opportunity to work for NATIONAL GEOGRAPHIC. "It was a challenging assignment," he recalls. "I constructed a giant diorama of the whole scene, and made models of the creatures. The Art Director, Chris Sloan, was very helpful and ended up making some of the models himself and then coming to my studio to help set the whole thing up." The project took eight months. Every step of the way, Mattelson's drawings were checked by experts. "They would show the drawings around to all the scientists and say 'what's wrong with this picture?' and they would always find something. But in the end, everyone finally agreed, and we were all happy with the result."

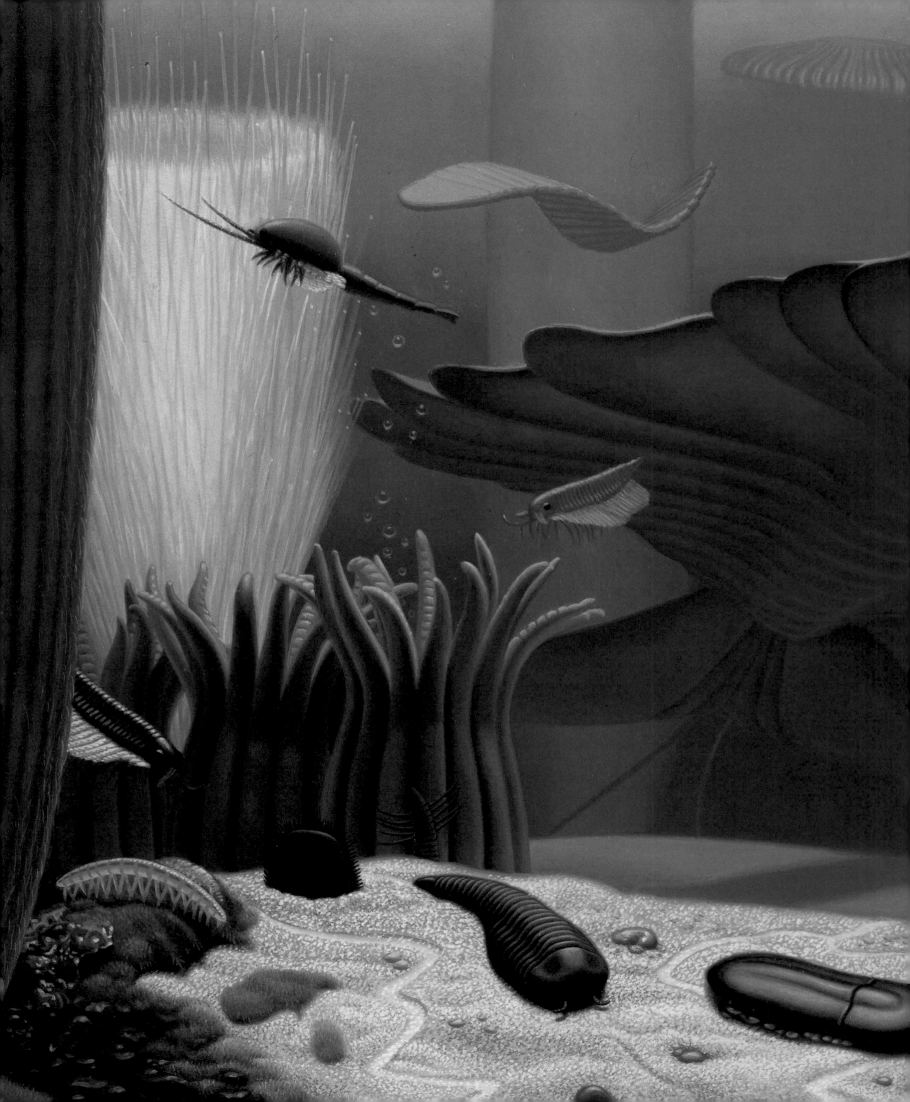

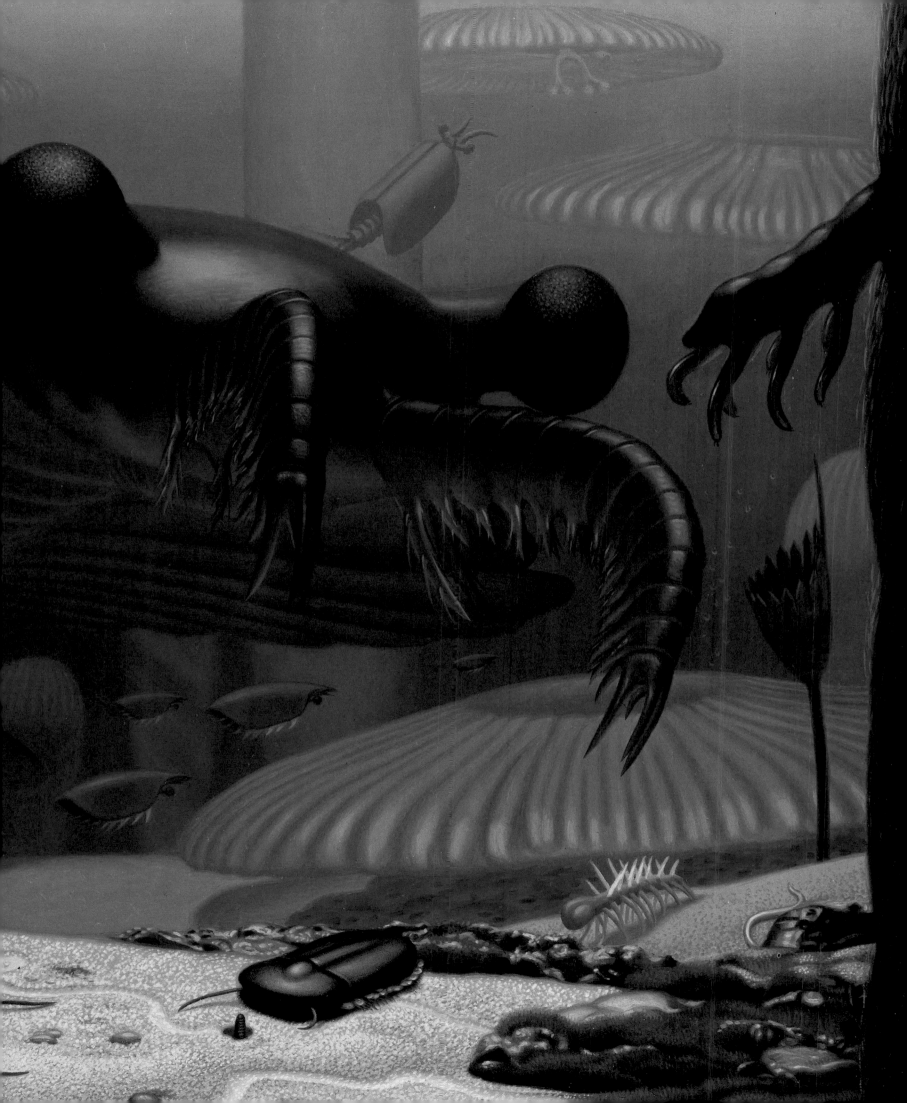

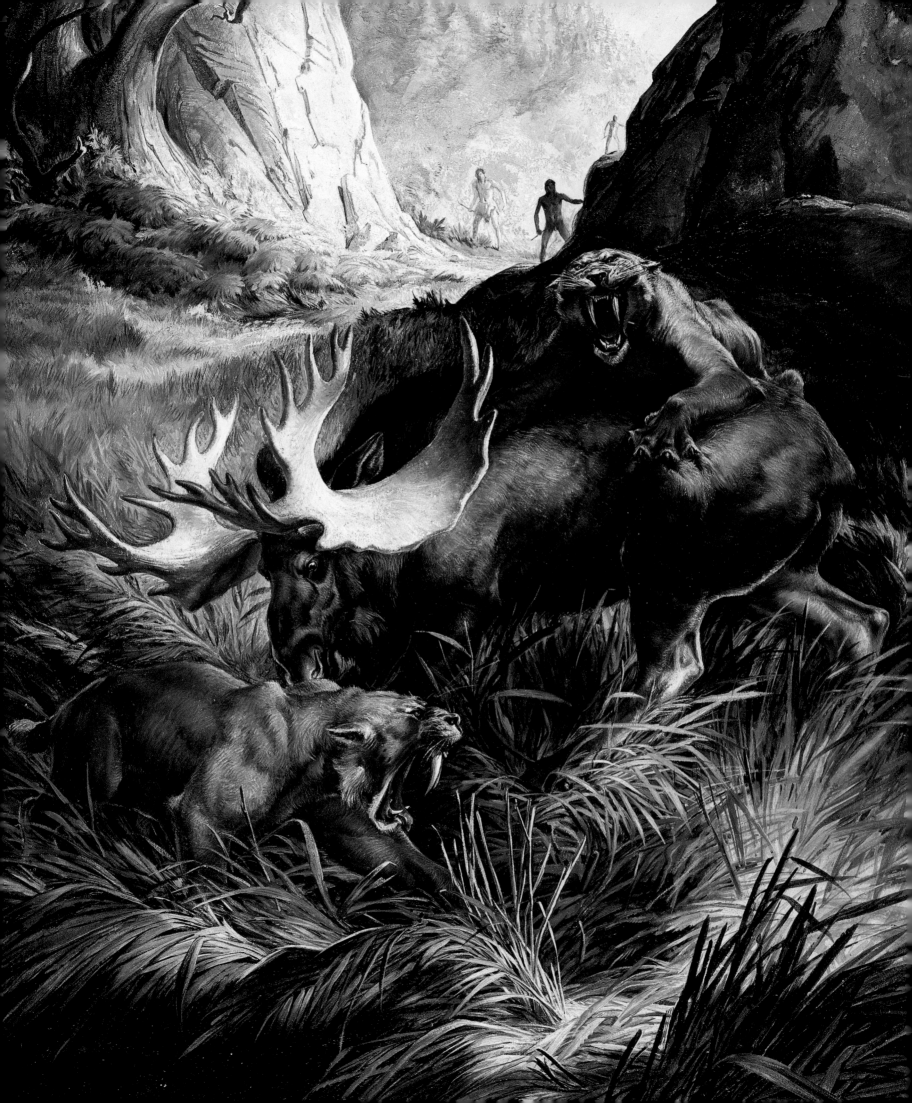

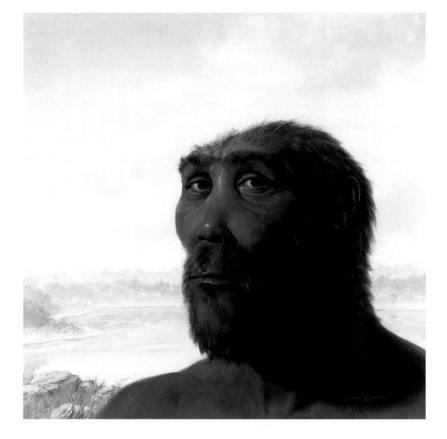

PETER BIANCHI

꧁꧂

(ABOVE) LOW BROWED AND LONG FACED,
DR. LEAKEY'S DISCOVERY POSSESSED A RELATIVELY
SMALL BRAIN. BASING THIS RECONSTRUCTION
ON A DRAWING BY NEAVE PARKER IN THE *ILLUSTRATED
LONDON NEWS,* ARTIST BIANCHI CLOTHES THE
SKULL WITH FLESH TO FIT THE SCIENTISTS'
CONCEPTION OF *ZINJANTHROPUS.* THIS EARLIEST
MAN YET FOUND LIVED BESIDE THE SHORE OF
A LONG-VANISHED LAKE.

————

"FINDING THE WORLD'S EARLIEST MAN"

September 1960

ANDRE DURENÇEAU

꧁꧂

(OPPOSITE) SABER-TOOTHED CATS, TERRORS
OF THE ICE AGE, STRIKE DOWN A MOOSELIKE DEER.

————

"ICE AGE MAN, THE FIRST AMERICAN"

December 1955

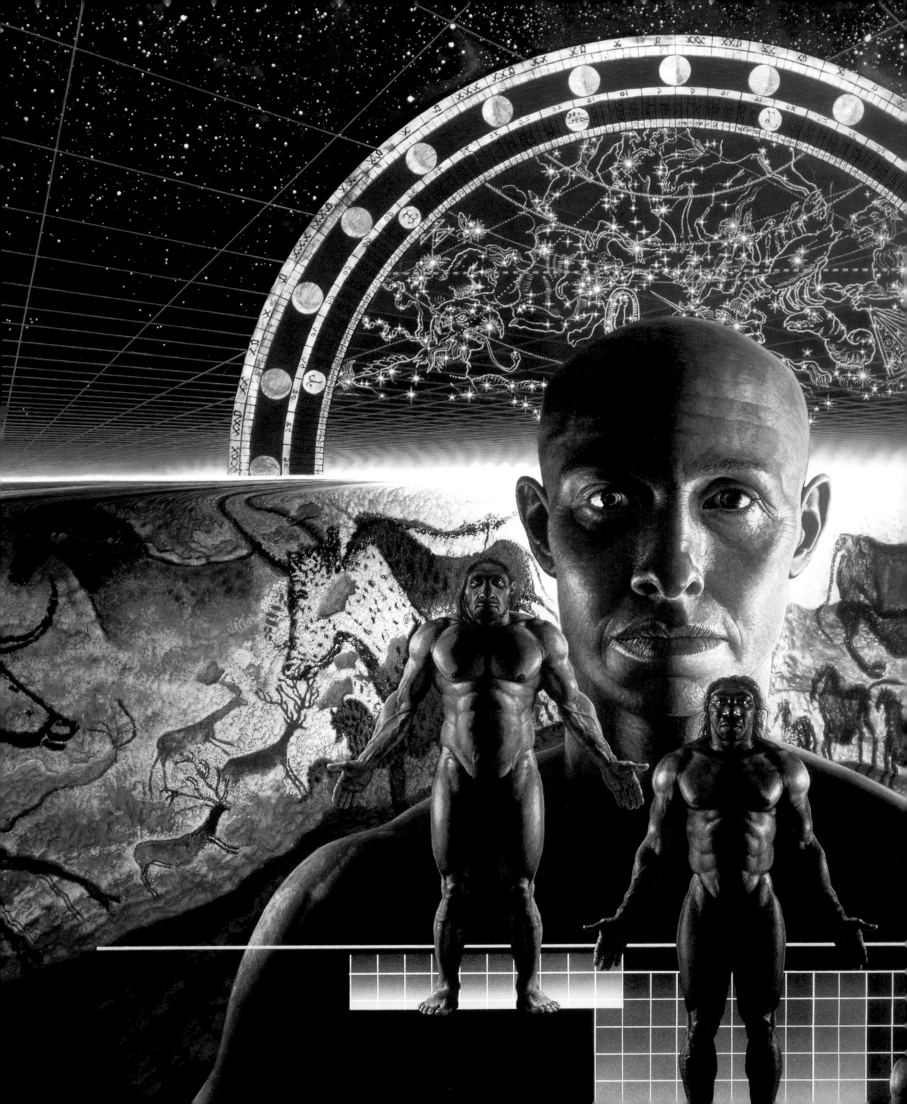

JOHN GURCHE

Upright. Toolmaker, fire builder, cave painter
stargazer. We are creatures who long to know.
What are we? How did we begin? The answers are
not certain. For some questions there is simply
not enough evidence. On nearly all issues,
researchers debate conflicting interpretations.
But the wealth of fossils discovered over
the past century, combined with new
dating methods and imaging tools, allows
scientists to examine our family history with
more precision than ever before. Using an
unprecedented assembly of hominid remains —
not only skulls but also backbones, shoulders,
hips, arms, legs, hands, and feet — artist
John Gurche gives flesh and expression
to more than four million years of
human ancestry.

"Seeking Our Origins"

Supplement, *February 1997*

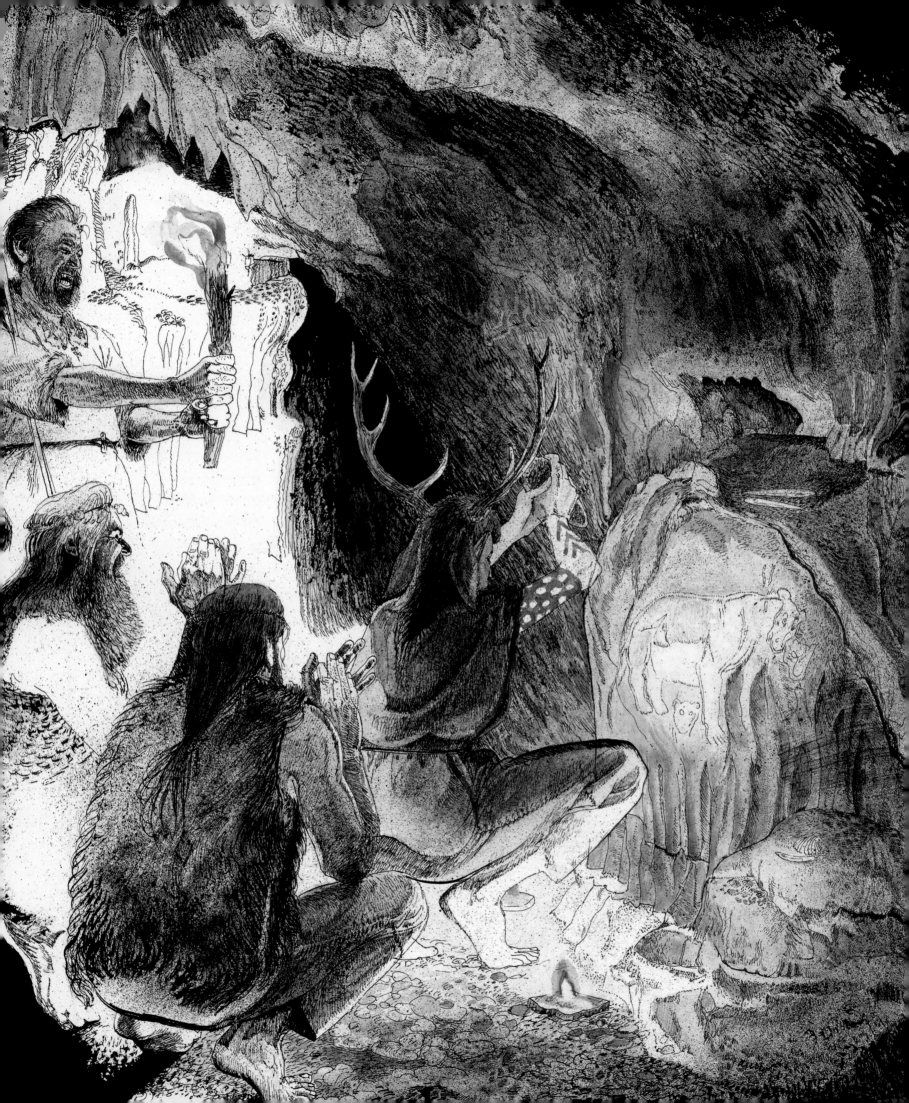

JACK UNRUH

(ABOVE) SHELLFISH IN UNLIMITED SUPPLY, GATHERED AT LOW TIDE,
MAY HAVE PROMPTED SETTLEMENT OF THE KLASIES RIVER MOUTH CAVES.

(OPPOSITE) FEARSOME CARNIVORE, A CAVE LION ENGRAVED ON A STALAGMITE
BEARS POCKMARKS AS IF STRUCK BY A BLUNT TOOL; A STONE PICK LIES NEARBY,
ALONG WITH SEASHELLS AND TORCH FRAGMENTS, IN TROIS FRÈRES CAVE.

———

"THE SEARCH FOR MODERN HUMANS"

October 1988

Although Jack Unruh's expressive style appears to spring directly from his imagination, in fact, like all NATIONAL GEOGRAPHIC artists, Unruh does extensive research for his assignments. "As an illustrator," Unruh writes, "I've crawled through caves in Europe to research paleolithic man, flown on helicopters, slept in cars to view the Valdez oil spill, visited research labs, refineries, deserts, coldrooms, tops of mountains, floated remote rivers in Alaska and Chile, and viewed every major brewery in Mexico."

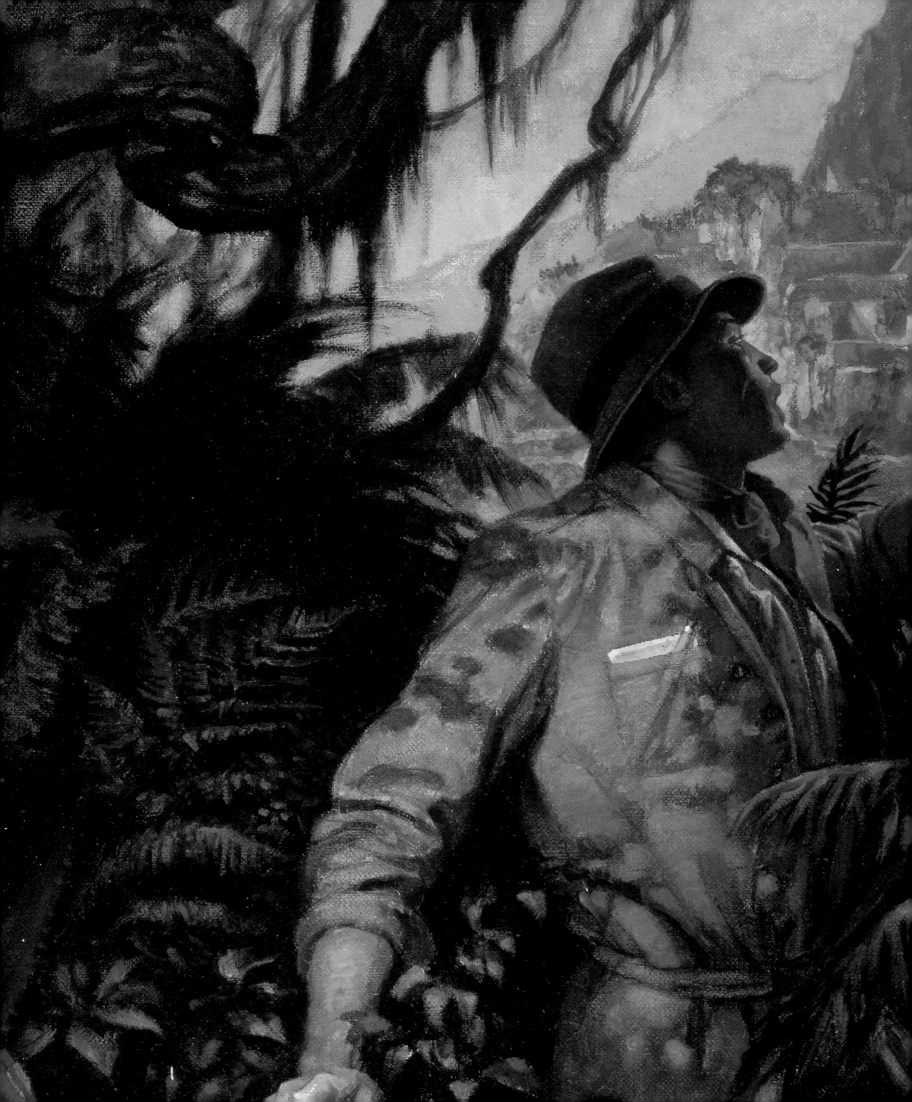

EXPLORATION AND DISCOVERY

EXPLORATION AND DISCOVERY

56 **66**I am a part of all that I have met. Yet all experience is an arch wherethro' gleams that untravell'd world, whose margin fades for ever and for ever when I move," declares Ulysses in Tennyson's famous poem about the ancient hero. For 19th-century explorers and scientists, it must have seemed that the horizon might never be reached, and that Tennyson's "untravell'd world" would hover forever, just beyond their grasp. Nevertheless, in spite of hazards and uncertainties, a succession of intrepid travelers dared the unknown. Some of these explorers traversed the globe; others were scientists whose discoveries shaped our view of the world. ∼ Charles Darwin and Alfred Russel Wallace incubated new ideas on evolution during their famous voyages, Darwin on HMS *Beagle* and Wallace on HMS *Erebus.* Thomas Henry Huxley made his voyage on HMS *Rattlesnake.* Like Darwin and Wallace, he took copious notes and kept a journal; but he was an artist as well, and his drawings, though unpolished, provide a compelling addition to the record of his voyage. Other explorers also documented their discoveries by creating artwork. English naturalist and artist Marianne North traveled the world from Borneo to Chile in the 1870s, cataloging plants and creating over 800 paintings. In the United States, illustrator George Catlin headed west to record the lives of American Indians. His book *Letters and Notes of the Manners, Customs, and Condition of the North American Indians,* which was published in London in 1841, contained 400 engravings. ∼ By the time the National Geographic Society had gained a membership large enough to sponsor exploration, travelers were not as likely to pack a sketchpad. The camera — even in its infancy, when photography proved a cumbersome and time-consuming process — was a more efficient and accurate way to describe a journey. ∼ When the first Society-sponsored expedition, led by Israel C. Russell, trekked to Alaska in 1890–1891 to map the Mount St. Elias region, Russell's equipment included four tents, two ice-axes, a canvas boat, a sextant

(PRECEDING PAGES) **THOMAS BLACKSHEAR**
THE ADVENTURE OF ARCHAEOLOGY 1989

and other survey equipment, several rifles (each with a hundred rounds of ammunition), and two camera outfits. Within his company was Mark B. Kerr, a topographer and artist with the United States Geological Survey. Kerr drew maps and sketched the landscape, carefully documenting the journey for NATIONAL GEOGRAPHIC. However, when Russell's account of the trip was published, the author's own arresting photographs of towering glaciers and forbidding mountains were the most impressive images. They brought an immediacy the paintings lacked, made credible by the camera's unblinking eye. ∿ In 1911, membership exceeded 100,000, and the Society, blessed with a sizable surplus, was able to help sponsor Hiram Bingham's travels through the Andes on his legendary search for the ruins of Machu Picchu. Bingham took over 200 photographs, all formally composed in black and white: groups of Peruvians in native dress, herds of llamas, a four-horned sheep, and the ruins themselves. After almost a century, the photographs are still captivating; yet understandably there was no camera crew following Bingham through the tangled jungle waiting to snap the shutter when he caught his first glimpse of the fabled city. That historic moment was most certainly fraught with excitement, confusion, and considerable doubt. Is this really the place? ∿ Although photography is clearly the best way to chronicle an expedition scrupulously, there are still moments that require an artist's viewpoint. Seventy-four years after Hiram Bingham found Machu Picchu, Thomas Blackshear recorded the moment of discovery with the drama and the clear vision that artistic interpretation affords. The artist's version of the event (pages 54–55) is an idealized one: Bingham moves aside a palm frond and gasps in wonder. Any doubt is peeled away, along with the tangle of jungle growth that, in fact, covered the temples and took several years to clear. In Blackshear's painting the triumphant explorer looks up to see the Inca's magnificent metropolis gleaming in the sun — the mirage that is the margin of Bingham's "untravell'd world" at last attainable.

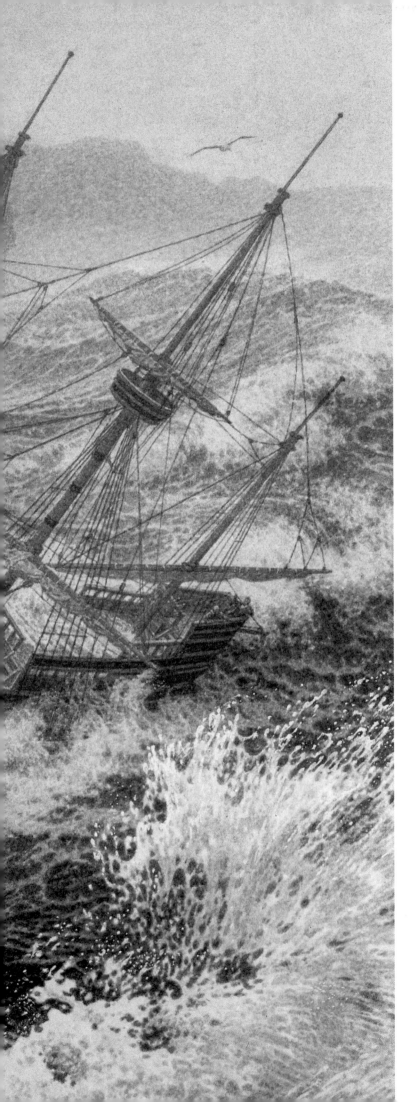

AN "INTOLLERABLE TEMPEST" BUFFETS THE
GOLDEN HIND ON HER SECOND DAY IN THE PACIFIC
AFTER PASSING THROUGH THE STRAIT OF MAGELLAN.
THE STORM HOWLED FOR NEARLY TWO MONTHS.
"THE WINDS WERE SUCH AS IF THE BOWELS
OF THE EARTH HAD SET ALL AT LIBERTIE," TOSSING
SHIP AND MEN "LIKE A BALL IN A RACKET."

————————

"QUEEN ELIZABETH'S FAVORITE SEA DOG:
SIR FRANCES DRAKE"

February 1975

66I discovered a small picture by the artist Jean-Leon Huens in a British design annual," recalls former NATIONAL GEOGRAPHIC Senior Assistant Editor Howard Paine. "I was so impressed with his ability that I wrote to him in Belgium and requested more samples of his work. He sent me a beautiful postcard-size drawing completely rendered in colored pencil with a note saying, 'This is the original. Guard it with your life!'" Paine sent the original drawing back and commissioned Huens to create these illustrations for the February 1975 issue of NATIONAL GEOGRAPHIC.

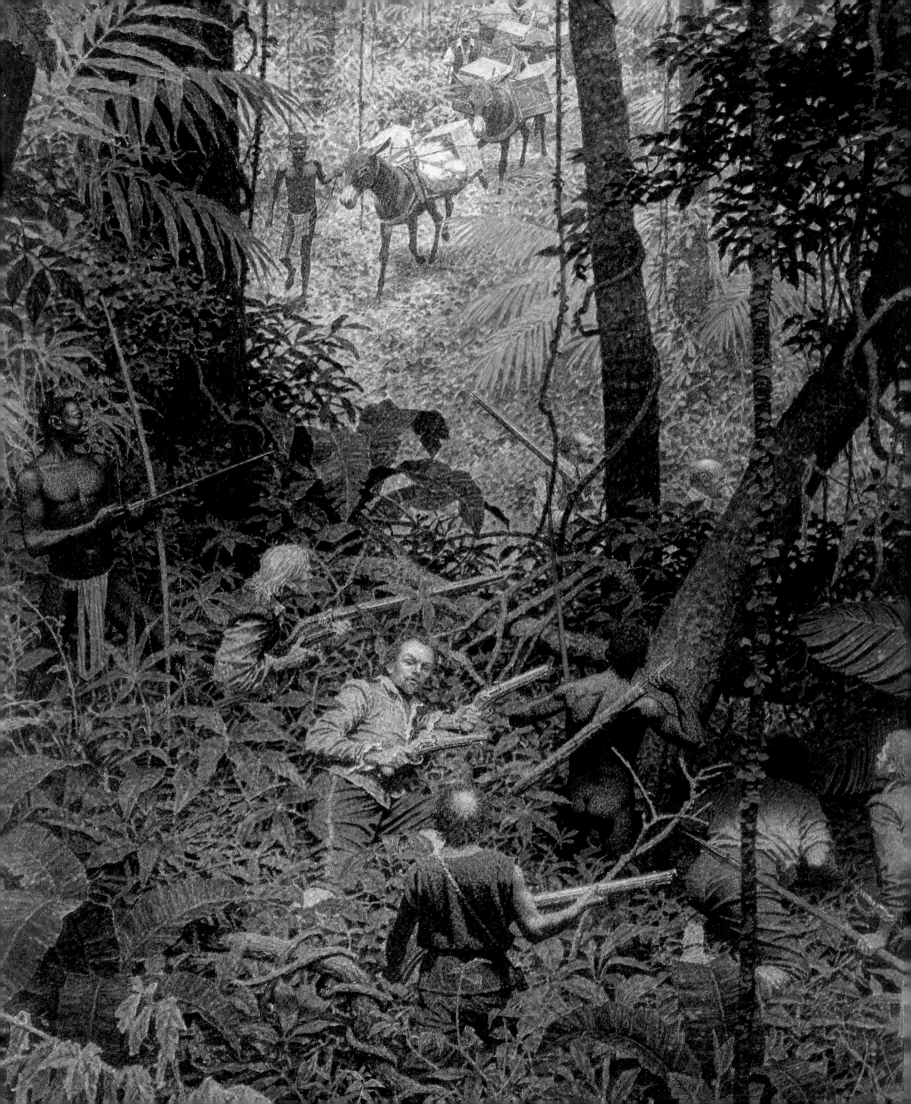

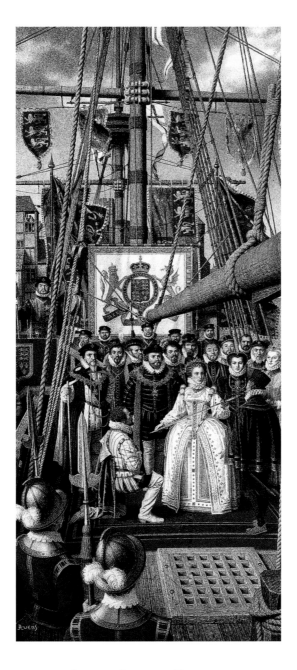

JEAN-LEON HUENS

(ABOVE) POMP AND GLORY GILD THE *GOLDEN HIND,*
AS QUEEN ELIZABETH IN 1581 CREATES A KNIGHT AND
STOKES THE WRATH OF THE KING OF SPAIN.

(OPPOSITE) DRAKE'S COMMANDO TACTICS, SUCH AS
HIS AMBUSH OF A MULE TRAIN BEARING TREASURE ACROSS
PANAMA IN 1573, ENDED THE TRANQUILITY OF SPAIN'S
RICH COLONIAL EMPIRE IN THE AMERICAS.

"QUEEN ELIZABETH'S FAVORITE SEA DOG:
SIR FRANCES DRAKE"

February 1975

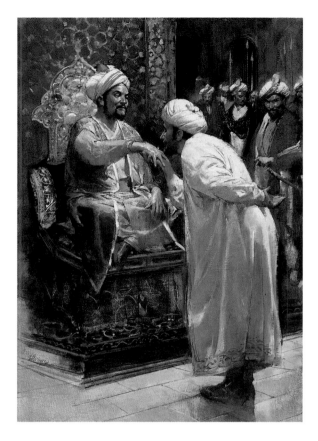

BURT SILVERMAN

(ABOVE) "EVERY TIME HE SAID ANY ENCOURAG NG
WORD TO ME, I KISSED HIS HAND," SAID IBN BATTUTA OF
HIS FIRST MEETING WITH THE DELHI SULTAN MUHAMMAD
IBN TUGH_UQ, BELIEVED BURIED IN THE RUINS OF
TUGHLUQABAD. SUCH FAWNING HELPED HIM
SURVIVE SEVEN YEARS AS A JUDGE UNDER THE SULTAN,
AN UNPREDICTABLE TYRANT WHO DECREED THREE
DAYS' PUBLIC DISPLAY OF THOSE HE EXECUTED.

———

"IBN BATTUTA, PRINCE OF TRAVELLERS"

December 1991

THOMAS BLACKSHEAR

(LEFT) GREECE 1876: HEINRICH AND SOPHIA
SCHLIEMANN UNEARTH A NOBLEWOMAN'S RICHES AT
THE ANCIENT CITADEL OF MYCENAE.

———

THE ADVENTURE OF ARCHAEOLOGY

1989

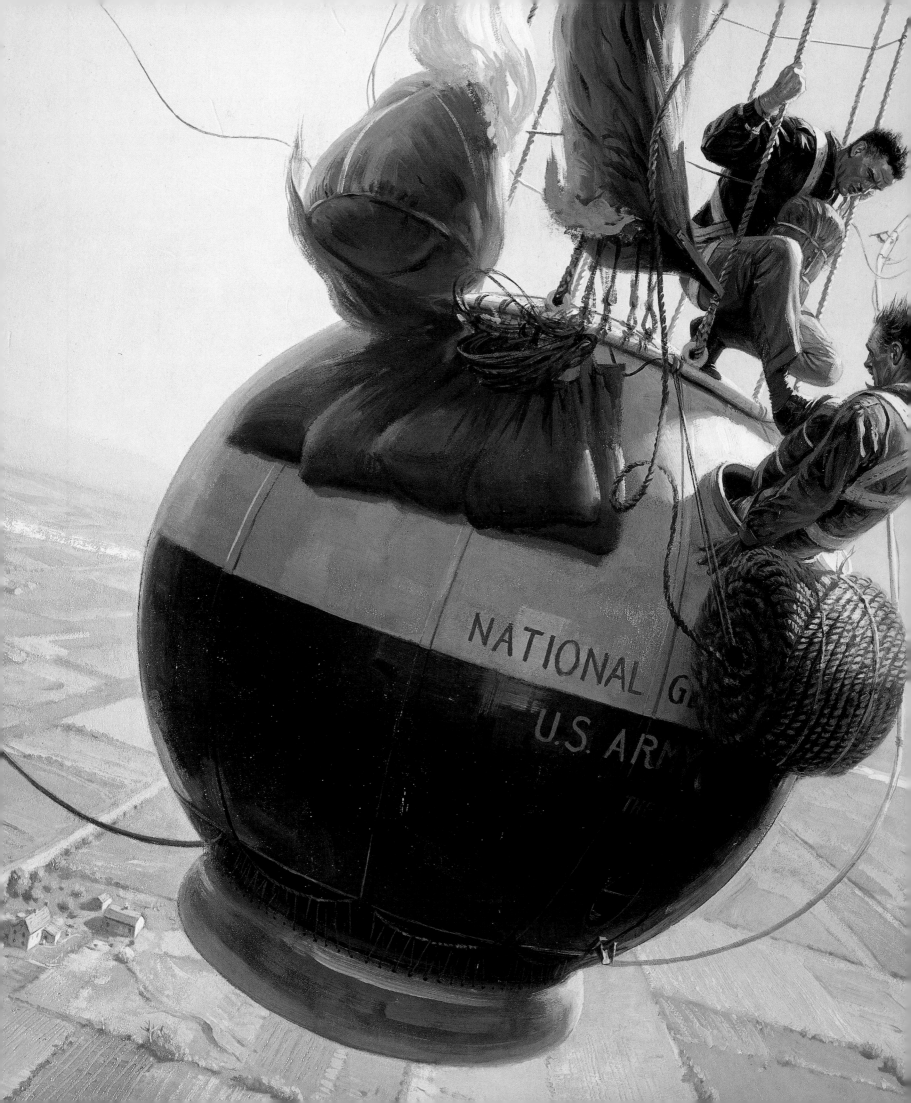

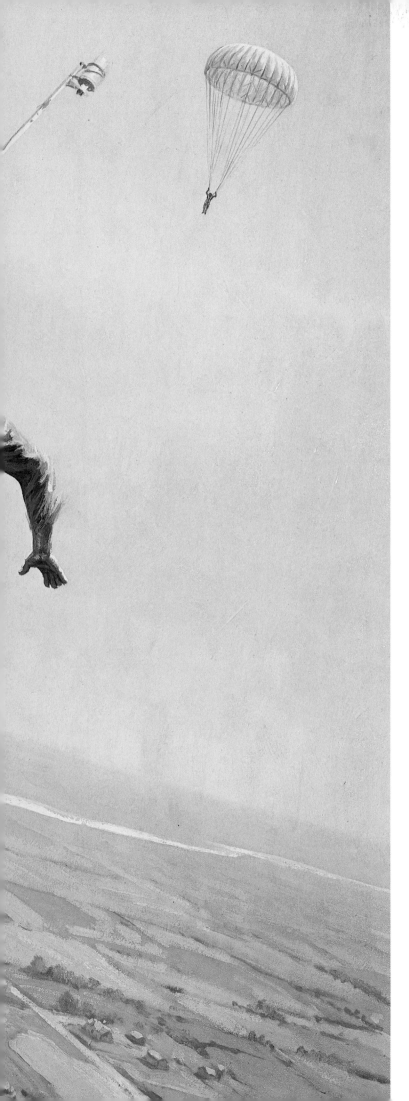

TOM LOVELL

GAS BAG SHREDDED, *EXPLORER I* DROPS A MILE A
MINUTE WITH ONLY 800 FEET TO GO. KEPNER'S FRANTIC KICK
FREES THE AUTHOR AS ANDERSON FLOATS SAFELY TO EARTH
IN THE DISTANCE. KEPNER JUMPED AT 300 FEET.

*GREAT ADVENTURES WITH NATIONAL GEOGRAPHIC:
EXPLORING LAND, SEA, AND SKY*

1963

In July 1934, sponsored by the National Geographic Society and the United States Army Air Corps, Maj. William E. Kepner and Capts. Orvil A. Anderson and Albert W. Stevens set out to explore the stratosphere in the largest balloon ever constructed. Ascending peacefully, they reached 60,000 feet before hearing a clattering noise. "Suddenly and without warning there came a great rent in our balloon," Stevens later wrote in NATIONAL GEOGRAPHIC. Although the tear was serious enough to abort the trip, the three men kept their equanimity as they began the long descent through air that approached the thinness of a vacuum. When, at 6,000 feet, the rip grew alarmingly, the decision was made to abandon the craft. Despite the fact that they were wearing parachutes, escape was not easy. Anderson bailed out; but as Stevens and Kepner prepared to jump, the balloon suddenly disintegrated, causing the gondola to drop like a stone. Relying on Stevens's accounts of the calamity, Tom Lovell recreated the dramatic moment when Stevens, trapped by the pressure of rushing air, is kicked free from the craft. All three men landed safely.

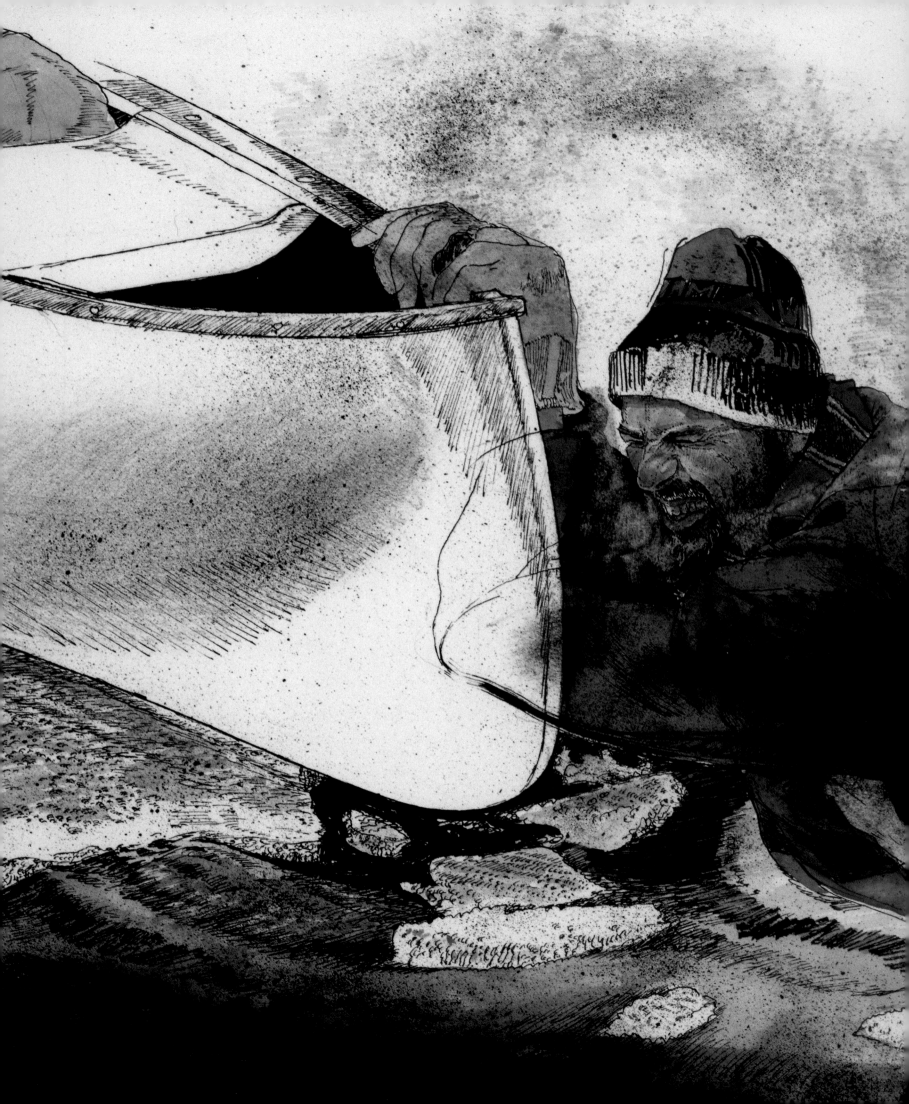

JACK UNRUH

WITH HEART-STOPPING CRUNCHES,
THE NOATAK RIVER'S THICKENING SHEET OF ICE
BROKE BENEATH ME SEVERAL TIMES ON MY
PUSH TO THE CHUKCHI SEA.

"ALONE ACROSS THE ARCTIC CROWN"

April 1993

The assignment to illustrate Keith Nyitray's story of his epic trek across Alaska's Brooks Range presented Jack Unruh with a problem. In order to document Nyitray's journey accurately, Unruh had to request that the author relive his most traumatic moments. "So I said, let's get Keith to Washington, D.C. and we'll use the Geographic studio," Unruh recollects. "We recreated a lot of scenes and even figured out where the sun would have been and at what angle. To show the incident where he fell through the icy river and clutched his canoe through the ice, I said, 'we've got to shoot a reference photo for this, so think about what it was like and then scream; make an actual sound and put a facial expression to it.' He did just that, and it was terrific — really great."

NEWELL CONVERS WYETH

(ABOVE & DETAIL, OPPOSITE) URGED EVER ONWARD BY THE QUEST OF THE UNKNOWN, THE
DAUNTLESS LEADER, SYMBOLIC OF MAN'S AGE-OLD STRUGGLE TO MASTER THE EARTH, HAS BRAVED THE SEA,
CONQUERED THE DESERT, PIERCED THE JUNGLE, SCALED THE MOUNT. AT LAST HIS TIRED EYES
BEHOLD THE GOAL OF HIS DREAM. IT IS HIS GIFT TO WORLD KNOWLEDGE.

———

THE DISCOVERER
SUPPLEMENT, *March 1928*

(FOLLOWING PAGES) UNDER THE GOLDEN GLOW OF A MIDNIGHT SUN, THE VALIANT BYRD,
EMPLOYING GEOGRAPHY'S NEWEST ALLY IN EXPLORATION, IS THE FIRST TO REACH, WITH WINGED
SPEED, THAT GOAL WHICH HIS COMPATRIOT, THE INSPIRED PEARY HAD WON, FOOT BY FOOT.

———

THROUGH PATHLESS SKIES TO THE NORTH POLE
SUPPLEMENT, *May 1928*

Wyeth began planning "The Discoverer" in the same way that he started every new painting. He etched the scene in his mind before ever touching brush to canvas, mapping it out first in his imagination and investing his idea with energy and emotion. Brimming with enthusiasm, he scrawled a letter to National Geographic Society Vice President John Oliver La Gorce.

I am thinking of it in terms of an early Spanish discoverer breaking from a tangle of jungle perhaps, mounting an eminence from which he ecstatically gazes for the first time upon the wide reaches of an unknown sea. Behind him emerging from the thickets, his faithful followers — weather-beaten, torn, and tired. They observe their leader's exaltation and are hastening to join him. At their backs will lie a great vista which will tell the story of their struggles — a deep valley of tropic forests and water courses receding into a haze of humid and miasmic mists....Contrasting this prospect is the other before them of the great blue sea sparkling in the sun, and above the sea rising in various cumulous masses, gorgeous and fantastic clouds against a cobalt sky.

Wyeth's Brandywine studio, although spacious, was too small to accommodate the vast 30-foot-long canvas, forcing him to unroll the linen as he painted — an unwieldy and difficult task. Yet through false starts, 16-hour workdays, intensive historical research, and the mandatory consultation with academic experts required of all NATIONAL GEOGRAPHIC artists, Wyeth remained true to his original vision. "The Discoverer" was completed in 1927. Flanked by four other Wyeth canvases — "Through Pathless Skies to the North Pole," "The Caravels of Columbus," and maps of the discovery routes for both Eastern and Western Hemispheres, "The Discoverer" still hangs majestically in Hubbard Hall where Wyeth installed it. Easily recognizable from the artist's initial description are the noble explorer, his stouthearted followers, the immense wilderness, and the shimmering blue of an unknown sea.

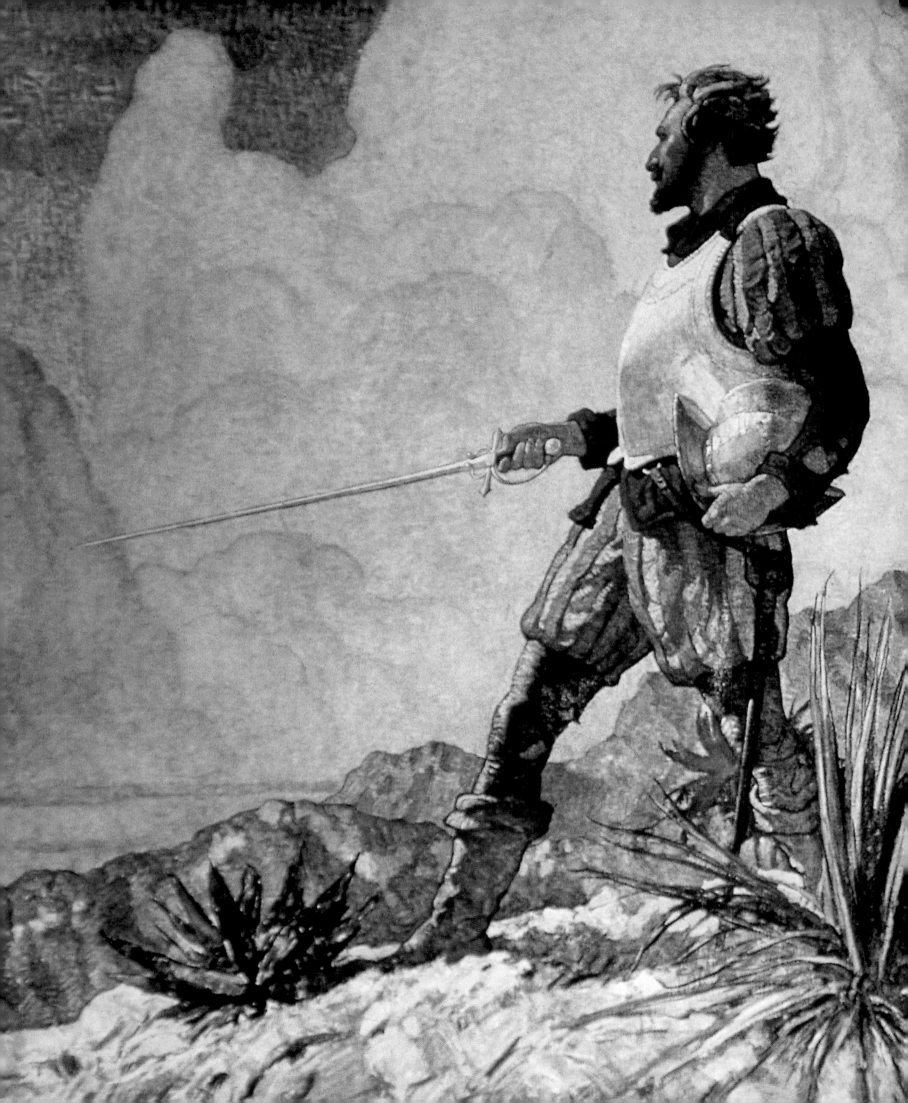

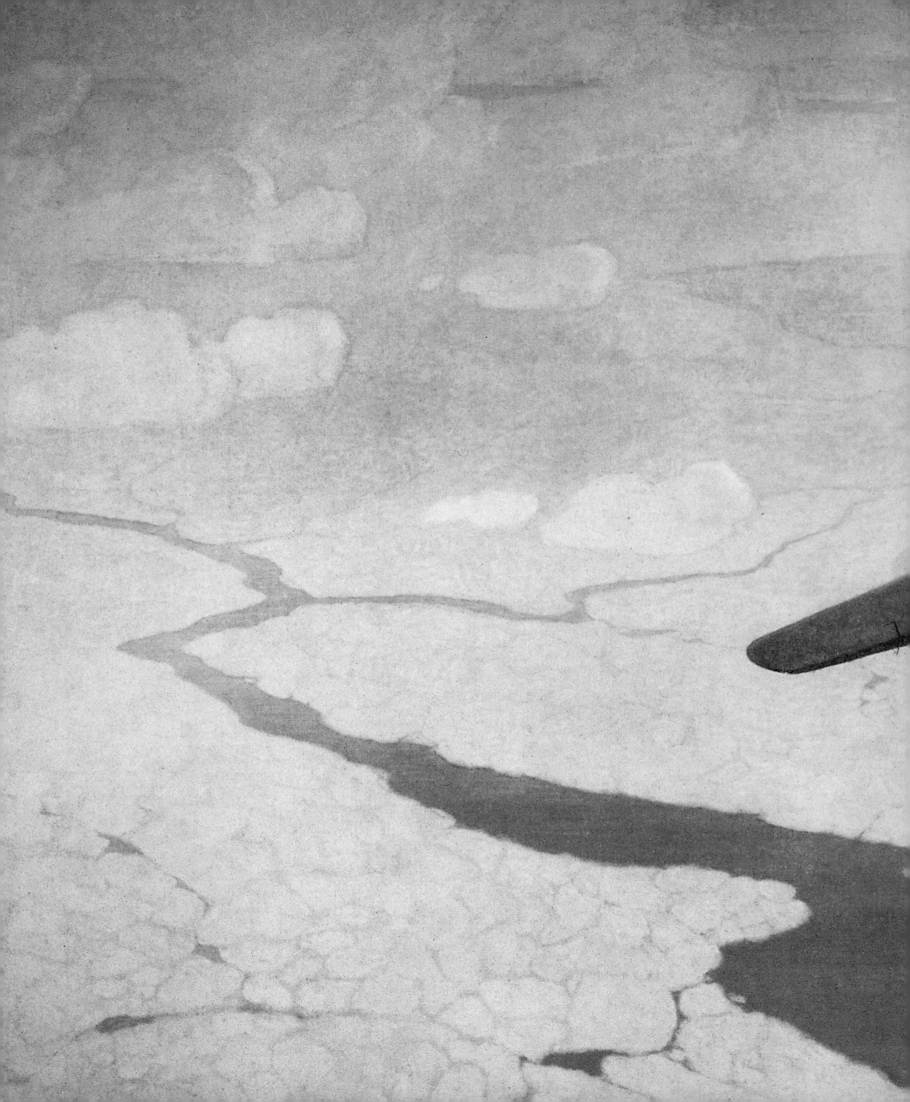

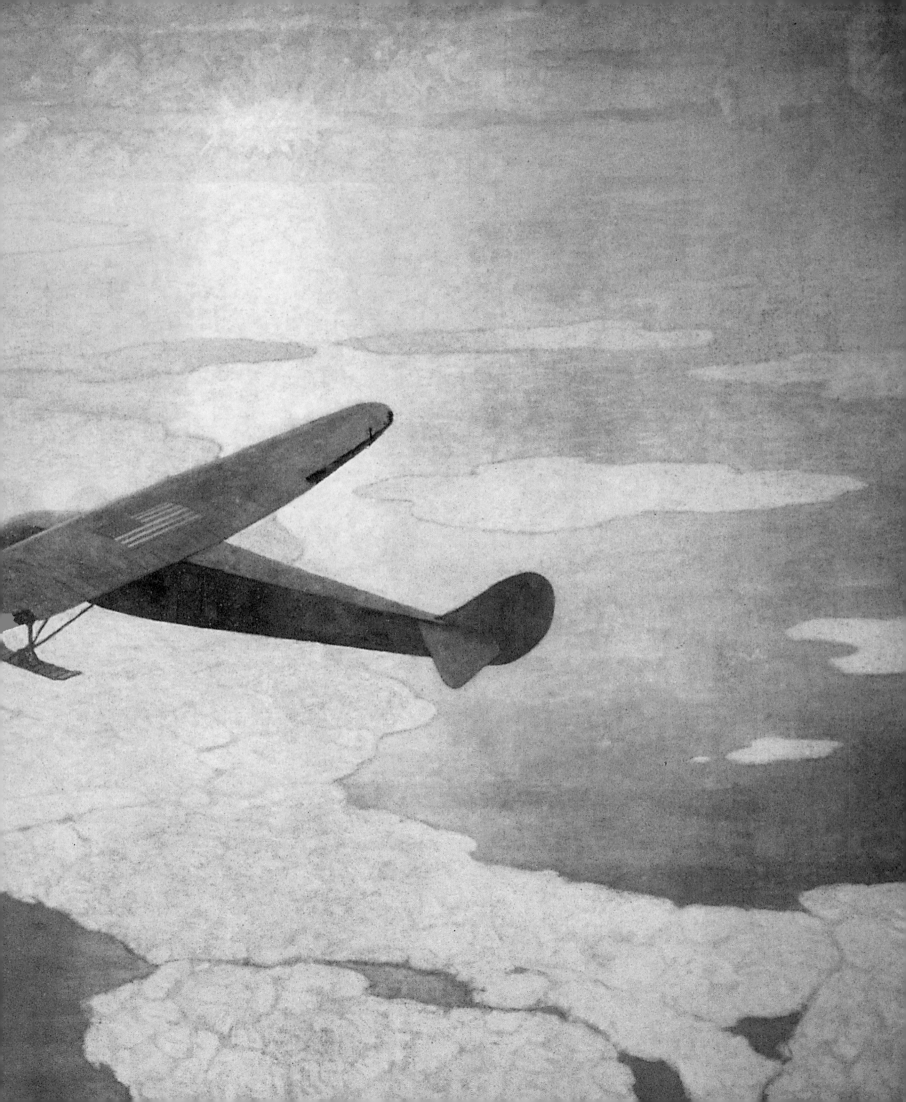

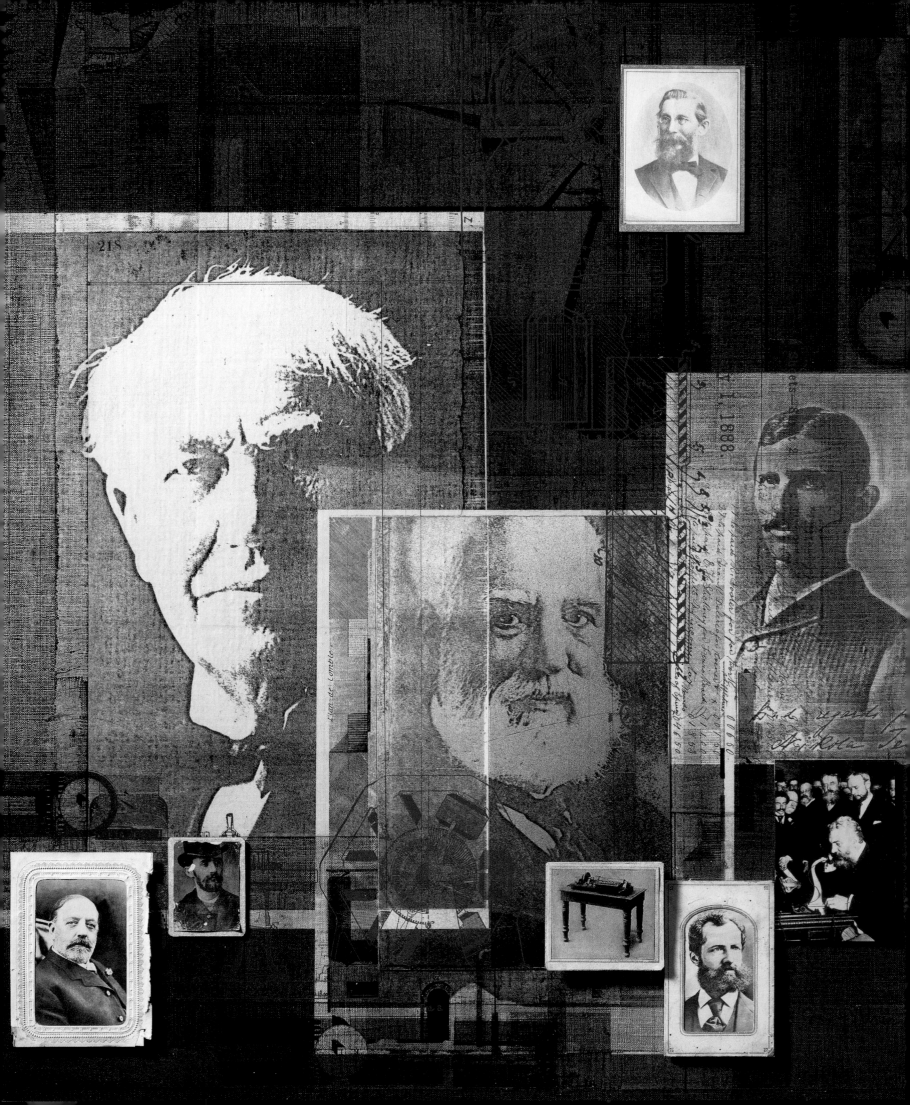

FRED OTNES

(OPPOSITE) "DISCOVERIES AND INVENTIONS
ARISE FROM THE OBSERVATION OF LITTLE THINGS,"
SAID ALEXANDER GRAHAM BELL, INVENTOR OF THE
TELEPHONE AND THE NATIONAL GEOGRAPHIC
SOCIETY'S SECOND PRESIDENT.

———

"ONE HUNDRED YEARS
OF INCREASING AND DIFFUSING
GEOGRAPHIC KNOWLEDGE"

January 1988

NED M. SEIDLER

(ABOVE) "NO MORE PLEASANT SIGHT HAS MET MY
EYE THAN THIS OF SO MANY THOUSANDS OF LIVING
CREATURES IN ONE SMALL DROP OF WATER,"
WROTE ANTON VON LEEUWENHOEK IN 1676. WITH
HIS DISCOVERY OF PROTOZOA AND BACTERIA,
LEEUWENHOEK, AN UNSCHOOLED DUTCHMAN,
ASTONISHED THE 17TH-CENTURY INTELLECT.

———

"SEVEN GIANTS WHO LED THE WAY"

September 1976

Fred Otnes's collage celebrating American inventors of the 1880s appeared in the centennial issue of NATIONAL GEOGRAPHIC. Alexander Graham Bell is pictured in the center and the lower right of the illustration. Thomas Edison is on the left. Nikola Tesla (right center) patented the alternating-current motor. Ottmar Mergenthaler (bottom right) invented the electric-powered Linotype. Louis E. Waterman, pictured in the upper right of the collage, designed the first fountain pen. The rotund William Horlick (lower left) was the creator of malted milk. George Eastman (in the hat) invented the Kodak box camera.

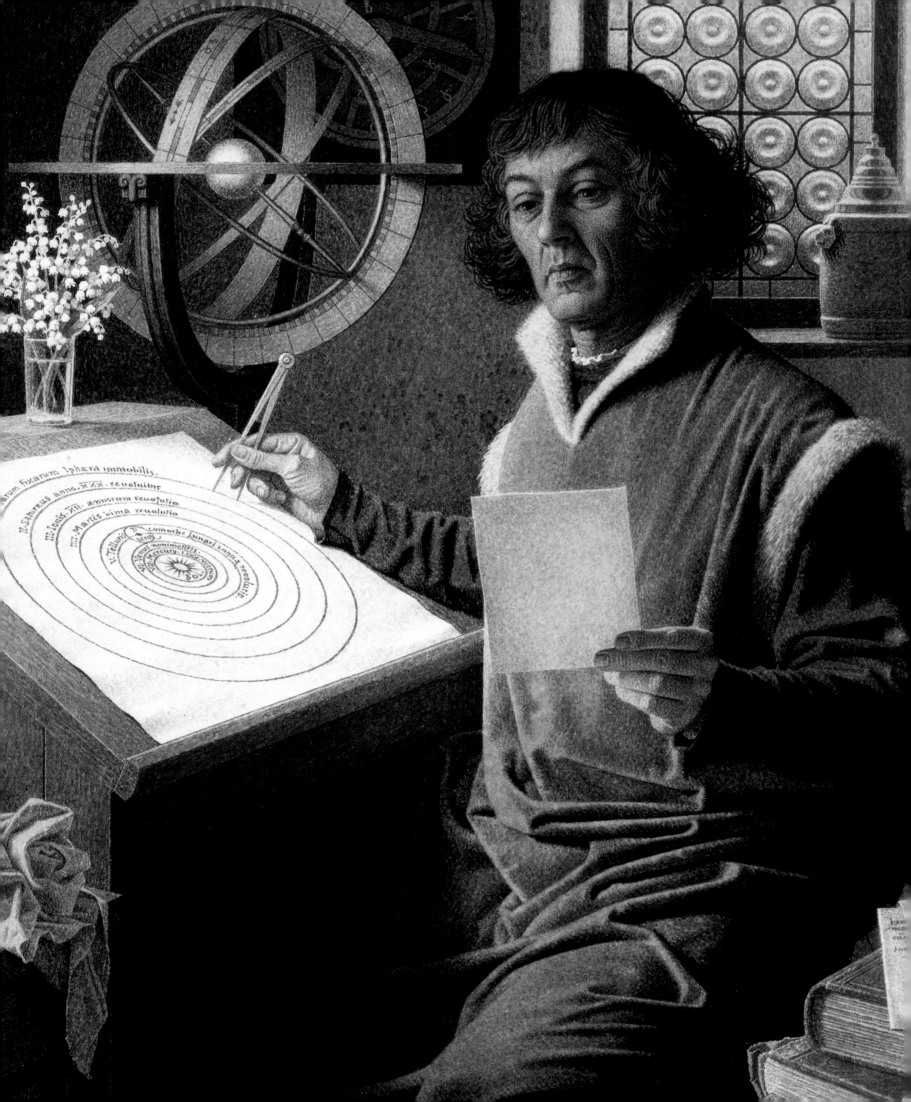

JEAN-LEON HUENS

(OPPOSITE) "THE EARTH...LIES RIGHT IN THE MIDDLE OF
THE HEAVENS," THE GREEK ASTRONOMER PTOLEMY ASSERTED. HIS
CONCEPT HELPED SHACKLE MEN'S MINDS FOR MORE THAN A MILLENNIUM.
THEN NICOLAUS COPERNICUS, A SCHOLARLY AND UNASSUMING ADMINISTRATOR
IN THE ROMAN CATHOLIC CHURCH, TRIGGERED A REVOLUTION THAT
DISLODGED EARTH — AND MAN — FROM THE CENTER OF
THE UNIVERSE.

(FOLLOWING PAGES) WHEN BUBONIC PLAGUE PARALYZED ENGLAND
IN 1665, ISAAC NEWTON, THEN 22, LEFT CAMBRIDGE UNIVERSITY TO
CARRY ON HIS STUDIES AT HOME. EIGHTEEN MONTHS LATER, WHEN THE
PLAGUE HAD SUBSIDED, NEWTON HAD DETERMINED BASIC PRINCIPLES OF LIGHT
AND COLOR, CREATED INTEGRAL AND DIFFERENTIAL CALCULUS,
AND BEGUN TO DEFINE THE WORKING OF GRAVITY.

———————

"PIONEERS IN MAN'S SEARCH
FOR THE UNIVERSE"

May 1974

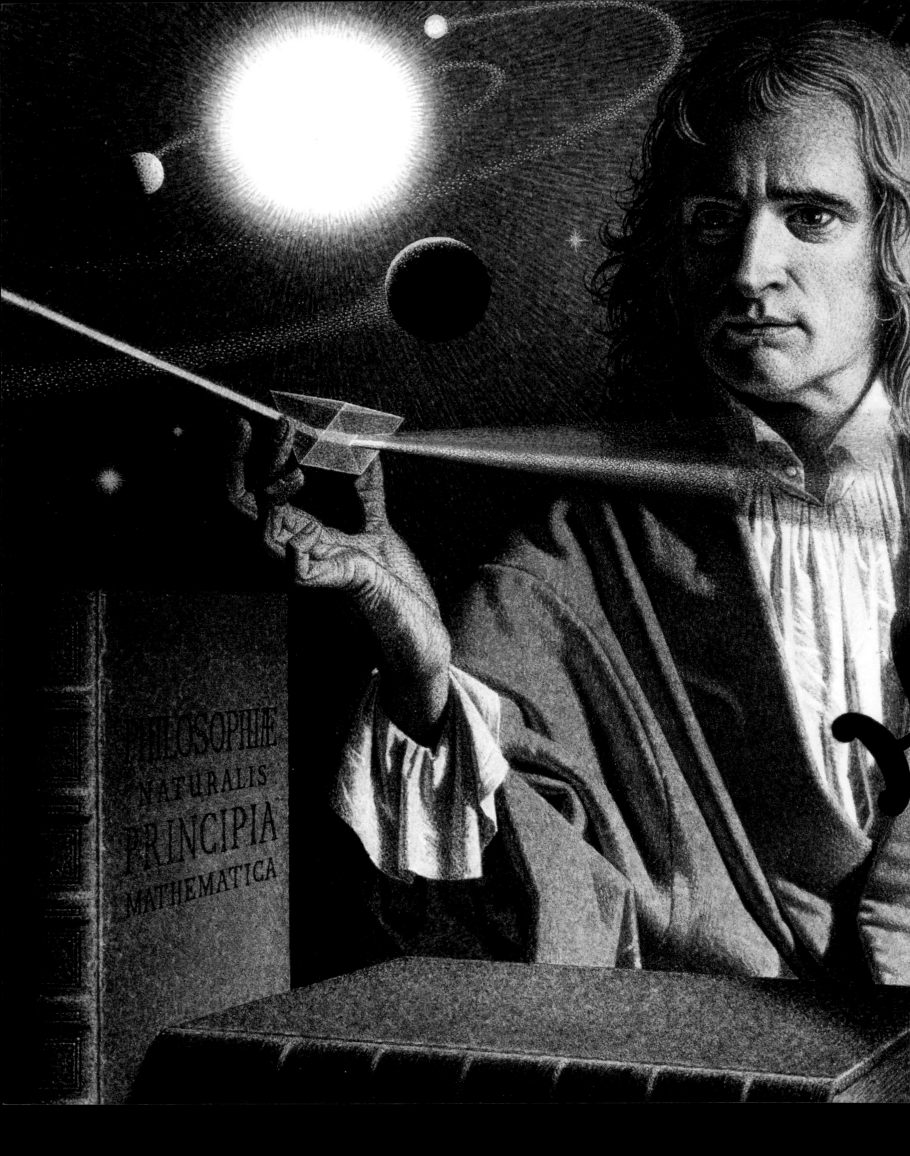

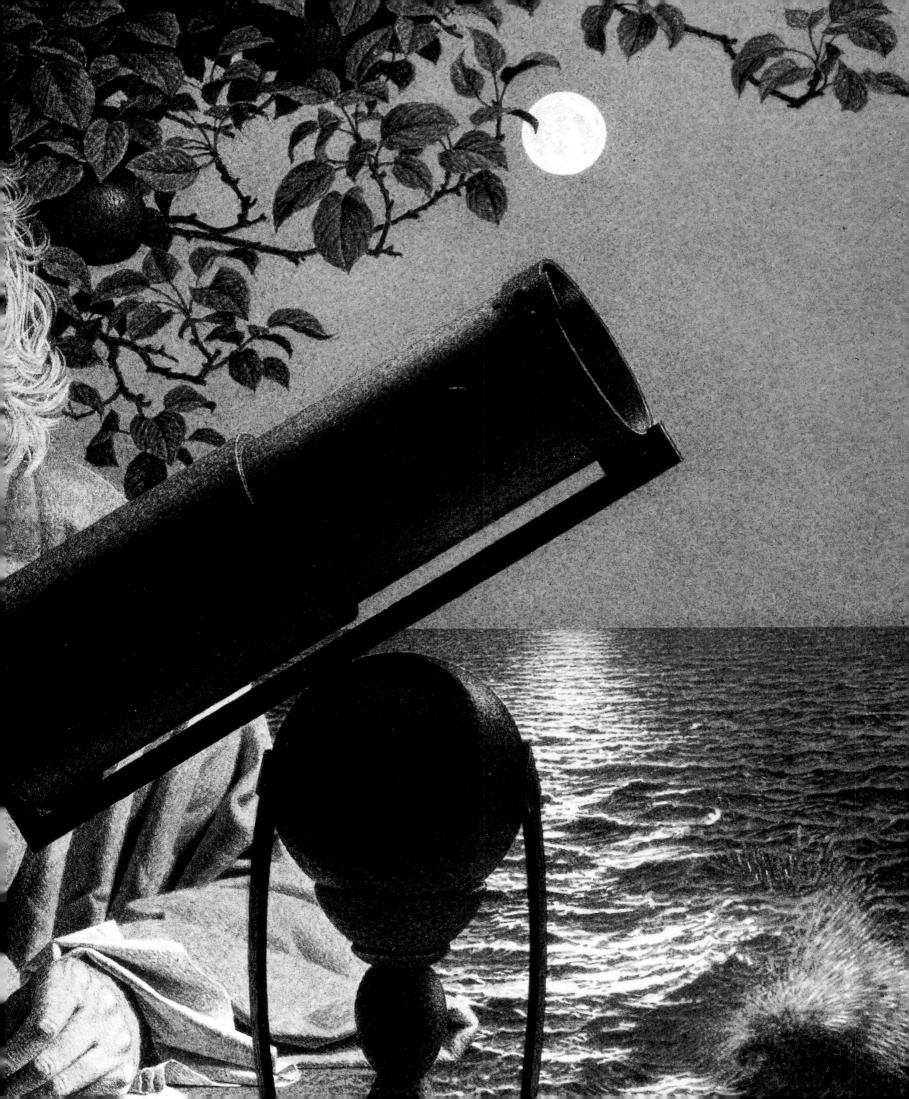

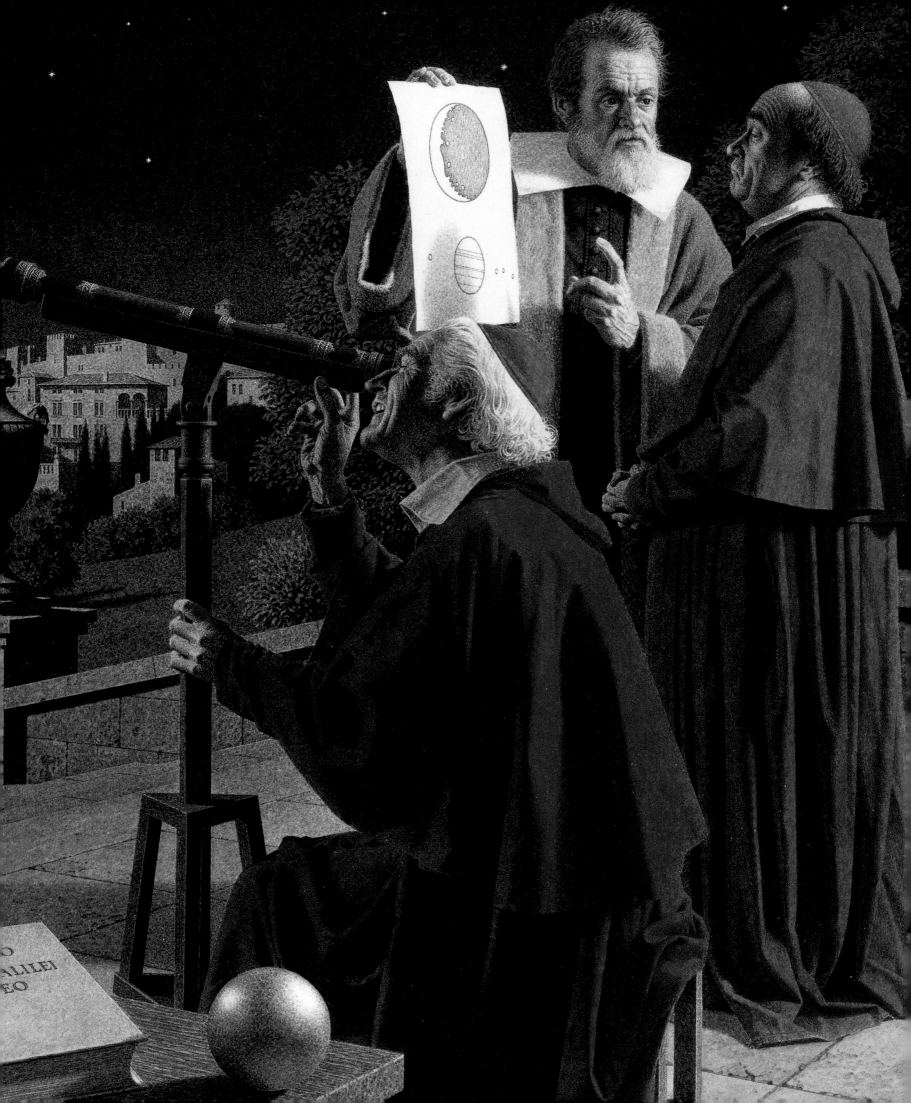

$$E = mc^2$$

JEAN-LEON HUENS

(ABOVE) THE NEWS SPREAD WITH LIGHTNING SPEED THAT SPRING OF 1919:
SCIENTISTS OBSERVING AN ECLIPSE OF THE SUN HAD TESTED — AND VERIFIED —
ALBERT EINSTEIN'S REVOLUTIONARY THEORY THAT GRAVITATION BENDS LIGHT.
ALMOST INSTANTLY, "RELATIVITY" BECAME AN EVERYDAY TERM.

(OPPOSITE) WONDROUS VISTAS OPENED IN 1609 TO GALILEO GALILEI,
FIRST MAN TO SEE THE HEAVENS THROUGH A TELESCOPE. DELIGHTEDLY THE
ITALIAN ASTRONOMER-PHYSICIST DISCOVERED MOUNTAINS ON THE MOON,
THE PHASES OF VENUS, THE FOUR "LITTLE STARS" ATTENDING
JUPITER. SCANNING THE MILKY WAY, HE BEHELD COUNTLESS STARS
NEVER BEFORE SEEN. OBSERVING SUNSPOTS TRAVERSING THE
SOLAR DISK, HE DEDUCED THAT THE SUN ROTATES.

"PIONEERS IN MAN'S SEARCH FOR THE UNIVERSE"

May 1974

Jean-Leon Huens's paintings of scientists whose discoveries helped to shape our understanding of the universe are meticulously researched and finely rendered. Conforming to the conventions of classic portraiture, they resemble the paintings of Hans Holbein the Younger. In the tradition of Holbein, Huens surrounds each of these great scientific explorers with icons representing their singular contributions.

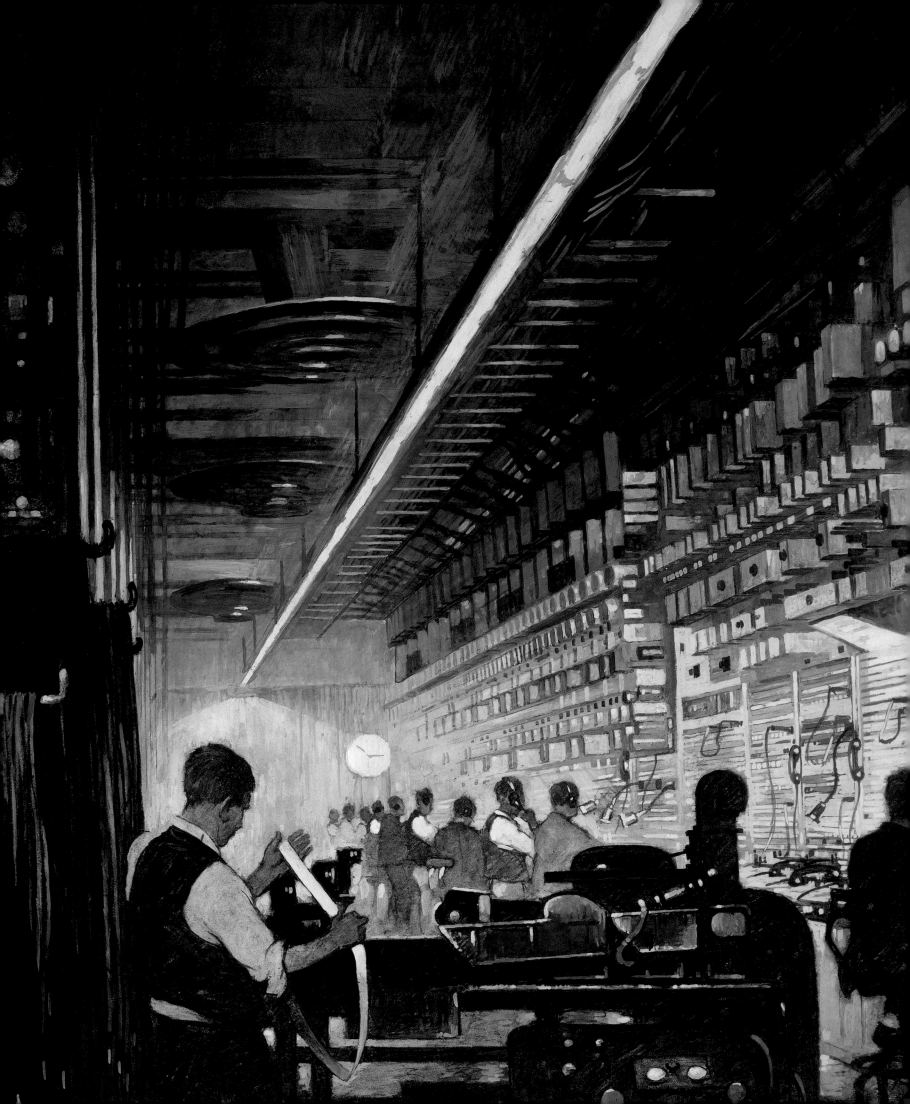

THORNTON OAKLEY

(ABOVE) WIND TUNNELS HURL SUPERHURRICANES
FOR TESTING AIRPLANES.

(LEFT) THROUGH INSTRUMENTS OF THE
RADIOTELEPHONE CONTROL ROOM COME VOICES
FROM THE ENDS OF THE EARTH.

(FOLLOWING PAGES) MACHINE FOR
TESTING SPEED AND PULL DEMONSTRATES
POWER OF NEW GIANT LOCOMOTIVES.

"SCIENCE WORKS FOR MANKIND"
December 1945

In March 1944, Thornton Oakley was commissioned to produce "a series of paintings to illustrate the development of new materials and equipment being studied and perfected for postwar production." The project was open-ended, and Oakley was advised that "Almost anything which will contribute to the benefit of mankind in the future may be considered a suitable subject for illustration." To help narrow the list of possible topics, it was suggested that Oakley contact Charles Kettering, president of General Motors Research Corporation, who was a member of the Society's Board of Trustees. Oakley agreed to supply the NATIONAL GEOGRAPHIC with 16 watercolors. He was to be paid $250 for each painting, plus $1,000 to cover the cost of traveling the country to complete his research for the project.

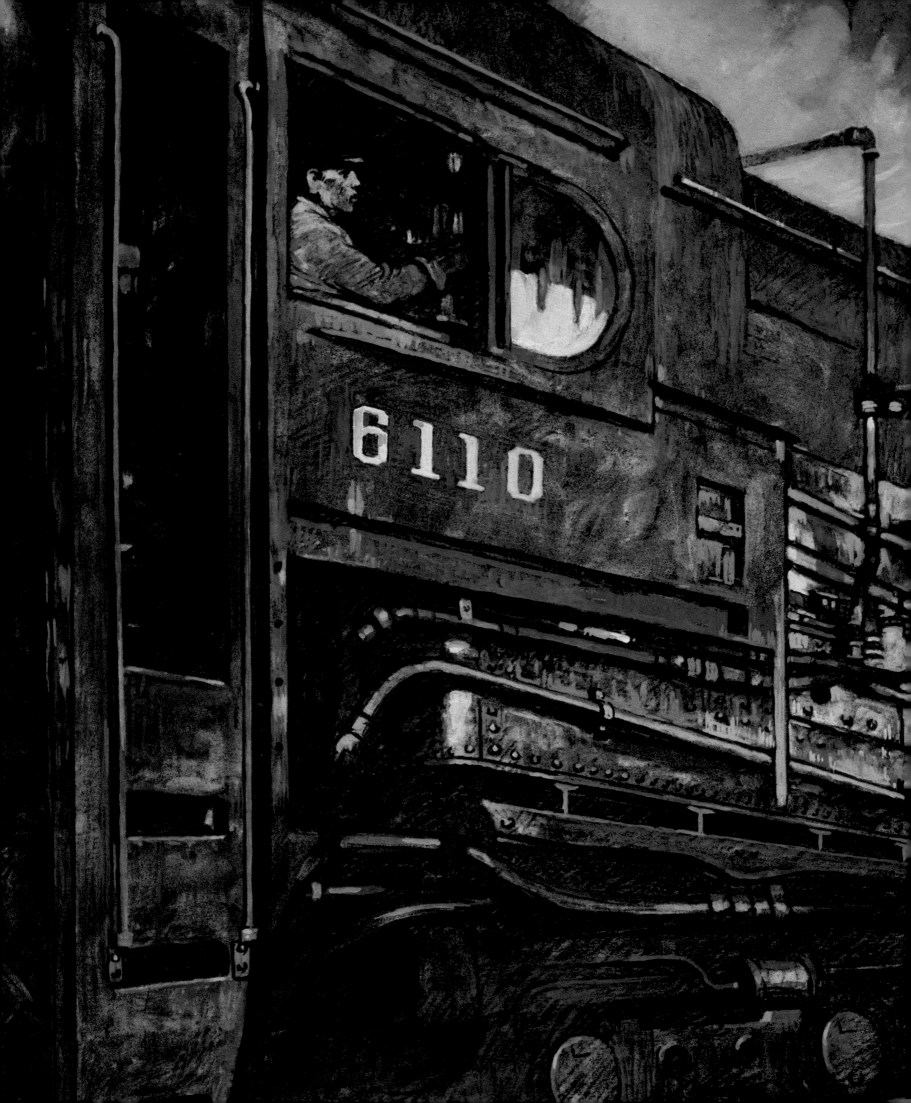

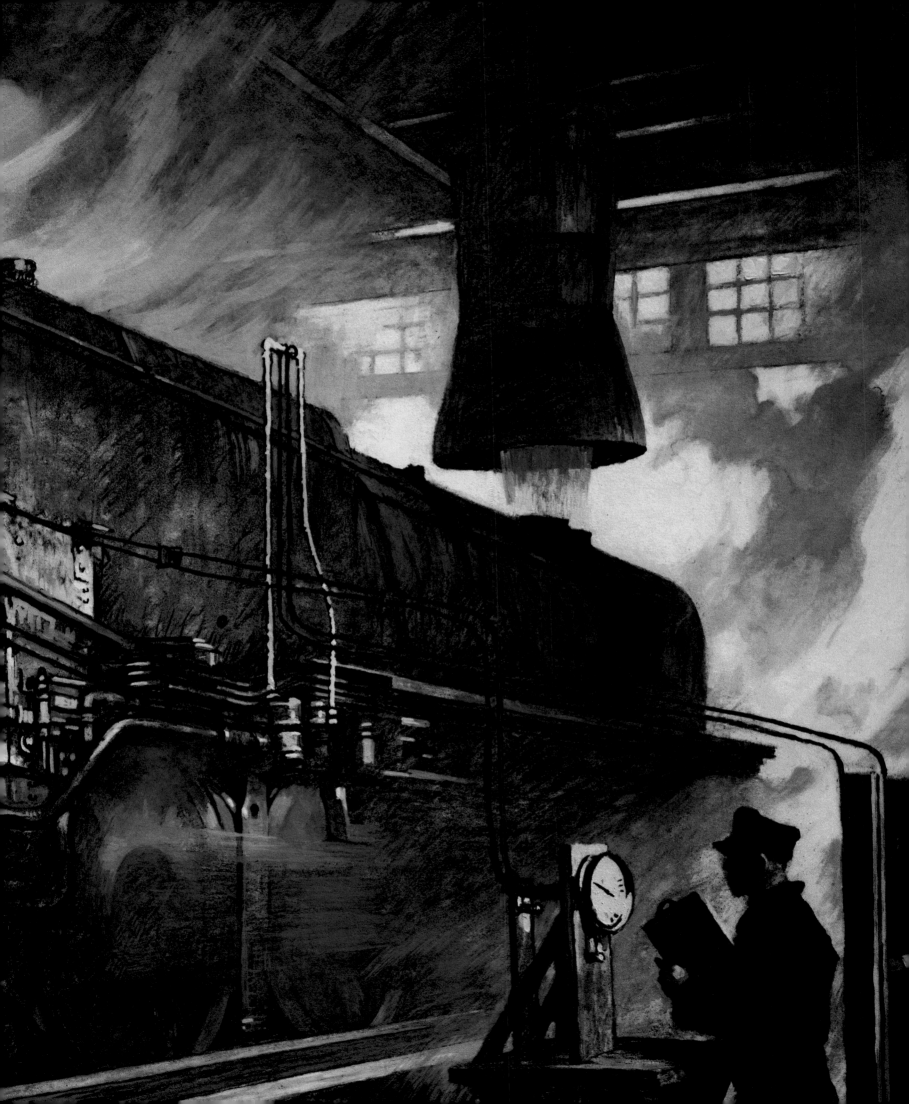

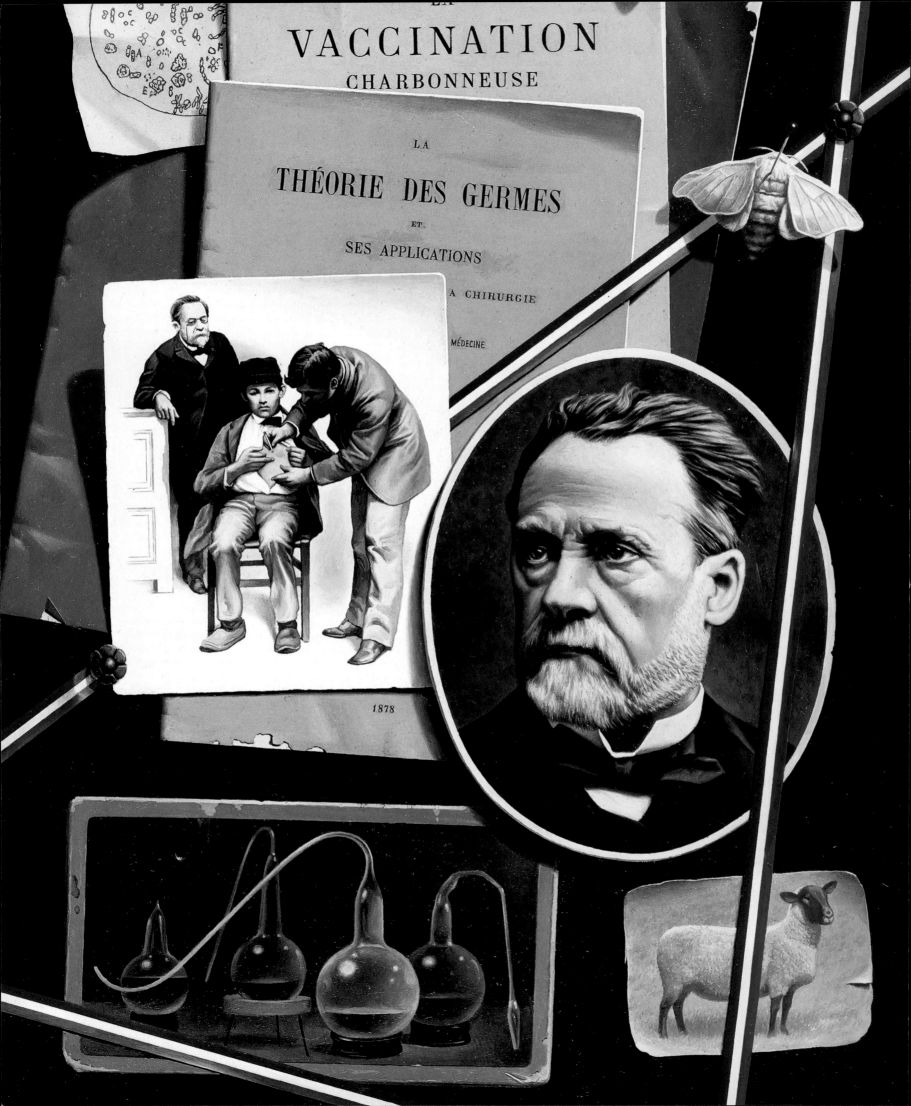

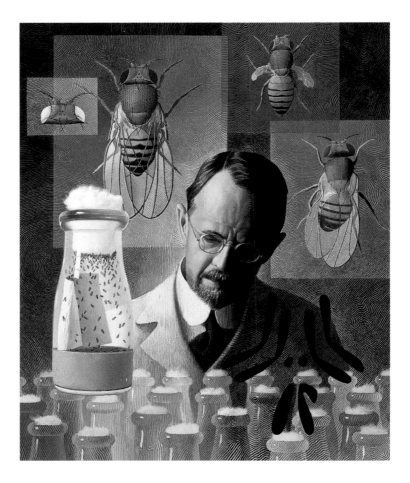

NED M. SEIDLER

❧

(ABOVE) FOR NEARLY TWENTY YEARS, THOMAS HUNT MORGAN'S "FLY ROOM"
AT COLUMBIA UNIVERSITY WAS ALIVE WITH BOTTLEFULS OF THE FRUIT FLY *DROSOPHILA* —
AND WITH SOME OF THE GREATEST MINDS IN GENETICS.

(OPPOSITE) IN THE 1860S, LOUIS PASTEUR TAUGHT THE FRENCH HOW TO KEEP WINE
FROM SOURING. THAT ALONE WOULD HAVE MADE HIM A NATIONAL HERO. PASTEUR PROVED
THE YEASTS THAT TURN GRAPE SUGARS INTO WINE ARE LIVING BEINGS AND THAT
FERMENTATION IS A PRODUCT OF THEIR DIGESTION. THIS SHOWED THAT
BASIC LIFE PROCESSES ARE CHEMICAL REACTIONS.

———————

"SEVEN GIANTS WHO LED THE WAY"

September 1976

Ned Seidler's portraits of influential biologists were difficult, time-consuming projects requiring considerable research as well as many hours at the drawing board. In his detailed illustration of Thomas Hunt Morgan, shown above, the artist textured the surface of his painting with tiny subtle lines that resemble fingerprints. When the series was published in NATIONAL GEOGRAPHIC, the paintings were widely praised; the Society received a letter of appreciation from the scientist's son, Howard K. Morgan, complimenting Seidler on his wonderful painting. Accolades also came from fellow artist and former vice president of the American Watercolor Society, portrait painter Gordon C. Aymar. Seidler's portraits inspired Aymar to send the following quote from Samuel Coleridge to the Society's headquarters. "Examine nature accurately, but write [or paint] from recollection, and trust more to your imagination than to memory."

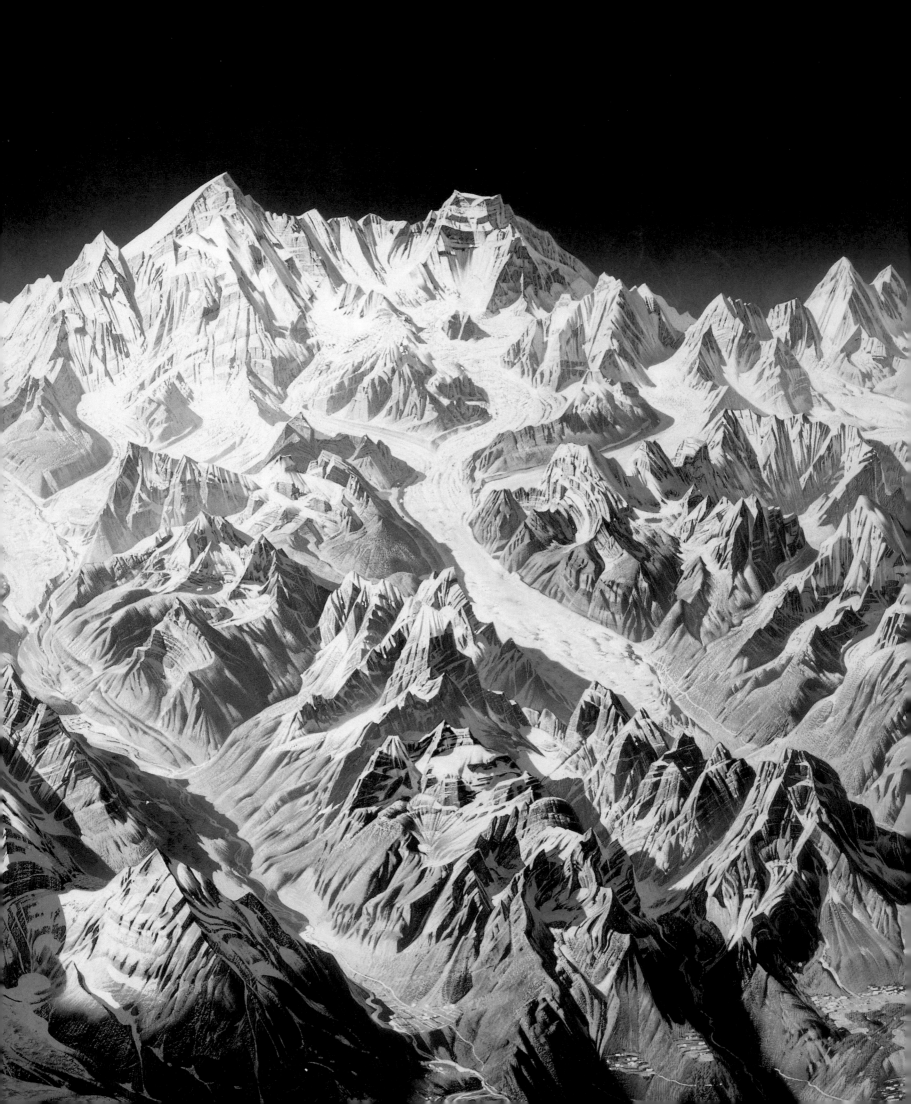

NATURAL HISTORY

NATURAL HISTORY

A puma slips into the jungle, an owl glides through a starry sky on a silent desert night, strangely luminescent fish hunt their prey in a jet-black sea. Although black-and-white drawings and diagrams appeared in NATIONAL GEOGRAPHIC at the turn of the century, Louis Agassiz Fuertes's ornithological paintings, published in 1913, comprised the first important series of full-color illustrations reproduced in the magazine. Since that time, many outstanding artists have treated Society members to an astounding array of remarkable natural history paintings. In "Sky World of the Himalayas," world-renowned panoramist Heinrich C. Berann painted a 35-mile sweep of Sherpaland. He based his work on personal observation and on more than a hundred photogrammetric views made by the noted Himalayan mapper and climber Erwin Schneider between 1955 and 1963. ∼ Illustrators like Berann with the expertise necessary to create these complex images are not easy to find, however, since they must possess both extraordinary artistic skill and extensive scientific knowledge. In 1956, Walter A. Weber, who produced hundreds of wildlife illustrations during his 22-year tenure as a staff illustrator, was asked if he would train an assistant. It was suggested that perhaps the Society should hire a young artist as an understudy, whom Weber could then instruct in special illustration techniques and shortcuts. Weber was scandalized by the idea and wrote a lengthy memo informing his editors that there was no easy or quick path to becoming a wildlife illustrator. ∼ Weber's own career was a study in hard work and dedication. His enthusiasm for art began at the age of four, when his drawing of a white peacock — sketched on a sandwich wrapper at the Chicago Zoo — astounded his parents. From that day on, he spent as much time as possible at the zoo with a sketchpad. He began his formal training at the age of nine in the Saturday children's class of the Art Institute of Chicago, continuing those classes through high school. Weber majored in biology at the University of Chicago, graduated summa cum laude in 1927, and was offered a scholarship to continue on for his doctorate. He turned the offer

(PRECEDING PAGES) **HEINRICH C. BERANN**
"SHERPALAND, MY SHANGRI-LA" *October 1966*

down, electing instead to become a full-time student at the School of the Art Institute of Chicago. ~ Weber's first opportunity to illustrate professionally came in 1928, when he secured a position on an expedition sponsored by Chicago's Field Museum of Natural History. Under its auspices, he spent a year in the South Pacific, where he painted 40 watercolors of birds and mammals and completed 123 color sketches of fish. The Field Museum was so pleased with the illustrations that Weber was hired full time to design exhibit backgrounds. In spite of a busy schedule at the museum, Weber continued his training in oil painting, drawing, and composition. A six-month hiatus in British Columbia, working with renowned ornithological illustrator Allan Brooks, completed his education. ~ In 1935, the National Park Service hired Weber and subsequently transferred him to Washington, D. C., where he distinguished himself as chief illustrator. His first opportunity to work for NATIONAL GEOGRAPHIC came in 1939, when he was commissioned – along with his mentor, Allan Brooks – to contribute ornithological illustrations for the article "Sparrows, Towhees, and Longspurs." In 1949, after the almost four decades of hard work and extensive study he began as a child, he accepted a position as a staff artist. ~ During his years at NATIONAL GEOGRAPHIC, Walter Weber collected, studied, and dissected over 5,000 birds and about 2,000 mammals, as well as numerous insects and fish. Accurate and meticulously detailed, Weber's compelling paintings evoke the mysterious beauty of the natural world. He took no shortcuts with either art or science. ~ In recent years, the genre of wildlife painting has become even more complex as artists are called upon to create entire habitats populated by species that range in size from the microscopic to the massive. Nevertheless, artists like John Dawson, Jay Matternes, and Ned Seidler have risen to the challenge, fulfilling what current Board of Trustees Chairman Gilbert M. Grosvenor maintains is the charge of all National Geographic artists, "to make geographic knowledge accessible without demeaning its scientific value."

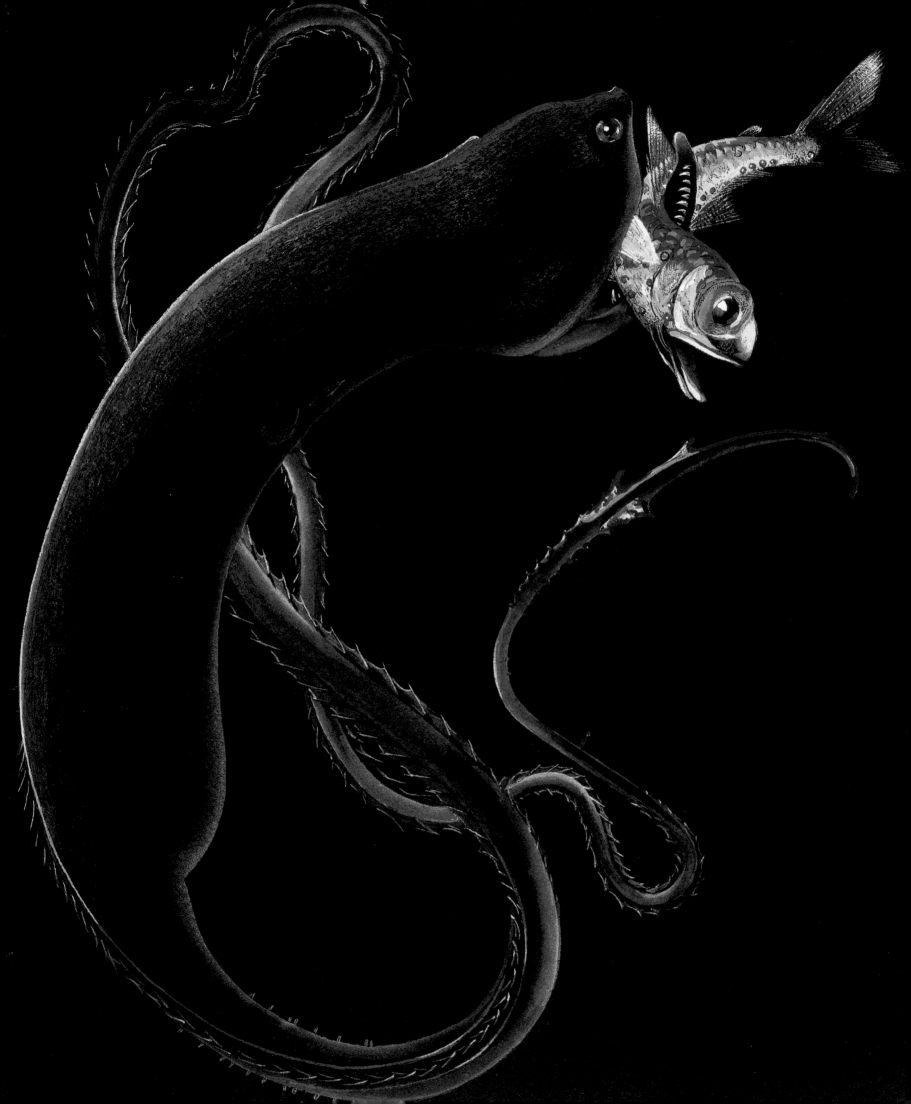

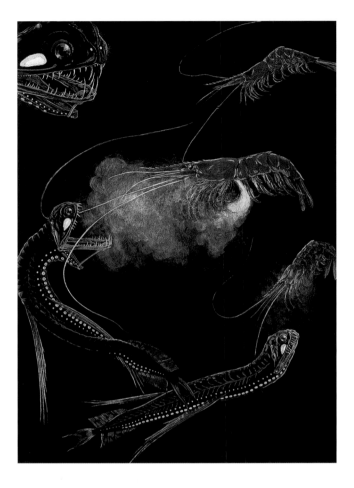

ELSE BOSTELMANN

(ABOVE) FIGHTING WITH "FLAME" HALF-A-MILE-DOWN. LIKE
FLAMMENWERFER OF THE WORLD WAR, THE SCARLET SHRIMP SHOOTS
FORTH A CLOUD OF LUMINOUS FLUID TO BLIND ITS ASSAILANT.

(OPPOSITE) THE LARGEST BERMUDA DEEP-SEA FISH EVER TAKEN IN A NET.
THE GREAT GULPER EEL, 55 INCHES LONG, IS THE BIGGEST SPECIMEN
THAT HAS YET BEEN BROUGHT TO THE SURFACE FROM THE DEPTHS.
HERE IT IS DEVOURING A GIANT LANTERNFISH PROBABLY LURED
WITHIN STRIKING DISTANCE BY THE FLAMING-RED LIGHT
ORGAN NEAR THE TIP OF ITS TAIL.

"A HALF MILE DOWN"
December 1934

Else Bostelmann accompanied William Beebe on oceanographic expeditions to the waters off Bermuda from 1929 to 1934. In order to assure the accuracy of her illustrations, Bostelmann was known to don a copper diving helmet and paint in oils at a depth of 14 feet. For these two illustrations, she was unable to work from life because the dramas depicted here took place deep in the sea. Relying on Beebe's descriptions of his descent in his Bathysphere, the paintings were conjured up in her imagination.

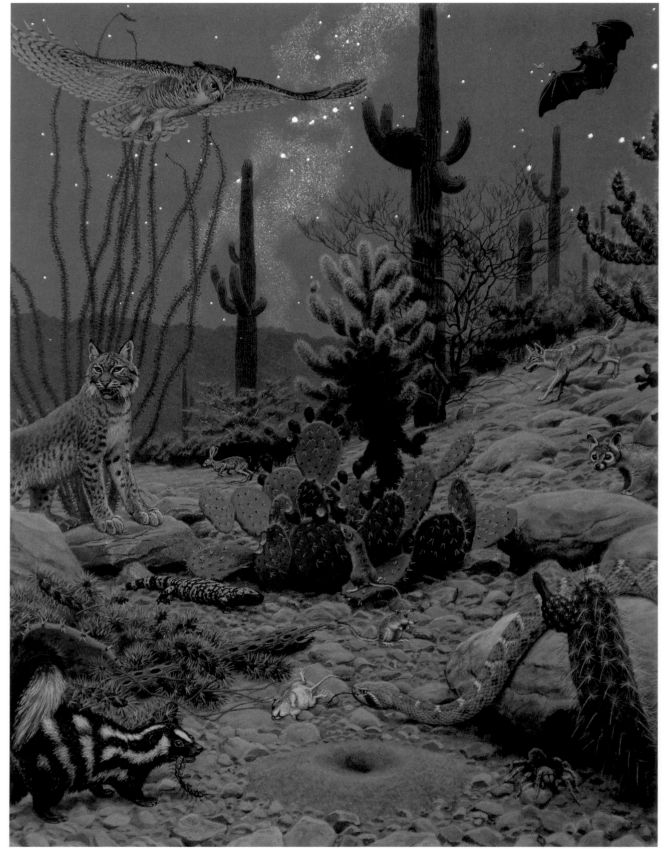

Darkness and the cool of a summer evening rouse a variety of nocturnal animals, including most of the large mammals, from their inactivity during the day. *Great American Deserts* 1972

JAY H. MATTERNES

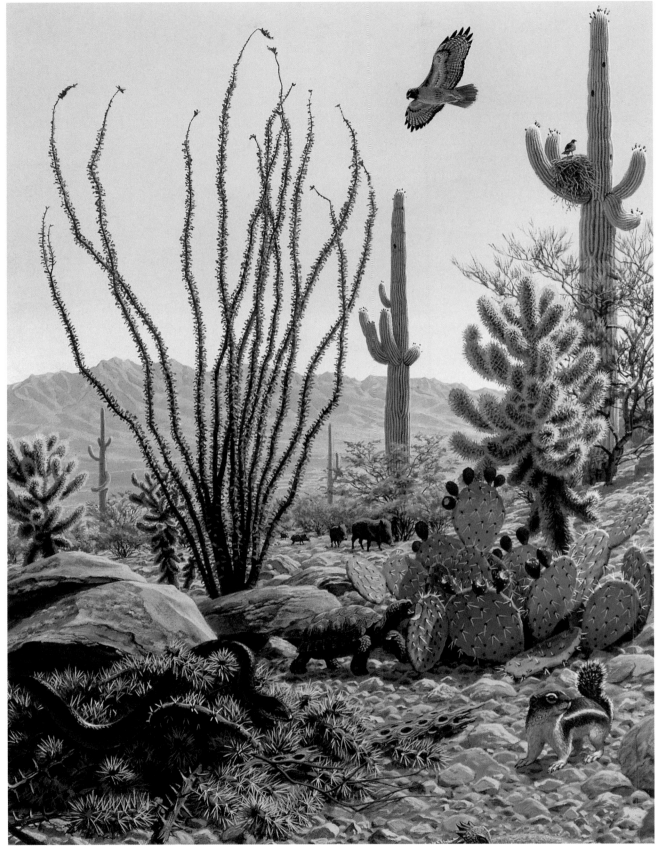

Coasting on a current of air, a red-tailed hawk scans the Sonoran Desert of Arizona for rodents, snakes, and insects in this representation of desert plant and animal life on an early morning in July; the hawk's mate guards their nest in towering saguaro cactus. *Great American Deserts 1972*

JAY H. MATTERNES

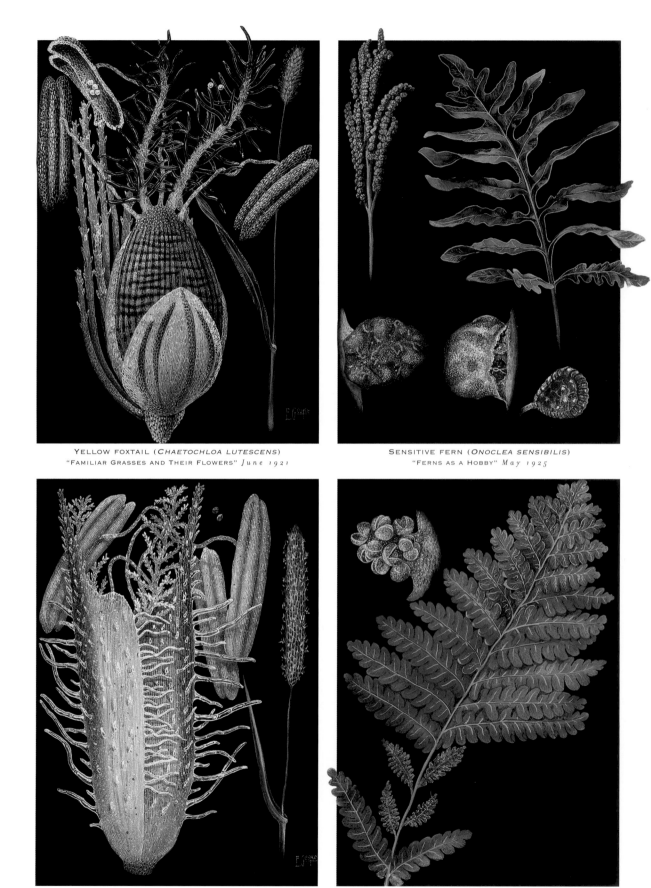

YELLOW FOXTAIL (*CHAETOCHLOA LUTESCENS*)
"FAMILIAR GRASSES AND THEIR FLOWERS" *June 1921*

SENSITIVE FERN (*ONOCLEA SENSIBILIS*)
"FERNS AS A HOBBY" *May 1925*

TIMOTHY (*PHLEUM PRATENSE*)
"FAMILIAR GRASSES AND THEIR FLOWERS" *June 1921*

INTERRUPTED FERN (*OSMUNDA CLAYTONIANA*)
"FERNS AS A HOBBY" *May 1925*

ERICH J. GESKE

ERICH J. GESKE

(OPPOSITE) YELLOW FOXTAIL, SENSITIVE FERN,
TIMOTHY, AND INTERRUPTED FERN.

HASHIME MURAYAMA

(FOLLOWING PAGES) BROOK TROUT, BLACK BASS,
GREEN TURTLE AND HAWKSBILL TURTLE, TARPON.

Erich J. Geske was an obscure botanist who was affiliated with the College of
Medicine of the University of Cincinnati. Between 1921 and 1925, he painted
30 full-page botanical illustrations for NATIONAL GEOGRAPHIC. While observing
plant specimens under a microscope, some of which were magnified up to 75 times,
Geske carefully sketched their structure. From his observations and notes, he com-
posed the beautiful watercolors featured on the following pages.

To ensure that he had a complete understanding of the fish he would be paint-
ing for the August 1923 NATIONAL GEOGRAPHIC article "Our Heritage of the
Fresh Waters," the Society sent staff artist Hashime Murayama to New York to work
with the author, New York Aquarium Director Charles Townsend. Although
Townsend went to great trouble to assure that Murayama had the best information
possible, his plans went awry. Murayama described the problem in a letter to
Geographic Vice President John Oliver La Gorce. "About ten days ago Dr. Townsend
sent a man to New Jersey and [he] brought back thirty living specimens of rainbow
trout, lake trout, and brook trout. Unfortunately they all died in a few days after
arrival because the water in his aquarium did not agree with them." Luckily,
Muryama had finished painting the rainbow and lake trout before their untimely
demise. The watercolor of the brook trout was eventually finished when new speci-
mens arrived and presumably lived long enough to pose for their portraits.

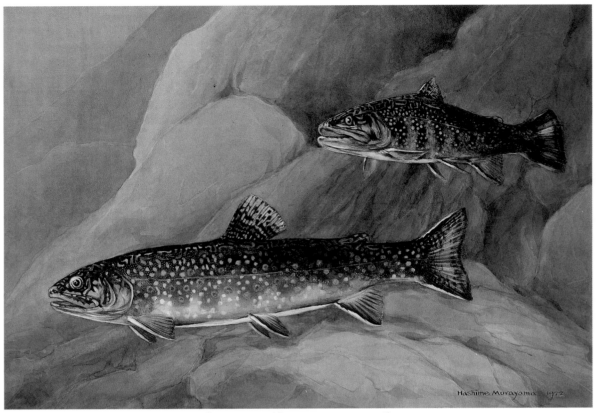

BROOK TROUT (*SALVELINUS FONTINALIS*)
"OUR HERITAGE OF THE FRESH WATERS" *August 1923*

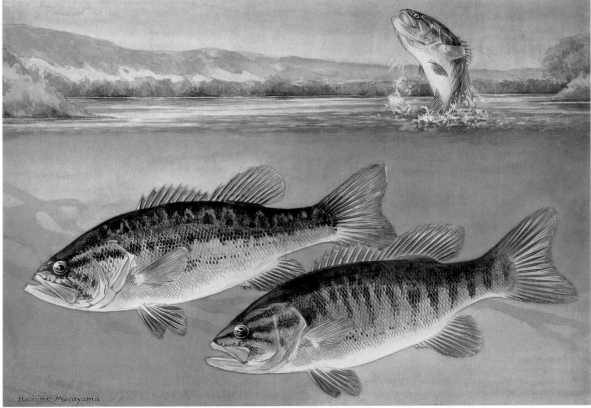

LARGE-MOUTHED BLACK BASS (*MICROPTERUS SALMOIDES*, UPPER); SMALL-MOUTHED BLACK BASS (*MICROPTERUS DOLOMIEU*, LOWER)
"OUR HERITAGE OF THE FRESH WATERS" *August 1923*

HASHIME MURAYAMA

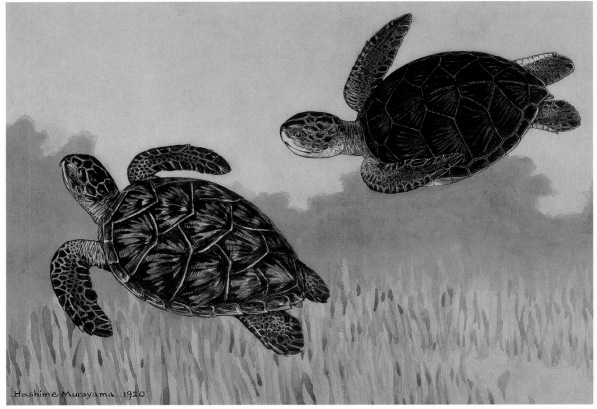

GREEN TURTLE (*CHELONIA MYAAS*, UPPER); HAWKSBILL TURTLE (*ERETMOCHELYS IMBRICATA*, LOWER)
"CERTAIN CITIZENS OF THE WARM SEAS' *January 1922*

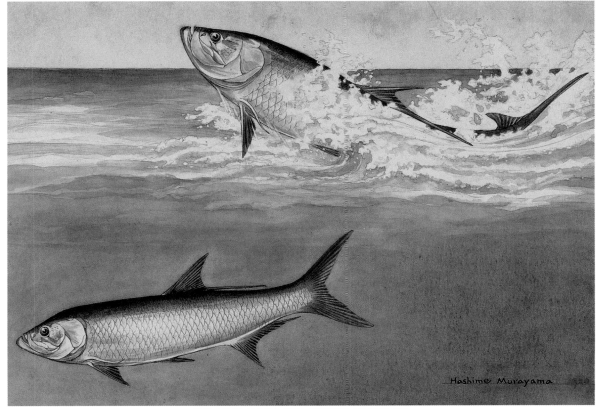

TARPON OR SILVER KING (*TARPON ATLANTICUS*)
"CERTAIN CITIZENS OF THE WARM SEAS" *January 1922*

HASHIME MURAYAMA

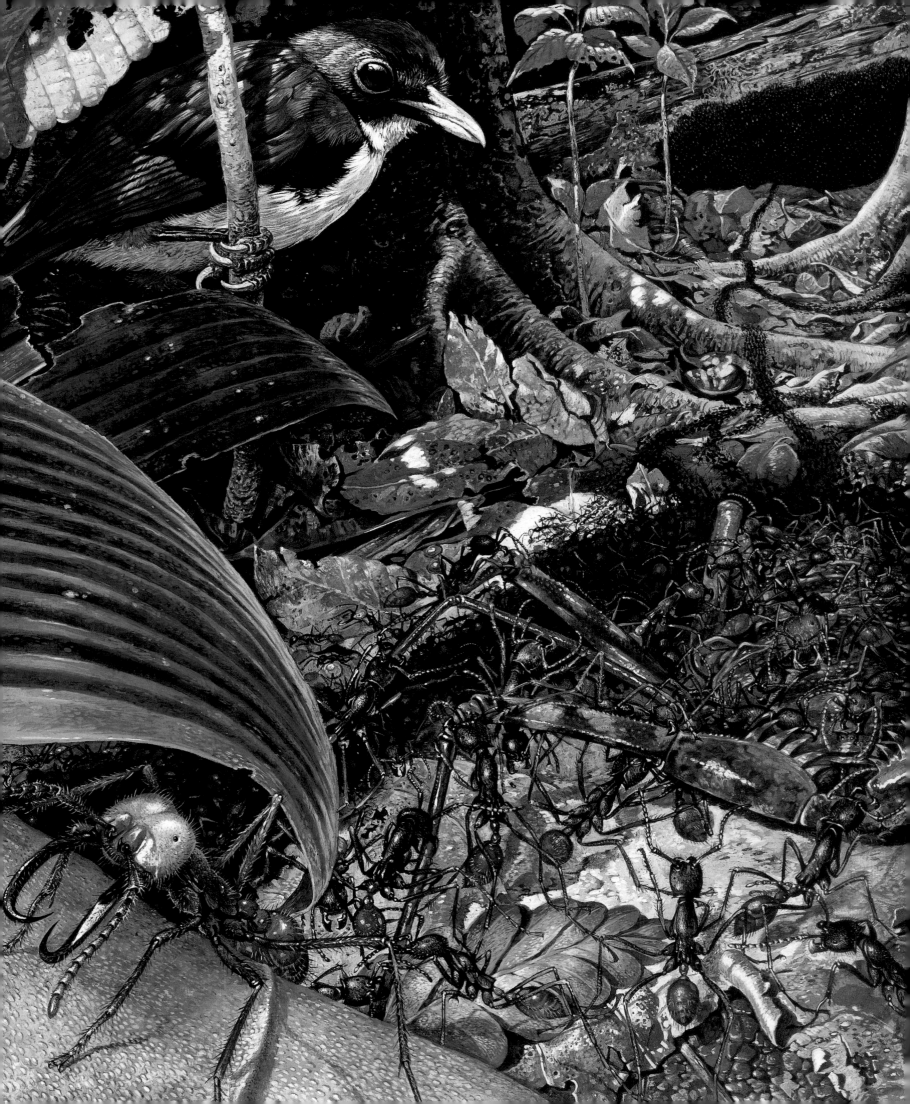

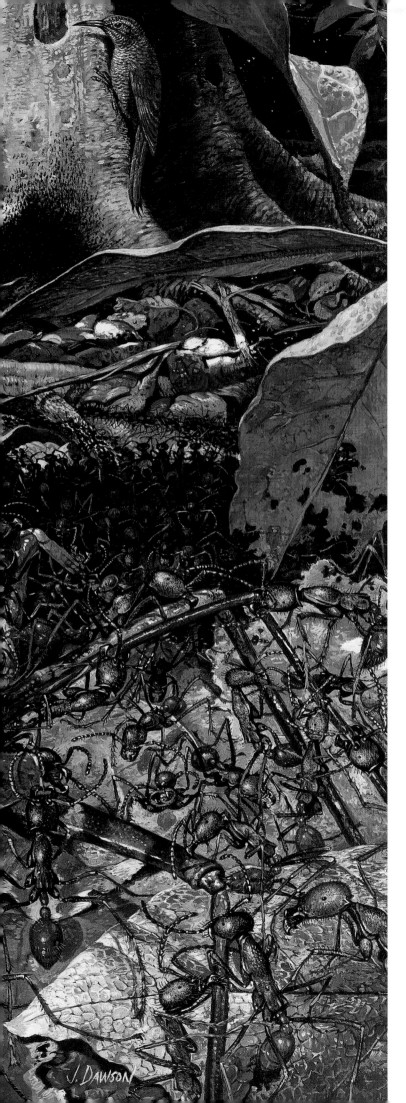

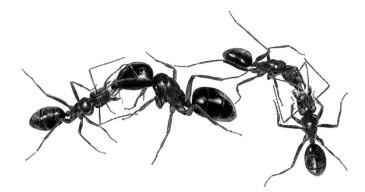

JOHN D. DAWSON

(LEFT) STREAMING FROM THEIR BIVOUAC
NEAR THE BASE OF A TREE, ARMY ANTS
OVERWHELM A WHIP SCORPION.

(FOLLOWING PAGES) FIGHTING MOCK BATTLES IN A
DESERT TOURNAMENT. WHEN RIVALS MEET, HONEY ANTS
WAGE ELABORATE DISPLAY, NOT WAR.

"THE WONDERFULLY DIVERSE WAYS OF THE ANT"

June 1984

Although John Dawson was an experienced artist when Senior Assistant Editor Howard Paine gave him an assignment to illustrate two articles on ants for NATIONAL GEOGRAPHIC, he was just getting started as a wildlife painter. "I had drawn a few ants for biology books," Dawson remembers, "but this assignment was a big break for me. I was very grateful to Howard Paine for taking a chance on my work." The project took two years to complete. Dawson, who had never studied ant behavior before, went to Harvard University to work with Bert Hölldobler, author of one of the NATIONAL GEOGRAPHIC articles, and his colleague, Edward O. Wilson. When he returned home to his studio in Idaho, Dawson used the notes from his Harvard visit, additional sketches he made in his studio while viewing specimens through a microscope, and Hölldobler's slides to create more than 20 exquisitely rendered paintings.

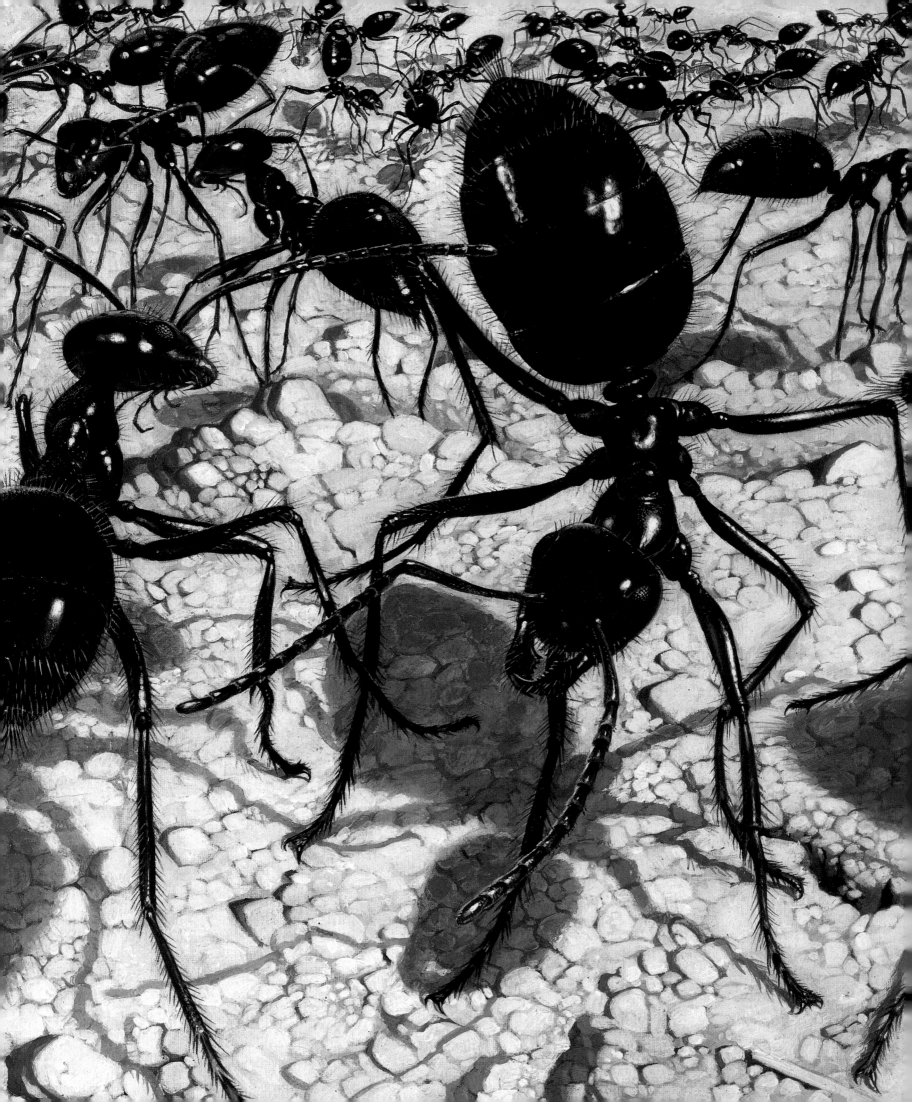

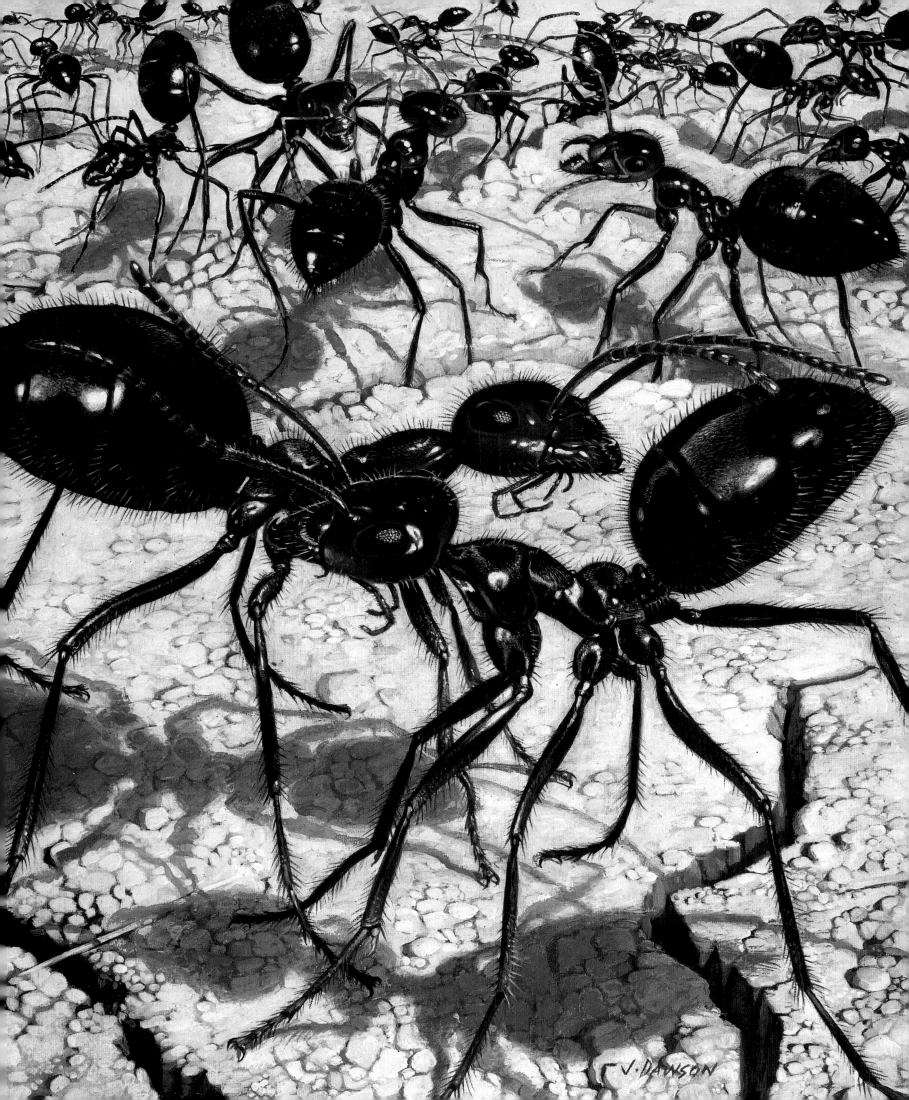

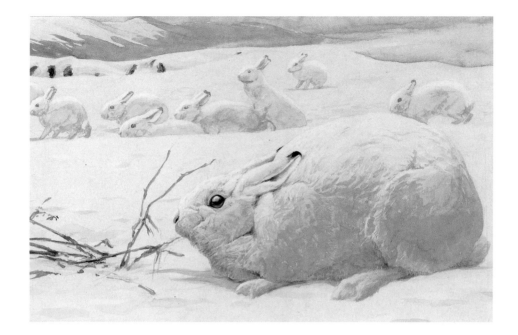

LOUIS AGASSIZ FUERTES

(ABOVE) ARCTIC HARE (*LEPUS ARCTICUS*)

———

"SMALLER MAMMALS OF NORTH AMERICA"

May 1918

(OPPOSITE) THE LARGEST CARNIVOROUS
ANIMAL EXTANT: THE ALASKA BROWN BEAR.

———

"THE LARGER NORTH AMERICAN MAMMALS"

November 1916

Since he specialized in ornithological illustration, Louis Agassiz Fuertes was stunned when NATIONAL GEOGRAPHIC Editor Gilbert H. Grosvenor requested that he illustrate an article on the mammals of North America. Years later, Grosvenor remembered the conversation: "I asked Mr. Fuertes if he would do a series on animals. He said, 'I don't know anything about animals.' 'Well,' I said, 'the Geographic will finance you for a year if you will study the animals and then proceed to make the pictures.' So that was the arrangement."

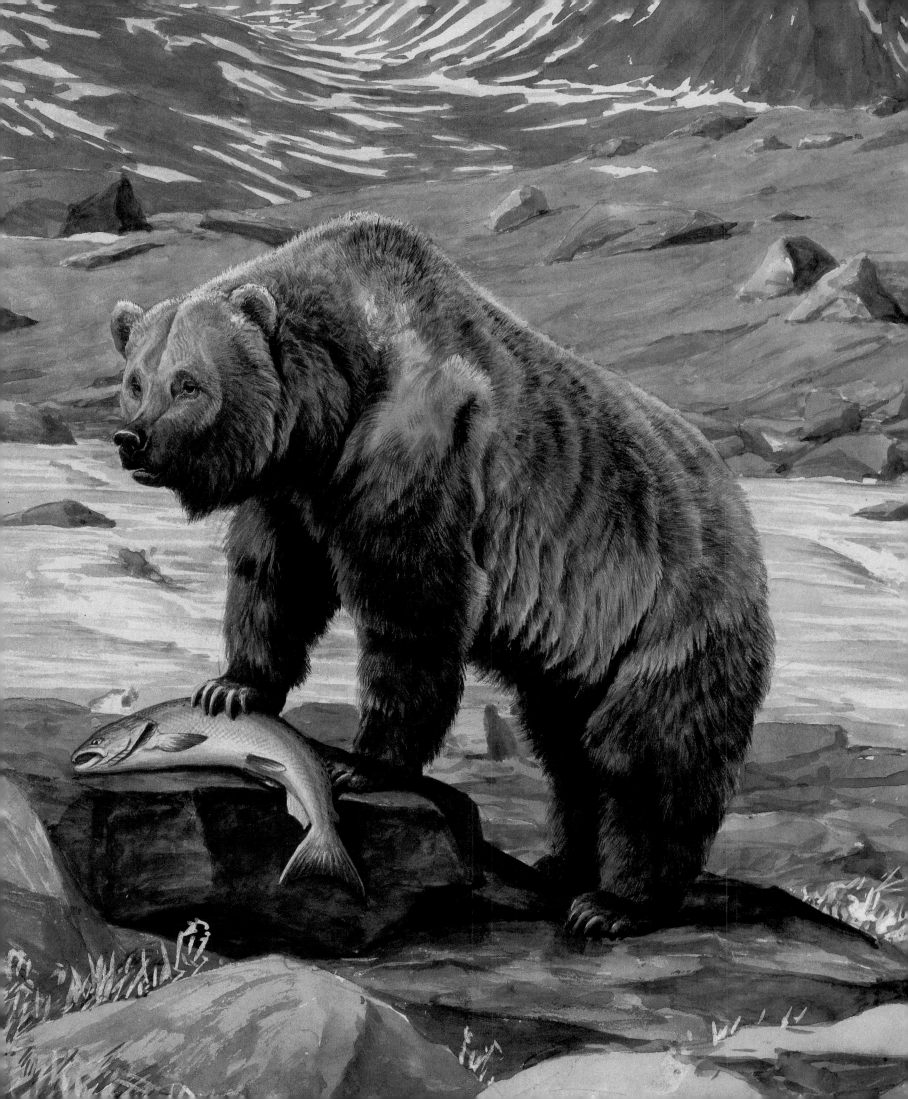

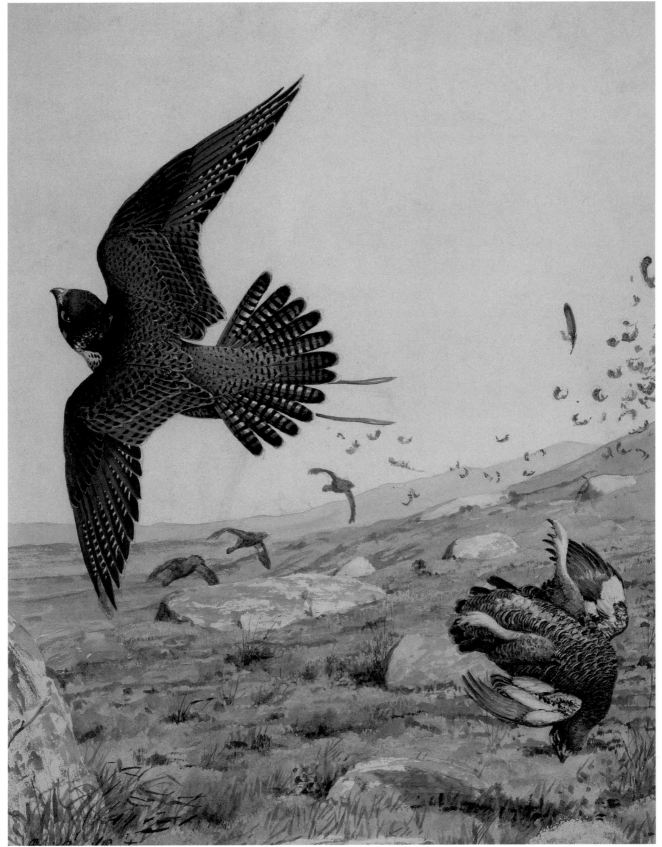

TIERCEL GENTLE: A HIT ON GROUSE.
"FALCONRY, THE SPORT OF KINGS" *December 1920*

LOUIS AGASSIZ FUERTES

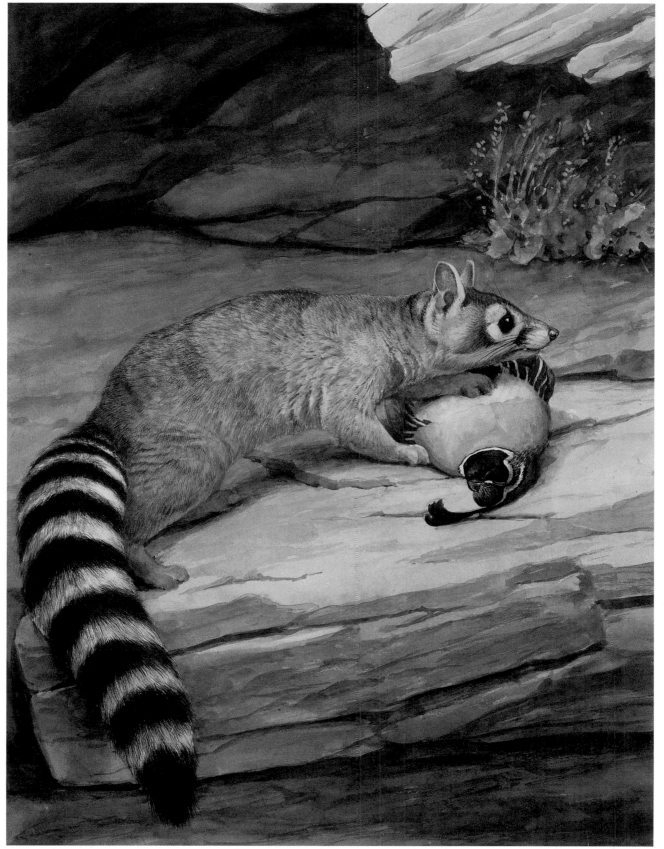

RING-TAILED CAT (*BASSARISCUS ASTUTUS*)
"SMALLER MAMMALS OF NORTH AMERICA" *May 1918*

LOUIS AGASSIZ FUERTES

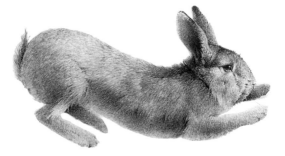

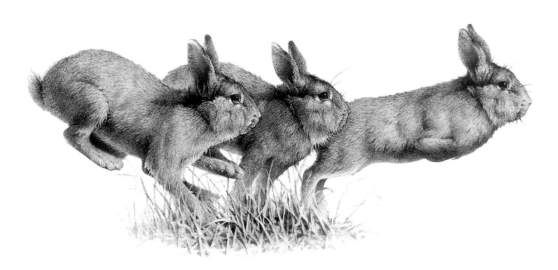

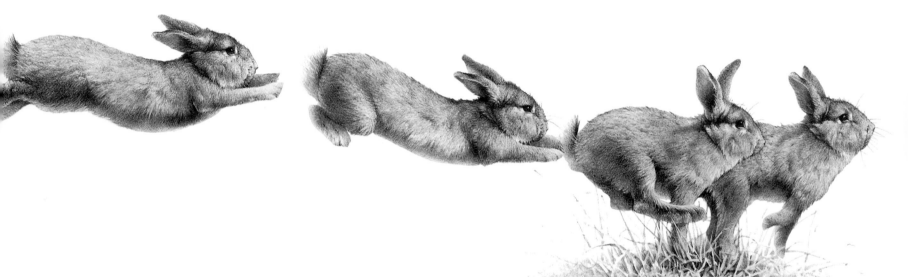

ROBERT HYNES

(ABOVE) A SUCCESSION OF LOW, ALMOST GLIDING
LEAPS PROPELS A RABBIT FIVE TO TEN FEET AT A
BOUND — AT SPEEDS OF 18 TO 20 MILES PER HOUR.
IN FULL FLIGHT THE HIND FEET HIT THE
GROUND IN FRONT OF THE FOREFEET, PRODUCING
A SEEMINGLY REVERSED TRACK PATTERN.

WILD ANIMALS OF NORTH AMERICA

1979

GEORGE FOUNDS

(ABOVE) NEARLY EXTINCT IN THE
UNITED STATES, ITS DESERT HABITAT WHITTLED BY
FENCES, HIGHWAYS, AND URBAN SPRAWL, THE
SONORAN PRONGHORN ANTELOPE IS CONFINED LARGELY TO
THE 860,000-ACRE CABEZA PRIETA GAME RANGE.

———

WILDERNESS U.S.A.

1973

(OPPOSITE) IN PLAY AND DISPLAY THE GORILLA SEEKS
AN OUTLET FOR ITS ENERGY AND FOR PENT-UP EXCITEMENT.
CHEST BEATING CAN CONVEY A VARIETY OF MESSAGES.

———

MARVELS OF ANIMAL BEHAVIOR

1972

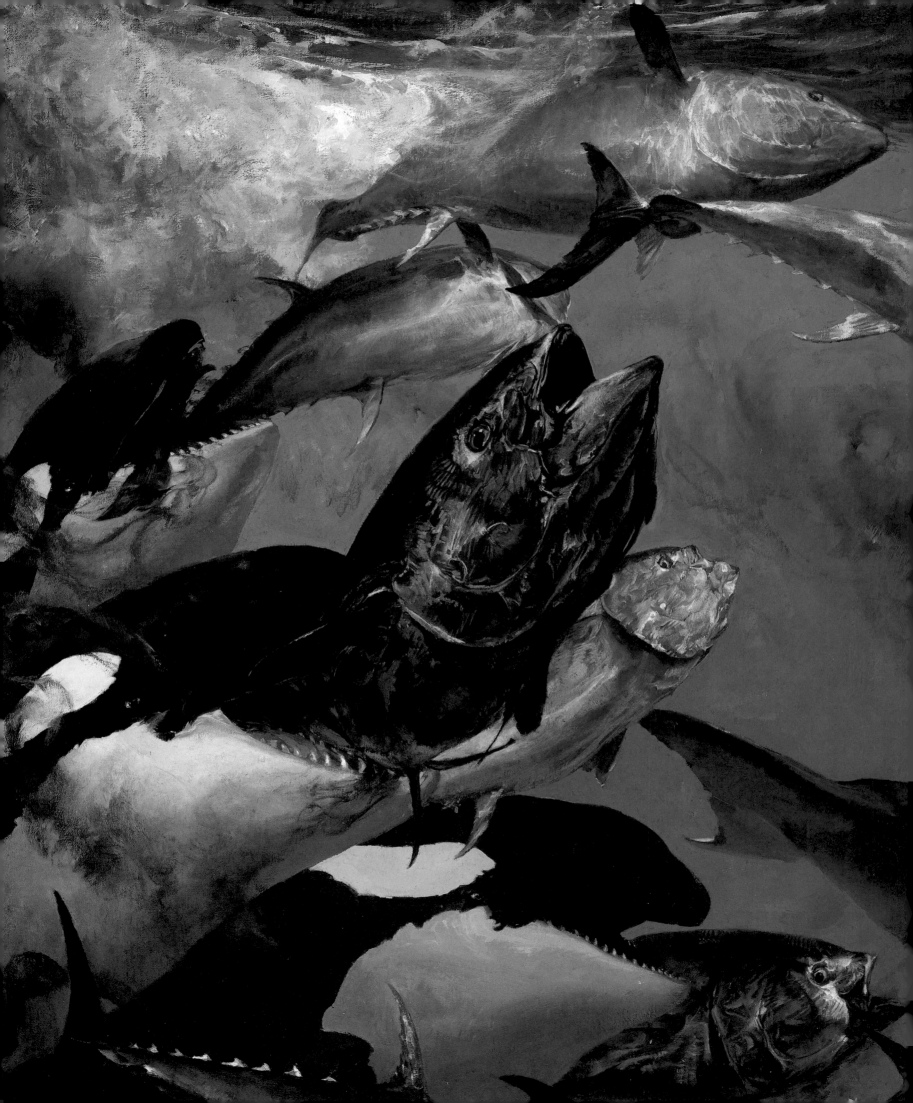

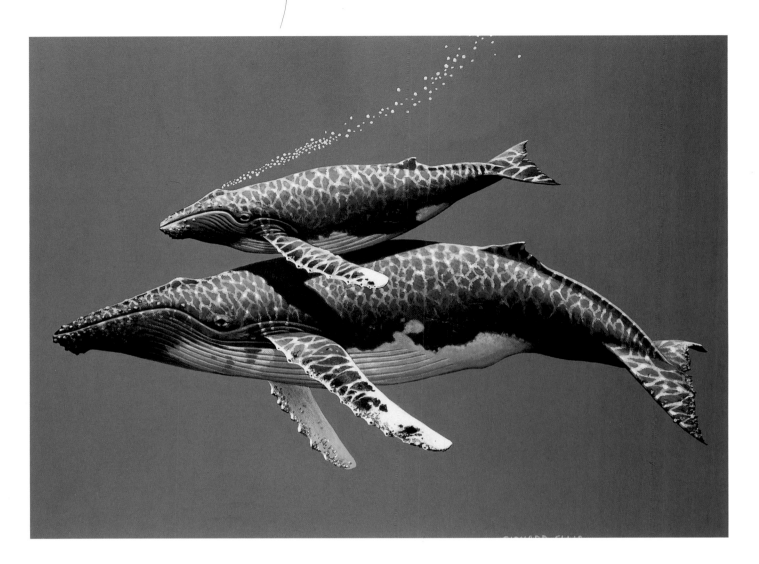

RICHARD ELLIS

(ABOVE) WHALES GREAT AND SMALL: HUMPBACK WHALE
(MEGAPTERA NOVAEANGLIAE).

(FOLLOWING PAGES) WHALES GREAT AND SMALL: SPERM WHALE
(PHYSETER CATODON).

———

WILD ANIMALS OF NORTH AMERICA

1995

STANLEY MELTZOFF

(OPPOSITE) SUPERFISH MEETS SUPERMAMMAL. ALONG WITH MAKO SHARKS,
KILLER WHALES ARE PROBABLY THE ONLY CREATURES IN THE
SEA THAT CAN OUTSWIM A GIANT BLUEFIN.

———

"PLIGHT OF THE BLUEFIN TUNA"

August 1982

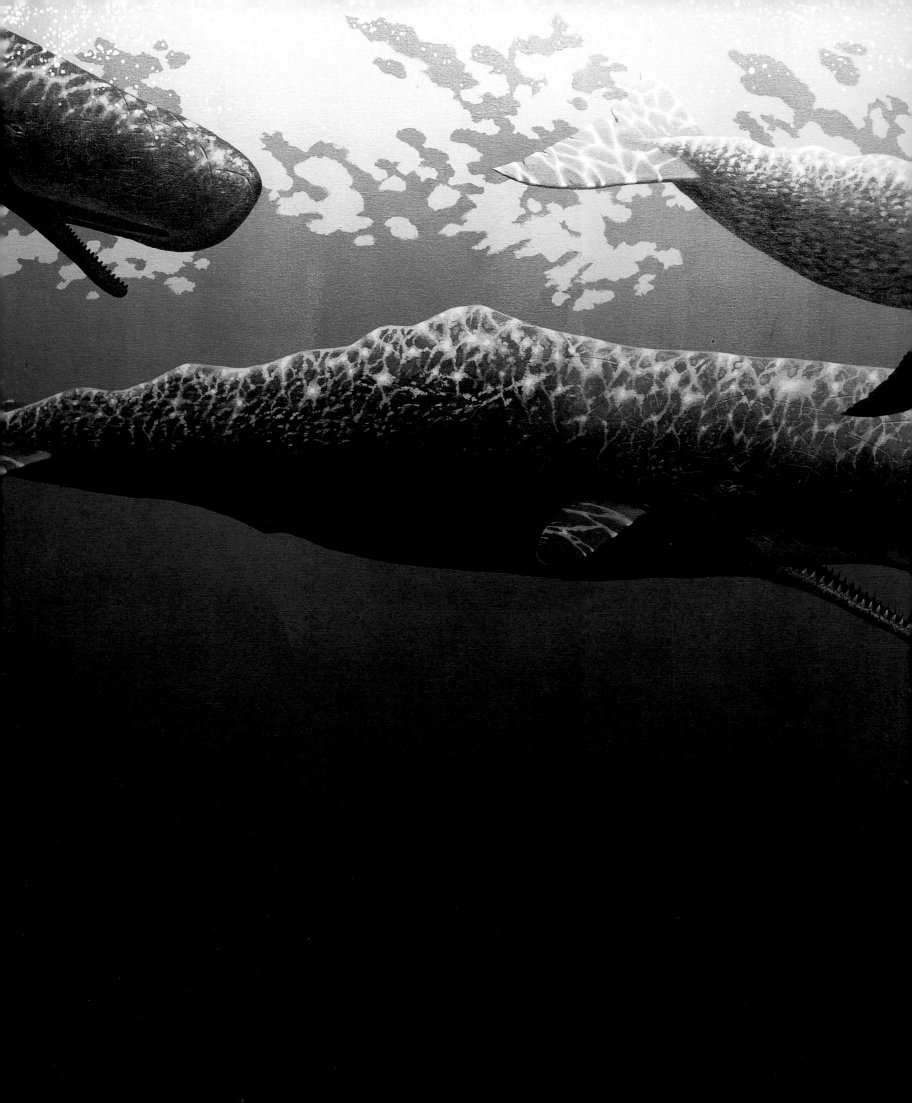

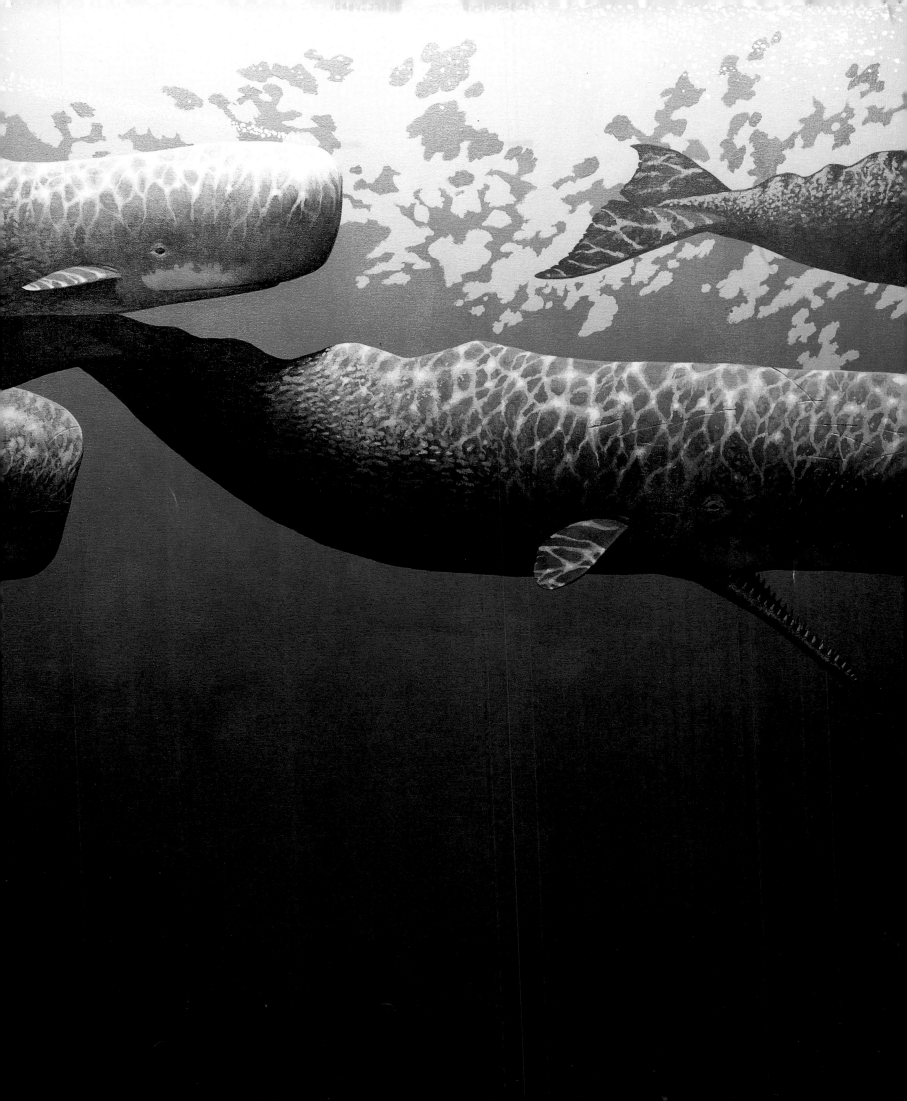

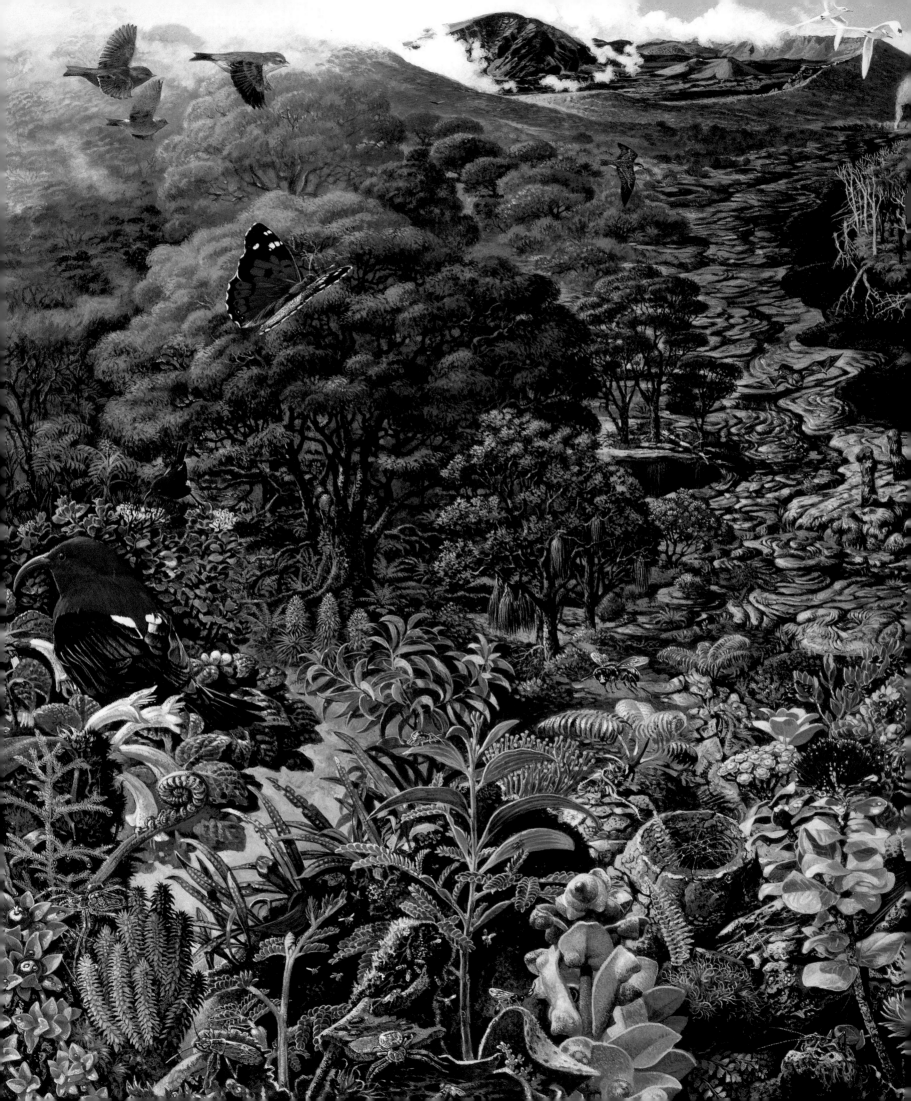

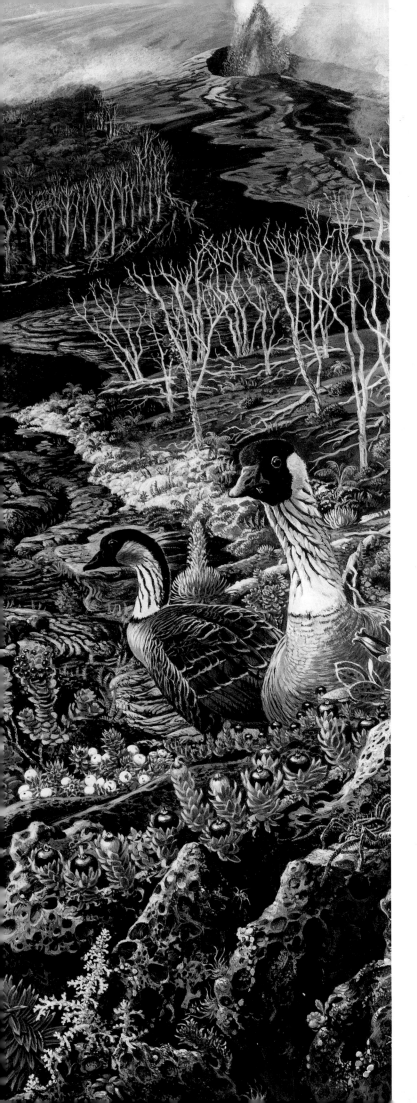

JOHN D. DAWSON

A VIOLENT LANDSCAPE
SHELTERS A WORLD OF ITS OWN.

———

"HAWAII'S VOLCANIC CRADLE OF LIFE"

July 1990

John Dawson spent three weeks touring the Hawaiian
Islands to complete his research for this complex paint-
ing. Asked to show how life evolved on all the islands, the
assignment seemed daunting. "I came up with the idea of
putting all the islands in one composition," Dawson recalls. "I
started on the right-hand side with the Big Island of Hawaii,
which is the youngest, and ended on the left-hand side with
Kauai, which is the oldest island. Maui, with all its magnifi-
cent vegetation, is in the middle." The assignment proved to
be a pivotal one in the artist's career. Awed by the natural
beauty of the islands, Dawson and his wife Kathleen, who
work as a team, decided to move from their home in the
Sawtooth Mountains of Idaho to the island of Hawaii, where
they have lived since the early 1990s.

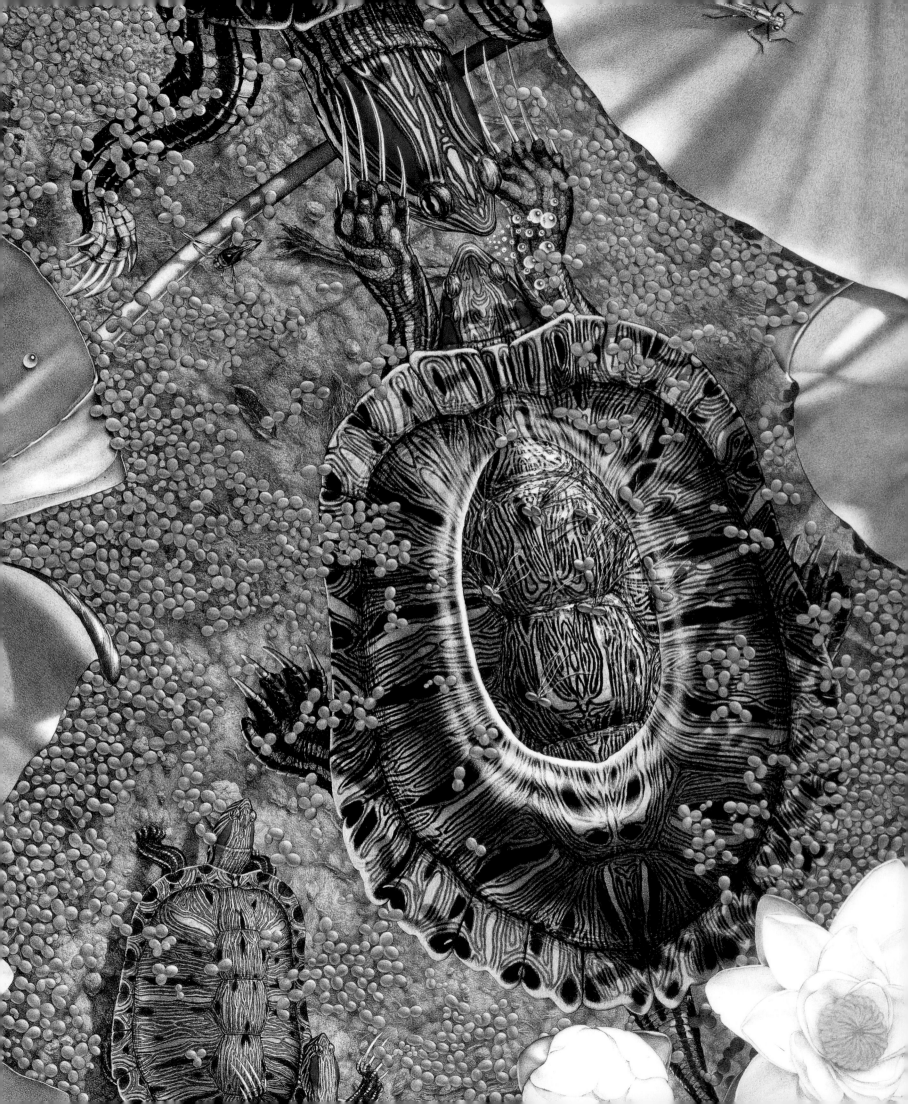

KAREL HAVLICEK

(ABOVE & DETAIL, OPPOSITE) COURTSHIP BEGINS
ON A POND SURFACE WHEN A MALE RED-EARED SLIDER
TICKLES A FEMALE'S NECK AS HE SWIMS BACKWARD AND SHE FORWARD.
THE TWO SINK TO THE POND BOTTOM, AND THE MALE CLIMBS ATOP
THE FEMALE'S SHELL, CURLING HIS TAIL UNDER TO MATE.

"DESIGNED FOR SURVIVAL: FRESHWATER TURTLES"

January 1986

Prague-born illustrator Karel Havlicek's mixed-media painting of red-eared slider turtles required that the artist become well acquainted with his subject. The usual consultations with experts and thorough library research failed to provide enough visual information, so Havlicek, more than willing to sacrifice comfort for accuracy, left his studio to study the turtles in their natural environment. "It was an exciting assignment," Havlicek remembers. "We went to Florida to skin dive in a small, very secluded river, where there were seven species of turtles. I was told to be careful not to walk on the root balls of the reeds because that was where the alligator snapping turtles liked to hide. I had heard that they can snap your toes off, so I was careful to watch my step!"

SPECIMENS OF *PHYSARUM VIRIDE*, MAGNIFIED 50 DIAMETERS, SUGGEST EGGS AND GOLF BALLS ABOUT TO PEEL.
"MARVELS OF THE MYCETOZOA" *April 1926*

WILLIAM CROWDER

A SPECIES OF SLIME MOLD FOUND THROUGHOUT THE WORLD: THE DELICATE, FUNGUS-LIKE ORGANISMS KNOWN AS MYXOMYCETES OR MYCETOZOA ARE COMMON IN ALL THE MOIST, WOODED REGIONS OF THE EARTH. "MARVELS OF THE MYCETOZOA" *April 1926*

WILLIAM CROWDER

NED M. SEIDLER

(LEFT) INCREDIBLY CLEAR WATER IS HELD IN
SUBTLY COLORED ROCK BASINS. SHIMMERING
BANDS OF LIGHT RACE ACROSS THE STREAMBEDS,
PATTERNS PROJECTED THROUGH THE SWIRLING
SUN-FILTERING SURFACE ABOVE.

———————

"UNSEEN LIFE OF A MOUNTAIN STREAM"

April 1977

(FOLLOWING PAGES) WHAT IS A POND?
TO A FISHERMAN IT MAY OFFER A BASS,
TO A BOY A JAR OF TADPOLES, BUT TO A BIOLOGIST
IT SERVES AS A LESSON IN THE
BALANCE OF NATURE.

———————

"TEEMING LIFE OF A POND"

August 1970

Ned Seidler, a staff artist for the NATIONAL GEOGRAPHIC for 18 years, went to Noxontown Pond, near Middletown, Delaware, with biologist William H. Amos to gather the information necessary to begin the beautiful and intricate illustration on the following pages. Seidler packed more than 50 different plants and animals into his composition before carefully rendering it in watercolor and gouache. Amos, who wrote the text for the article and supplied photographs, was awestruck when he saw the final painting. In a letter to the Society, he raved, "Ned's painting is not only exquisite, it *is* Noxontown Pond. I fail to understand how anyone could put so much into one picture…. The painting in my opinion really is a masterpiece." Seidler was pleased, too; and although the Society owns the original art, a color print of the illustration occupies a place of honor in his studio.

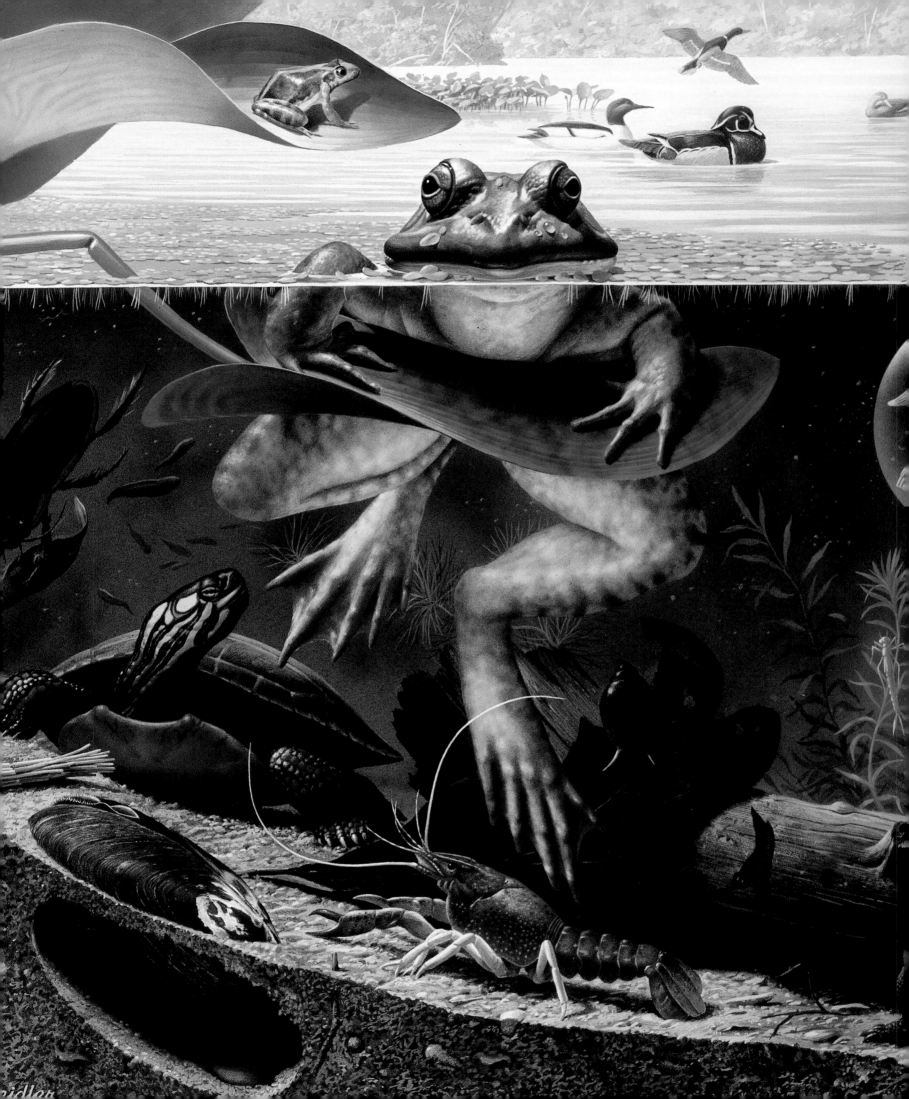

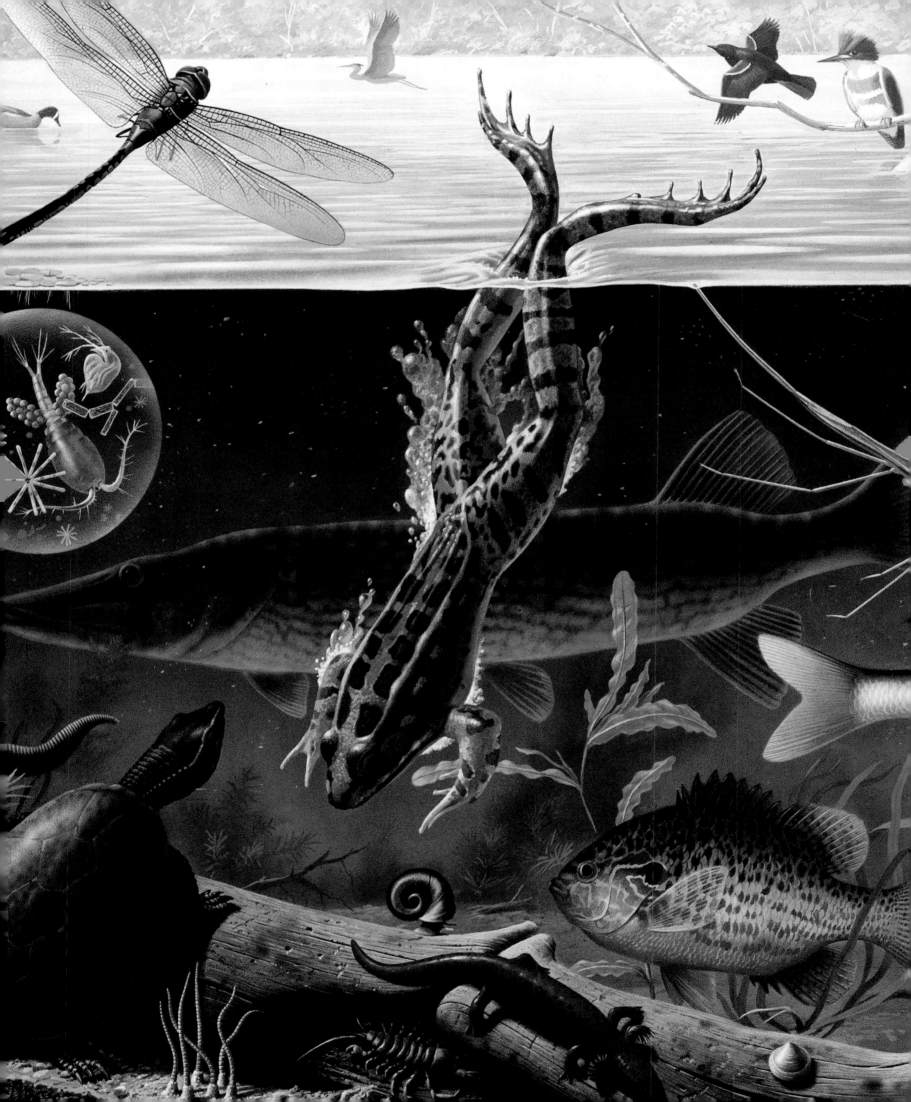

124

VERMONT: RED CLOVER (*TRIFOLIUM PRATENSE* L.).
"OUR STATE FLOWERS," *June 1917*

WEST VIRGINIA: MOUNTAIN AMERICAN RHODODENDRON
(*RHODODENDRON MAXIMUM* MICHX.). "OUR STATE FLOWERS," *June 1917*

JACK-IN-THE-PULPIT (*ARISAEMA TRIPHYLLUM* L.) TORR.
"COMMON AMERICAN WILDFLOWERS," *June 1916*

KENTUCKY: TRUMPET VINE (*BIGNONIA RADICANS* L.).
"OUR STATE FLOWERS," *June 1917*

MARY E. EATON

MARY E. EATON

(ABOVE) GROUND IVY (*GLECOMA HEDERACEA* L.). MINT FAMILY
PITCHERPLANT (*SARRACENIA PURPUREA* L.). PITCHERPLANT FAMILY
PALE WILDBERGAMOT (*MONARDA MOLLIS* L.). MINT FAMILY

"EXPLORING THE MYSTERIES OF PLANT LIFE"

June 1924

The National Geographic Society owns 672 botanical watercolors painted by Mary Eaton between 1915 and 1928. Although NATIONAL GEOGRAPHIC Editor Gilbert H. Grosvenor considered Eaton's work "exquisitely beautiful," he was willing to pay only $12.50 per painting. In 1926, the Society agreed to increase her payment to $15 but attempted to make up the difference by offering only $10 for paintings of less colorful specimens. When Eaton complained that "the less colorful subjects take as long to paint — sometimes longer," the Society wisely reconsidered and agreed to meet her price.

126

BUTTERFLY BLOSSOMS TYPIFY THE USEFUL PEA FAMILY.
"FLORAL GARLANDS OF PRAIRIE, PLAIN, AND WOODLAND" *August 1939*

EDITH S. CLEMENTS

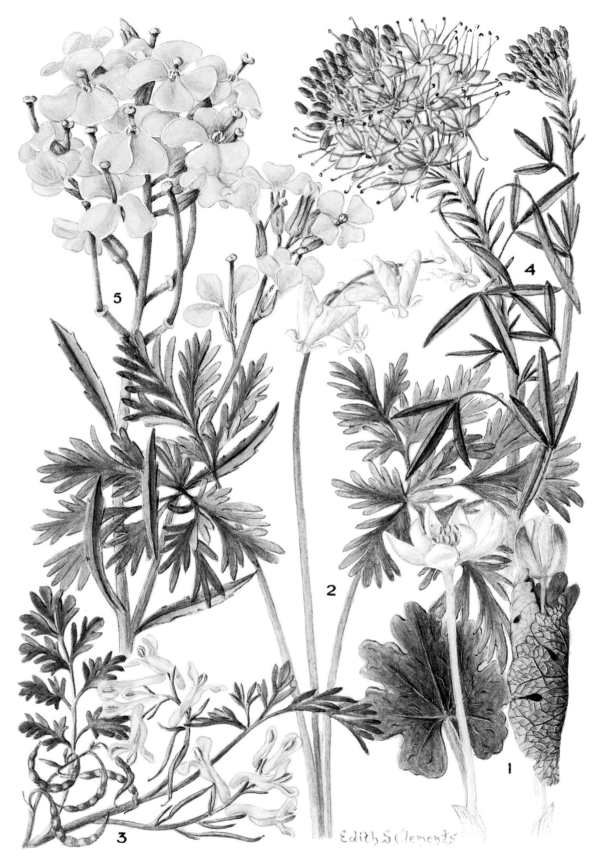

5

4

2

1

3

Edith S Clements

BLOODROOT AND DUTCHMAN'S-BREECHES ARE DESCRIBED BY THEIR NAMES.
"FLORAL GARLANDS OF PRAIRIE, PLAIN, AND WOODLAND" *August 1939*

EDITH S. CLEMENTS

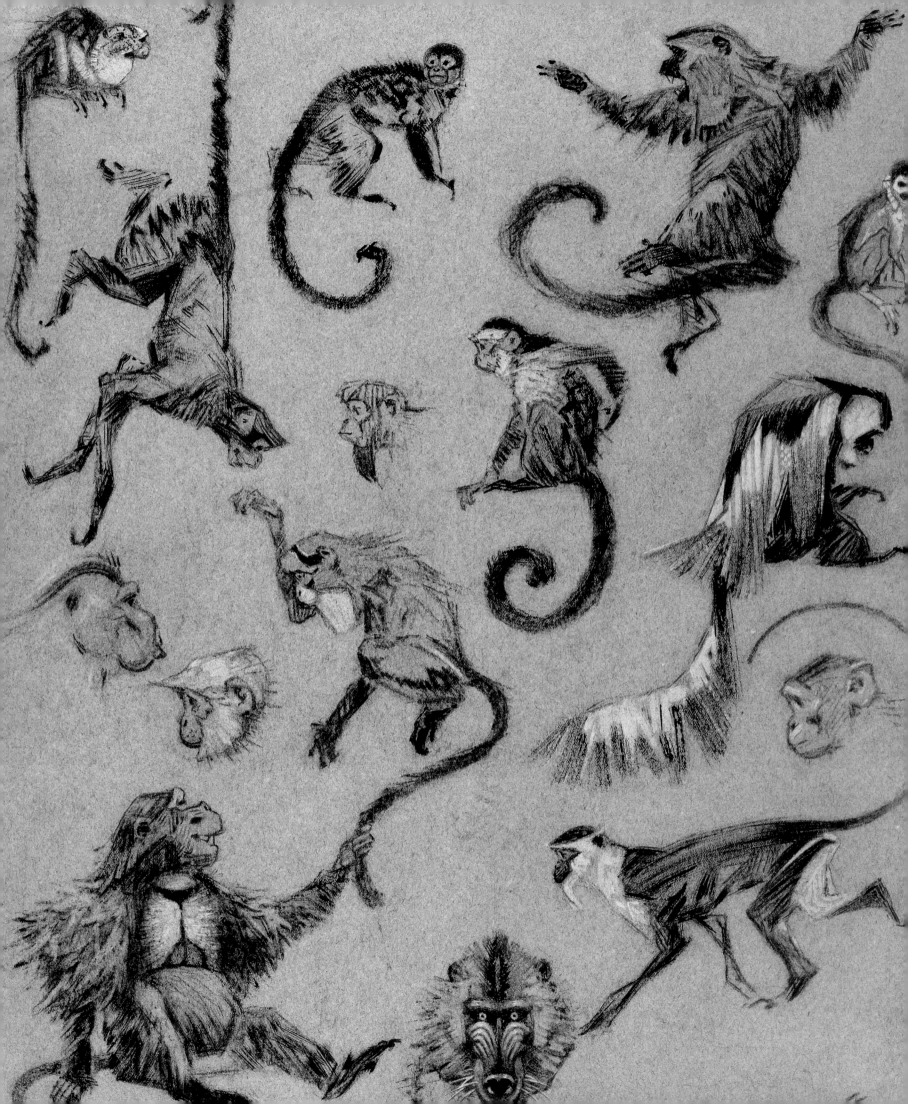

ELIE CHEVERLANGE

(ABOVE) POOR MIXER, THE ORANGUTAN SHUNS
THE SOCIETY OF OTHER APES.

———

"MANLIKE APES OF JUNGLE AND MOUNTAIN"

August 1940

(OPPOSITE) MONKEYSHINES FROM
THE ARTIST'S NOTEBOOK

———

"WHO'S WHO IN THE MONKEY WORLD"

August 1940

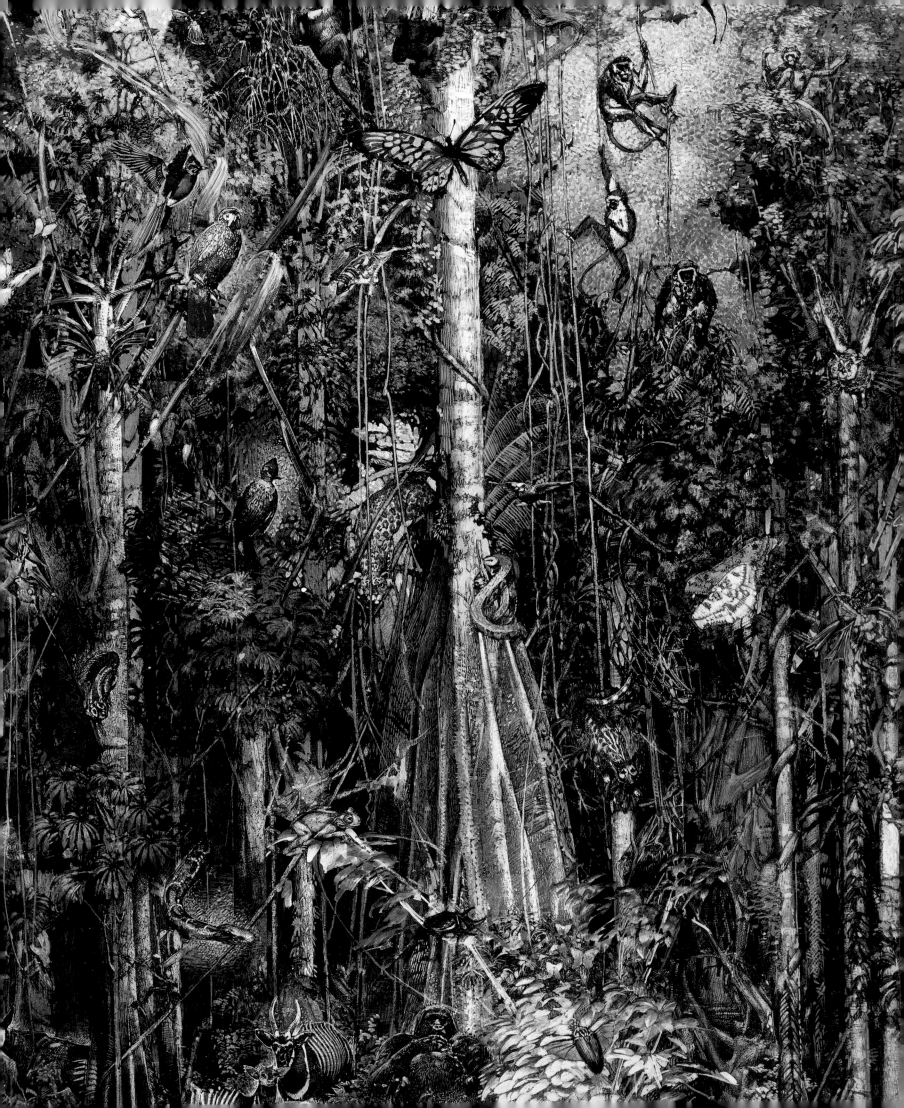

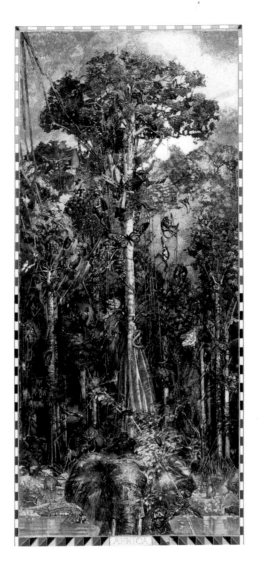

BARRON STOREY

(ABOVE & DETAIL, OPPOSITE) LAYERS OF LIFE IN THE AFRICAN RAIN FOREST

(FOLLOWING PAGES) SOUTH AMERICA'S ABUNDANT RAIN FOREST

———

"NATURE'S DWINDLING TREASURES:
RAIN FORESTS"
January 1983

Barron Storey enjoyed this commission from the NATIONAL GEOGRAPHIC. "It gave me a chance to deal with real content and not style – not trend." However, when the Society initially asked Storey to come to Washington to discuss the job, he felt intimidated. "I love history, American history in particular, and I have a real respect for American institutions. NATIONAL GEOGRAPHIC certainly falls under that category," Storey says. "But I was anxious when I went to the Society because I hadn't brought good clothes, just an old leather jacket. I shouldn't have worried. They were all adventurers at heart, with romanticism under their suits."

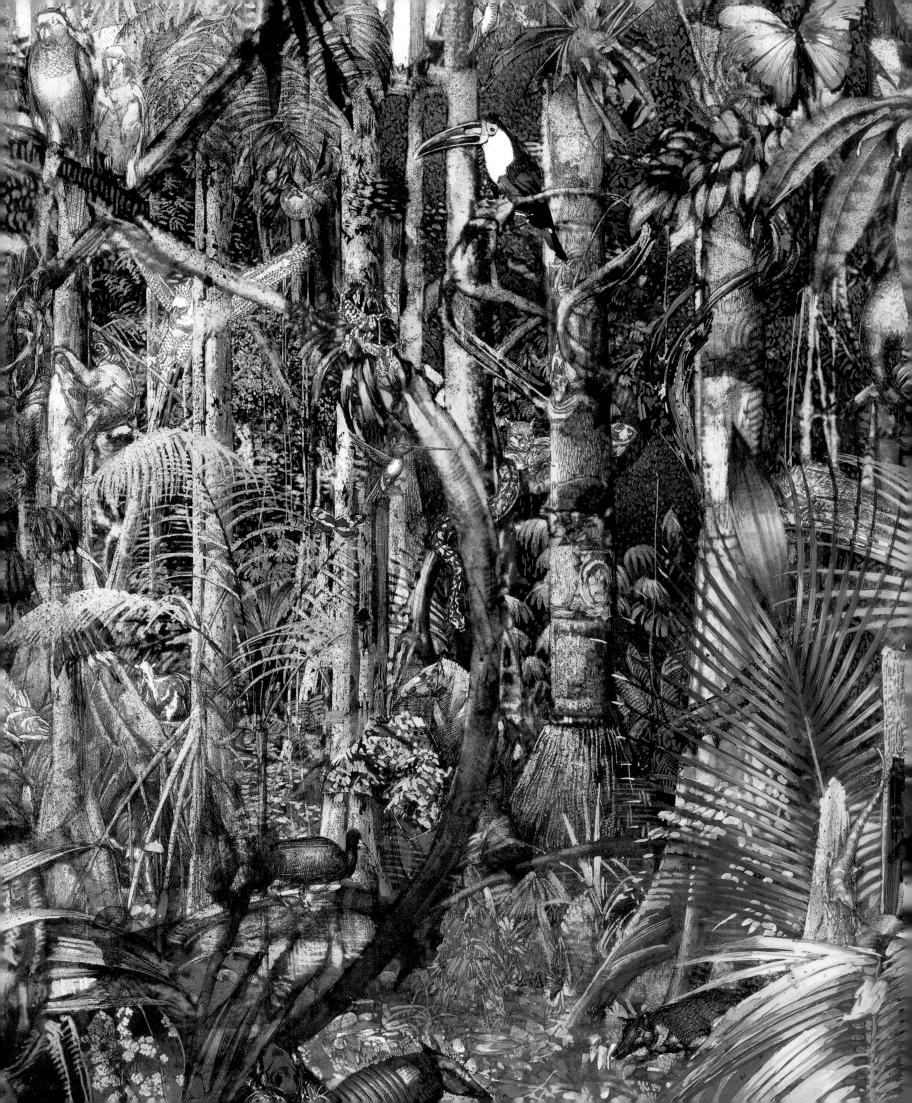

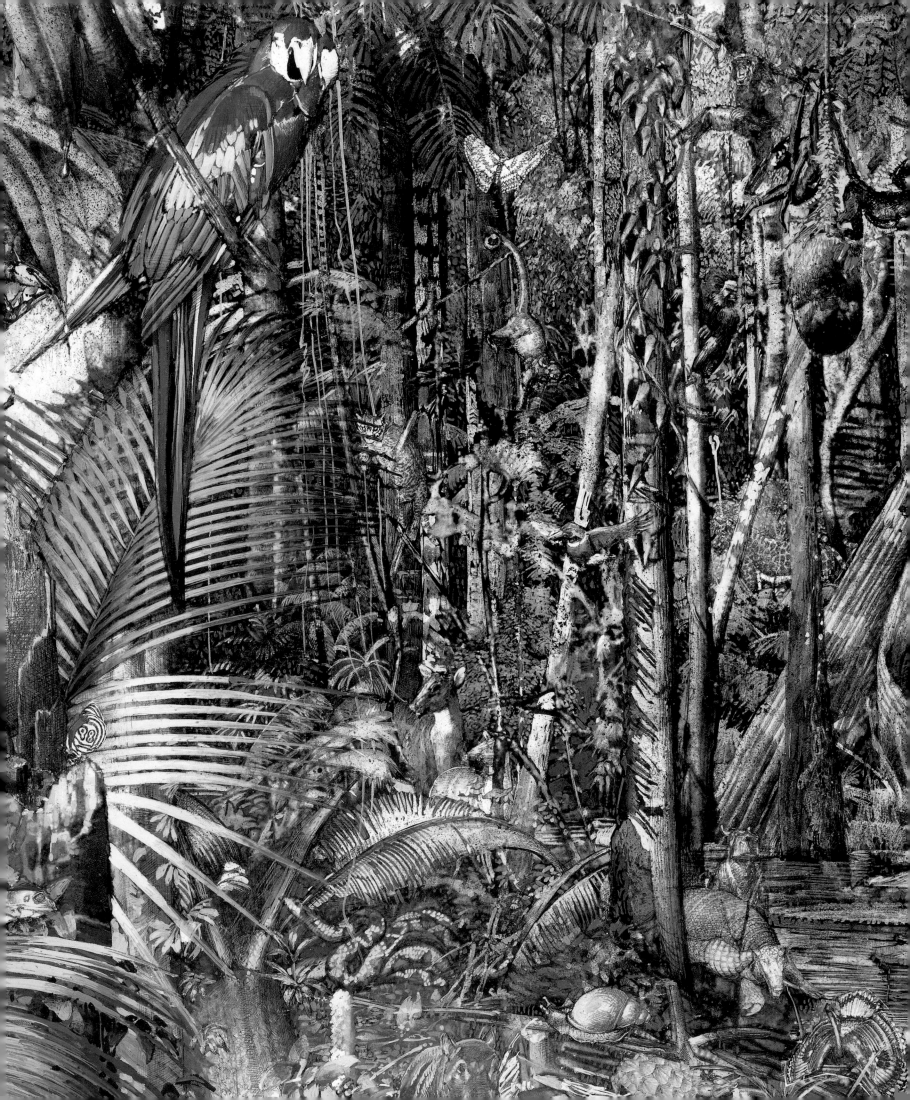

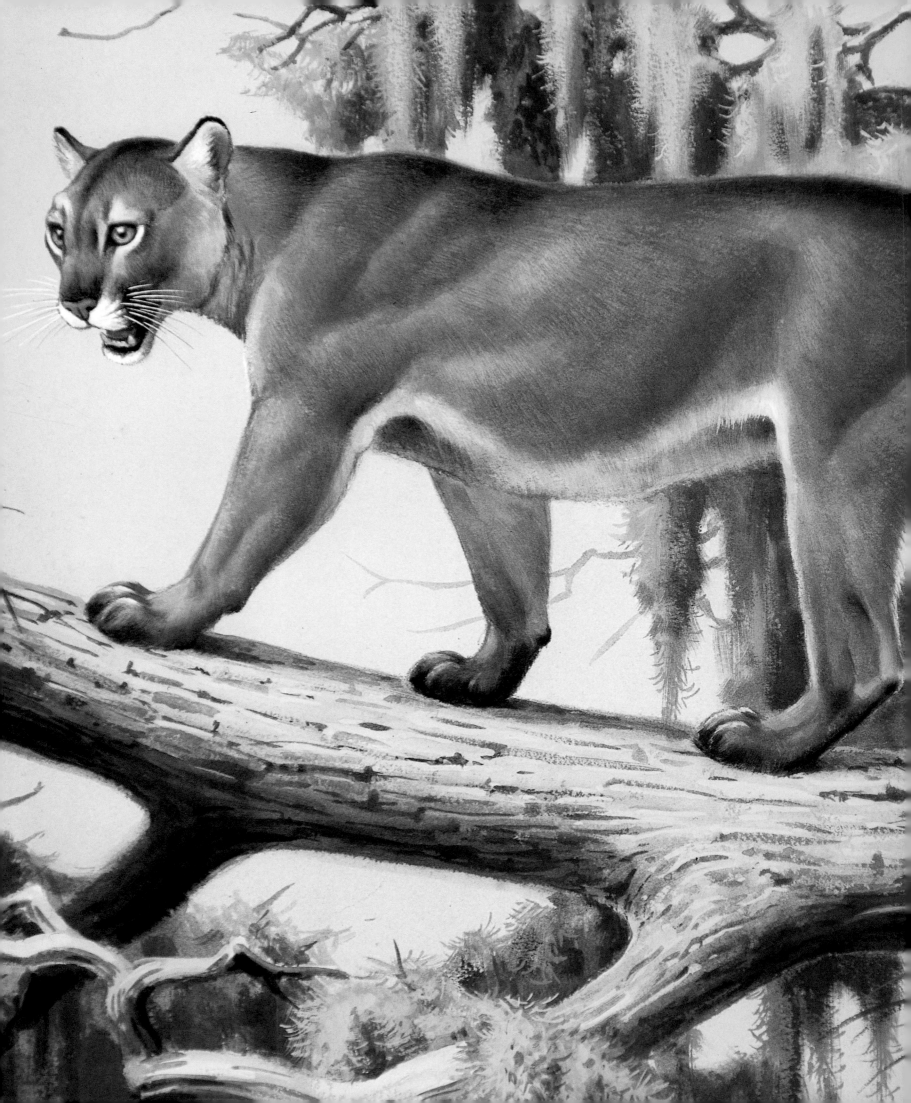

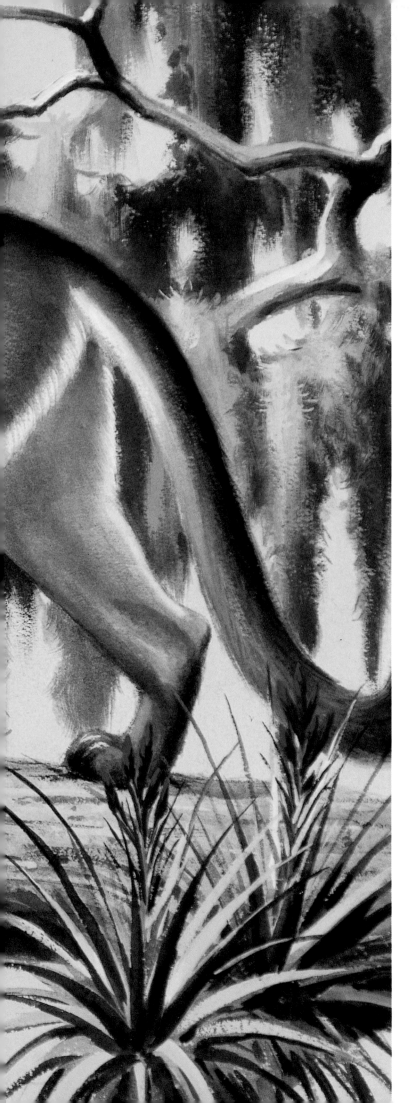

WALTER A. WEBER

❦

(LEFT) A PUMA SLINKS ON SILENT PAWS
THROUGH MOSS-HUNG EVERGLADES NATIONAL PARK,
HIS LAST SANCTUARY EAST OF THE MISSISSIPPI.

———

"WILDLIFE OF EVERGLADES NATIONAL PARK"

January 1949

(FOLLOWING PAGES) NO HOLDS ARE BARRED
WHEN SCALY SCRAPPERS MEET; FOR ONE, A THREE-
FOOT DINNER HANGS IN THE BALANCE.

———

"OUR SNAKE FRIENDS AND FOES"

September 1954

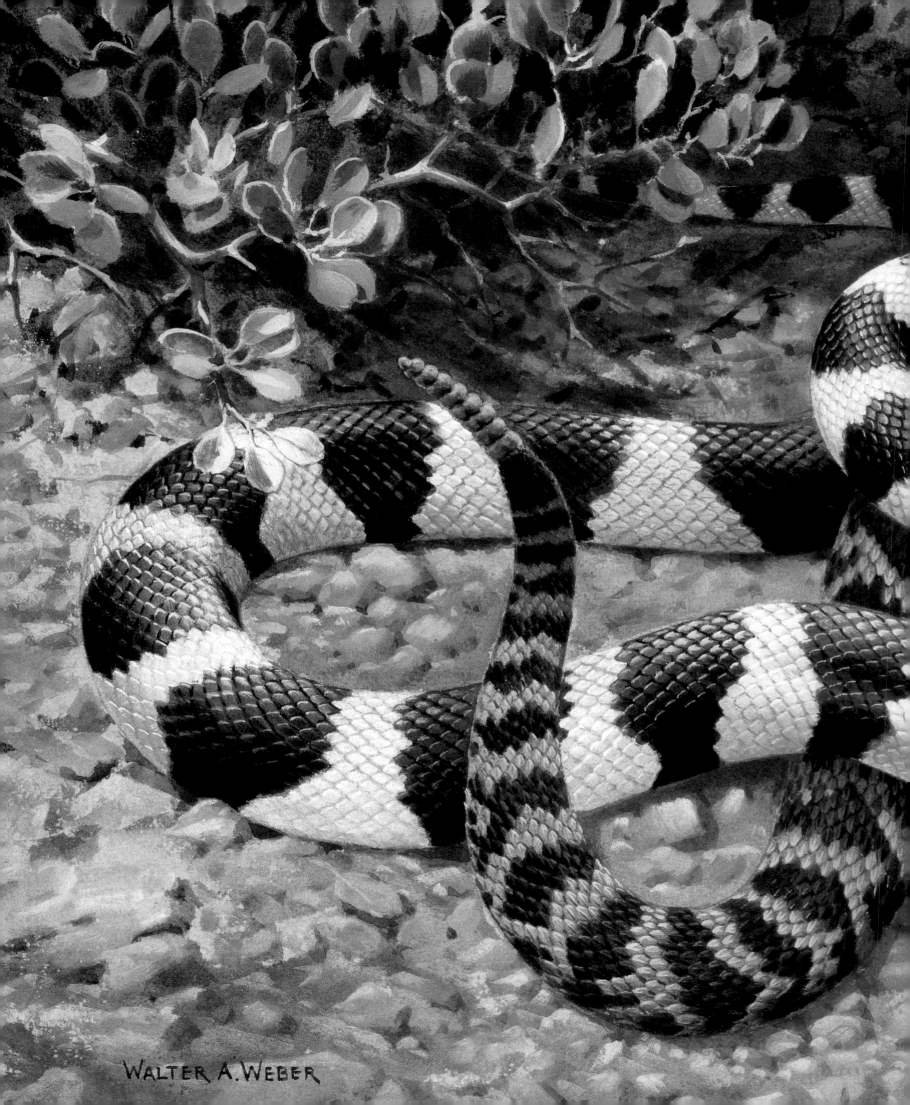

WALTER A. WEBER

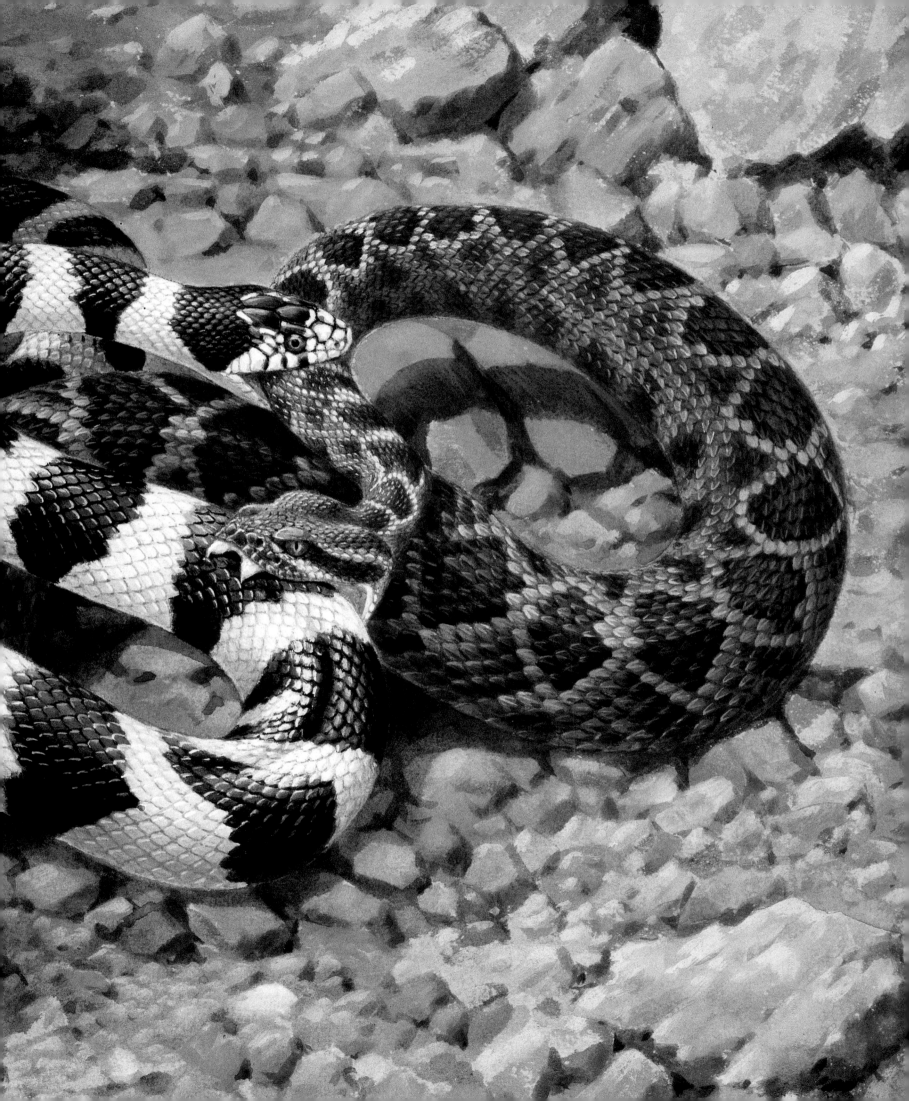

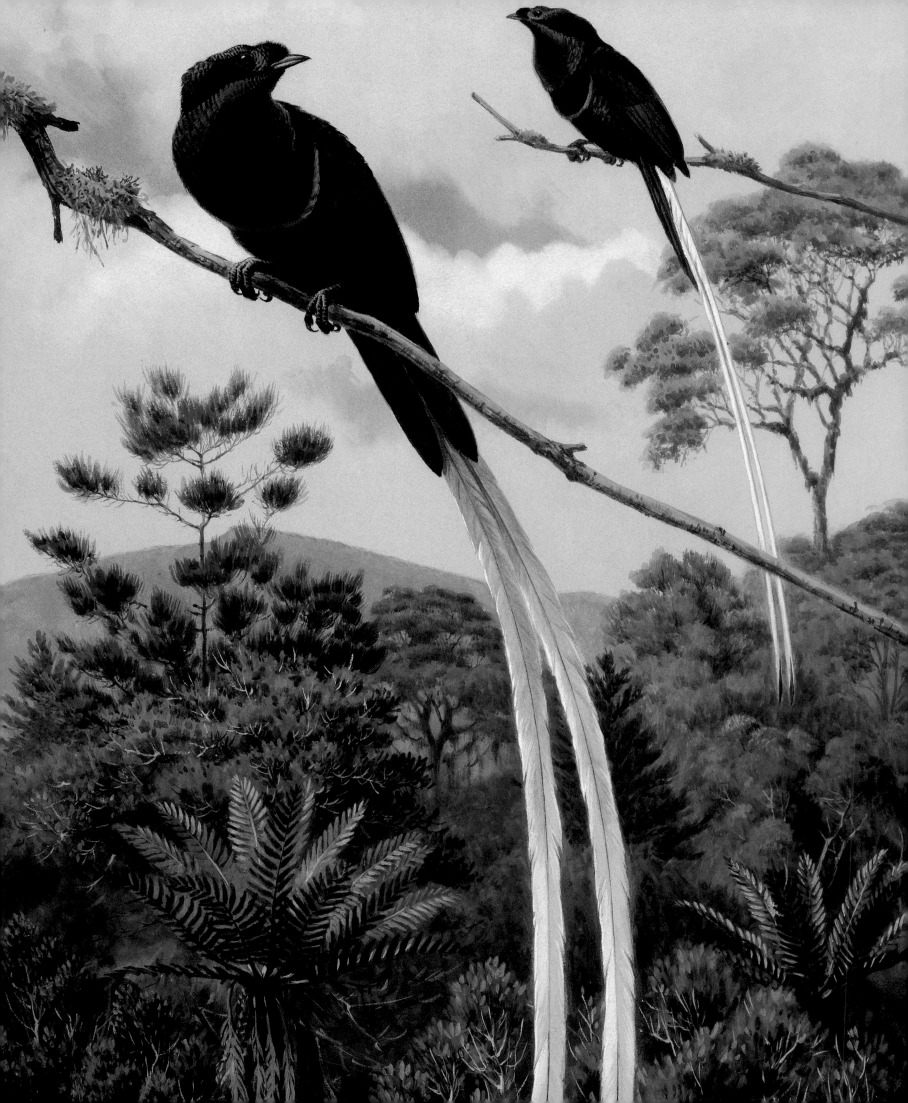

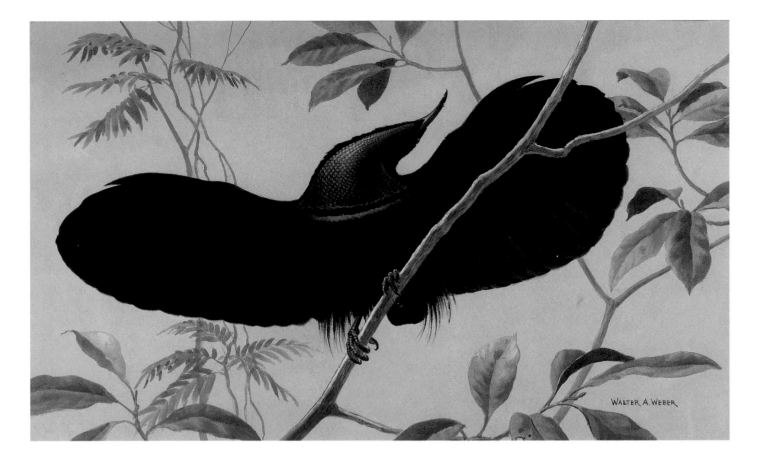

WALTER A. WEBER

(ABOVE) ARCHED WINGS ARE EXTENDED SUDDENLY
WITH A DULL PLOP AS THE MAGNIFICENT RIFLEBIRD DISPLAYS
HIS GORGEOUS NECKPIECE.

(OPPOSITE) RIBBON-TAILED BIRDS OF PARADISE
TRAIL TWIN FEATHERS TWO FEET LONG.

———

"STRANGE COURTSHIP OF BIRDS OF PARADISE"

February 1950

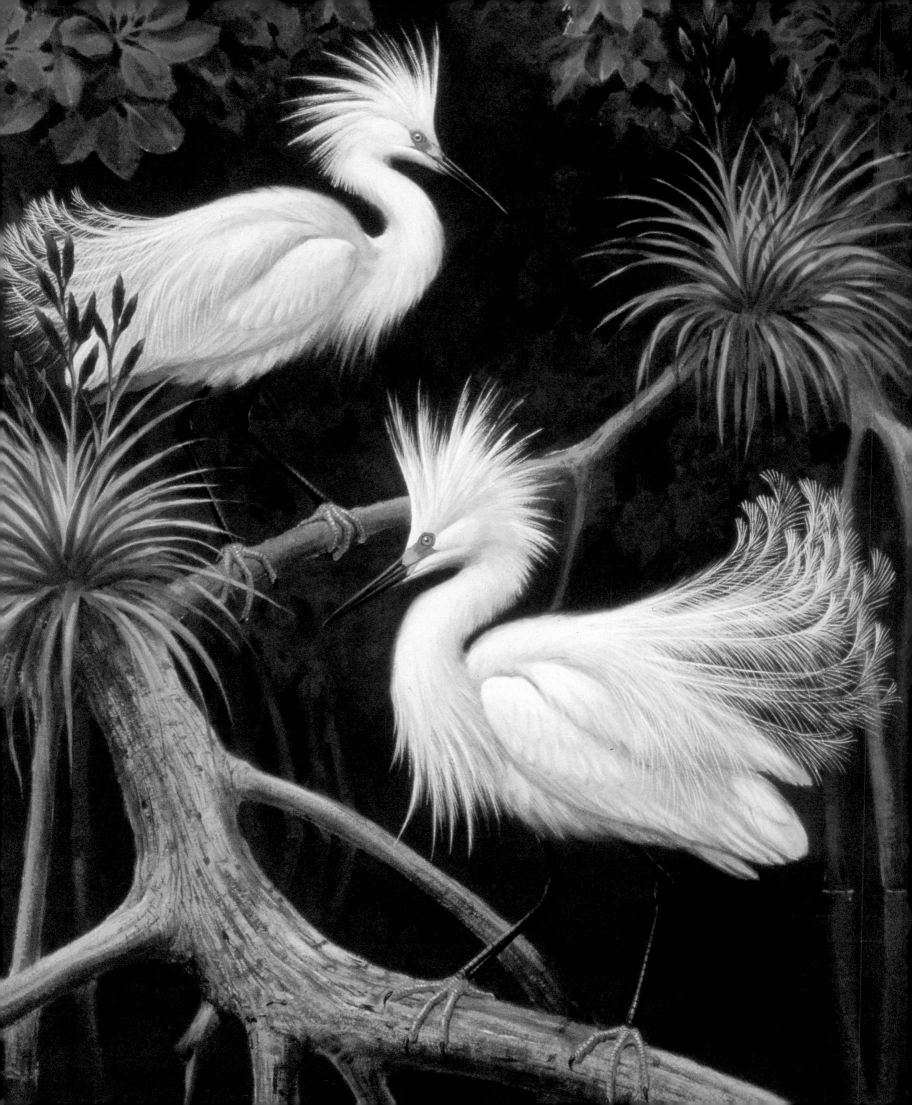

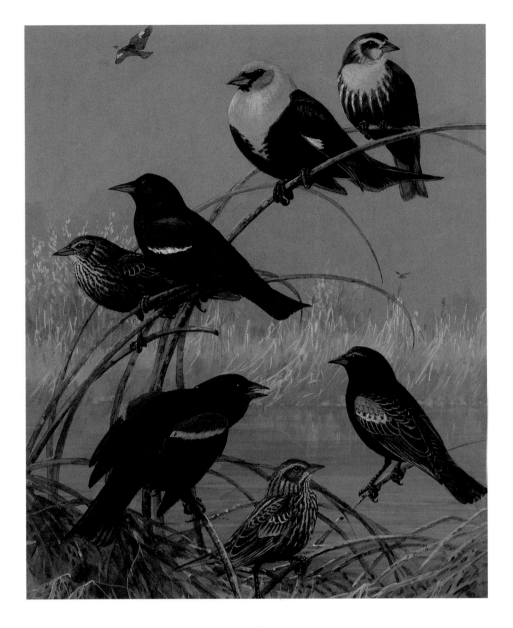

ALLAN BROOKS

꧁

(ABOVE) GENERALS OF THE MARSHES PARADE
ON GOLD BRAID OR BRILLIANT EPAULETS.

―――

"BLACKBIRDS AND ORIOLES"

July 1934

WALTER A. WEBER

꧁

(OPPOSITE) SNOWY EGRETS DISPLAY THEIR HEAVENLY
COURTSHIP PLUMAGE IN A MANGROVE SWAMP.

―――

"WILDLIFE OF EVERGLADES NATIONAL PARK"

January 1949

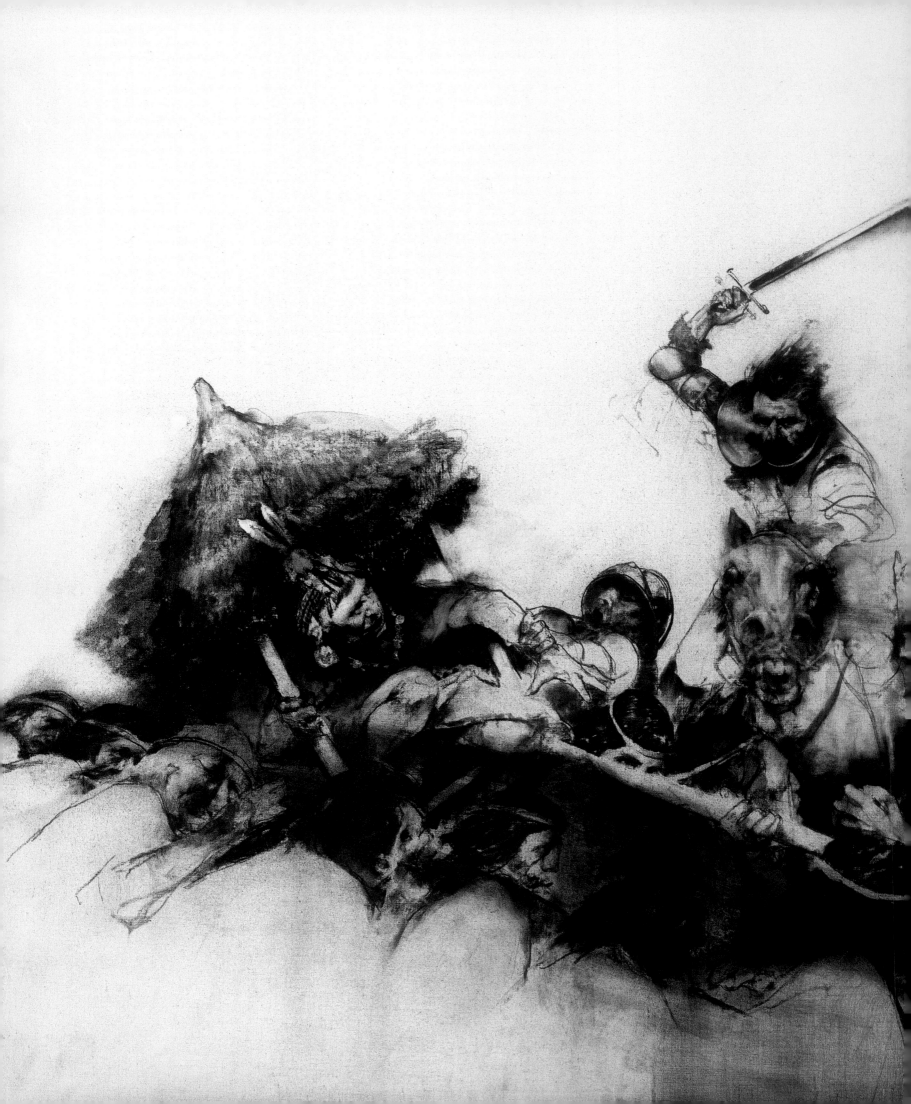

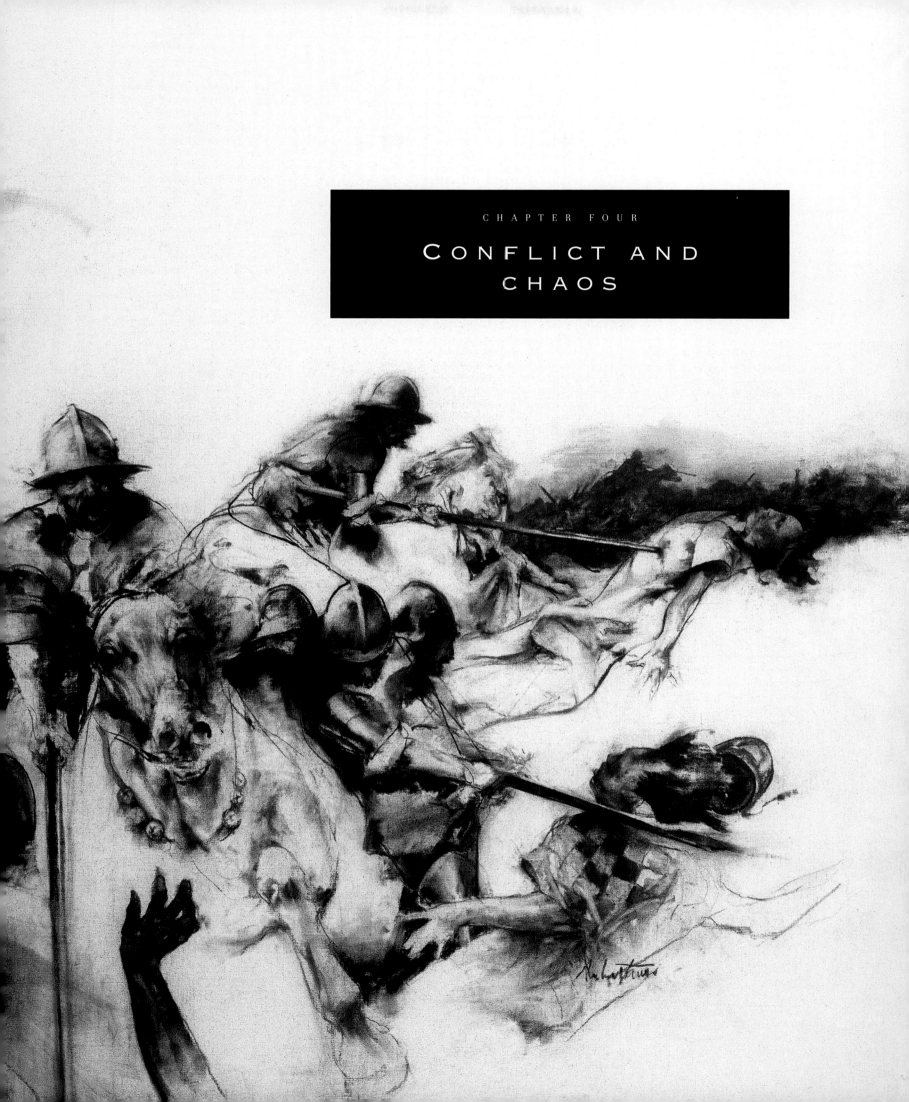

CONFLICT AND CHAOS

CONFLICT AND CHAOS

144

urvivors said that it was over in less than three minutes. There was no time to think and
barely time to flee. On May 8, 1902, Mont Pelée exploded on the island of Martinque,
and an estimated 30,000 people died in the nearby city of St. Pierre, incinerated in a cloud
of flaming gas and steam. When a team from the National Geographic Society arrived 13 days later, the
volcano was still rumbling ominously. Cameras in hand, they set out to document the aftermath of the
eruption, although they feared for their lives. Robert T. Hill, a member of the expedition, wrote, "I took
many photographs, but do not hesitate to acknowledge that I was terrified." Hill attempted to locate
survivors of the catastrophe so he could form a comprehensive picture of the events on that terrible
day. There were few witnesses left, and their reports understandably differed and were clouded in con-
fusion. The scope of the tragedy begged for visual representation, but there were no photographs of the
actual eruption. Lacking a picture to shed light on the disaster, Hill opened his July 1902 article for
NATIONAL GEOGRAPHIC, "Report by Robert T. Hill on the Volcanic Disturbances in the West Indies,"
with a quote from the Bible: "The Lord rained fire and brimstone and the smoke of the country went up
as of a furnace." ∼ In 1963, the Society reprinted Hill's gripping account of the 1902 calamity in its
book *Great Adventures*. This time the text was augmented with a painting. Artist Paul Calle illustrated an
account by one of the few survivors, Charles Evans, who described with horror, a "sudden and instan-
taneous conflagration of the city." Although Calle began his painting 61 years after the tragedy, he had
the skill and imagination to recreate the devastation of St. Pierre with vivid intensity. ∼ When a cat-
aclysm occurs, it often transpires amid panic and confusion, when no one has a camera ready or a

(PRECEDING PAGES) **HERBERT TAUSS**
"PIZARRO: CONQUEROR OF THE INCA" *February 1992*

sketchpad open. Even when disaster is expected, it is difficult to comprehend, in the intensity of the

moment, what will take on historic importance. Anticipating the start of the Civil War, two of the

nation's most influential publications stationed artists where hostilities seemed most likely to occur.

Once the war began, artists and photographers flocked to the battlefronts. Luminaries like Winslow

Homer and Mathew Brady, as well as many less-renowned artists, recorded the conflict, yet pivotal

events went undocumented. There is one blurred photograph of Lincoln at Gettysburg, and no one was

on hand to record the surrender of the Confederate Army in Wilmer McLean's parlor in the town of

Appomattox Court House. ∼ From its inception, the National Geographic Society has documented

and researched the conflicts and natural disasters that affect our world. Photography has immediate

impact and brings an authenticity that paintings can never match, yet when no photograph is available,

an artist's interpretation is often the only way to capture a momentous event. Sometimes it is also the

best way. NATIONAL GEOGRAPHIC Editor Melville B. Grosvenor was disappointed when he saw sketches

by Tom Lovell for his landmark painting, "The Surrender at Appomattox." "Is there not an on spot pho-

tograph of this scene?" he asked in a note to Art Director Andrew Poggenpohl. For better or worse,

there was no photograph. Although Lovell scrupulously researched every detail of the painting, from

the pattern on the rug to the insignia on the uniforms, he also was able to take some artistic license.

Perhaps Grant did not really look so noble, nor Lee so valiant. Lovell was not attempting to mimic pho-

tographic reality, however, but to record something more. His emotional canvas exemplifies the

rebirth of the nation from the ravages of war, and the wisdom of a surrender that was not a defeat.

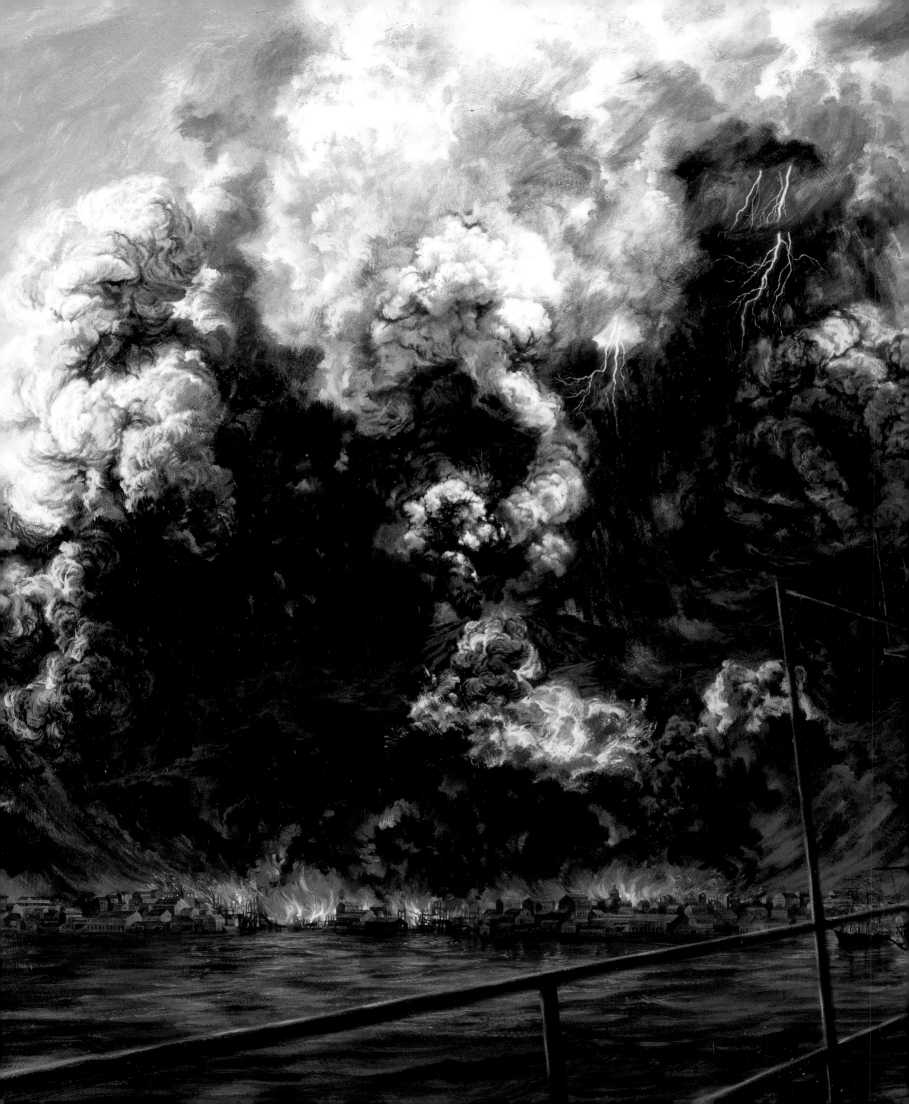

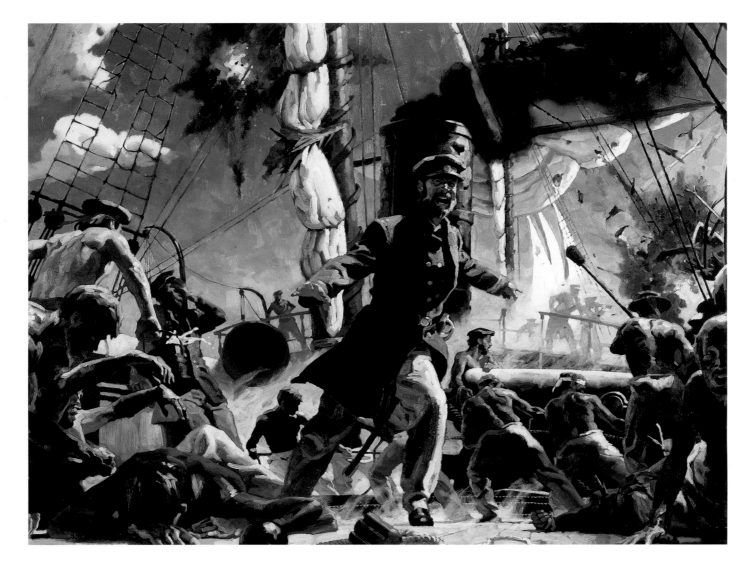

YANG HSIEN-MIN

(OPPOSITE) WITH THE CRACK OF A WHIP..., THE
NEW REGIME WIELDED MERCILESS FORCE TO
CONSOLIDATE TOTAL POWER IN THE HANDS OF THE
EMPEROR. HE SENT 700,000 CONSCRIPTS TO BUILD HIS
GREAT WALL AS A DEFENSE AGAINST NOMADIC
TRIBESMAN OF CENTRAL ASIA.

———

"CHINA'S INCREDIBLE FIND"

April 1978

GREGORY MANCHESS

(ABOVE) BATTLE'S BLOODIEST MOMENT: AFTER A
SHELL EXPLODES AT A GUNPORT OF THE *ALABAMA* —
KILLING OR WOUNDING NEARLY HALF OF THE 22-MAN GUN
CREW — MANGLED BODIES ARE REMOVED AND FIRST
LIEUTENANT KELL, CENTER, YELLS FOR REPLACEMENTS.

———

"WRECK OF THE C.S.S. ALABAMA:
AVENGING ANGEL OF THE CONFEDERACY"

December 1994

It took Gregory Manchess over a year to complete his painting of the wreck of the C.S.S. *Alabama*. "NATIONAL GEOGRAPHIC gave me a paper diagram of the ship that helped me determine the angle of the light and the direction of the wind in every possible position. Each sketch was checked and re-checked for accuracy." Manchess called hobby shops all over the country to find a model of the *Alabama* and finally located one in a store in the Midwest. Halfway through constructing the model, he discovered that the deck configuration was inaccurate. "I had to make a cardboard model of my own, and I used it to get the proper angle of vision. I wanted to compose the painting from the point of view of someone actually standing on the deck and that was difficult."

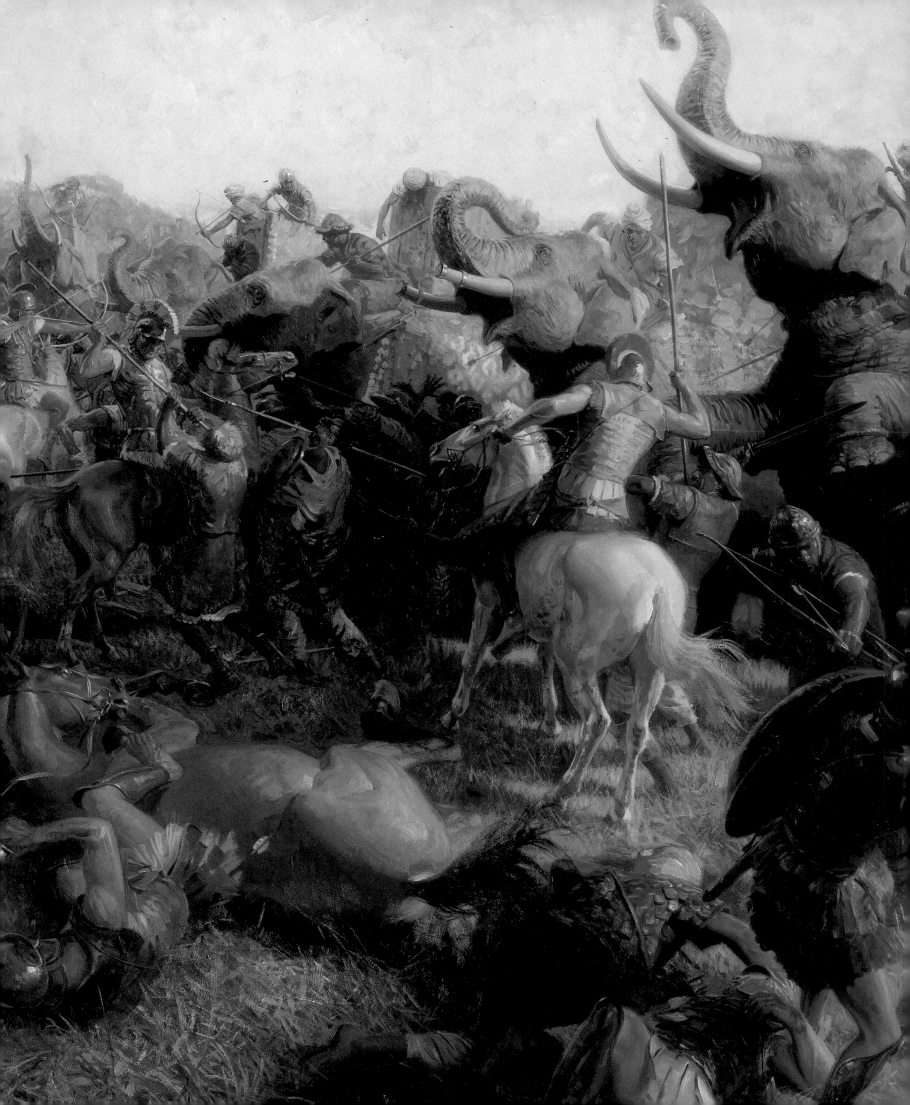

TOM LOVELL

151

(LEFT) LAST GREAT BATTLE: ALEXANDER'S
INFANTRY AND CAVALRY OVERWHELM THE INDIAN ARMY
OF KING PORUS AT THE JHELUM RIVER. "MADDENED
BY THE DISASTER," THE KING'S ELEPHANTS
"KEPT COLLIDING WITH FRIENDS AND
FOES ALIKE," ACCORDING TO ARRIAN.
SOON AFTER THIS VICTORY, ALEXANDER'S MEN,
WEARY AND HOMESICK, DEMANDED
THAT HE TURN BACK.

———

"IN THE FOOTSTEPS OF ALEXANDER THE GREAT"

January 1968

STANLEY MELTZOFF

(FOLLOWING PAGES) ROMAN "RAVEN" SMASHES ITS
IRON BEAK INTO CARTHAGINIAN DECK OFF MYLAE, SICILY,
IN 260 B.C. UNCLAD LEGIONARY SETS GRAPPLING
HOOK AND LEAPS CLEAR; SOLDIERS RUN ACROSS
TO WIN A SEA BATTLE WITH LAND WEAPONS.

———

GREECE AND ROME: BUILDERS OF OUR WORLD

1977

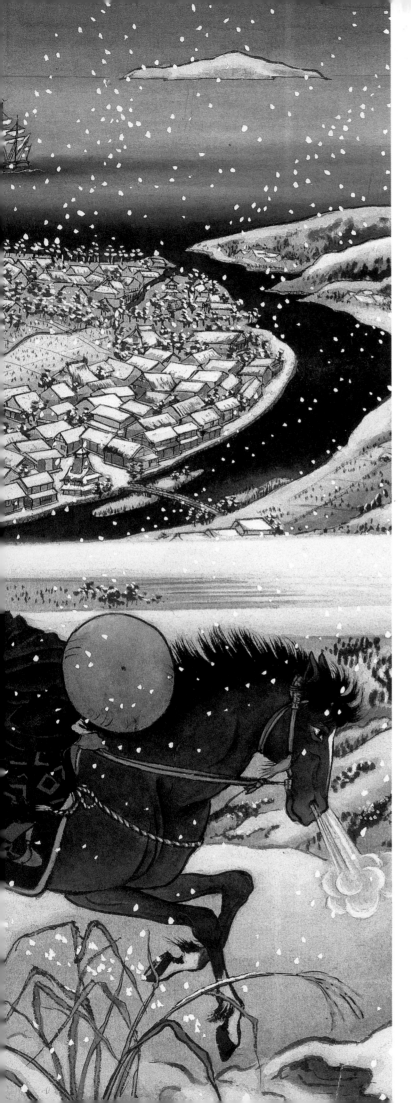

KINUKO Y. CRAFT

(ABOVE) CUTTING THROUGH WAVES OF A SEA THAT HAD HISTORICALLY WALLED JAPAN IN AND THE WORLD OUT, YOSHIDA SHOIN, A YOUNG SAMURAI-TEACHER, RIDES IN 1854 TO A MEETING WITH COMMODORE MATTHEW C. PERRY, COMMANDER OF YANKEE WARSHIPS THAT HAVE SHATTERED THE NATION'S SECLUSION. "TAKE ME TO AMERICA," YOSHIDA ASKS, CONVINCED THAT JAPAN NEEDS TO STUDY WESTERN TECHNOLOGY TO SURVIVE.

(LEFT) A HORSEMAN RACES WITH NEWS OF WAR. FIRING A SYMBOLIC BROADSIDE FROM EMPTY CANNON ABOARD A COMMANDEERED WESTERN-BUILT SHIP, HAGI'S REBELS IN 1865 SERVE NOTICE THAT UNLESS THE TOWN'S CONSERVATIVE FORCES YIELD, THEY WILL BE DESTROYED. AFTER WINNING THE CASTLE TOWN, THE REVOLUTIONARIES WENT ON TO CRUSH THE SHOGUN, USHERING IN REFORMS THAT BROUGHT JAPAN INTO THE MODERN AGE WITH MUCH OF ITS HERITAGE INTACT.

"HAGI: WHERE JAPAN'S REVOLUTION BEGAN"

June 1984

Kinuko Craft went to Hagi, Japan, to gather reference and inspiration for these illustrations documenting the beginnings of Japan's revolution. "I went up to the mountain at Hagi to see the view, which seemed unchanged after over a hundred years," Craft remembers. "I also visited a museum and walked all around the town looking at everything of historical interest and conditioning myself in the spirit of those times so that I could paint the illustrations with confidence."

TOM LOVELL

(ABOVE) FOR SIX WEEKS IN 1097, CRUSADERS
BESIEGED THE TURKISH CAPITAL, HACKED APART A
RELIEF ARMY, WATCHED THEIR OWN MEN SLAIN.

(LEFT) IN THE FOOTSTEPS OF THE CRUSADERS:
A BAREFOOT CHRISTIAN ARMY CIRCLES BESIEGED
JERUSALEM, GOAL OF THE CRUSADES.

THE MIDDLE AGES

¹9 7 7

While Tom Lovell was working on the night scene shown above for the National Geographic Society book initially published in 1963 as *The Age of Chivalry*, Art Director Andrew Poggenpohl cautioned him to avoid putting too many stars in the sky. "Please have so few of them that no one could fault us for not plotting them in — or else go ahead and plot in a portion of the eastern sky for that month and latitude," Poggenpohl warned. After considering his options, Lovell decided to hide the heavens under a blanket of clouds.

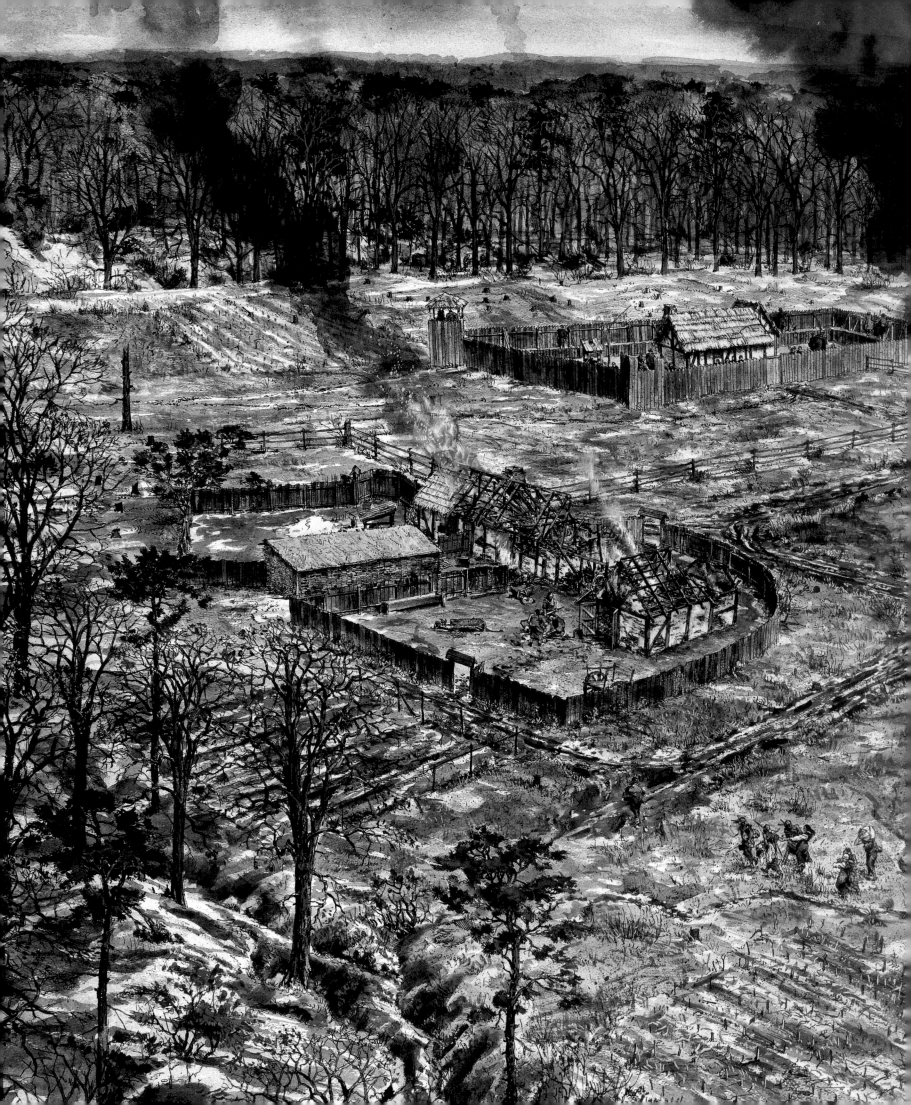

RICHARD SCHLECHT

(LEFT) "TREACHERY AND CRUELTY HAVE DONE
THEIR WORST TO US," A COLONIST WROTE OF
"THAT FATAL FRIDAY MORNING" OF MARCH 22, 1622.
SMOKE AND ASH BILLOWED INTO THE SKY DURING
SIMULTANEOUS INDIAN ATTACKS ON MORE
THAN A SCORE OF HOMESTEADS, INCLUDING THOSE
OF MARTIN'S HUNDRED.

———

"NEW CLUES TO AN OLD MYSTERY"

January 1982

TOM LOVELL

(FOLLOWING PAGES) LEE ACCEPTS THE SURRENDER TERMS:
DRESSED IN A NEW UNIFORM OF CONFEDERATE GRAY,
LEE ACCEPTS THE GENEROUS TERMS OFFERED BY GRANT.
AT LEE'S SIDE STANDS LT. COL. CHARLES MARSHALL,
HIS SECRETARY. ACROSS THE ROOM IN MUDDY BOOTS
AND A PRIVATE'S BLOUSE DECORATED WITH THE THREE STARS
OF HIS RANK, GRANT GAZES WITH COMPASSION ON HIS
RECENT ADVERSARY. BEHIND HIM, LEFT TO RIGHT:
MAJ. GEN. PHILIP H. SHERIDAN, COL. ORVILLE E. BABCOCK,
LT. COL. HORACE PORTER, MAJ. GEN. EDWARD O.C. ORD,
MAJ. GEN. SETH WILLIAMS, COL. THEODORE S. BOWERS,
COL. ELY S. PARKER, AND MAJ. GEN. GEORGE A. CUSTER.
"WE WALKED IN SOFTLY,..." SAID PORTER, "VERY MUCH
AS PEOPLE ENTER A SICK-CHAMBER WHEN THEY EXPECT
TO FIND THE PATIENT DANGEROUSLY ILL."

———

"APPOMATTOX: WHERE GRANT AND LEE
MADE PEACE WITH HONOR A CENTURY AGO"

April 1965

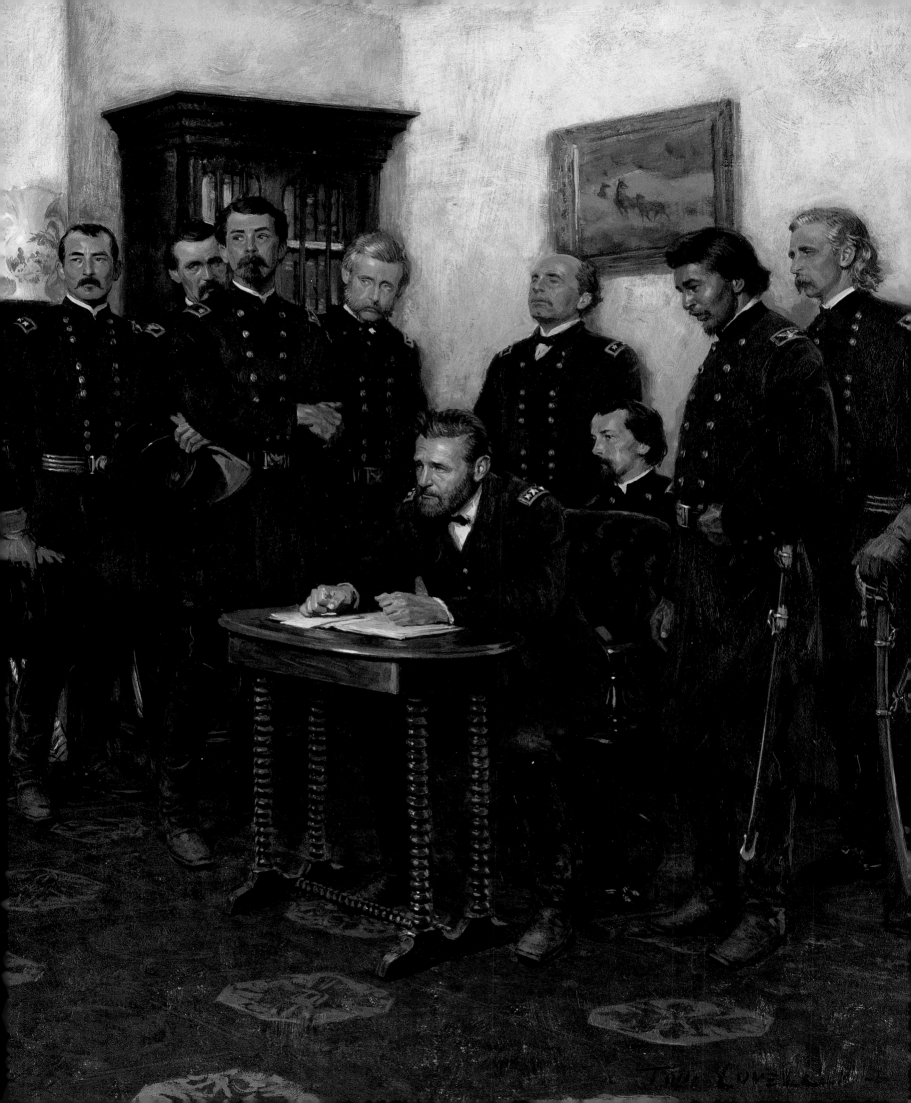

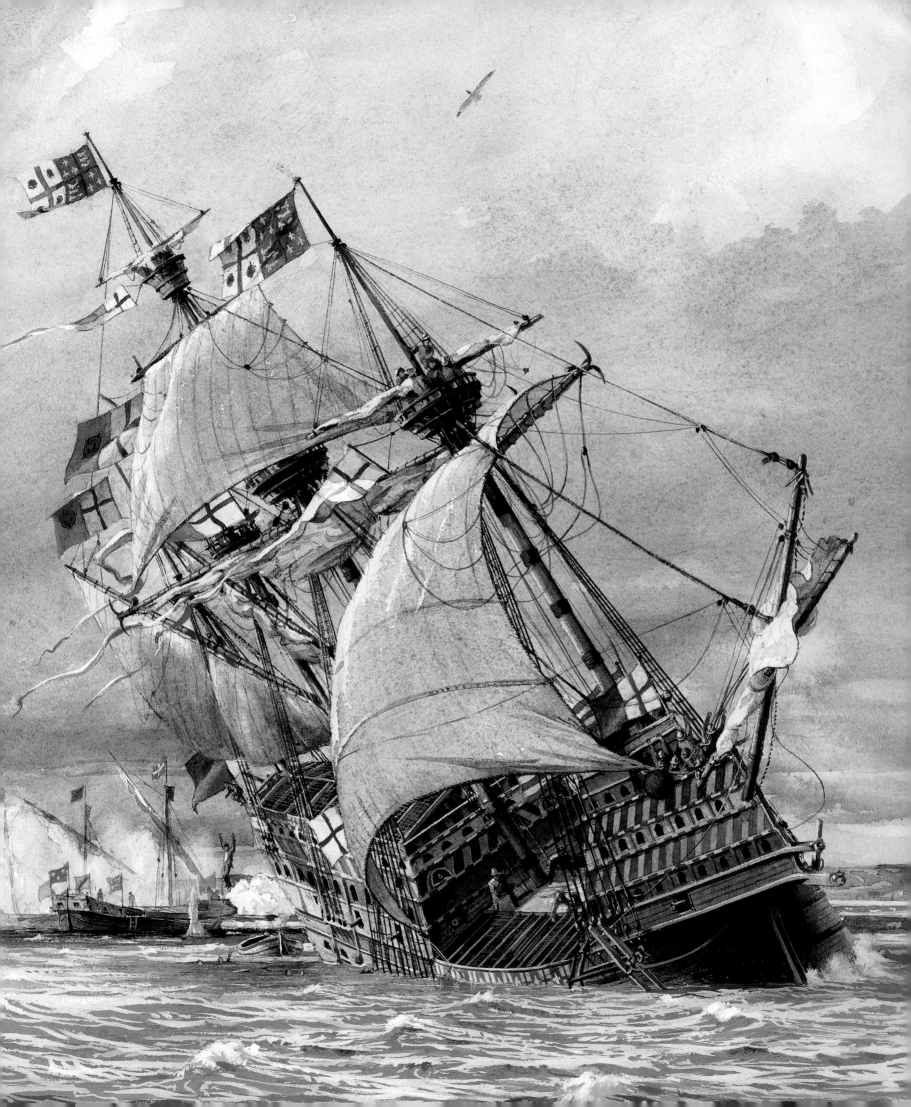

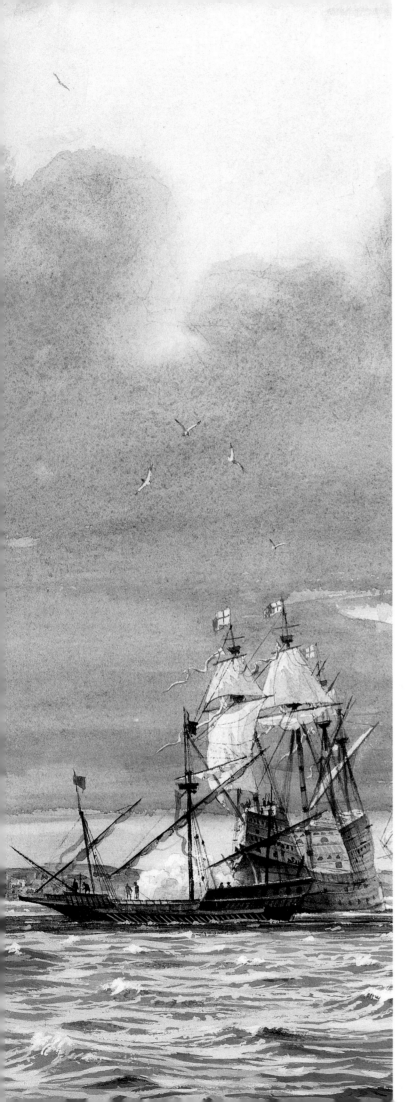

RICHARD SCHLECHT

࿓

IT HAPPENED SO FAST. A SHORE BREEZE CAME UP
AND *MARY ROSE* HOISTED SAIL TO ENGAGE THE ENEMY.
THEN SUDDENLY SHE SWUNG AWAY FROM THE BATTLE,
HEELING DANGEROUSLY ON HER SIDE. WATER
BEGAN FLOODING INTO HER LOWER GUNPORTS,
CANNON CRASHING HEADLONG ACROSS HER SLANTING
DECKS. IN LESS THAN A MINUTE SHE SANK
TO THE BOTTOM LIKE A STONE.

———

"LEGACY FROM THE DEEP:
HENRY VIII'S LOST WARSHIP"

May 1983

Richard Schlecht's own search for the Tudor warship *Mary Rose* began in England in the dead of winter, in the middle of the biggest blizzard in 40 years. Schlecht made his way to Portsmouth — where the wreck lay submerged in the harbor — on a bus that plowed through alarmingly high snowdrifts. Once he arrived, the artist found a wealth of information such as historical documents and artifacts from the wreck, as well as some contemporary paintings. To compose his illustration, Schlecht drew on all his research; he also used his imagination. "You have to interpret the historical facts," he contends. "You can't be afraid to use probabilities and possibilities to tell a story."

TOM LOVELL

࿓

(FOLLOWING PAGES) HURRICANE SHATTERS A
HOMEBOUND SPANISH TREASURE FLEET OFF THE EAST
COAST OF FLORIDA, JULY 31, 1715. WAVES SWALLOWED
$14,000,000 IN GOLD AND SILVER. DIVERS BEGAN WORK
SOON AFTER, RECOVERING HALF THE LOSS.

———

WORLD BENEATH THE SEA

1967

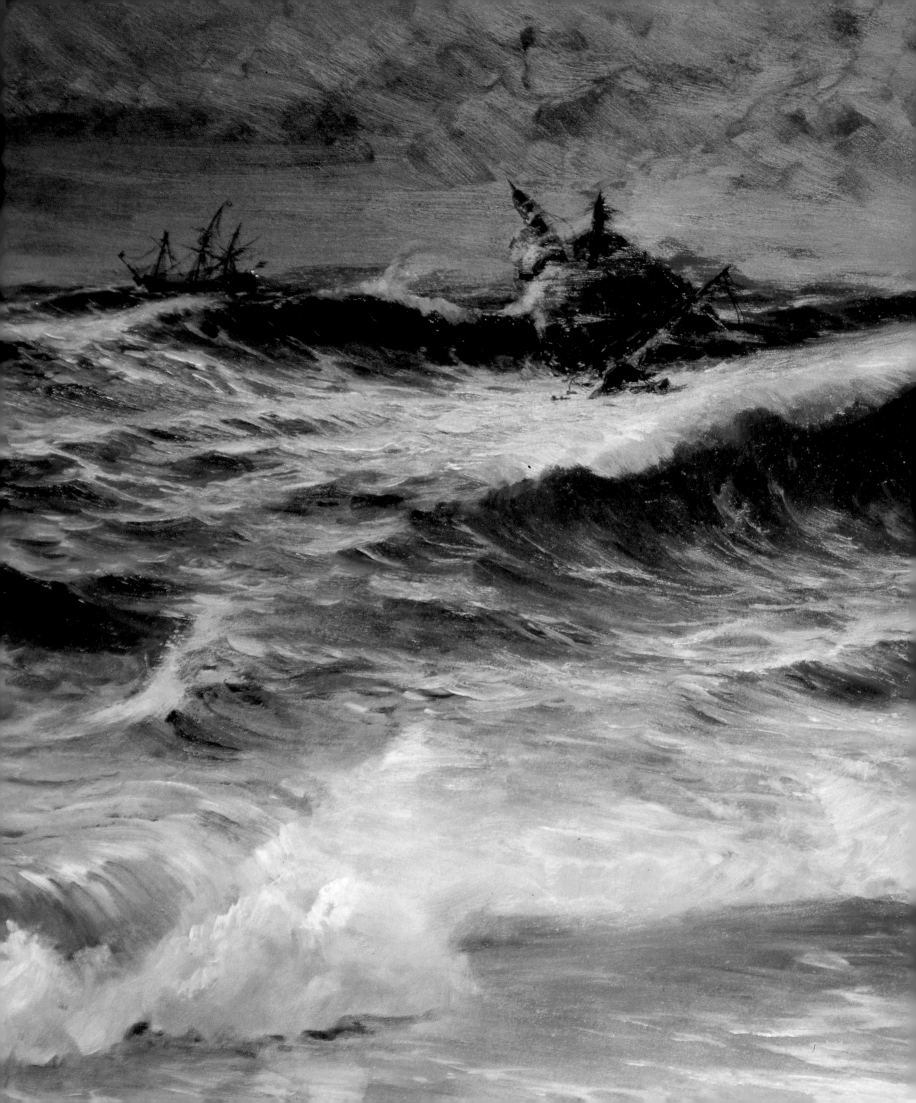

WILLIAM H. BOND

GERMANY STRUCK THE DOCKS ON
THAT FIRST DAY, ATTACKING WITH HEINKEL
HE 111 BOMBERS AND FIGHTERS ARMED WITH
INCENDIARY AND HIGH-EXPLOSIVE BOMBS.
CAUGHT BY SURPRISE, LONDON'S 90 ANTI-AIRCRAFT
GUNS WERE OVER-MATCHED BY THE GERMAN ARMADA.
FLAMES ENGULFED WAREHOUSES AND HOMES;
WHEN NIGHT FELL, THE FIRES GUIDED GERMAN
PILOTS RETURNING WITH MORE BOMBS.

"REMEMBERING THE BLITZ"

July 1991

For Bill Bond, researching this painting of the Blitz brought back many memories, since he had been living in the East End of London, the area shown in his illustration, at the time. "I remember when it was bombed," Bond says. "I was in a crowded shelter with my family when the Germans dropped incendiary bombs and land mines. There was a lot of damage on my block, and the front windows of our house were all blown in." When Bond went back to his boyhood neighborhood, he found that not much was left of it. "Still," he says, "I tried to make my illustration as accurate as possible. I painted what I felt."

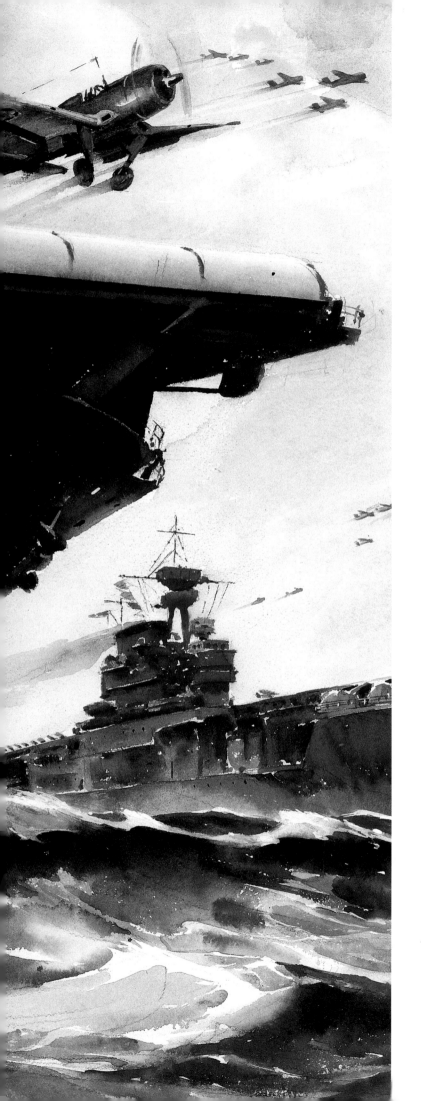

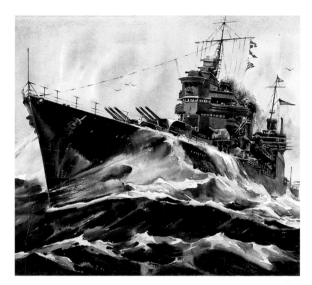

ARTHUR BEAUMONT

(ABOVE) HEAVY AND LIGHT CRUISERS
RANGE FAR TO SCOUT OR FIGHT: U.S.S. *ASTORIA*.

(LEFT) PLANES ROAR INTO ACTION FROM
U.S. AIRCRAFT CARRIERS *WASP* AND *ENTERPRISE*.

———

"SHIPS THAT GUARD OUR OCEAN RAMPARTS"

September 1941

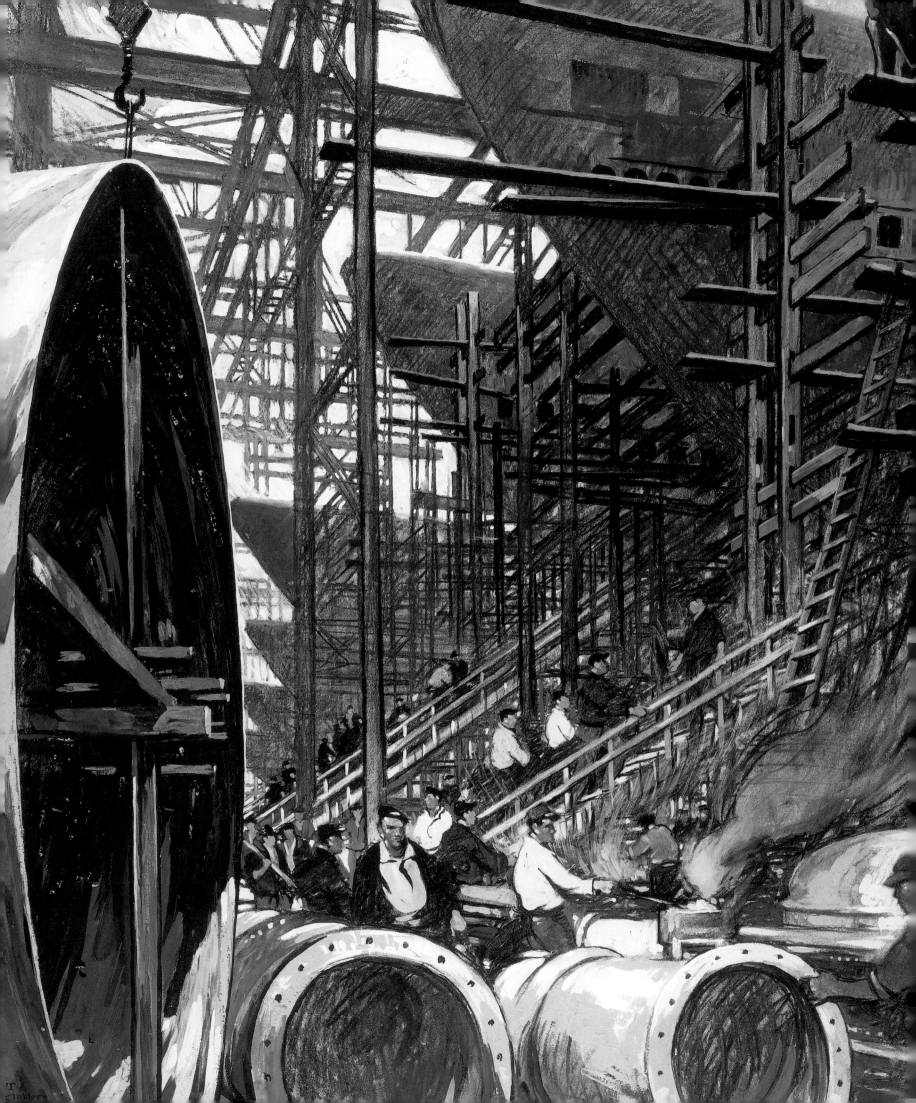

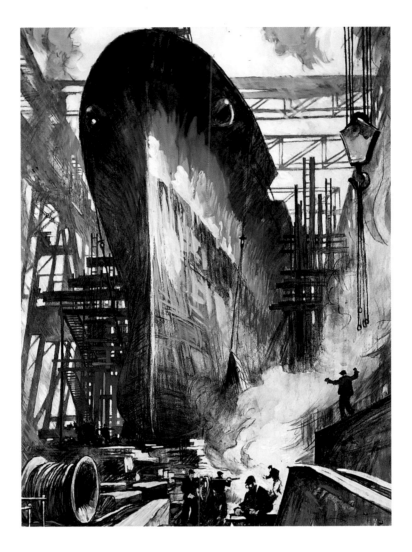

THORNTON OAKLEY

(ABOVE) OUR GROWING NAVAL POWER: BATTLESHIP *ALABAMA*
READY FOR LAUNCHING

(OPPOSITE) GRIM TREAT TO ENEMY NAVIES: U.S. SUBMARINES IN MASS PRODUCTION

"AMERICAN INDUSTRIES GEARED FOR WAR"

December 1942

In the 1940s, Franklin L. Fisher, Chief of the NATIONAL GEOGRAPHIC Illustrations Division, commissioned Thornton Oakley to paint 48 watercolors for three separate articles on American industrial production. Fisher, who was instrumental in initiating many of the greatest photographic series in the magazine, would have preferred to hire a photographer for the articles. However, in this case, with war impending, artwork was his only option. "I may state," he wrote in defense of the Oakley paintings, "that the Geographic uses paintings of such subjects not only because they provide dramatic illustrations but because of the ease with which secret or restricted material can be omitted from the compositions."

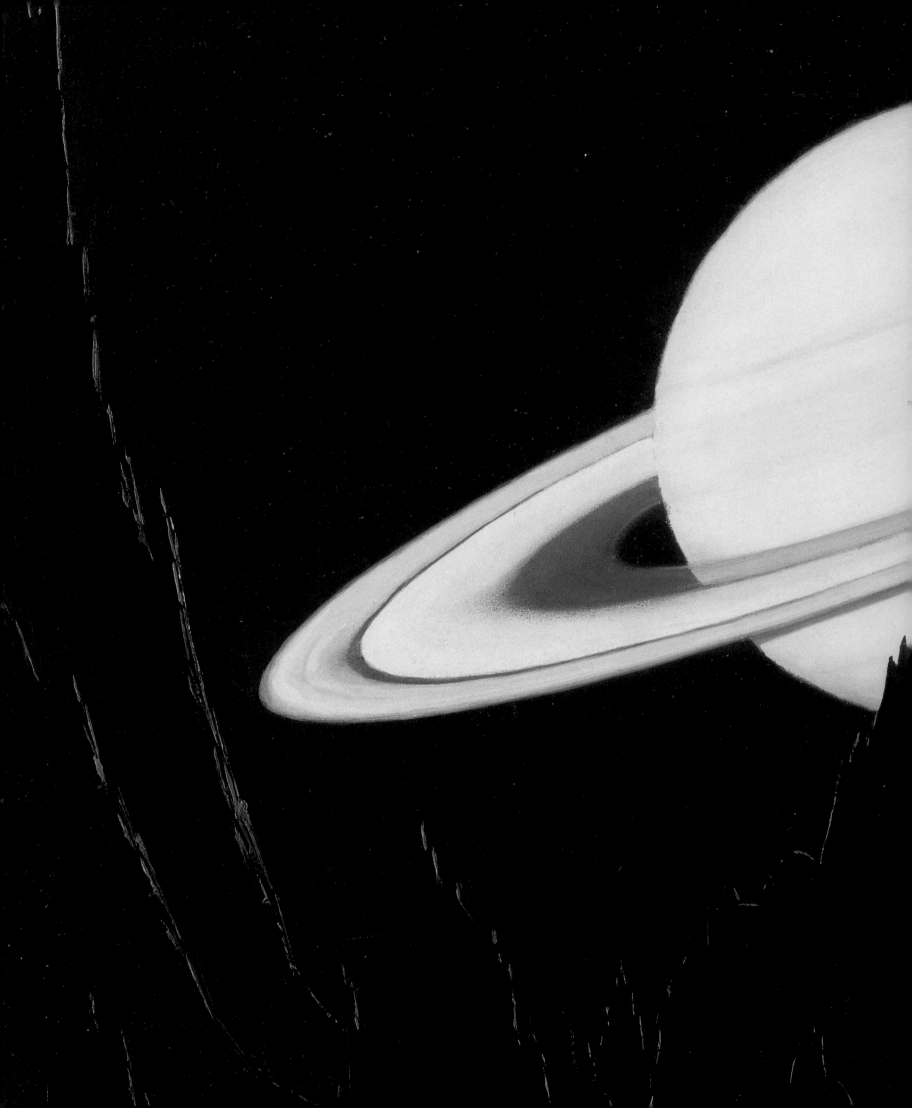

Universe

UNIVERSE

In 1918, when NATIONAL GEOGRAPHIC Editor Gilbert H. Grosvenor began planning an article on the wonders of the universe, he decided that astronomical paintings would be an invaluable addition. In those days, the Society's preferred artist was Louis Agassiz Fuertes, whose detailed watercolors of birds and mammals were popular features in the magazine. "I wish you would tackle the heavens next," Grosvenor wrote to Fuertes. "I would give anything if we could find somebody to depict the stars in a picturesque and intelligent way." Fuertes, who had no training in astronomical illustration, refused; 20 years would pass before Grosvenor found someone he trusted to paint the heavens. ～ That artist was Charles Bittinger, and his credentials were impressive. A bright, inquisitive young man, Bittinger initially planned a career as a physicist and studied at the Massachusetts Institute of Technology for three years until a vacation abroad caused him to change his plans abruptly. Deeply affected by the artwork he saw in the great museums of Europe, he resolved to devote himself wholly to the subject of art. Bittinger attended the École des Beaux Arts in Paris from 1901 to 1905, and when he returned to the United States, he enjoyed a successful career as a painter. By the time the Society first commissioned his work, he had exhibited at the National Arts Club, the Art Museum of St. Louis, the Boston Athenaeum, and the Metropolitan Museum of Art. ～ In 1939, Bittinger completed eight illustrations of the solar system for the July issue of NATIONAL GEOGRAPHIC. His painting "A Blue Globe Hanging in Space – The Earth As Seen from the Moon," proved remarkably factual, anticipating the view that would awe the Apollo 11 astronauts 30 years later. Bittinger's illustrations were based on the best scientific evidence of the time, supplied by astronomers at several major observatories. However, in the 1930s even the largest land-based telescopes could not characterize the surface of the planets; so while Bittinger's moon looked realistic, Mars and

Saturn, still shrouded in mystery, took on a more simplistic appearance, and much of the topography the artist delineated proved erroneous. Nevertheless, Bittinger's work exhibited an ethereal grandeur and a reverence for the mysteries of the cosmos — qualities considered of prime importance to the talented astronomical illustrators who have since contributed to Society publications. ∼ Readers of NATIONAL GEOGRAPHIC were treated to a return voyage through the solar system in 1970, courtesy of science writer Kenneth F. Weaver and astronomical illustrator Ludek Pesek. Buoyed by the onslaught of information brought back by Russian and American deep-space probes, Pesek's paintings present a complex and alien environment that sharply contrasts with Bittinger's celestial calm. Pesek's planets seem threatening. Viewed at close range from their moons, they hover ominously, pushing beyond the margins of his paintings as if trying to break free. It is impossible to look at these illustrations without feeling like a very small scrap in a vast and hostile universe. Yet Pesek's paintings, like Bittinger's, are no longer entirely accurate. The Viking, Pioneer, Voyager, and Galileo space probes have returned amazing data that have dramatically increased our understanding of the geography of the solar system. ∼ Astronomical artists create their paintings from the best available information, with the understanding that new discoveries will probably date their work. For that reason, Vincent Di Fate, many of whose dramatic paintings have appeared in Society publications, maintains that although scientific accuracy is essential, the primary task of any artist is the creation of a striking work of art. "As a viewer, when I look at an astronomical illustration and feel that I'm in that place, that perhaps I've crossed light years to be in that place, then I know that the artist has succeeded," Di Fate says. "Any artist who can paint within the limitations of scrupulous accuracy and still create a masterful painting has really accomplished something special."

CHARLES BITTINGER

(ABOVE) WHEN NEARING THE SUN A COMET GROWS A TEMPORARY TAIL.

(OPPOSITE) A BLUE GLOBE HANGING IN SPACE — THE EARTH AS
SEEN FROM THE MOON

"NEWS OF THE UNIVERSE: SOLAR SYSTEM'S ETERNAL SHOW"

July 1939

Charles Bittinger found his 1939 commission to paint astronomical illustrations for NATIONAL GEOGRAPHIC inspiring. While planning and working on the eight paintings that accompanied the article, he wrote, "I came to feel more than ever that astronomy is the greatest monument to human intelligence, which has explored out into unimaginable depths of space with nothing more tangible than the fragile waves of light. Astronomy gives us, as nothing else can, an appreciation of the power and wisdom of the unseen hand of the Creator which has produced and governs this stupendous Universe."

Ludek Pesek

(LEFT) Raw flank of the red planet Mars
looms less than 4,000 miles away, as
depicted from the satellite Phobos.

———

"Voyage to the Planets"

August 1970

(FOLLOWING PAGES) A broken moon?
Or a moon that never was? Astronomers
do not yet know how Saturn's rings came to be.
Full of icy particles, a ring seems to blur
into a band of unearthly hail around the
planet. One ring is so thick with rubble that
almost no light can pass through it.

———

*National Geographic Picture
Atlas of Our Universe*

1994

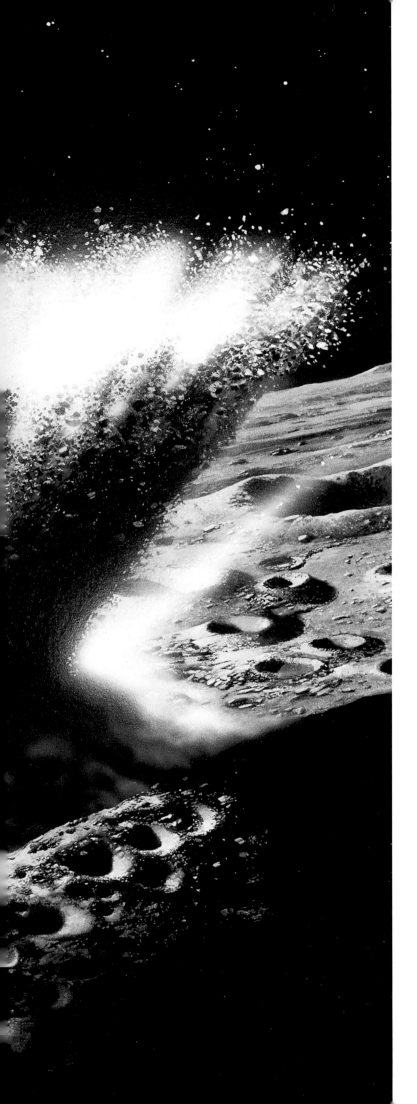

CHRIS FOSS

A SCAR IS BORN ON MERCURY'S CRATERED FACE
AS A METEOROID SLAMS DOWN. IF THIS WERE EARTH,
DEBRIS AND AIR WOULD MIX IN GREAT DUSTY
BILLOWS AND THE BOOM OF THE IMPACT WOULD ECHO
AFAR. BUT ON AIRLESS MERCURY THE DEBRIS
SPRAYS UP AND SPREADS OUT IN A SILENT VEIL-
LIKE SPLASH OF ROCK AND DUST.

———

*NATIONAL GEOGRAPHIC PICTURE
ATLAS OF OUR UNIVERSE*

1994

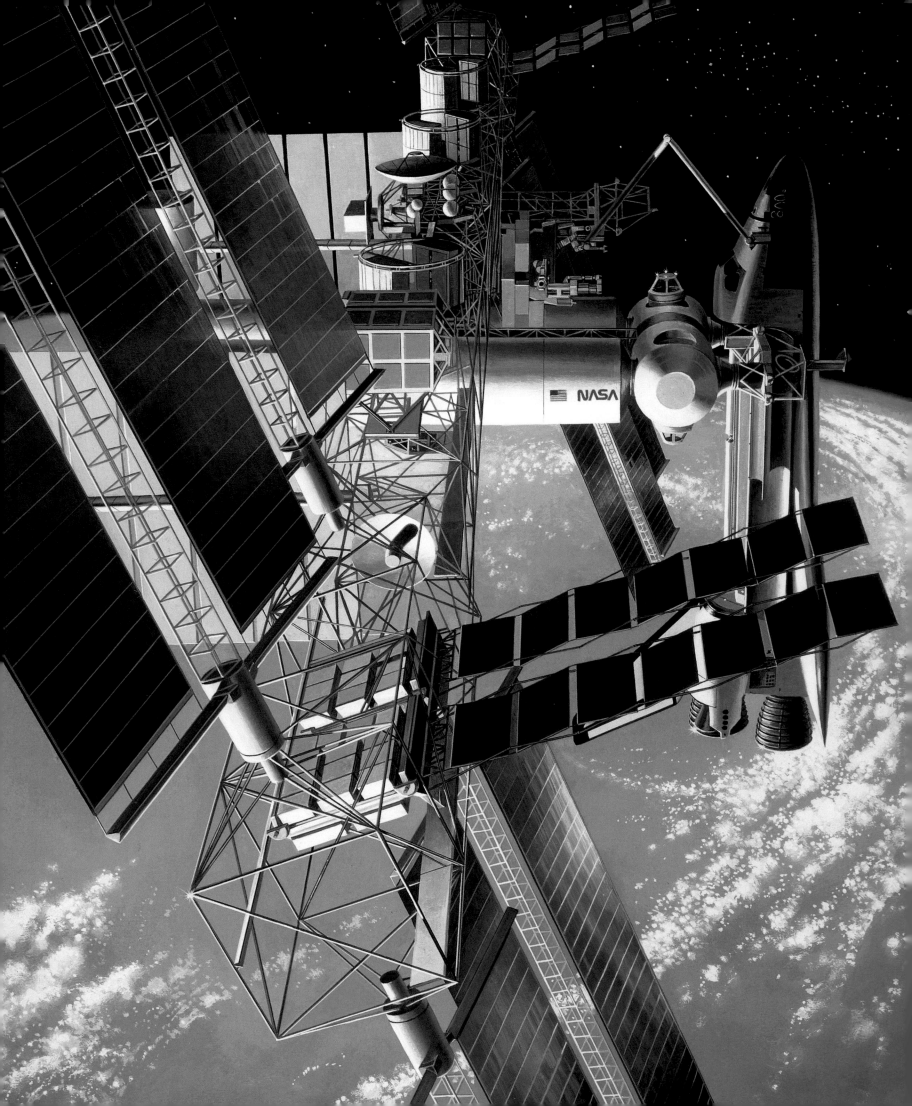

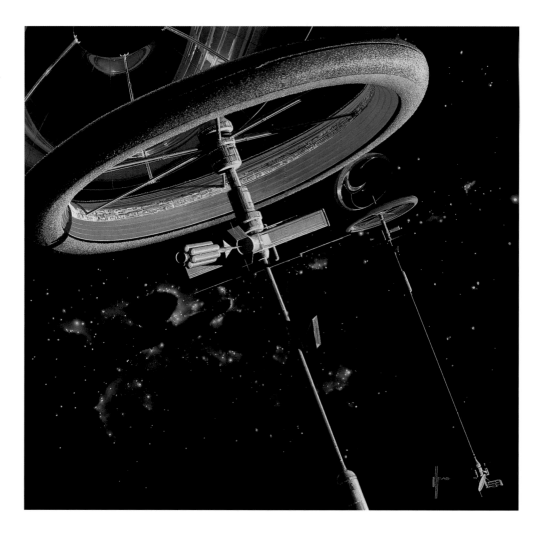

DAVIS MELTZER

(OPPOSITE) SHRINKING THE SPACE STATION:
BUDGET BATTLES, DESIGN REVIEWS, AND DEBATES
ABOUT MANNED-VERSUS-UNMANNED SPACE
EXPLORATION HAVE MEANT DELAYS AND DESIGN
CHANGES FOR SPACE STATION FREEDOM SINCE
ITS AUTHORIZATION IN 1984.

———

"SATELLITE RESCUE"

November 1991

SYDNEY MEAD

(ABOVE) CITIES IN SPACE MAY LOOK LIKE BIG
BICYCLE WHEELS, EACH WITH A FREE-FLOATING
MIRROR TO GATHER IN THE SUNLIGHT.

(FOLLOWING PAGES) BOXY ROBOT CRAFT CALLED
WARDENS TEND THE FUEL GLOBES OF AN
UNMANNED DAEDALUS STARSHIP.

———

*NATIONAL GEOGRAPHIC PICTURE
ATLAS OF OUR UNIVERSE*

1994

Sydney Mead created his complex illustrations for the *National Geographic Picture Atlas of Our Universe* to show how man might one day colonize outer space. Mead recalls that the assignment was not a simple one: "It was a challenge to visually dramatize our 'best guess' possibilities for the future of space exploration." For the present, Mead's vision of encampments in outer space is a flight of the imagination. "Deep space exploration has become the province of small, efficient packages that are more and more autonomous," he notes. "These relatively tiny bundles of electronic wizardry race ahead of our ability to send humans, with their delicate life support envelopes and social imperatives, on extended space explorations. The saga of human space travel in the near future is now relegated to solar system planets and science fiction fantasy."

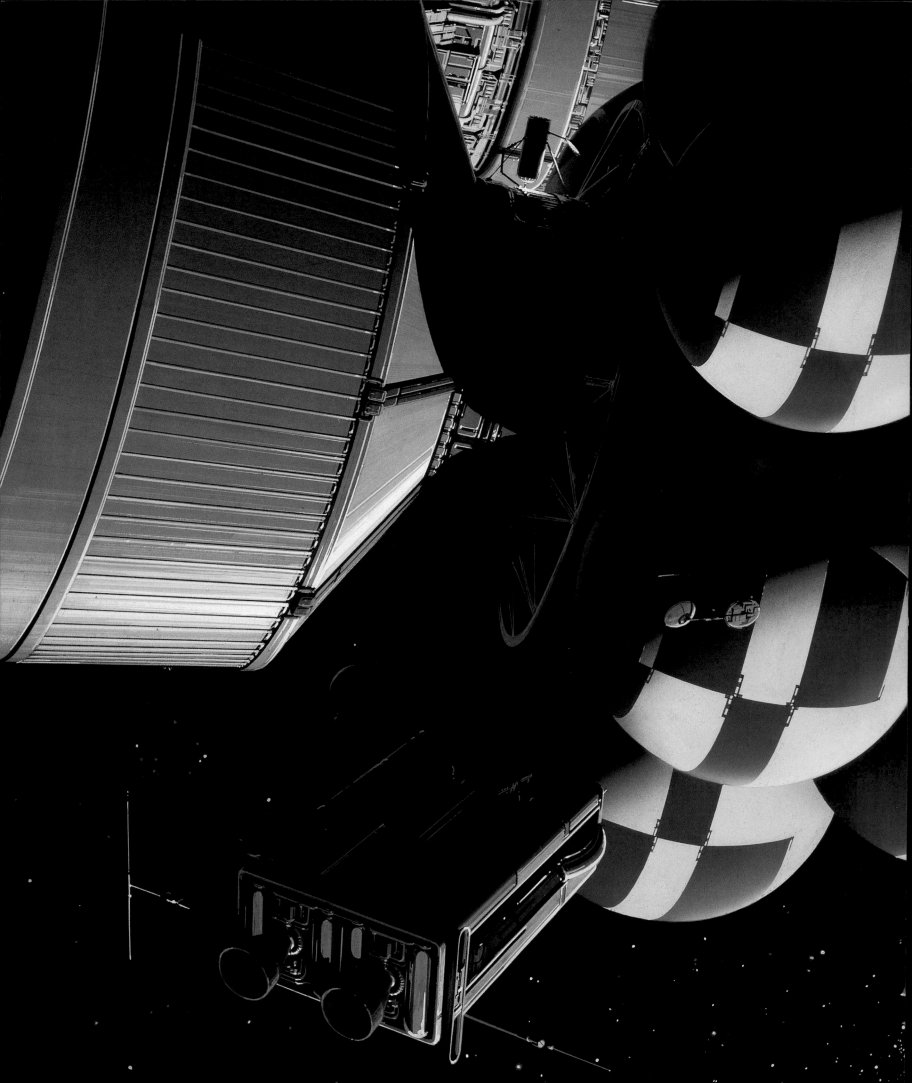

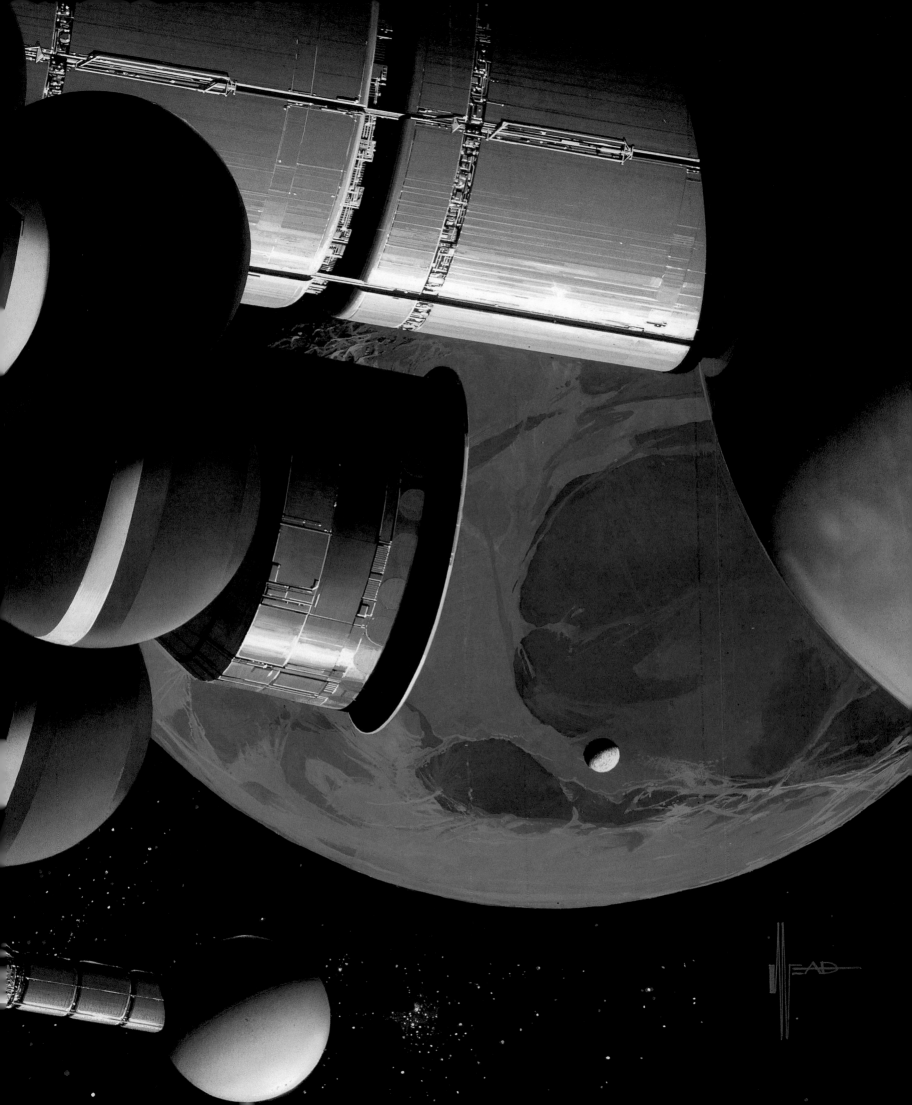

ROY ANDERSEN

(ABOVE) LEAVING BEHIND A BASE CAMP FOR
FUTURE EXPLORATIONS, THE MARS CREW LIFTS
OFF IN THE LANDING VEHICLE'S ASCENT STAGE TO
REJOIN THE ORBITING MOTHER SHIPS.

———

"MISSION TO MARS"

November 1988

LUDEK PESEK

(LEFT) IN THIS ARTIST'S VIEW ACROSS THE
GREAT RED SPOT, A CHILLY SUN AND CRESCENT IO
FLOAT ABOVE A CLOUDSCAPE VASTER THAN ANY EARTHLY
OCEAN. BELOW, LIGHTNING STABS INTO LAYERS
CHURNING WITH CHEMICALS NEEDED FOR LIFE. BUT
LIFE SEEMS UNLIKELY TO FORM AMID SUCH VIOLENCE.

———

*NATIONAL GEOGRAPHIC PICTURE
ATLAS OF OUR UNIVERSE*

1994

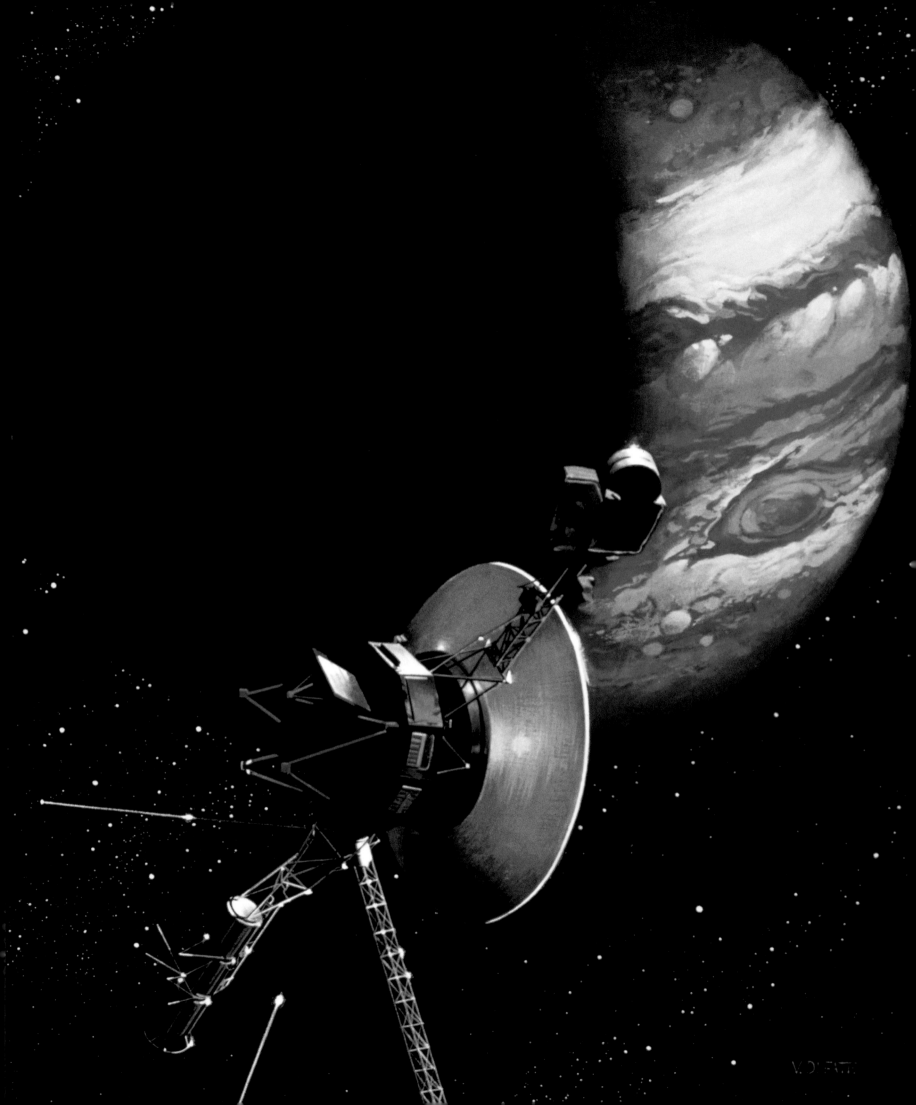

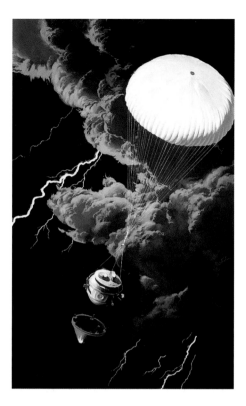

VINCENT DI FATE

(ABOVE) SHEDDING ITS RED-HOT SHIELD, A PROBE PLUMMETS INTO
JUPITER'S CLOUDS. IT WILL SAMPLE THE ATMOSPHERE UNTIL CRUSHED BY ITS
PRESSURE. A SECOND CRAFT IN ORBIT RELAYS DATA TO EARTH. NAMED
GALILEO, THE PROBE WAS LAUNCHED FROM A SPACE SHUTTLE.

NATIONAL GEOGRAPHIC PICTURE
ATLAS OF OUR UNIVERSE

1994

(OPPOSITE) SPACE CRAFT VOYAGER 1 TRAINS ITS TELEVISION CAMERAS
AND RADIO ANTENNAS ON THE LARGEST PLANET, JUPITER, IN 1979.

INVENTORS AND DISCOVERERS

1988

Vincent Di Fate's interest in astronomy began at age four, when he went to see
the movie *Rocket Ship XM*. He still remembers it, not only for its terrifying
aliens and improbable plot – a crew of astronauts headed for the Moon inexplicably
takes a wrong turn and ends up on Mars – but also for its evocative, red-tinted
images of the Martian surface. At the age of seven, when he discovered the astro-
nomical illustrations of Chesley Bonestell in *Life* magazine, Di Fate decided on a
career in art. Twenty-six years later, when the National Geographic Society first
published the lavishly illustrated *Picture Atlas of Our Universe*, both Vincent Di Fate
and the man who had inspired him to become an illustrator, Chesley Bonestell, were
among the artists featured.

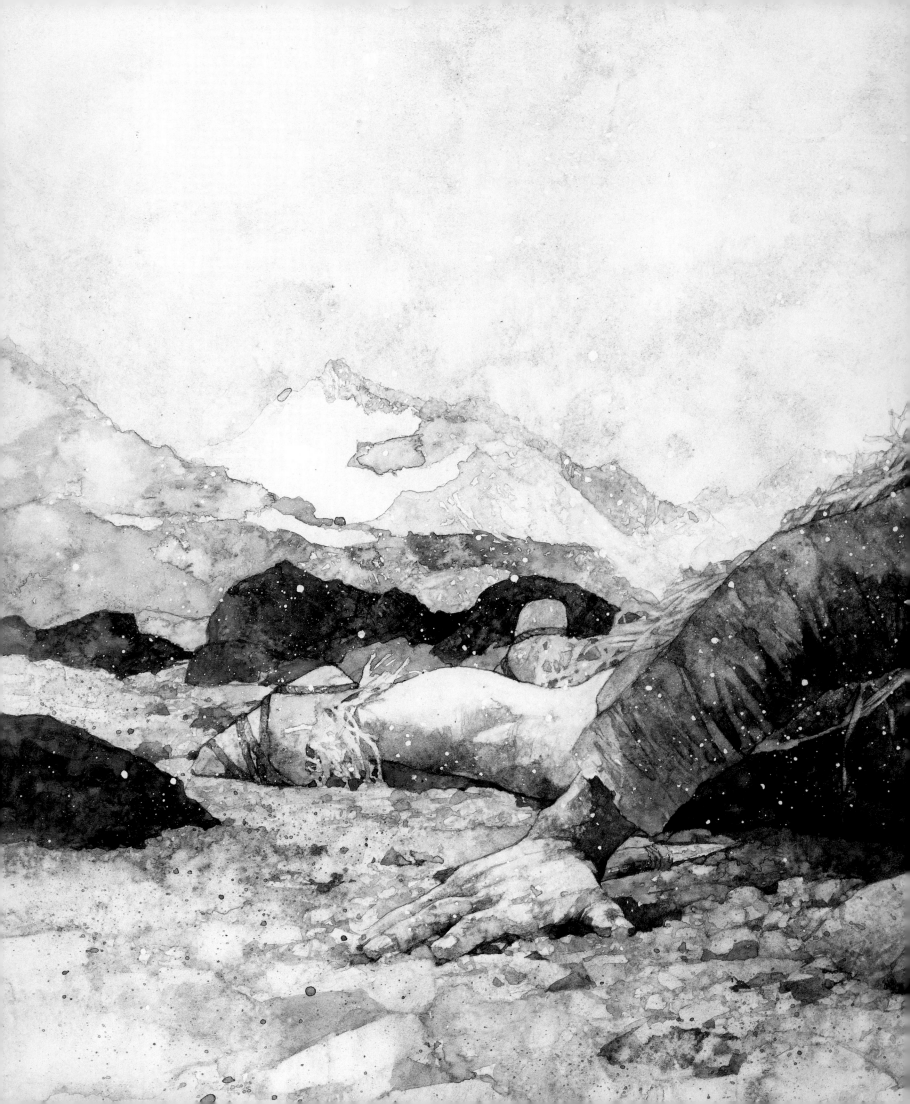

WORLD CULTURES

World Cultures

194 Sometimes the evidence is scarce: a copper ax, a shell necklace, bits of pottery, or a crumbling wall. At other times it is more impressive: a pharaoh's golden mask, 2,000 pages of hieroglyphs, the walls of an ancient city preserved for centuries under desert sands. Whatever the clues, the National Geographic Society has chronicled the saga of human history since the organization was founded in the 19th century. Both the rise and fall of empires and the unusual customs and conventions of the world's diverse cultures have fascinated Society members as essential components of geographic knowledge. As Frances W. Parker pointed out in an article published in NATIONAL GEOGRAPHIC in 1894, "Each and every characteristic of the earth's surface has had a determining influence on the history of mankind." ∼ In 1915, pen and ink drawings of artifacts discovered at Machu Picchu had appeared in NATIONAL GEOGRAPHIC, but since photographs of excavations usually provided enough visual information to interest Society members, it was not until the 1930s that artists were routinely commissioned to reconstruct the panorama of entire civilizations. Once published, however, these paintings proved so popular that, in the ensuing years, the Society hired a series of gifted illustrators to depict the lives of our ancestors. ∼ The complicated task of reassembling the past requires that artists work closely with scientific experts. Together they pore over relics, study thousands of photographs, read archival manuscripts, and often visit archaeological sites. Sometimes the job demands considerable daring. ∼ In order to re-create the culture of 16th-century Basque whalers in America, illustrator Richard Schlecht journeyed to Red Bay, a small harbor on the south coast of Labrador. There, under 30 feet of bitterly cold water, lay the flayed ribs of a 400-year-old Basque galleon. The only way to

study the vessel was to visit the silt-covered site beneath rough, frigid waters. Schlecht, who had no previous experience scuba diving, registered for a course near his home in Virginia in preparation for the assignment. ～ Diving in Red Bay proved more difficult than Schlecht had imagined. Because the water was only 29°F, the salvage crew working on the vessel used a special system to stay warm. Hot water from a central boiler of the diving barge was sent through rubber hoses connected to the divers' wet suits. By the time it reached the marine archaeologists, the water was a comfortable 105 degrees. ～ Given his tight schedule, however, Schlecht was forced to use a standard wet suit because of the time needed to learn how to use the heated ones. "You could only stay down for about 15 minutes before you ran the risk of getting hypothermia," Schlecht recalls. Despite the obstacles, he managed to gather enough information to create several beautifully conceived paintings of Basque whalers that elicit the unique flavor of those distant times. In one painting, seven men in a small boat in heaving seas thrust a lance into the back of an enraged whale. In another, a tryworks bustles with activity as whale blubber is rendered to yield oil. A third depicts a Basque whaler dying onboard his ship, anchored in a strange land thousands of miles from home, dictating his last will and testament on Christmas Eve 1584. ～ The work was difficult and exacting. Every drawing had to be checked and rechecked for accuracy. Nevertheless, Schlecht, like all of the talented artists who have the interest and ability to tackle these complex assignments, seems to relish the challenge. He remembers the assignment as an enjoyable one and thinks back fondly on the few challenging days he spent at Red Bay. "We were battling black flies and diving in icy waters," he remarks with characteristic good humor. "Otherwise, it was great fun!"

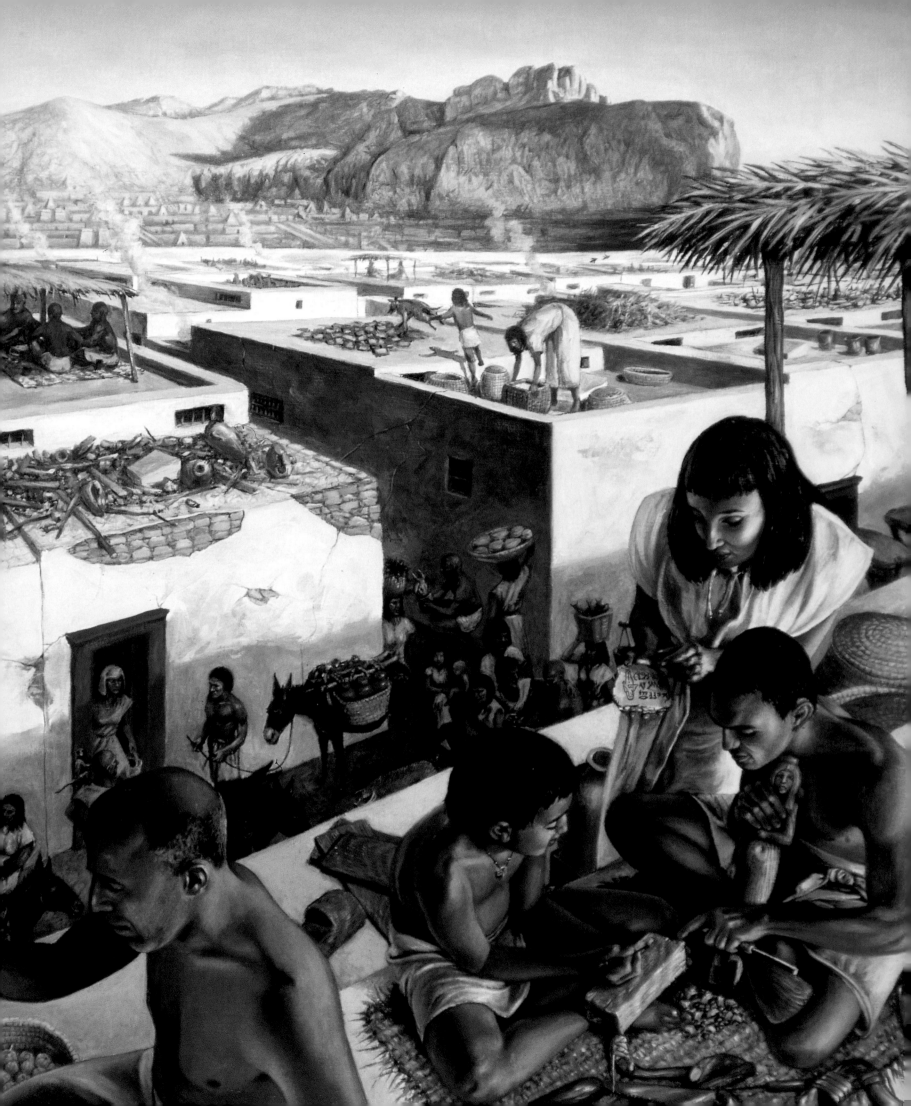

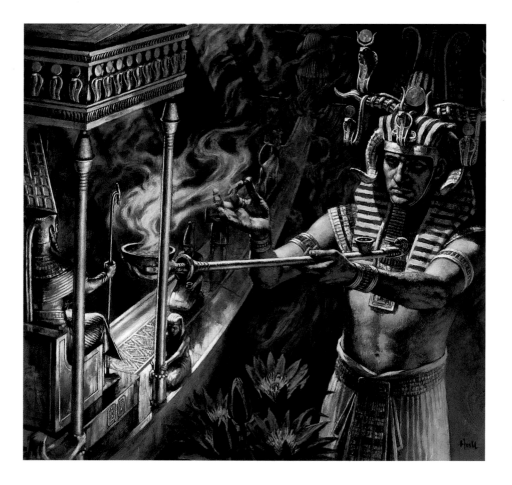

CHRISTOPHER A. KLEIN

(OPPOSITE) ARTISANS OF THE AFTERLIFE:
THE VILLAGE OF DEIR EL-MEDINA WAS HOME
TO THE CRAFTSMEN WHO BUILT
THE ROYAL TOMBS.

———

"VALLEY OF THE KINGS"

September 1998

H. TOM HALL

(ABOVE) FOLLOWED BY PRIESTS, THE PHARAOH ENTERS
WEARING THE SOLAR CROWN WITH SOLAR DISKS, RAMS'
HORNS, AND COBRAS — SYMBOLS OF DIVINE RULE. RAMSES
OFFERS FLOWERS AND INCENSE, DROPPING AN AROMATIC
PELLET INTO A BURNER AND WAFTING SMOKE TO THE GODS.

———

"RAMSES THE GREAT"

April 1991

Staff artist Christopher Klein traveled to Egypt twice to research this painting of an artisan's village in the Valley of the Kings. The first time, he never got beyond the office of Egypt's Director of Antiquities, where the crew from NATIONAL GEOGRAPHIC sat for three days hoping to get a permit to visit the tombs at Luxor. After it became evident that the situation was hopeless, they were called back to Washington, D.C. Klein returned to Egypt six months later, this time with all the proper permits. Once he reached his destination, the weather was oppressive. He remembers that his hotel had no air conditioning and the heat, combined with a three-day Egyptian wedding celebration going on next door, conspired to keep him awake for several miserable days. "The wind would come down from the mountains; I've never experienced anything like it," Klein recalls. "It was like opening the doors of an oven. But then you'd go into the valley and into the tombs, where it was cool and it was worth all the hardships to see the most fabulous art in the world." Klein feels a kinship to the ancient artists whose work he has had the opportunity to study during his tenure at NATIONAL GEOGRAPHIC. Their talent is obvious to him, and he considers them just as skilled as anyone working today. Only their tools were different.

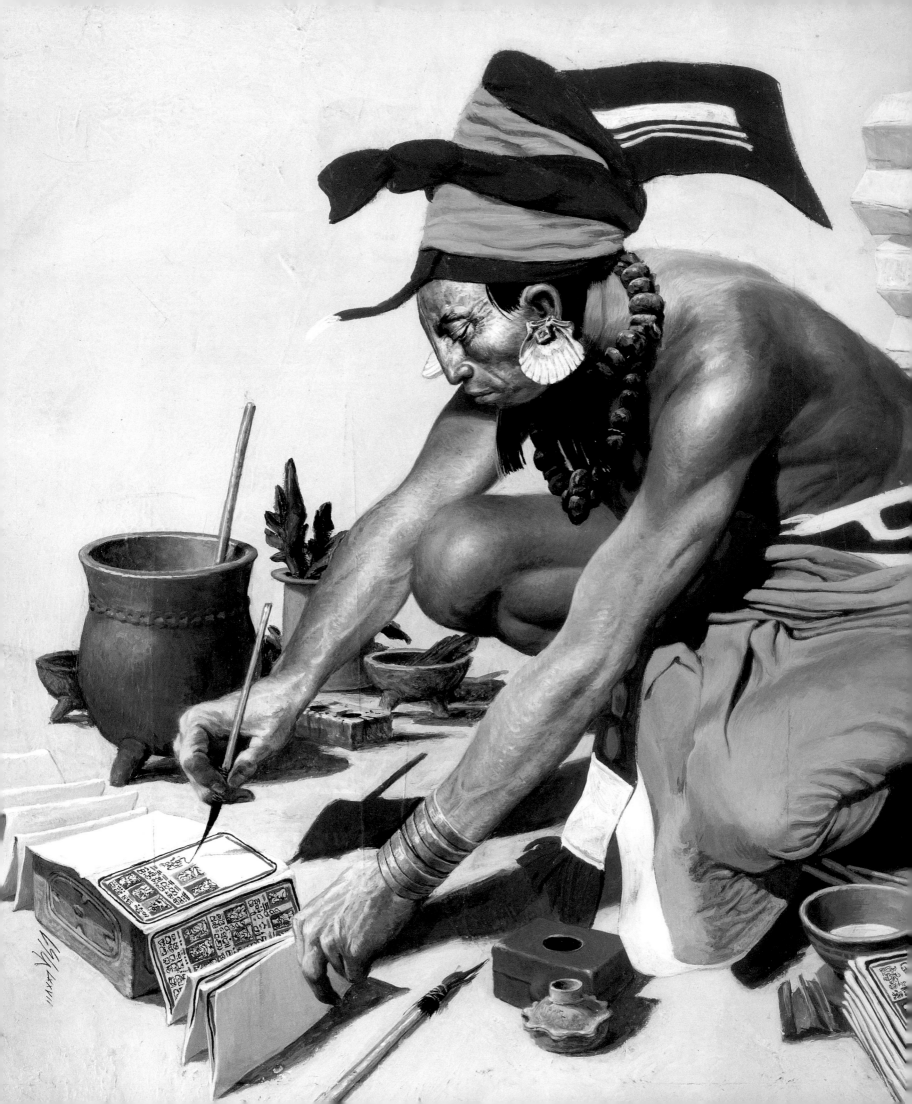

LOUIS S. GLANZMAN

A SCRIBE COPIES A TEXT FROM THE CLASSIC
PERIOD AS A SERVANT SMOOTHES A BARKPAPER
STRIP WITH A WOODEN MALLET AND ANOTHER CHECKS
A THIN WHITE PLASTER COATING. FOLDED LIKE
A SCREEN, SUCH STRIPS MAKE UP A
HANDWRITTEN BOOK, OR CODEX.

———————

THE MYSTERIOUS MAYA

1 9 8 3

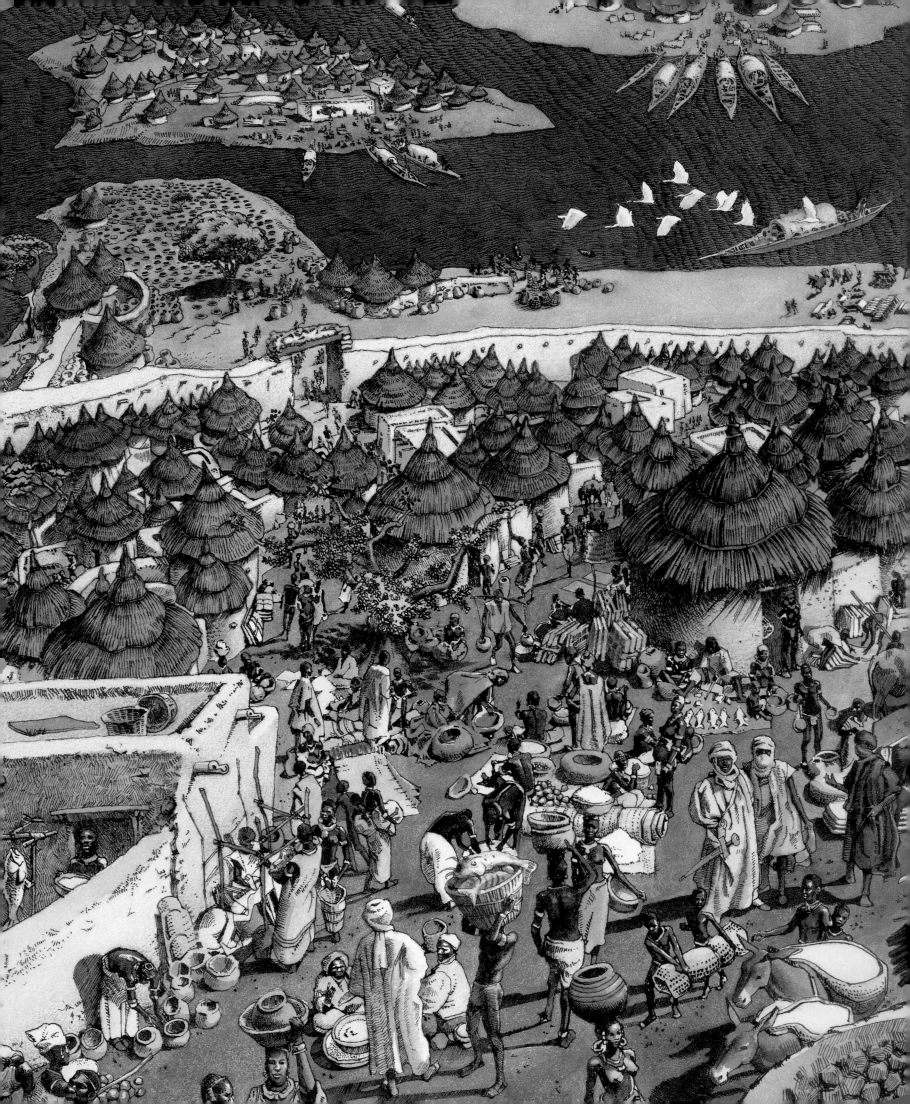

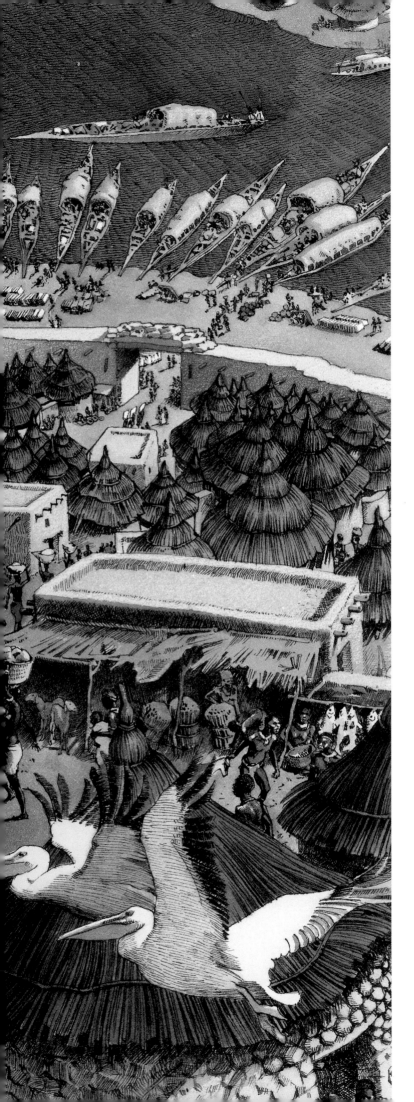

CHARLES SANTORE

꠸꠸꠸

THE HUM OF LIFE ECHOES
FROM JENNE-JENO'S MARKETS CIRCA A.D. 1000,
AS INHABITANTS GATHER TO BARTER RICE
AND MILLET, BASKETS AND POTTERY, AND FISH.

———

"FINDING WEST AFRICA'S OLDEST CITY"

September 1982

Charles Santore spent more than six weeks working on this historical recreation of the West African city of Jenne-jeno. He began the project by flying from his home in Philadelphia to Houston to discuss the assignment with the discoverers of the site, husband-and-wife team Susan and Roderick McIntosh, both professors of anthropology at Rice University. Santore spent several days at Rice going over thousands of slides of the excavations. He also studied contemporary photographs, assuming that the modern residents of West Africa probably resembled their ancestors. "Working with the McIntoshes was very fruitful," Santore recalls. Both the artist and the archaeologists were satisfied with the final painting, which Santore says went surprisingly smoothly.

LOUIS S. GLANZMAN

꠸꠸꠸

SEAMEN OF A.D. 1450 BEACH
THEIR DUGOUTS AND UNLOAD THEIR WARES: ON THE
LARGEST CRAFT A CANOPY SHADES A VISITING DIGNITARY
AND HIS CONSORT. WOMEN CAME FROM AFAR TO
THE OFFSHORE ISLAND OF COZUMEL TO WORSHIP IXCHEL,
GODDESS OF HEALING AND OF CHILDBIRTH.

———

THE MYSTERIOUS MAYA

1983

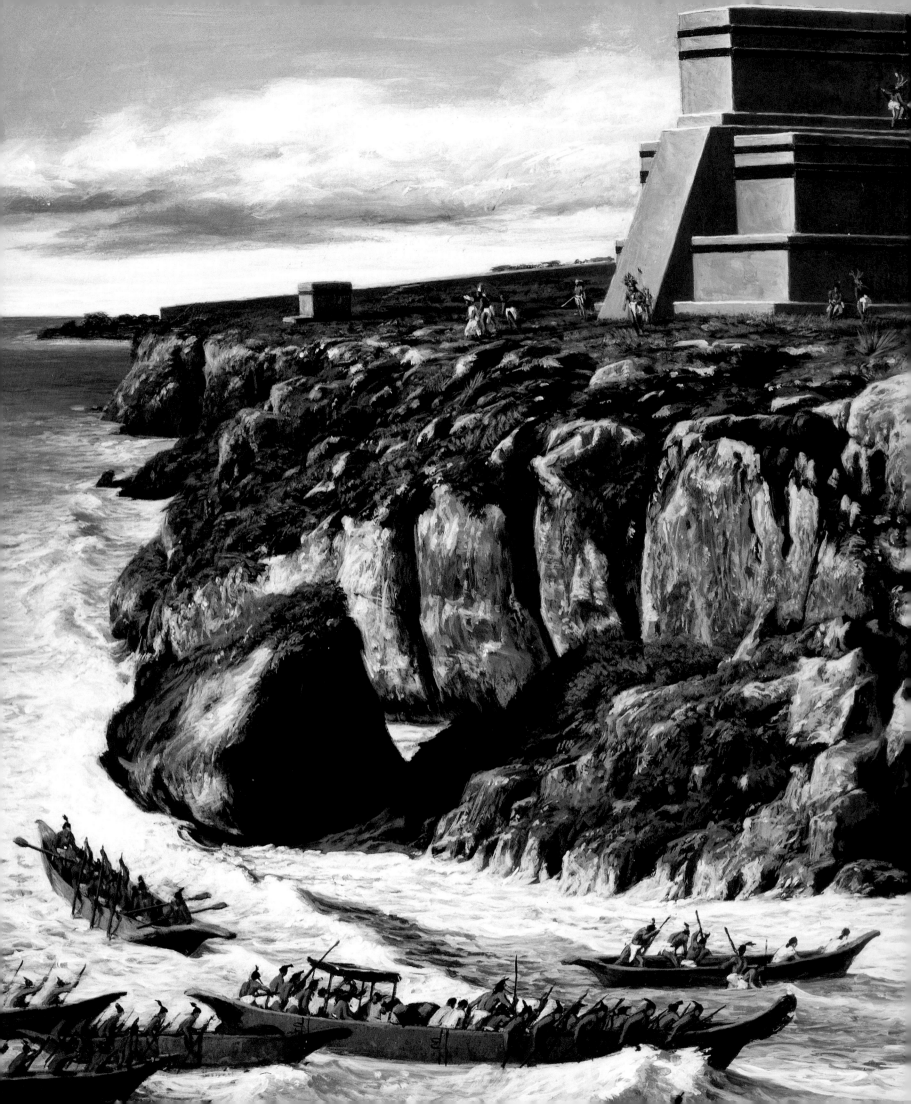

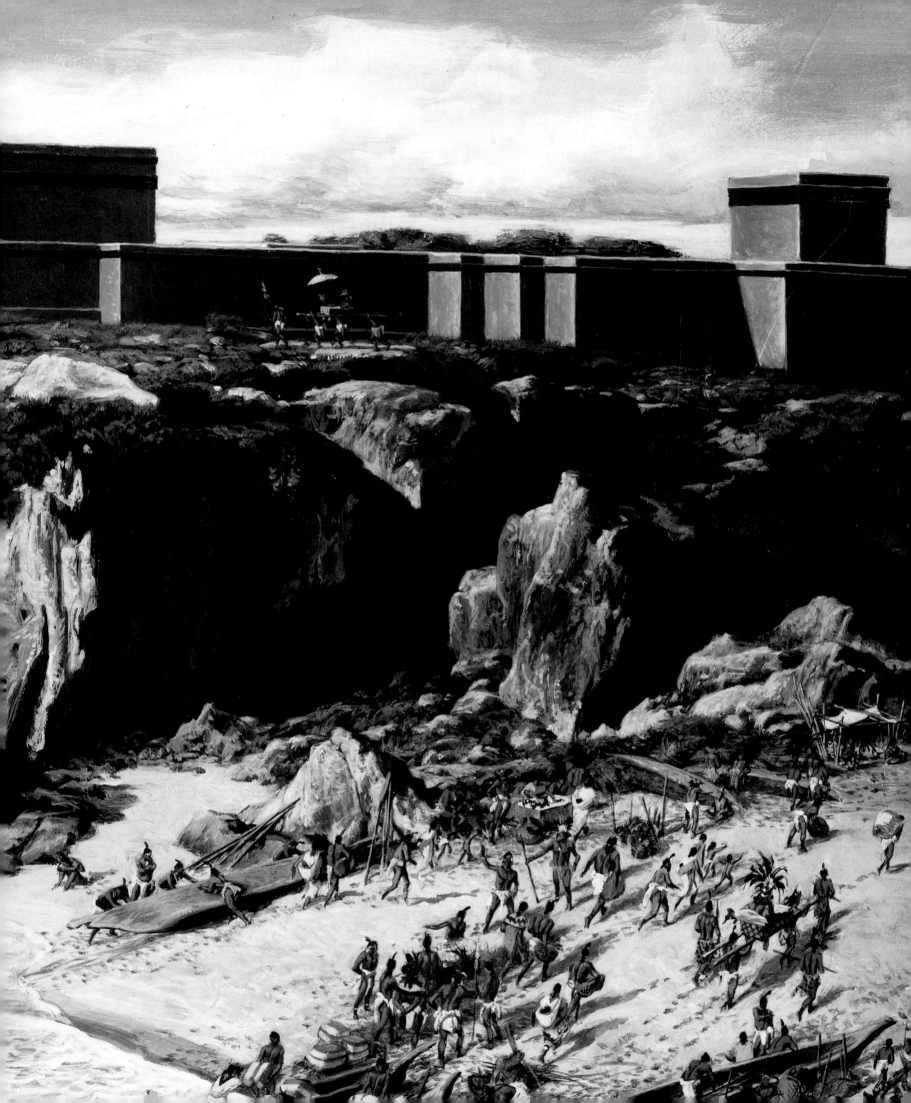

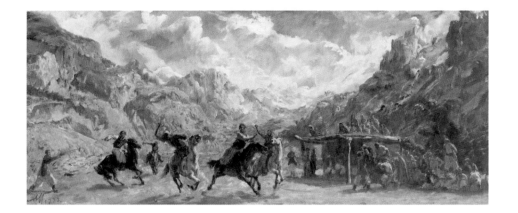

ALEXANDRE IACOVLEFF

(ABOVE & OPPOSITE) THEIR MALLETS SWINGING,
RACING RIDERS HIGH ON A ROCKY PLATEAU DRIVE
THE WOODEN BALL TO ITS GOAL.

———

"WITH THE NOMADS OF CENTRAL ASIA"

January 1936

In 1931–32, Russian artist Alexandre Iacovleff traveled across Asia, from the Mediterranean coast of what was then Syria to China, with the historic Citroën-Haardt expedition; Maynard Owen Williams was the National Geographic Society representative on the journey. The caravan of explorers crossed the continent in tractors until faced with the dangerous passes of the Himalaya, where they were forced to abandon their vehicles and continue for 700 miles on horseback and camels. It was during this difficult phase of the journey, on the cold plateaus of the Himalaya, that Iacovleff painted the canvas reproduced here. Sometimes the temperature plunged as low as 35 degrees below zero, and Iacovleff, his hands cracked by the cold dry air, warmed his palette over an open fire to keep his paint from freezing. Only 11 men completed the entire journey from Beirut to Beijing, which covered 7,370 miles.

JEAN-LEON HUENS

(FOLLOWING PAGES) THREE GENERATIONS OF 7,000
YEARS AGO GATHER AT EVENING IN THEIR
WATTLE-AND-MUD HOUSE. THIS ARTIST'S RENDITION,
BASED ON ARCHAEOLOGICAL DATA, PORTRAYS THE SELF-
SUFFICIENT FARMING FAMILY IN A ONE-ROOM HOME
EQUIPPED WITH BONE TOOLS AND CLAY VESSELS;
RUSH MATS COVER THE EARTHEN FLOOR.

———

"ANCIENT BULGARIA'S GOLDEN TREASURES"

July 1980

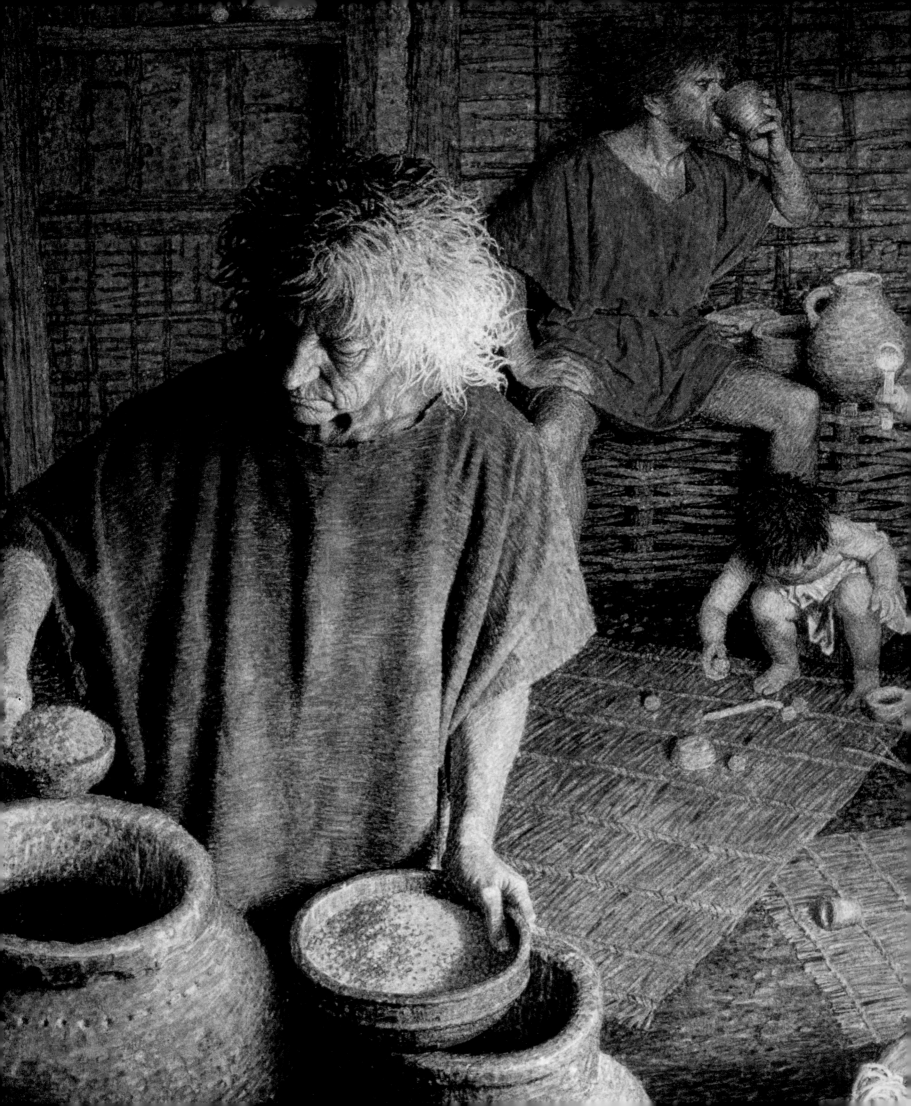

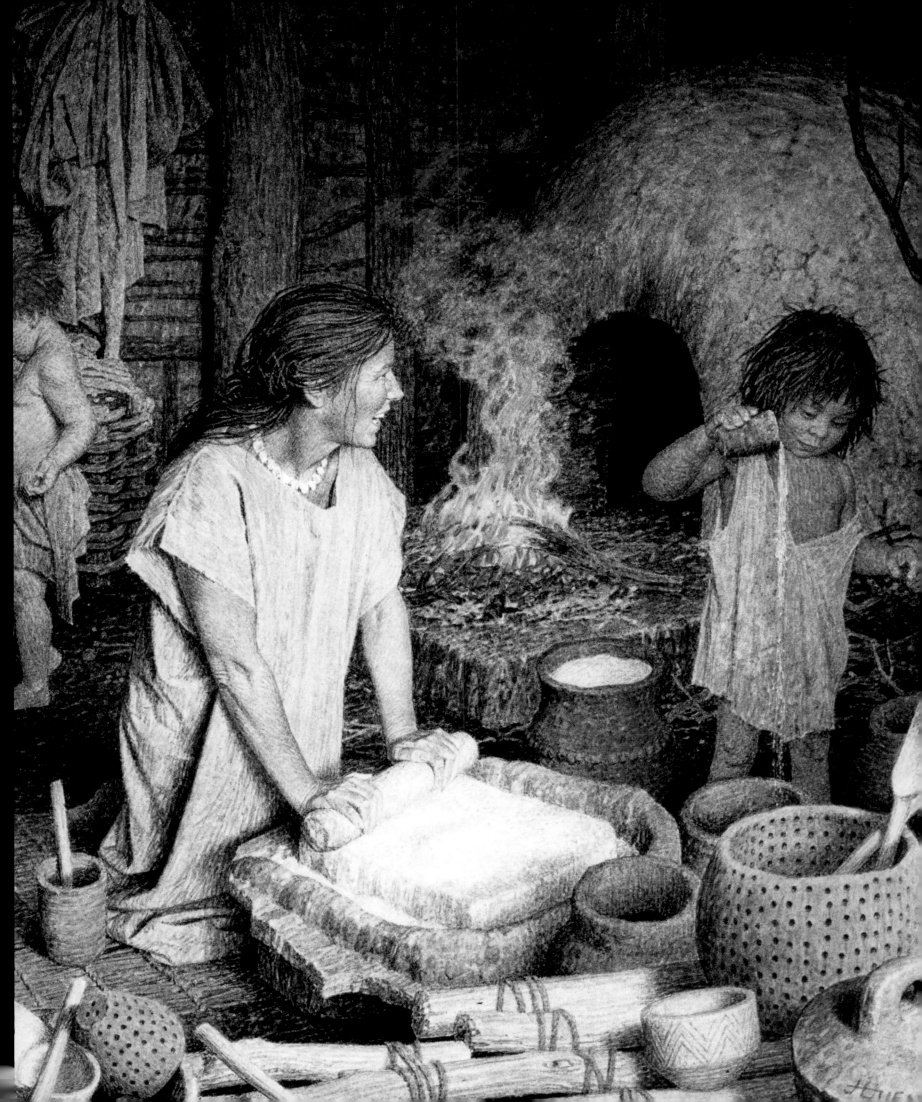

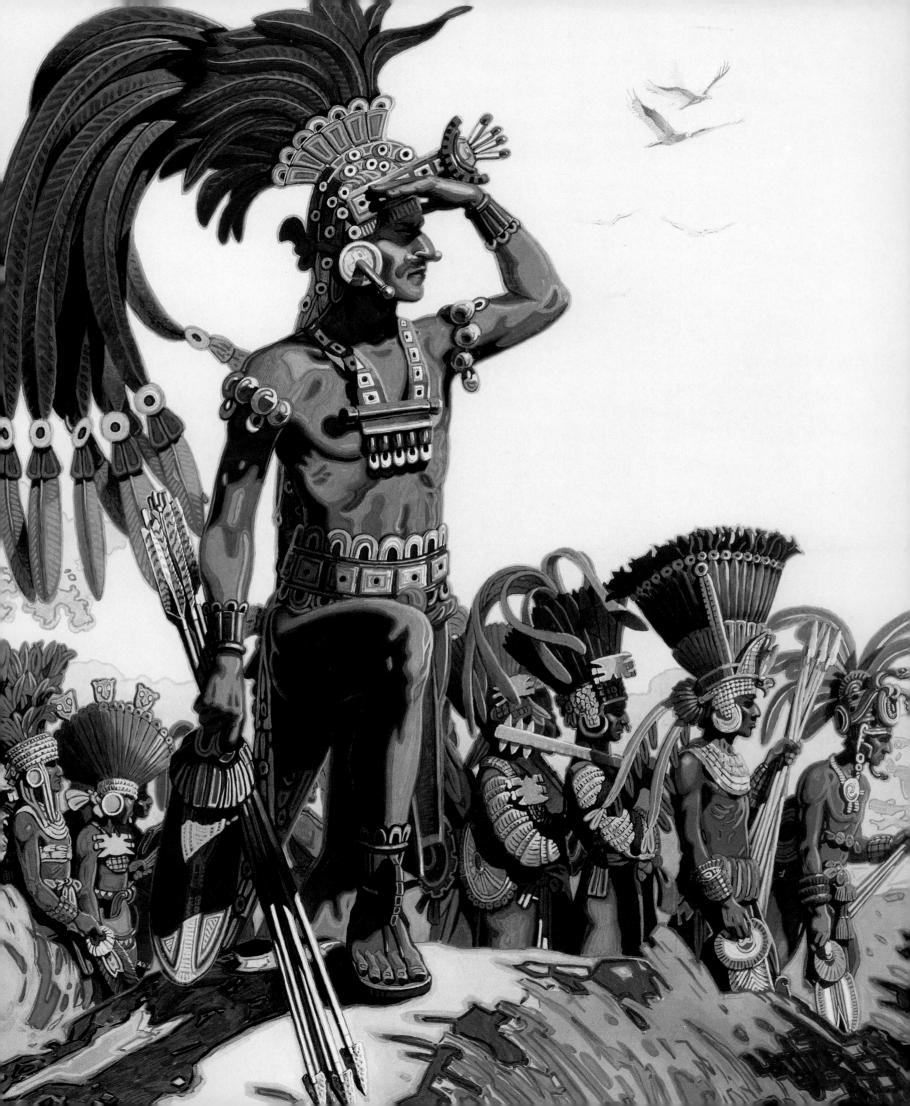

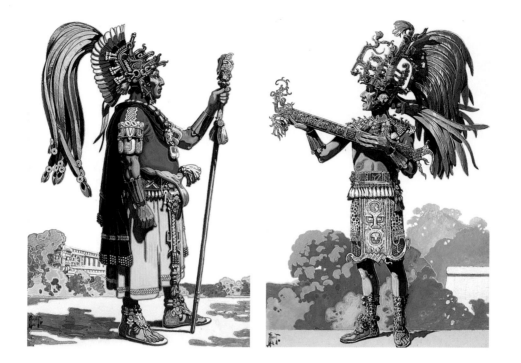

HERBERT M. HERGET

(ABOVE LEFT) ELEGANT AND COLORFUL ATTIRE CLOTHED A PORTLY NOBLE.

(ABOVE RIGHT) QUETZAL BIRD AND JAGUAR SUPPLIED HIS RAIMENT.

(OPPOSITE) BRONZED WARRIORS LOOK WITH STOLID PRIDE UPON
A CITY THEIR FORBEARS CONQUERED.

———

"LIFE AND DEATH IN ANCIENT MAYA LAND"

November 1936

Herbert Michael Herget was a private man whose personal life remained a mystery during the 15 years he painted for NATIONAL GEOGRAPHIC. After publishing Herget's illustrations in the magazine for eight years, Franklin L. Fisher, Chief of the Illustrations Division, who didn't even know the artist's first name, requested a biography. Herget supplied only a few lines that attested to the fact that he was a life-long resident of St. Louis and had attended Washington University there. "Other than that," Herget wrote, "I don't think there is much more to say. Details would bore you I am sure." Although the Society paid him well for his paintings, when Herget died in February 1950, he was apparently penniless. After his death, a perplexed acquaintance wrote a letter to the Society requesting information about the evasive artist. "What astonished us about Mr. Herget was – what did he do with his money? When I knew him he lived in North St. Louis in an upstairs flat without any show of income, either by furnishings, clothing, or external living. As I recall he neither smoked nor drank and lived very quietly with his wife, producing oil paintings when commissioned to do so. His life to those who knew him was an enigma."

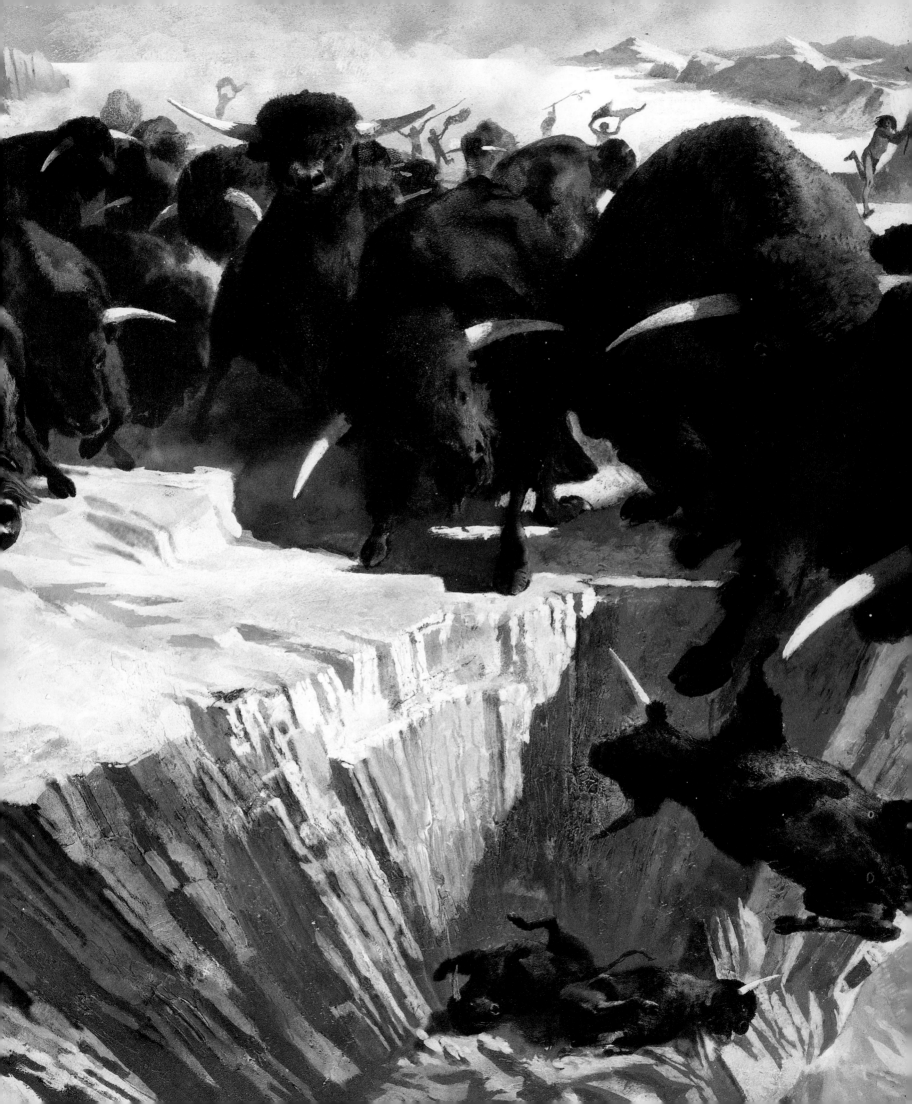

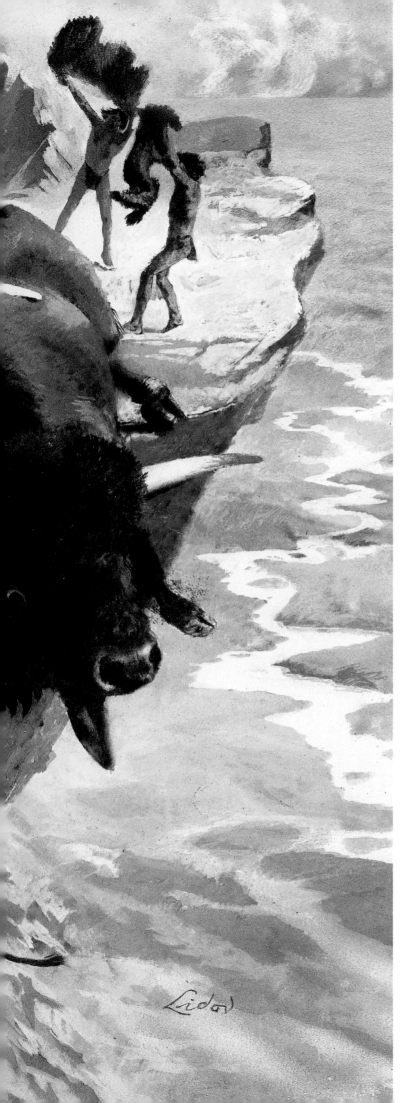

W. LANGDON KIHN

(ABOVE) ABOVE A RAPID, HIS CHIEF'S EXCLUSIVE
FISHING GROUND, A TSIMSHIAN SPEARS SALMON.

"INDIANS OF OUR NORTHWEST COAST"

January 1945

ARTHUR LIDOV

(LEFT) THUNDER FROM THE GROUND ECHOES
ACROSS THE PLAINS AS HUNTERS OF PERHAPS A HUNDRED
CENTURIES AGO STAMPEDE BISON OVER A CLIFF.

WORLD OF THE AMERICAN INDIAN

1974

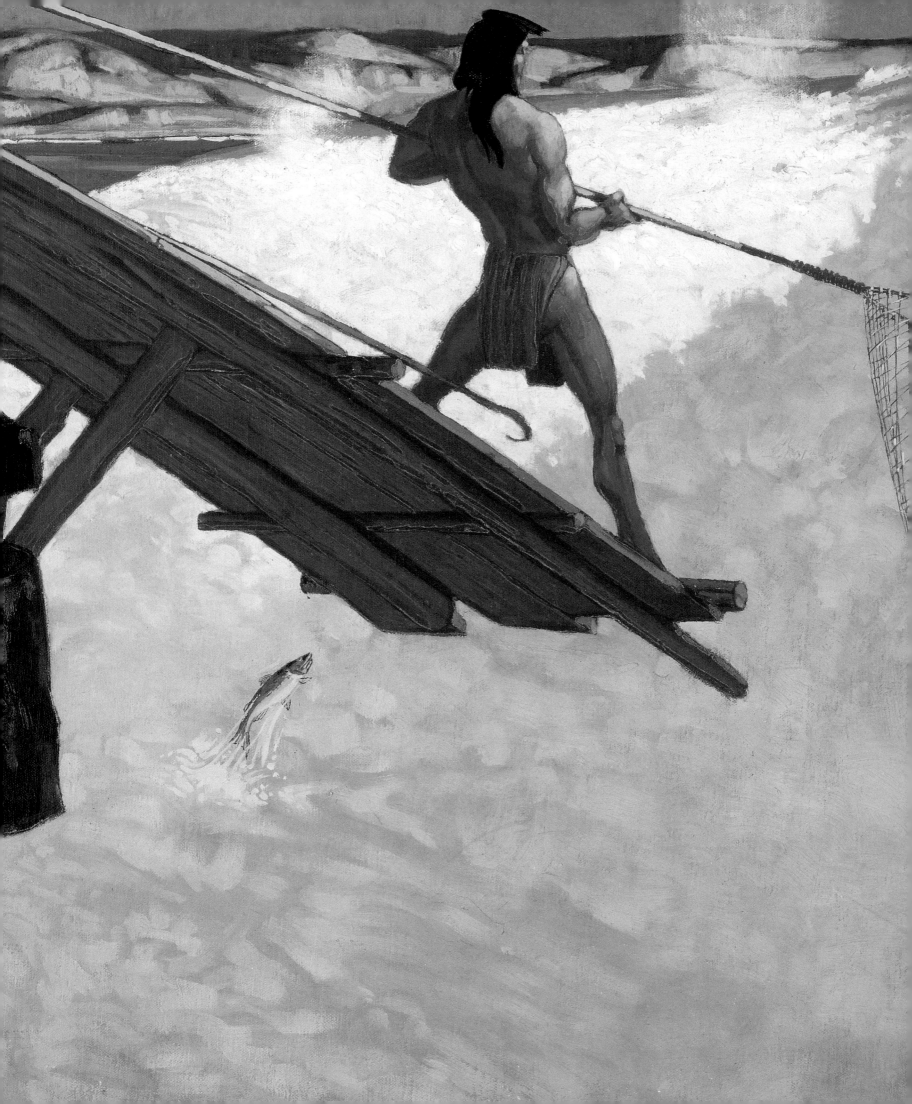

W. LANGDON KIHN

(ABOVE) CANOE MAKERS WERE
MASTER CRAFTSMEN OF THE CHIPPEWA.

———

"WHEN RED MEN RULED OUR FORESTS"
November 1939

(LEFT) BRACED ON HIS ANCESTRAL FISHING STAND,
A COLUMBIA RIVER INDIAN NETS SALMON IN THE
CHURNING WATERS OF CELILO FALLS.

———

"INDIANS OF THE FAR WEST"
February 1948

(FOLLOWING PAGES) WITH HIS LAST ARROW, A HUNTER
TAKES AIM AT THE MOOSE HE HAS TRAILED
THROUGH THE SNOW.

———

"AMERICA'S FIRST SETTLERS, THE INDIANS"
November 1937

W Langdon Kihn

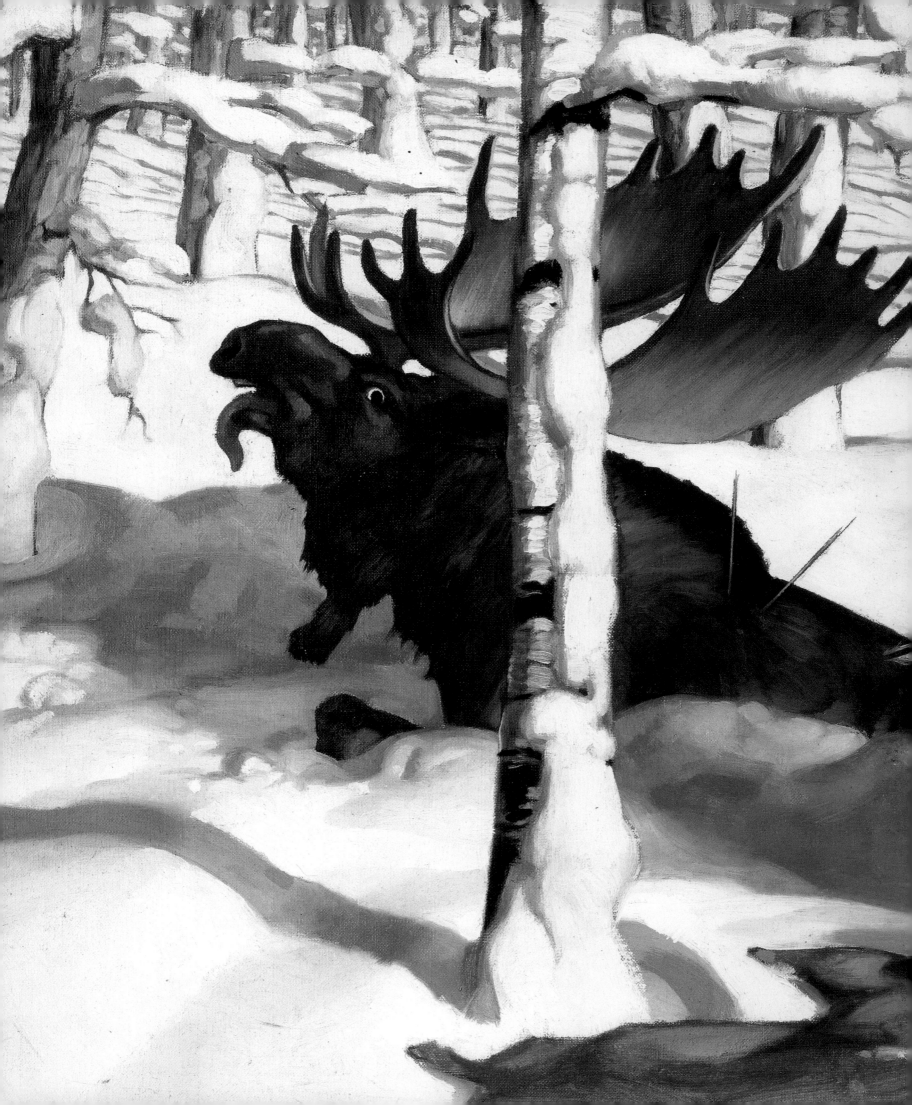

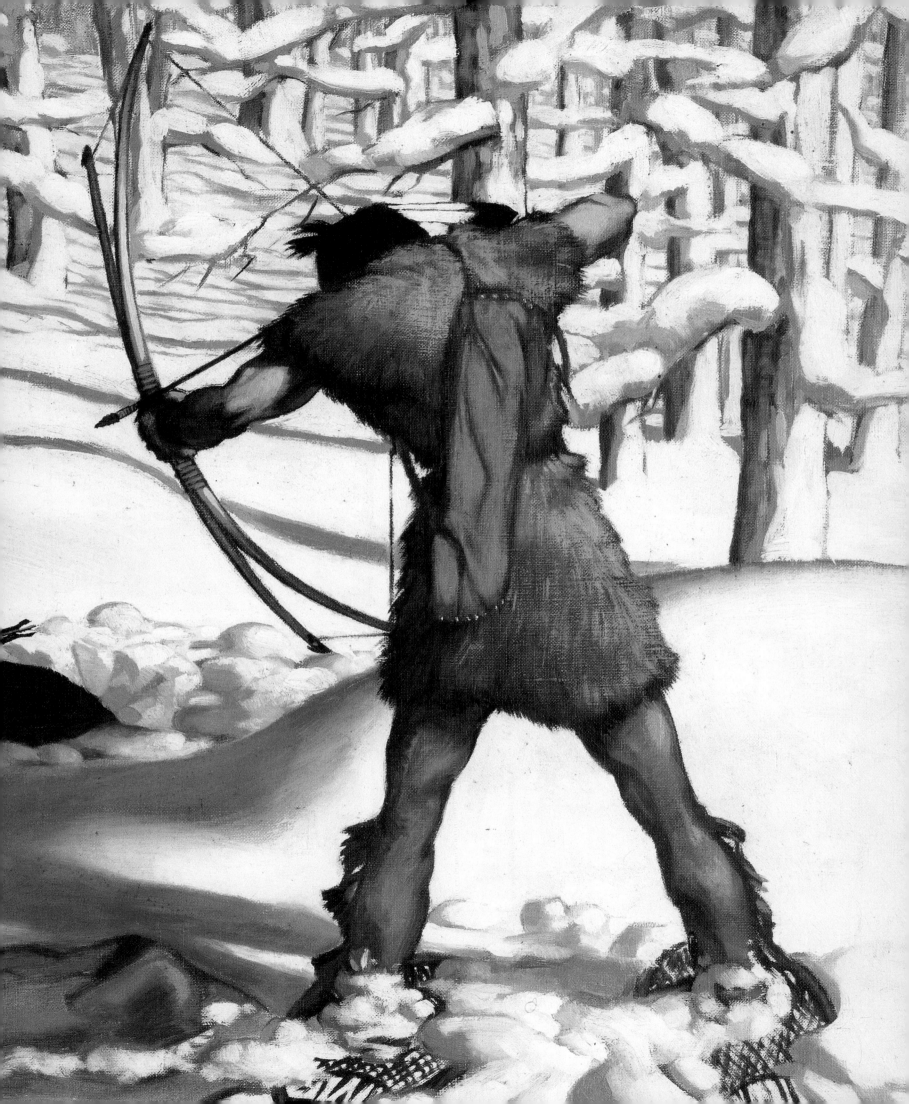

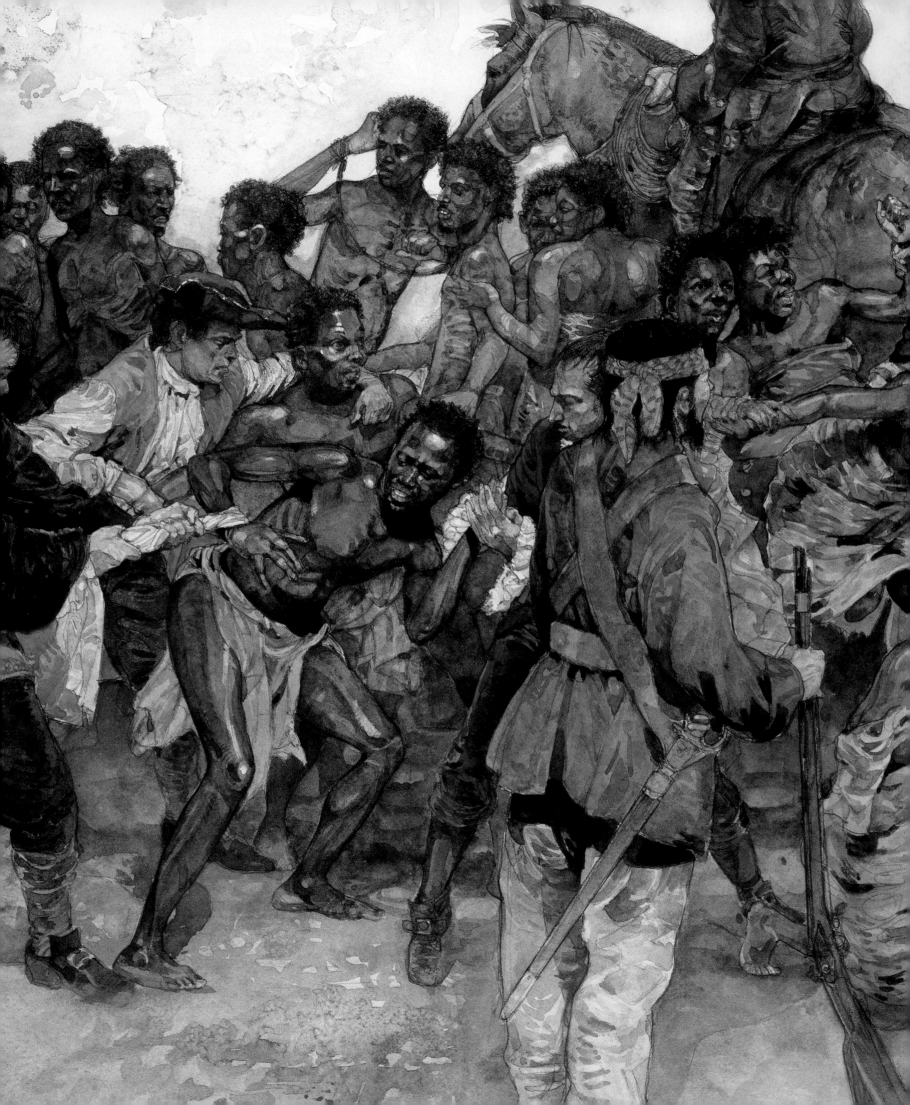

JERRY PINKNEY

(ABOVE) THE YOUNG WARRIOR IS CAPTURED.

(LEFT) SURVIVOR FOR SALE: UPON DOCKING IN
BRAZIL'S RIO DE JANEIRO, THE AFRICANS ARE SHOVED
TOWARD A CROWD OF WAITING WHITE MEN. ONE FIRES A
GUN IN THE AIR TO START THE "SCRAMBLE" AUCTION WHERE
SLAVES ARE GRABBED, BUNDLED TOGETHER WITH ROPES
AND SASHES AND SOLD FOR A SET PRICE.

———

"AFRICAN SLAVE TRADE:
THE CRUELEST COMMERCE"
September 1992

Jerry Pinkney received a gold medal from the New York Society of Illustrators for this painting of a scramble auction, which he describes as the most difficult assignment of his entire career. "As an African American, I really feel a strong emotional connection to the piece," Pinkney recalls. "It was important for me to show that the enslaved Africans were human beings. I wanted to make the viewer feel the disorientation that the captives might have felt after suffering that much time in the middle passage, not knowing where they were going to end up." Pinkney wanted to give some sense of dignity to the victims in the midst of their trials. "It demanded a lot of me to tell that story," Pinkney says, "the horror of it all, and at the same time their heroic will to survive."

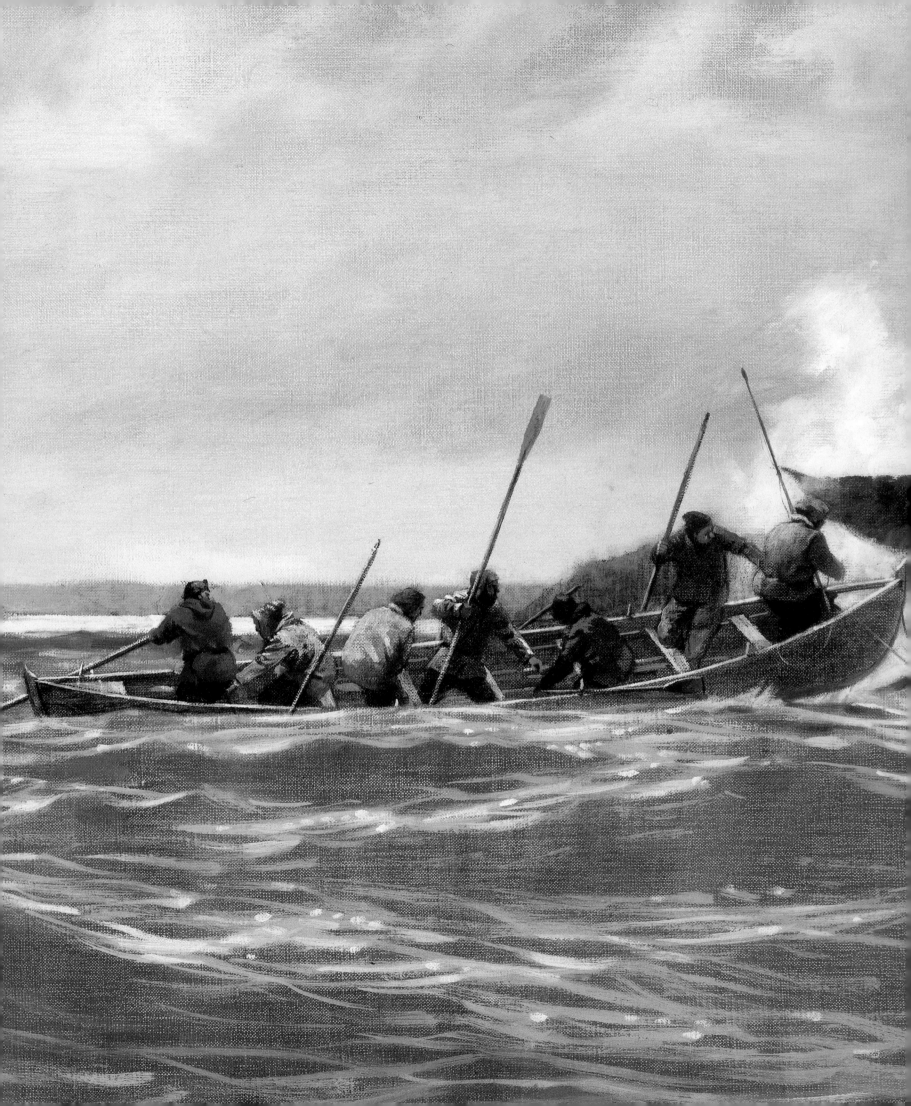

RICHARD SCHLECHT

THRUST OF DEATH DRIVES A LANCE DEEP INTO
THE BACK OF A RIGHT WHALE AS IT SOUNDS NEAR
RED BAY. THE SIXTEENTH-CENTURY BASQUE WHALEBOAT,
OR *CHALUPA*, WAS TOO FRAGILE A CRAFT TO WITHSTAND
A NANTUCKET SLEIGHRIDE — THE WILD TOW THAT
OFTEN ENSUED CENTURIES LATER WHEN STURDIER NEW
ENGLAND BOATS MADE FAST TO A WHALE
WITH A HARPOON LINE.

———————

"16TH-CENTURY BASQUE
WHALERS IN AMERICA"

July 1985

(FOLLOWING PAGES) SEWING THE WHALE'S MOUTH SHUT
SEALS IN BUOYANT GASES AND KEEPS WATER
FROM SINKING THE CARCASS AS MAKAH WHALERS
IN 36-FOOT CANOES TOW IT TO SHORE.

———————

"1491: AMERICA BEFORE COLUMBUS"

October 1991

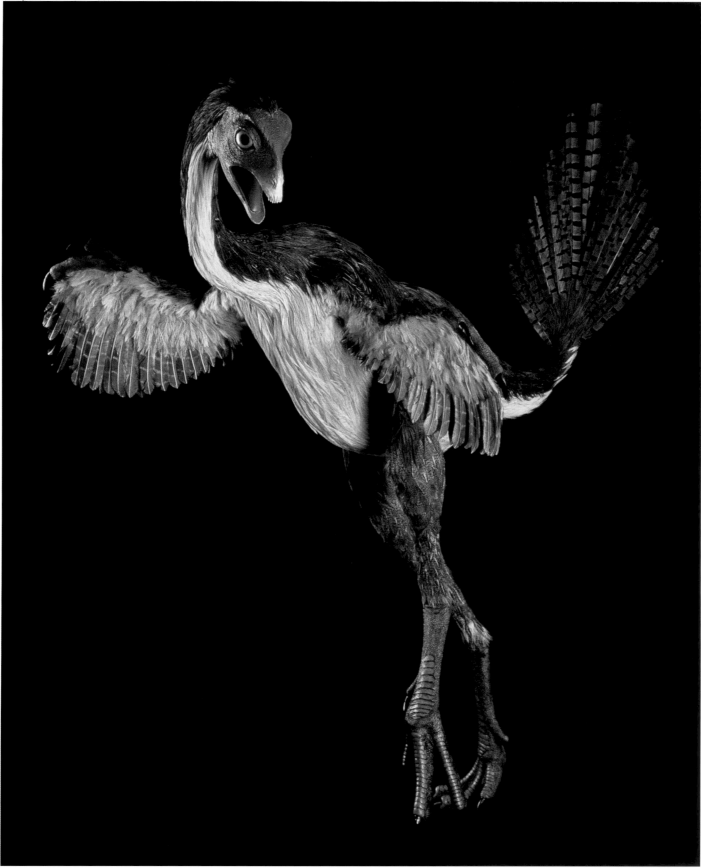

Brian Cooley's flightless, feathered dinosaur.

The Art of Adventure:
Behind the Scenes at National Geographic
Christopher P. Sloan
Art Director, NATIONAL GEOGRAPHIC magazine

The flickering lights of headlamps 50 feet below me were no consolation as I dangled from a ladder as wobbly as a broken spider web. I was in the center of a deep black pit called La Sima de los Huesos, at Atapuerca in north-central Spain. Someone or something tossed dozens of our ancestors down this hole 300,000 years ago, and no one knows if they were dead or alive when they fell. Their bones, mixed with those of hapless animals that accidentally fell in, form a dense bed at the bottom of the pit. I wondered if my bones would join the pile.

What was I doing there? I was on assignment for NATIONAL GEOGRAPHIC's Art Division. Photography is forbidden in the cave, but I obtained special permission to prepare an illustration. Armed with pencil and paper, my job was to take the few minutes I had in the cave to figure out what the illustration had to show. Working from my sketches and my notes about colors in the pit, artist Richard Schlecht later created the first depiction of what may have taken place at Atapuerca in prehistoric times. His dramatic pen and watercolor illustration appeared in NATIONAL GEOGRAPHIC in January 1996.

Great effort goes into each piece of artwork presented in NATIONAL GEOGRAPHIC magazine and the Society's books. Artists, art directors, and researchers often travel to gather information, but they accomplish the bulk of their work in their offices and studios, where "travel" means going to a library or the nearest photocopy machine. High standards for aesthetics and accuracy have forged a unique system at NATIONAL GEOGRAPHIC that Schlecht, a veteran of many assignments, calls "a

discipline all its own." Few readers are aware of what this discipline entails.

Each art piece goes through a process that involves research, sketches, the final rendering, and — throughout the process — several reviews by experts. The life cycle of each project is different, however. Some quietly plod on for years; others are brief and chaotic.

"Designing artwork to make it exciting so that readers will stop and look at it is the most difficult part of the process," says Bill Bond, a veteran of 30 years as a staff illustrator at NATIONAL GEOGRAPHIC. "The painting part is a breeze." Bond is a jack-of-all-trades. He paints rats and dogs, planets and volcanos, cathedrals and skyscrapers. He even painted the Society's familiar globe. Because he is so versatile, he frequently has made last-minute changes to the final art of other artists by matching their styles. Bond was painting pictures for NATIONAL GEOGRAPHIC that enchanted me as a kid. Little did I know that, years later, I would be the art director to send him on one of his last assignments before he retired.

In 1994, Russian archaeologists discovered an unplundered Pazyryk tomb on a plateau in the Altay Mountains. They planned to open the tomb within days, and chances were high that there was a body frozen in the coffin. Within 48 hours, Bond was in the air over Siberia. A shaky Russian helicopter was rearranging his bones as it thundered for five hours toward the 7,500-foot-high plateau.

Bond huddled around the excavation with television crews, photographers, and others to sketch the

layout of the tomb. The nauseating smell of death wafted up from the pit as sacrificial horses, once frozen in permafrost, rotted in the sun. In the evenings, Bond retreated to a cold hut with a tundra floor and, in the mornings, sipped instant coffee made from lake water filled with insect larvae. Each of the several days he was there, he returned to the putrid tomb to obtain information and to review sketches with the archaeologists.

In the end, his drawings were transformed into a painting of a noblewoman, draped in gold, lying in her coffin. It was among the very first published reconstructions of the tomb. When discoveries like this require quick reporting, there is no substitute for sending an artist directly to the scene. By traveling to Siberia, Bond had access to all the information he needed; the visual raw material and the experts were right there.

How do you ensure accuracy when there is very little visual material to work with and the information is vague? That was the dilemma we faced when we began a story about David Thompson, an early 19th-century explorer who mapped much of Canada.

Although Thompson recorded his wilderness adventures in several notebooks, we had no visual evidence of what the explorer looked like, nor the specific places where his adventures occurred. This obviously made it difficult to illustrate a dramatic event such as Thompson's canoe capsizing over a waterfall. A photographer can give us a sense of place with landscape pictures, but only an artist can populate a story with historical figures.

I asked Gregory Manchess, who had recently completed his first assignment for the magazine, if he liked canoeing, camping, and hiking. "Count me in," he said,

Painting from left page of sketchbook shows how artist Gregory Manchess's canoe trip in Canada helped him re-create the world of 19th-century explorer David Thompson.

knowing that his skills as a woodsman were more than a little rusty. Manchess was to accompany a writer and a photographer on a canoe trip retracing part of Thompson's route along a remote river in Sasketchewan. The artist immediately began practicing his j-strokes in a rented canoe.

The task at hand was to relive Thompson's experience, but instead of writing in notebooks, Manchess was to fill them with sketches. This was the best way to re-create scenes of Thompson's adventures along the river 200 years earlier.

Six weeks after my phone call, Manchess was on the river battling clouds of mosquitoes and black flies. His art gear consisted of watercolor cakes he made himself, along with collapsible brushes, a water bottle, a camera, and 20 rolls of film. He couldn't pack a regular watercolor pad, so he cut a sketch book in half to form two long horizontal booklets. He filled the books with watercolor sketches, capturing the shapes, actions, and emotions of the canoe trip.

The wilderness Manchess traveled through was unaltered since Thompson's time. "It was like being on a movie set without the actors," he says. "All I had to do for my paintings was insert the people." Since the artist frequently used himself as a model, it is no accident that, in the final illustrations, David Thompson looks like Manchess.

The original plan was for Manchess to prepare oil paintings from his sketches. On his return, however, his sketches stunned us with their freshness and how evocative they were of the outdoor experience a 19th-century explorer might have had. We decided to change our plans and stick with Manchess's sketchbook style.

Painting from right page of Gregory Manchess's sketchbook documenting his canoe trip in Canada.

Brian Cooley spent two-and-a-half months sculpting his model, then placed partridge, pheasant, and rooster feathers on it to achieve a realistic appearance.

Flexibility was also a necessity for Canadian sculptor Brian Cooley's second NATIONAL GEOGRAPHIC project. The project involved the discovery in China of a dramatic new dinosaur fossil. Impressions of feathers attached to the arms and tail of the turkey-size dinosaur were convincing evidence that birds descended from dinosaurs. Certain that this was a hot story, I decided to pull out all stops and hire Cooley to create a lifelike sculpture of the feathered creature. The project turned out to be of the brief, chaotic sort.

Cooley had just completed a clay model of the animal when I received a call from paleontologist Philip J. Currie, who informed me that Chinese scientists had found yet another type of feathered dinosaur. The preservation of the feathers on this new specimen was superior to that of the animal Cooley had just modeled. Two days before Christmas, we held a conference call between Currie in China, Cooley in Canada, and myself. Changing plans would cost valuable time, but we decided to transform our first model into the new animal — *Caudipteryx*.

As Currie called off measurements of the new animal over the phone from China, Cooley — with phone to his ear — lopped off hunks of clay from the model to make the changes. Fortunately for our schedule, the bodies, legs, and necks of the two animals were essentially identical. The artist shortened the tail, reduced the arms by half, and chopped off the head to rework it completely.

"Being in on the discovery gives me an adrenaline rush," says Cooley. "I can't wait to get the model to some kind of realization so we can see it...so we can meet it."

Working over the holiday, the artist completed the clay model. The art department shipped photos of the model to Currie — by then in Denmark — who gave Cooley his comments on New Year's Eve. With the clay model approved, Cooley's work was just beginning. His model was naked, and the job that lay ahead of him would be like putting feathers back on a plucked chicken.

By this time, the magazine's deadline was quickly approaching, so Cooley enlisted the help of his artist wife Mary Ann Wilson, her sister Barbara, and sculptor Lisa Godwin. Godwin prepared the all-important wings of the animal. The others, sometimes all working at the same time, hovered over the three-foot-tall creature and applied thousands of feathers, one by one. Many feathers had to be custom shaped with scissors to make them appear primitive.

On the day the final model was to be flown to NATIONAL GEOGRAPHIC headquarters, the team found itself

short on partridge feathers. They had already gone through six sets of partridge feathers, hundreds of rooster feathers, and fourteen sets of pheasant feathers. As they sat wondering what to do, Cooley's mother-in-law sauntered into the house for a visit. "Look at what I have," she announced. She was holding a dead partridge. During her morning stroll, the bird had collided with a high-voltage wire and dropped dead at her feet! Completely unaware of the feather crisis, she picked up the bird and brought it to the Cooley's house, where it promptly donated its feathers to art.

Phil Currie presented the stunning model of *Caudipteryx* at a press conference when he announced the discovery of the dinosaur-birds. In keeping with its mission of public education, the Society made photographs of the model available to the press. The media covered the story extensively, and Cooley's model was featured prominently in the coverage. Fifty-four million people either read about it or saw it on television.

Artists like Brian Cooley bring a special expertise to their art beyond their aesthetic sense and skill. Scientists rely on reconstructions like these to bring their fossil discoveries to life in the minds of the public, and with years of experience building dinosaurs for museum exhibits, Cooley is now something of an expert in reconstructing the extinct animals. Scientists respect him for his accuracy and attention to detail.

Ken Eward is another artist for whom there is no line between science and art. Trained in physiology and cellular biophysics, Eward creates beautiful images of DNA and complex molecules. Unlike the illustrators mentioned above,

Eward works solely on a computer; his paintbrush is a self-assembled computer system he calls "a Frankenstein."

I commissioned Eward to prepare artwork for a story on the origins of life. Billions of years ago, the planet was an alchemist's cauldron of molecules undergoing chemical reactions. I wanted to show how scientists thought life originated from that chemical soup. The scientist side of Eward could grapple with the difficult chemistry using software designed for chemists. By using graphics software designed for artists, he could make the chemistry beautiful.

Eward put more research into the art project than any other project he had worked on. "It was as much research as I would do for a scientific experiment," he says. Art researcher Hillel Hoffmann put Eward in contact with leading theorists in California and Germany. He spent 15 hours on the phone with them, making sure he understood every detail of the chemical reactions and the early organisms he was depicting.

Preparing art on a computer does not necessarily make the task any easier. Eward says that if he had known what he was getting into, he would have run away screaming. To achieve the complex visual effects he desired for this project, Eward had to master new software and experiment with new techniques, some of which he stumbled on accidentally. "It was a steep learning curve," says a reflective Eward, "but I grew more as an artist working on that project than at any other time."

Many artists dream of an assignment from NATIONAL GEOGRAPHIC. What does it take to be seen on

one of those pages? As you can see from these examples, the artwork that appears in the magazine and the Society's books is the result of a tremendous effort. Each illustration you see on the pages of this book is like a reflection on the surface of a pool. It is beautiful, but there is much underneath it that you cannot see. Talented artists, art directors, editors, researchers, and expert consultants all contribute to the final result. "This isn't a job for the fiercely independent, 'creative' artist," says Richard Schlecht. "There is creativity, of course, but it has to be within the framework of the factual needs and editorial content of the job at hand."

Schlecht is right. The purpose of art in the magazine is to inform, but if the art is beautiful, that's all the better. It is certainly something we strive for, and achieve often, as this book amply attests. Being an artist for NATIONAL GEOGRAPHIC is not easy, but to artists with the same thirst for knowledge that members of the National Geographic Society have, it is rewarding. As Bill Bond puts it, "You never stop learning."

Eward experimented with different models and lattices to capture an atom's-eye view of chemistry in the primordial soup.

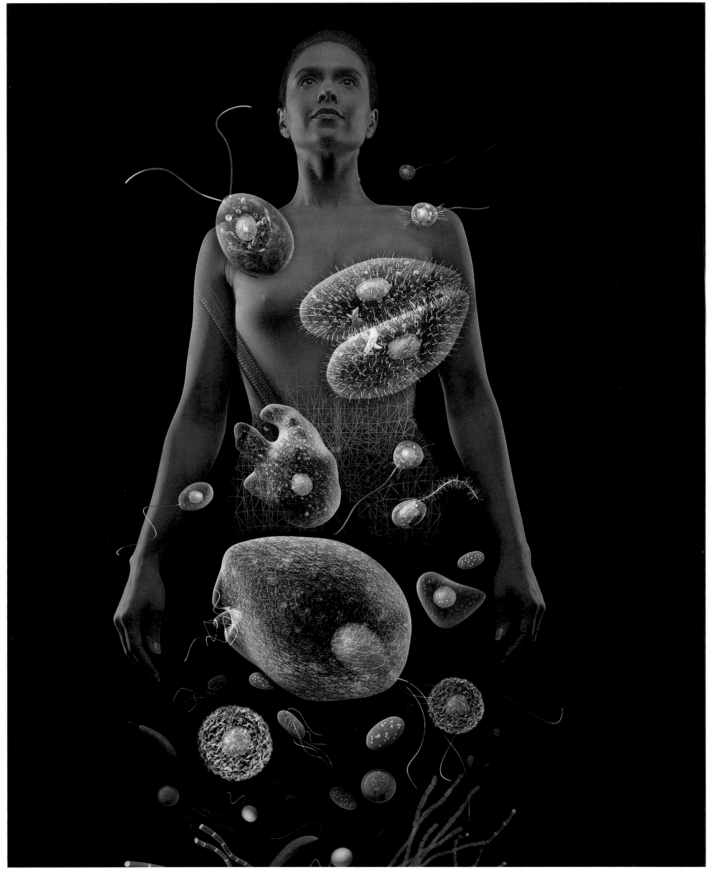

Computer artist Ken Eward's illustrations of early life-forms combined with a photograph of a woman create a evocative image recalling humanity's kinship to microbial life.

230

The artists whose work is included in The Art of National Geographic *have enjoyed careers as diverse as the subject matter they have depicted collectively. What they share is a connection to the National Geographic Society, either as freelance artists or as staff members. The unique career path each has taken is profiled briefly in the following biographical index. The numbers at the end of each entry indicate the pages where the artist's illustrations are reproduced.*

ROY ANDERSEN studied at both the Chicago Academy of Fine Art and the Art Center School of Design in Los Angeles. Some of his paintings that were used as covers for *Time* magazine are in the collection of the National Portrait Gallery; he also contributed a series of illustrations for stamps for the U.S. Postal Service. A resident of Sedona, Arizona, Andersen is working on a series of oil paintings of the American West. 189

A native of England, **ARTHUR BEAUMONT** (1891–1978) served for many years as the official artist of the U. S. Navy. He painted on-site at battles during World War II, as well as at Bikini Atoll when nuclear testing was under way there. His paintings have been exhibited at the National Gallery of Art, at the White House, and at naval bases throughout the United States. 168, 169

A resident of Lans, Austria, near Innsbruck, **HEINRICH BERANN** has painted European landscapes ranging from Mount Aetna to the Black Forest, many of them done with a panoramic perspective. In preparation for his wide-angled view of the Himalayan Mountains in the Everest region, he spent a month in India and Nepal and consulted with cartographers and Himalayan experts before beginning the 600 hours of work at his drawing board needed to complete the illustration. 86–87

PETER BIANCHI was a staff illustrator for NATIONAL GEOGRAPHIC for more than a decade in the 1950s and 1960s. An expert in historical re-creations, Bianchi's complex paintings covered a wide range of subject matter. In addition to appearing in the magazine, his work was included in the books *Everyday Life in Bible Times, The Age of Chivalry,* and *Great Adventures: Exploring Land, Sea, and Sky.* 49

A native of Washington, D.C., **CHARLES BITTINGER** (1879–1970) studied physics at MIT before leaving in 1901 for the École des Beaux Arts in Paris. He enjoyed a successful career as a painter; his work was exhibited at the National Arts Club, the Art Museum of St. Louis, and the Metropolitan Museum of Art. 172–173, 176, 177

THOMAS BLACKSHEAR II graduated from the American Academy of Art in Chicago and worked for both the Hallmark Card Company and Godbold/Richter Studio before becoming a freelance illustrator in 1982. He has designed many stamps for the U.S. Postal Service, including 28 portraits of famous African Americans for the 1992 Black Heritage series. Blackshear's commercial clients also include Anheuser-Busch, Jim Henson Studios, Milton Bradley, and Embassy Pictures. 54–55, 62

Born in London, **WILLIAM H. BOND** began his career in art after serving in the Royal Navy during World War II. He graduated from the Twickenham School of Art. Bond spent 15 years living and working in Toronto before moving to the United States, where he joined the staff of NATIONAL GEOGRAPHIC in 1966. The illustrator for several U.S. postage stamps, he is known for his depiction of subjects in natural history and physical sciences. 166

ELSE BOSTELMANN (1882–1961) attended the University of Leipzig, Germany, and the Grand-Ducal Academy of Fine Arts in Weimar; she had a one-woman exhibition of decorative pen-and-ink drawings in Berlin in 1909. She then moved to the United States and, between 1929 and 1934, accompanied oceanographic expeditions to Bermuda. During these trips, she created oil paintings underwater, using a diving helmet at depths of fourteen feet. 90, 91

Born in India, **ALLAN BROOKS** (1869–1946) traveled widely before and after World War I military service. He was a wildlife enthusiast and big-game hunter as well as an illustrator, and he was a member of both the American and British Ornithological Unions. While living in British Columbia in the 1930s, the National Geographic Society commissioned him to paint hundreds of illustrations for a series of ten articles on bird families of the United States and Canada. 141

PAUL CALLE was born in New York City and studied art at the Pratt Institute there. His career as an illustrator began when he was 19 with an assignment from *Liberty* magazine. Calle was named the official artist of the NASA Fine Arts Program; he created the illustration used for the U.S. postage stamp commemorating the Apollo lunar-landing mission. 146

An active marine and nature artist, **ELIE CHEVERLANGE** lived in Washington, D. C., and painted for the National Geographic Society during the 1930s. He later joined the staff of the Communicable Disease Center as an illustrator, and subsequently spent several years living in Tahiti. 128, 129

EDITH S. CLEMENTS (1874–1971) was born in Albany, New York, and received a Ph.D. from the University of Nebraska in 1904. She later moved to California, where she worked in an outdoor studio, and traveled back to the Midwest to find the floral specimens she painted for NATIONAL GEOGRAPHIC. She also published two books of illustrations: *Flowers of Mountain and Plain* (1925) and *Flowers of Coast and Sierra* (1928). 126, 127

KINUKO Y. CRAFT was born in Japan, where she attended the Kanazawa Municipal College of Fine and Industrial Arts. Craft's illustrations are sought after by both advertising agencies and publishers; her clients include AT&T, Celestial Seasonings, *Time, Atlantic Monthly,* and *Sports Illustrated.* Her painting illustrating the Dallas Opera's production of *Madame Butterfly* received a gold medal from the New York Society of Illustrators. 154, 155

WILLIAM CROWDER's association with the National Geographic Society spanned 21 years. During that time, he wrote, illustrated, and took photographs for four articles and contributed paintings for a fifth. His interests were as diverse as his talents, ranging from tiny slime molds to the aurora borealis. 118,119

JOHN D. DAWSON, whose family says he began drawing seriously at age three, studied at the Art Center College of Design in Pasadena. His meticulous illustrations have been published in *Audubon* and *Ranger Rick* magazines, and in the *World Book Encyclopedia;* other clients include the National Park Service, Chevron, and the American Museum of Natural History. He is co-author, with Charles Craighead, of the 1995 book *Grand Canyon: An Artist's View.* 98–101, 114

VINCENT DI FATE has produced more than 3,000 illustrations of science fiction, astronomical, and aerospace subjects. His work is included in many museum collections, including those of the Smithsonian Institution's National Air and Space Museum and the New Britain Museum of American Art. His many awards include both the Hugo and the Frank R. Paul Awards. Di Fate is the author of the 1997 book *Infinite Worlds: The Fantastic Visions of Science Fiction Art,* a history of the field. 190, 191

ANDRE DURENÇEAU trained at the École Des Beaux Arts and the Germain Pilion in Paris before moving to the United States. After teaching for five years, he began a career in freelance illustration; among his clients were hotels, ocean liners, and the 1939 World's Fair in New York. Durençeau also worked as a muralist, creating murals for prominent families such as those of Cornelius Vanderbilt Whitney and Morris Cafritz. 48

Born in Gloucestershire, England, **MARY E. EATON** (1873–1961) studied art at several schools, including the Royal College of Art. After moving to the United States, she created illustrations for the New York Botanical Gardens for 21 years. Eaton made 672 paintings for the National Geographic Society; some 200 were published in the magazine and in the Society's 1924 *Book of Wildflowers.* 124, 125

A graduate of the University of Pennsylvania, **RICHARD ELLIS** is known for his marine natural history illustrations. Among his many publications are *A Book of Whales* (1985), *A Book of Sharks* (1989), and, with John E. McCosker and Al Giddings, *Great White Shark* (1995). He has also contributed more than 30 articles to magazines such as *Audubon* and *Geo.* Ellis has

led cruises for the American Museum of Natural History to destinations such as Alaska and Antarctica. 111–113

A native of Devon, England, **CHRIS FOSS** briefly studied architecture at Cambridge University before turning to a career as an illustrator. Drawing on his boyhood fascination with transportation, he has become known for his dramatic illustrations of airplanes, ships, and space vehicles. His sketches for an early but unrealized film version of the Frank Herbert novel *Dune* led to a career depicting futuristic and fantasy subject matter. 182

GEORGE FOUNDS has created illustrations for such clients as William Morrow & Company, the National Wildlife Society, the American Optometry Association, and the U.S. Department of the Interior. After more than a decade as a commercial illustrator, Founds left the freelance field in 1988 to teach full-time; he teaches graphic design at LaRoche College in Pittsburgh. 108, 109

LOUIS AGASSIZ FUERTES (1874–1927) was born in Ithaca, New York, and graduated from Cornell University. After studying art with Abbott H. Thayer, he undertook many expeditions through the Western Hemisphere making sketches and collecting bird skins. Fuertes illustrated more than 35 books and contributed paintings to more than 50 other publications. His works are in the collections of the American Museum of Natural History and the Academy of Natural Sciences in Philadelphia. 103–106

ERICH J. GESKE, a botanist affiliated with the College of Medicine of the University of Cincinnati, wrote and illustrated two articles for NATIONAL GEOGRAPHIC. His detailed watercolors in "Beauties of Our Common Grasses,"

published in June 1921, and "Marvels of Fern Life," from May 1925, showed their subjects as a microscope would reveal them. 94

JOHN GURCHE combines his skills as a sculptor and illustrator with degrees in paleontology and anthropology to create his images of prehistoric subjects. His illustrations have appeared in periodicals such as *Discover*, *Natural History*, and *Smithsonian*. Four of his paintings of dinosaurs appeared on U.S. postage stamps in 1989, and his paintings and sculptures are a part of exhibits at the Denver Museum of Natural History, the Smithsonian Institution, and the American Museum of Natural History. 20–21, 25–27, 29, 51.

Not trained formally in art, **LOUIS S. GLANZMAN** taught himself to draw by studying classic texts on anatomy, reading *Art Instruction* magazine, and taking a correspondence course. Following military service, he sold his first paintings to *True* magazine in 1948; his work was also seen in *Collier's*, *Life*, *Saturday Evening Post*, and *Cosmopolitan*. Glanzman's painting commemorating Robert F. Kennedy appeared on the cover of *Time* magazine on June 14, 1968. 198, 202–203

JAMES M. GURNEY, best known for his critically acclaimed *Dinotopia* books, studied anthropology at the University of California, Berkeley, and art at the Art Center College of Design in Pasadena. After early work with illustrators such as Ralph Bakshi and Frank Frazetta, Gurney went on to provide cover illustrations for more than 70 books. He has created illustrations for Ace Paperbacks, backgrounds for animated films, and stamps for the U.S. Postal Service. 28

H. TOM HALL studied art at the Tyler School of Fine Art and the Philadelphia College of Art. He began freelance work in 1957 and illustrated children's books for 12 years before turning to adult book and magazine illustrations. Known for his adaptability, technical command, and eye for detail, his book covers have graced publications by Bantam, Fawcett, Ballantine, and Avon books. 197

An artist, naturalist, and teacher, **MARK HALLETT** is widely known for his illustrations of dinosaurs. He has painted murals for Natural History Museums in both Los Angeles and San Diego, and his illustrations have appeared in several books on dinosaurs. 31–33

GREG HARLIN is widely recognized for his watercolors of scientific and historical scenes. A graduate of the University of Georgia, he is now associated with Wood Ronsaville Harlin, Inc. of Annapolis, Maryland. His illustrations have appeared in *Smithsonian* and *Kid's Discover* magazines and have won awards from the New York Society of Illustrators, *Communication Arts*, and *American Illustration*. 192–193

KAREL HAVLICEK was born in Prague and attended art school there before emigrating first to Switzerland and then, in 1980, to the United States. He has created illustrations for such institutions as Sea World in San Diego and the American Museum of Natural History in New York; his clients include Delta Airlines, Coca-Cola, J. M. Smuckers, and Weyerhaeuser Paper. He received a Clio award in 1991. 116, 117

HERBERT MICHAEL HERGET (1885–1950) was born in St. Louis and studied art at the Washington University School of Fine Arts

there. An early interest in the native peoples of the Americas led to his creation of more than 150 paintings on early peoples of the Western World for the National Geographic Society. 208, 209

A native of Shangdong, China, **YANG HSIEN-MIN** emigrated to Taiwan at age 17. From 1969 to 1975, he was art director for a successful Taiwanese television company; he moved to the United States in 1975. For his paintings on historical subjects, Hsien-Min uses traditional materials such as rice paper and bamboo, but has developed a unique personal style. His work has been exhibited in museums throughout the country, as well as at the White House. 148

Born in Melsbroeck, Belgium, **JEAN-LEON HUENS** (1921–1982) studied art at La Cambre Academy. His career as an illustrator began in 1943, when his paintings were bought by a publisher for use in a children's book. Huens produced 600 paintings on commission from a tea company that illustrated centuries of Belgian history. 59–61, 74, 76–79, 206–207

A native of Washington, D. C., **ROBERT HYNES** attended the Corcoran School of Art and the University of Maryland. Among the many awards he has received for his natural history paintings is the 1986 Outstanding Children's Book Award from the Children's Book Council, given for the National Geographic Society book *Secret World of Animals*. He has painted 13 murals for the National Museum of Natural History, including a walk-through prehistoric seascape. 107

Born in Saint Petersburg, **ALEXANDRE IACOVLEFF** (1887–1938) was educated at the Imperial Academy of Fine Arts and was an active participant in the Russian avant-garde movement. Drawn to the landscapes and peoples of Asia and Africa, he left Russia in 1917 to travel and practice his art. Iacovleff served as official artist for two motorized vehicle treks sponsored by the Citroën Motor Company, one across the Sahara Desert in 1924–1925 and the other from Beyrouth (now in Lebanon) to Peking, in 1931–1932. 204, 205

Born in Brooklyn, **W. LANGDON KIHN** (1898–1957) studied at the Art Students League in New York City and with the artists Homer Bass and Winold Reiss. On a trip through the western United States with Reiss, he began a life-long series of illustrations depicting Native American cultures. Selections from his more than a hundred paintings were included in the 1983 book *Portraits of Native Americans by W. Langdon Kihn, 1920–1937.* 211–215

CHRISTOPHER A. KLEIN studied art at the University of Maryland and at Cooper Union in New York City. Following several years as a freelance illustrator, he has been a staff artist at NATIONAL GEOGRAPHIC since 1981. Klein's photorealist-surrealist paintings have been included in a number of exhibitions produced by the New York Society of Illustrators. 196

An interest in depicting wild animals led **CHARLES R. KNIGHT** (1874–1953) to his long association with the American Museum of Natural History. A scientist as well as an artist, Knight was the first artist to reconstruct the appearance of extinct animals. The murals he painted between 1911 and 1930, still admired today for their accuracy, were recently cleaned and installed as a part of the museum's newly renovated Lila Acheson Wallace Wing of Mammals and Their Extinct Relatives. 34, 35

ARTHUR LIDOV (1917–1990) painted historical, scientific, and medical illustrations for magazines such as *Fortune, Collier's, Saturday Evening Post, Good Housekeeping,* and *Sports Illustrated.* Although not formally trained in art – his degree from the University of Chicago was in sociology – Lidov's paintings have been exhibited at the Museum of Modern Art in New York, the Art Institute of Chicago, and the National Gallery of Art. 210

TOM LOVELL (1909–1997) was born in New York City and studied art at Syracuse University. Known for his illustrations of American history and the Old West, he was elected to the Society of Illustrators Hall of Fame in 1974. He later moved to Santa Fe to devote his time to painting western subjects, receiving awards from the National Academy of Western Art and the National Cowboy Hall of Fame. 64, 150, 156, 157, 160–161, 164–165

A native of Hong Kong whose family moved to New York in 1971, **KAM MAK**'s interest in painting was awakened through special art classes for inner-city youth. He later studied at the School of Visual Arts. His work has appeared in publications such as the *New York Times Magazine* and *Rolling Stone.* The Laurence Yep book *The Dragon Prince,* which Mak illustrated, received the Openheimer Platinum Medal as the best children's picture book of 1997. 44, 45

GREGORY MANCHESS graduated from the Minneapolis College of Art and Design in 1977. Among the clients for his illustrations are Walt Disney Pictures, Anheuser-Busch, and Polo/Ralph Lauren. His work has been reproduced in magazines such as *OMNI, Scholastic,* and *Atlantic Monthly.* He received a "best of show" award at the 1996 Society of Illustrators Los Angeles annual exhibition. 149

MARVIN MATTELSON has been creating award-winning illustrations for more than three decades. His images have graced the covers of magazines such as *Time, Newsweek, Der Spiegel,* and *Scientific American* as well as books published by Warner, Ballantine, and Simon & Shuster. He has created movie posters as well as record-album packaging. An accomplished portrait painter, Mattelson has received commissions to paint CEO portraits for ITT, NYNEX, and Met Life. 46–47

Born in the Philippines, **JAY H. MATTERNES** studied painting and design at Carnegie Mellon University in Pittsburgh. While an interest in landscape painting led to his career painting murals for natural science museums, he has become expert at depicting early human evolution based on reconstructions of fossil remains. His 1993 mural on primate evolution was installed in the new Hall of Human Biology and Evolution at the American Museum of Natural History. 36, 38–39, 92, 93

SYDNEY MEAD graduated from Art Center College in Los Angeles; his earliest professional assignments came from the Advanced Styling Center of Ford Motor Company. He established his own company, Syd Mead Inc., in 1970, and in the past three decades he has contributed designs to many major motion picture and automotive companies. Among the films to feature his work are *TRON, Startrek: The Motion Picture,* and *Bladerunner.* 185–187

DAVIS MELTZER painted illustrations for NATIONAL GEOGRAPHIC for 25 years, during which he covered subject matter from DNA molecules and evolution to space hardware and ocean-bottom geology. In recent years he has created a number of stamp designs for the U.S. Postal Service, including a portrait of Eddie Rickenbacker, a ballooning aerogramme, and the 15 illustrations that made up the "Celebrate the Century 1920–1929" stamp series. 184

STANLEY MELTZOFF, whose first work appeared in *Stars and Stripes* in the 1940s, created more than 60 cover illustrations for *Scientific American*. His work has also appeared in *Life* and *Saturday Evening Post*. Meltzoff began painting underwater subjects in 1969; the six years he later spent traveling the world to see marlin and billfish in their natural environment resulted in portfolios of paintings in *Sports Illustrated* and *Field and Stream*. 10–11, 110, 152–153

PIERRE MION studied at George Washington University and the Corcoran School of Art. His illustrations depicting topics from oceanography, outer space, and the physical sciences have appeared in *Air and Space Magazine*, *Smithsonian*, and *Reader's Digest*. Mion is known for his rendering of a tsunami that he painted from eye-witness accounts of the tidal wave on Prince William Sound generated by the earthquake there in March 1964. 2–3

HASHIME MURAYAMA (1878–1955) joined the staff of NATIONAL GEOGRAPHIC at a time before reproducing color photography was common. As chief colorist, he both hand-tinted photographs and produced original work. Dedicated to pictorial precision, he was known to have counted the scales of a fish to ensure the accuracy of his paintings. His

watercolors appeared regularly until his retirement in 1940. 96, 97

A native of Pittsburgh, **THORNTON OAKLEY**'s (1881–1953) illustrations reflect the dark industrial landscape of the steam era. He studied architecture at the University of Pennsylvania before training as an illustrator under Howard Pyle. Oakley wrote and illustrated for many magazines, including *Century*, *Collier's*, *Scribner's*, and *Harper's Monthly*. 80–83, 170, 171

FRED OTNES studied at the American Academy and the School of the Art Institute of Chicago. He has developed an approach to illustration that combines traditional techniques, collage, assemblage, and contemporary printing technology. His work has been included in publications such as *Saturday Evening Post*, *Fortune*, and *Reader's Digest*; among his clients for commissioned work are NASA, Exxon Corporation, and the National Academy of Sciences. 72

Now a citizen of Switzerland, **LUDEK PESEK** was born in Czechoslovakia and attended the Academy of Fine Arts in Prague. He became interested in astronomy and space art at age 19 and has created illustrations for books and magazines in Europe and the United States. In the early 1980s, he produced a series of 35 paintings on the planet Mars, and he has painted a number of 360-degree panoramas for projection in the domes of planetariums. Pesek has written several science-fiction novels, which he also illustrated. 178, 180–181, 188

The naturalist **ROGER TORY PETERSON** (1908–1996) was best known for his 50-volume Peterson Field Guide Series; the first,

A Field Guide to the Birds, was originally published in 1934. Peterson's talent for art developed during his childhood in Jamestown, New York, at the same time as his passion for nature. To extend learning about nature education to as many children as possible, he established the Roger Tory Peterson Institute in Jamestown in 1984 to provide nature education to teachers. 40

JERRY PINKNEY is widely known for his illustrations for children's books, for which he has received three Caldecott Honor Medals. He has also received numerous medals from the Society of Illustrators. Pinkney is particularly drawn to African-American subject matter because of the need he sees for those books. His work has been exhibited in more than 20 solo exhibitions and 100 group shows in the United States, Japan, Russia, Italy, Taiwan, and Jamaica. 216, 217

A native of Japan, **KAZUHIKO SANO** studied painting in Tokyo before moving to San Francisco to study at the Academy of Art College in 1975. Among his clients are American Express, Coca Cola, and Lucasfilm. Fifteen of his illustrations are reproduced on the U.S. Postal Service's "Celebrate the Century 1970–1979" series. Sano's work has been shown at the Central Museum, Tokyo, and the Museum of American Illustration, New York City. 42–43

A native of Philadelphia, **CHARLES SANTORE** studied illustration with Henry C. Pitz, Albert Gold, and Ben Eisenstat. His work has appeared in all the major illustration markets, including periodicals, book and record jackets, and advertising. In the mid-1980s, he left his commercial accounts behind for a new career illustrating classic children's stories such as Aesop's Fables, Snow White, and the *Wizard of*

Oz. Santore has received many awards for his work, including the prestigious Hamilton King Award from the New York Society of Illustrators. 200

RICHARD SCHLECHT began his career as a graphic artist while stationed in Washington, D.C. in the Army. Known for his illustrations for science articles and his reconstructions of historical and archaeological sites, his work has been published by Time-Life Books, the National Park Service, and Colonial Williamsburg. He has designed more than 24 stamps for the U.S. Postal Service, including the series commemorating Christopher Columbus's first voyage. 158, 162, 218, 220 – 221

Born in New York and educated at Pratt College and the Art Student's League, **NED M. SEIDLER** worked as a freelance illustrator for 21 years before becoming a staff artist for NATIONAL GEOGRAPHIC in 1967. Since his retirement from the magazine in 1985, Seidler has returned to freelance work and has created designs for a number of stamps for the U.S. Postal Service. His work has been shown at the New York Society of Illustrators and at the Brandywine Museum in Pennsylvania. 73, 84, 85, 120, 122 – 123

Born in Guildford, England, **JOHN SIBBICK** began a career as a freelance artist after being commissioned to illustrate a children's encyclopedia in 1972. He is best known today for his detailed depictions of dinosaurs; his work has appeared in the 1981 book *The Illustrated Encyclopedia of Dinosaurs* as well as in the BBC television series "Lost Worlds, Vanished Lives." 30

A native of Brooklyn, **BURTON SILVERMAN** studied art at the Pratt Institute, Columbia University, and the Art Students League. He has had solo exhibitions in New York, Boston, Philadelphia, and Washington, D.C., and his paintings are in the collections of museums such as the National Museum of American Art and the National Portrait Gallery. Silverman was named to the New York Society of Illustrators Hall of Fame in 1996. 63

BARRON STOREY is an educator and illustrator whose paintings have appeared in such publications as *Smithsonian, Scientific American,* and *American Heritage*; he contributed 14 cover illustrations to *Time* magazine between 1974 and 1984. Among his corporate clients are IBM, Chevron, Paramount Pictures, and McDonalds. Storey's mural of the South American rainforest is permanently installed at the American Museum of Natural History in New York. 130 – 133

HERB TAUSS's only training in art was at the High School of Industrial Arts in his native New York. After a stint as an apprentice in the Cooper Studio, he went on to provide illustrations for magazines such as *Saturday Evening Post, Redbook,* and *Good Housekeeping*. His recent work has concentrated on subjects of social significance such as the Holocaust and the Trail of Tears. He was named to the Hall of Fame of the Society of Illustrators in 1996. 142 – 143

JACK UNRUH studied at the University of Kansas and Washington University, St. Louis; he began his career as an illustrator in 1958. His work has appeared in *Rolling Stone, Audubon, Sports Illustrated,* and *Conde Nast Traveler,* and he has received commissions from commercial clients such as IBM, American Airlines, and Nieman Marcus. Unruh received the Hamilton King Award from the New York Society of Illustrators in 1998. 52, 53, 66

WALTER A. WEBER (1906 – 1979) served as a staff illustrator for NATIONAL GEOGRAPHIC for 22 years. Trained both as a biologist and an artist following an interest in drawing that began in early childhood in Chicago, his first position was with the Field Museum of Natural History. His painting of snowy egrets was reproduced on a 1947 U.S. postage stamp issued upon the creation of the Everglades National Park and was reissued on a special postal card commemorating the 50th anniversary of the park. 134, 136 – 140

ANDREW WYETH's long career as an artist has been recognized by both the Presidential Medal of Freedom, in 1963, and the Congressional Gold Medal, in 1990. His first major exhibition was at the Farnsworth Art Museum in Rockland, Maine, and his work has subsequently been exhibited worldwide. The Center for the Wyeth Family, which opened in Maine in 1998, houses a collection of nearly 4,500 artworks by Andrew Wyeth. 12

NEWELL CONVERS (N.C.) WYETH (1882 – 1945) was born in Needham, Massachusetts, and was a student of Howard Pyle, at the time the country's foremost art teacher. His first commercial sale, in 1903, was a cover illustration for *Saturday Evening Post,* for which he received $60. Between 1911 and 1939 he created widely acclaimed illustrations for more than 25 classic children's books published by Charles Scribner's and Sons. In the 1920s, the National Geographic Society commissioned Wyeth to paint five large murals for its headquarters in Washington, D.C. 68 – 71, 236 – 237, 240

(FOLLOWING PAGES) **NEWELL CONVERS WYETH**
THE CARAVELS OF COLUMBUS, SUPPLEMENT *July 1928*

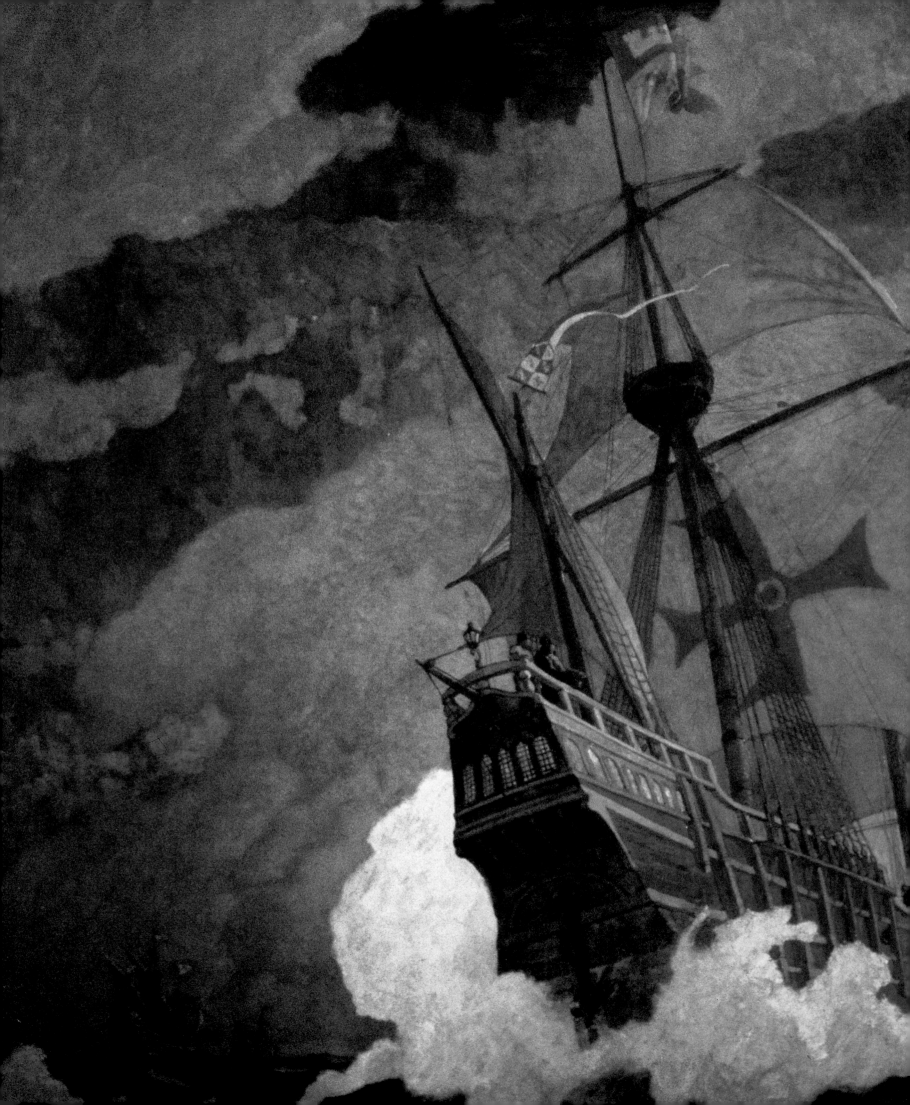

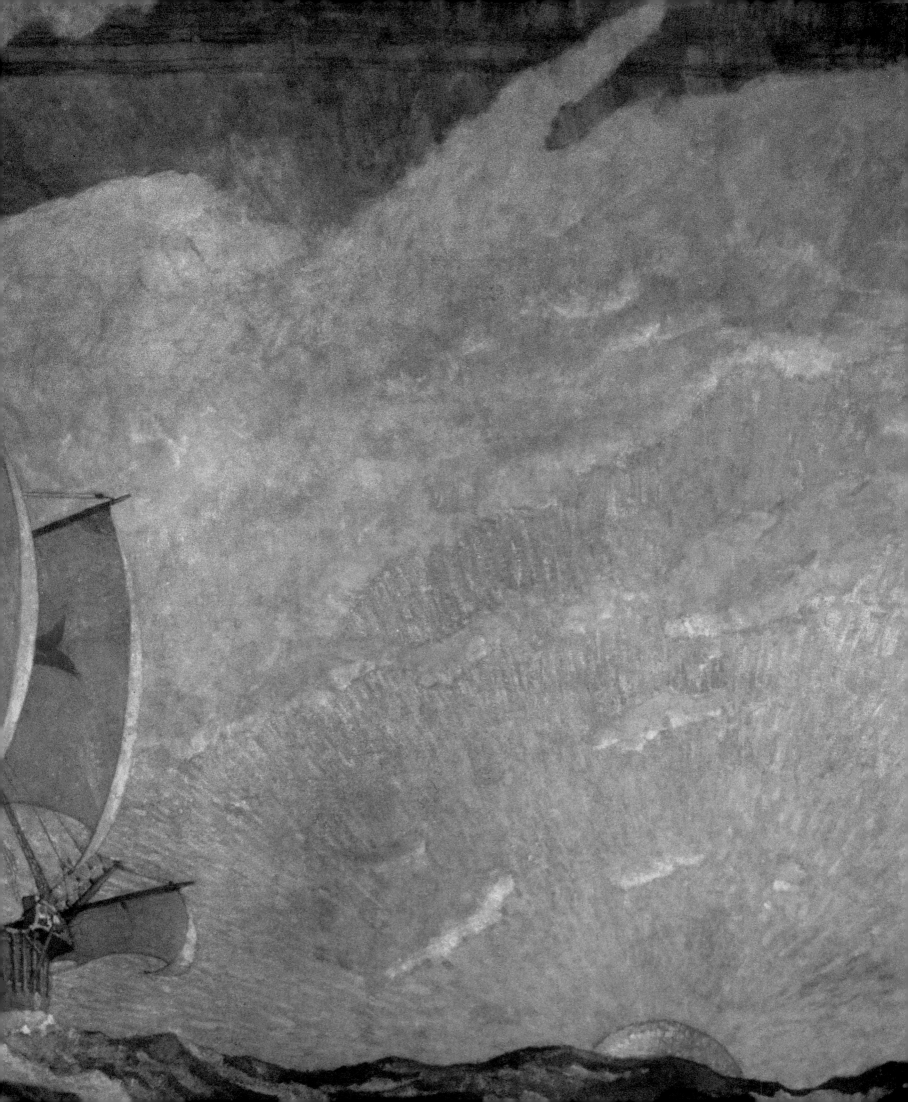

The illustrations reproduced in this book are just a small sample of the wealth of artwork in the National Geographic Society Image Collection, which contains approximately 12,000 drawings and paintings commissioned over the past century. These diverse holdings range from simple charts to priceless paintings; and while some of the work is framed for display at the Society's headquarters in Washington, D.C., most of it is out of public view, carefully wrapped in acid-free paper and stored in a temperature-controlled room.

Retired Senior Assistant Editor Howard Paine, Director of Cartography Allen Carroll, and present NATIONAL GEOGRAPHIC Art Director Christopher Sloan, each of whom share my appreciation for the history of illustration, recognized the value of the paintings in the Image Collection and, for a number of years, sought a venue for bringing this work into the public eye. *The Art of National Geographic* is the direct result of their interest and efforts. Chris Sloan and Howard Paine both have amazing memories for visual images, and selecting the paintings for this book would have been impossible without their help.

Image Collection Archivist Bill Bonner also merits credit for his assistance in curating this volume. Over a period of several weeks, he climbed ladders to retrieve unwieldy canvases and located, unwrapped, and refiled thousands of paintings as we searched out the best pictures. Conservator Robin Siegel was likewise a great help, as was Stephen St. John, Picture Editor for the National Geographic Image Collection, who lent me his office for several hours while I used his computer to search the archives. Staff artist Chris Klein provided a valuable inside look at the extensive amount of research required to complete NATIONAL GEOGRAPHIC assignments. Senior Art Assistant Kris Hannah and Publications Specialist Melissa Hunsiker helped with everything from tracking down paintings to locating artists. Thanks are also due to Leigh Marjamaa for her efforts in securing permissions.

The fascinating history of the National Geographic Society spans a century, and I am indebted to the people who shared that history with me. Gilbert M. Grosvenor, Chairman of the Board of Trustees; John M. Fahey, Jr., President and CEO of the National Geographic Society; and George E. Stuart, Senior Assistant Editor, Archaeology, were all generous with their time, knowledge, and experience. In the Records Library, Andrea Lutov spent hours searching for archival information and turned up letters and photographs unavailable elsewhere.

Finally, thanks are due to the team that created this book on a very tight schedule with good grace and unfailing professionalism. At the National Geographic Society, Senior Vice President Nina Hoffman championed the book from start to finish, and Book Division Assistant Director Charles Kogod coordinated the efforts of the staff members involved. Elizabeth Thompson checked and re-checked all the facts for accuracy, and Becky Lescaze gave the text a final editorial reading. Caroline Herter, of Herter Studio in San Francisco, managed the project with amazing expertise, using her sense of humor to keep the rest of us on track. Editor and writer David Featherstone edited the text, wrote all the artists' biographies, and added invaluable insight. Madeleine Corson, the talented designer for the book, and her staff at Madeleine Corson Design, did a magnificent job presenting such diverse imagery so beautifully. I feel very fortunate to have worked with such capable colleagues.

— Alice A. Carter